www.wadsworth.com

www.wadsworth.com is the World Wide Web site for Wadsworth and is your direct source to dozens of online resources.

At *www.wadsworth.com* you can find out about supplements, demonstration software, and student resources. You can also send email to many of our authors and preview new publications and exciting new technologies.

www.wadsworth.com

Changing the way the world learns®

From the Wadsworth Series in Broadcast and Production

Digital
Moviemaking fifth edition

Lynne S. Gross
California State University, Fullerton

Larry W. Ward
California State University, Fullerton

Australia • Canada • Mexico • Singapore • Spain
United Kingdom • United States

THOMSON
✳
WADSWORTH

Publisher: Holly J. Allen
Assistant Editor: Shona Burke
Editorial Assistant: Laryssa Polika
Technology Project Manager: Jeanette Wiseman
Media Assistant: Bryan Davis
Marketing Manager: Kimberly Russell
Marketing Assistant: Neena Chandra
Advertising Project Manager: Shemika Britt
Project Manager, Editorial Production: Mary Noel
Print/Media Buyer: Karen Hunt
Permissions Editor: Kiely Sexton

Production Service: Ben Kolstad,
 The Cooper Company
Text Designer: Ellen Pettengell
Photo Researcher: Myrna Engler
Copy Editor: Kay Mikel
Cover Designer: Preston Thomas
Cover Images (top to bottom): Getty Images/
 Garry Wade; Getty Images/Roy Massey; Getty
 Images/Steve Vaccariello
Compositor: R & S Book Composition
Text and Cover Printer: Quebecor World/Taunton

For more information about our products, contact us at:
Thomson Learning Academic Resource Center
1-800-423-0563
For permission to use material from this text, contact us by:
Phone: 1-800-730-2214 **Fax:** 1-800-730-2215
Web: http://www.thomsonrights.com

Library of Congress Control Number: 2003101803

ISBN 0-534-56291-4

Wadsworth/Thomson Learning
10 Davis Drive
Belmont, CA 94002-3098
USA

Asia
Thomson Learning
5 Shenton Way #01-01
UIC Building
Singapore 068808

Australia/New Zealand
Thomson Learning
102 Dodds Street
Southbank, Victoria 3006
Australia

Canada
Nelson
1120 Birchmount Road
Toronto, Ontario M1K 5G4
Canada

Europe/Middle East/Africa
Thomson Learning
High Holborn House
50/51 Bedford Row
London WC1R 4LR
United Kingdom

Latin America
Thomson Learning
Seneca, 53
Colonia Polanco
11560 Mexico D.F.
Mexico

Spain/Portugal
Paraninfo
Calle/Magallanes, 25
28015 Madrid, Spain

Contents

Preface

Digital Moviemaking, a concept in its infancy when this book was first published in 1991, has become the norm within a 10-year span. The use of electronic equipment in conjunction with traditional film techniques is now widespread, both academically and professionally. As a result, this fifth edition has had a name change—from *Electronic Moviemaking* to *Digital Moviemaking*—to emphasize the importance of all the digital technologies.

This edition, like its predecessors, is intended to meet the needs of professionals and students who deal with digital moviemaking and want to emphasize the directorial and storytelling functions of the media. Although we concentrate on the narrative moving picture, many of the principles discussed are useful for other forms, such as documentaries, commercials, and music videos. Overall, we focus on the forethought and care that must go into all aspects of production. A book like this cannot avoid the "techno-speak" associated with digital technologies, so we have included the technical information that we feel anyone engaged in production in this area should know. However, our main emphasis is on the creative process: the kinds of decisions that are made and the strategies that are developed.

In this new edition, we have abandoned the *preproduction, production, postproduction* organization because in the digital world these functions overlap much more than they have in the past. Chapters have been reorganized to accommodate this new way of working, and we have added a beginning chapter that overviews the moviemaking process and a final chapter that discusses both complex and simple forms of distribution and exhibition. In addition, there is now a separate chapter on directing.

The remaining chapters follow the previous pattern of a technological chapter followed by a chapter that deals with aesthetic approaches. However, all chapters have been greatly revised because of the advances in digital technology in the past few years. Students now often have much the same equipment as professionals, and everyone can create outstanding titles, visual effects, and audio tracks with minimal cost.

Here is a brief overview of the reorganization for the fifth edition:

Chapter 1 (Overview of Moviemaking) is a new chapter that describes the duties of the various members of the cast and crew and gives a bit of background on the evolution of the moviemaking process.

Chapter 2 (Planning the Movie) contains preproduction information but points out that some of the planning functions are ongoing.

Chapter 3 (Cameras) discusses both film and video cameras and includes a section on the new 24P high-definition digital cameras. It also covers lenses, camera supports, and connectors.

Chapter 4 (Approaches to Image Capturing) explains the principles related to traditional shooting but also encourages filmmakers to experiment.

Chapter 5 (Lights and Filters) places an emphasis on newer fluorescent lighting and talks about the various light meters, lamps, color factors, filters, lighting instruments, and mounting devices used for moviemaking.

Chapter 6 (Approaches to Lighting) compares lighting for film, standard definition TV, and high-definition TV and discusses principles for both indoor and outdoor lighting.

Chapter 7 (Microphones and Recorders) delves into the nature of sound and discusses various types of microphones, cables, connectors, recorders, and mixers.

Chapter 8 (Approaches to Sound Recording) describes the overall principles for recording good sound and then covers specifics related to miking dialogue, ADR, VO, Foley, ambient sounds, and music.

Chapter 9 (Directing) relates the role of the director to interactions with the script, the

writer, the crew, and the cast and covers the director's duties and approaches during rehearsal and shooting.

Chapter 10 (Editing) emphasizes the nonlinear process, discussing how to prepare material for editing and explaining the various stages from logging through outputting.

Chapter 11 (Approaches to Editing) covers the conventional Hollywood continuity editing process and also discusses a number of alternatives to this style of editing.

Chapter 12 (Enhanced Audio, Graphics, and Visual Effects) has a great deal of new material, especially in relation to visual effects. It also details the audio process from spotting through mixing.

Chapter 13 (Approaches to Enhanced Audio, Graphics, and Visual Effects) delves into the various functions of sound and how to achieve them and gives tips for creating eye-catching graphics and functional visual effects.

Chapter 14 (The Final Stages of Moviemaking) is a new chapter devoted to distribution and exhibition and includes a section on digital projection.

We have also included a number of special features that we hope will aid the reader. The glossary defines all the words that appear in the text in boldface print. Many chapter endnotes contain additional content for those who want to understand a subject more deeply. The book's Web site http://communication.wadsworth.com/gross contains useful links, chapter summaries, and sample test questions for students.

This edition includes more than 140 new or greatly revised photos, charts, drawings, and screengrabs. We are greatly indebted to Brian Gross (www.b12x12.com) for acting as photo researcher, photographer, and artwork coordinator, obtaining many new pictures and other artwork for this edition. We also want to thank Michael Swank and Donny Sianturi for their work related to the drawings.

Many movie professionals were consulted during the course of revising this text. They were most helpful in giving up-to-date information, in meeting with us, in allowing access to their facilities, and in reviewing material after it was written. They include Claudia Acosta, editor; Harry Box, 24P camera operator; Matt Compton, line producer and unit production manager; Peter Dana, film laboratory account executive; Mark Dooring-Powell, director of photography; Neal Fredericks, cinematographer; Kevin Gross, computer sound network technology engineer; Wolfgang Hastert, producer and cinematographer; Ann Lu, director/writer; Mark McNabb, production sound recordist; Nancy Malone, director; Robb Navrides, supervising sound editor; Kevin O'Neill, visual effects supervisor; Nancy Robinson, TV Academy visiting artists' coordinator; Jennifer Winslow, sound assistant; and Diane Zaelke, video operations supervisor.

We also want to thank the academics who reviewed the text, namely Mark Biggs, Southwest Missouri State University; Scott Cook, University of North Texas; Tamara Leah Falicov, University of Kansas; Tammy A. Kinsey, University of Toledo; and Richard C. Tomkins, City University of New York.

Finally, we wish to thank the staff at Wadsworth for their input, guidance, patience, and cooperation.

Lynne S. Gross
Larry W. Ward

About the Authors

LYNNE GROSS is a professor at California State University, Fullerton, where she teaches radio-television-film production and theory courses. In the past she has taught at Pepperdine University, Loyola Marymount University, and Long Beach City College.

She has worked in the television business as program director for Valley Cable TV and as producer for several hundred television programs, including the series *From Chant to Chance* for public television, *Effective Living* for KABC, and *Surveying the Universe* for KHJ-TV.

Her consulting work includes projects for Children's Broadcasting Corporation, RKO, KCET, CBS, the Olympics, Visa, and the Iowa State Board of Regents. It has also taken her to Russia, Malaysia, Swaziland, Estonia, Australia, and Guyana, where she has taught production and consulted on both film planning and post-production equipment.

She is active in many professional organizations, serving as a governor of the Academy of Television Arts and Sciences and president of the Broadcast Education Association. She is the author of 10 other books and numerous journal and magazine articles.

LARRY WARD is a professor of radio-TV-film at California State University, Fullerton, where he teaches primarily film and television production and film history and aesthetics.

While at the university, he has produced hundreds of hours of sports and public affairs programming broadcast and cablecast in the Los Angeles–Orange County area. He was producer-director for *The Science Report,* a series of 20-minute educational tapes for sixth-grade students, funded by Union Oil and the Placentia School District. Before that he was director-editor for *The Moving Picture Boys in the Great War,* a one-hour documentary film for Post–Newsweek Television Productions, and *Lowell Thomas Remembers I and II,* a series for public broadcasting.

He has published a number of articles and papers and one other book, *The Motion Picture Goes to War.* He has also served as the western regional coordinator for the Motion Picture Academy's Nicholl Fellowships in Screenwriting Contest.

Digital Moviemaking fifth edition

chapter one
Overview of Moviemaking

It has been said that to create art a poet needs only paper and a pencil, a painter needs only a canvas and paint, but a moviemaker needs a bank and an army.[1] This may be a bit of an exaggeration, but moviemaking is a collaborative art. It is very difficult for one person to be all the actors, the director, the camera operator, the costumer, the audio operator, the editor, and so on. Moviemaking has specialists, and it has a fairly set process. Yet there are many variations from one movie to another.

For example, a science fiction movie will, in all likelihood, deal with more technical special effects than a romantic comedy. A documentary may not need anyone to design sets, whereas a drama may need 20 people to handle the development and execution of sets. Music videos and action adventures might both have scripts, but they will be very different. A commercial may have all the elements of narrative form, but, of course, it is very short. When a movie is shot in a country other than the United States, the Americans working on it may have to alter their styles because production conventions vary from one country to another. People working on a high-budget feature may have many luxuries that students making a first film cannot afford.

Throughout this book we will try to take into account different forms of moviemaking and a variety of ways that directors and others approach their jobs. However, it is impossible to talk of every combination and permutation found in the movie industry. By the time you have finished this book, we hope you will understand the production process for a Hollywood narrative film, know some of the variations used in other situations, and have a thorough grasp of how to produce a quality student film. To that end, we will start by looking at the various duties of moviemaking; then we will explore the essence of the overall process of putting a movie together.

Cast and Crew

Just who are all those people whose names roll past on a movie's credits? No two movies have the same personnel involved. Producers and directors often select people they have worked with in the past. They know these people will perform, and they have worked up "shorthand" with them that enables them to communicate without time-consuming discussions. But each movie brings new challenges and new people, and a comparison of the credits for various movies will show both similarities and differences. Let's begin with a description of the most common moviemaking positions as they relate to the different functions of moviemaking.

Producing

Producers are usually the first people attached to a movie (see Chapter 2). They often come up with the concept and convince movie studios, networks, or individuals to invest in the movie. They hire the writers and directors and often are involved in selecting some of the cast and crew. Once the movie is produced, they see that it is publicized and distributed. The degree to which a producer becomes involved in the actual production depends on the individual. Some producers are mainly dealmakers; once they have made the deal, they hand the day-to-day operation over to others and go off to make another deal.

Several types of producers are often listed in the credits for a movie. **Executive producers** usually oversee several projects at a time and are not involved in any particular project on a day-to-day basis. They sometimes finance a film or set up the financing. In some instances they are studio executives and are listed as executive producer on all the movies their studio (Miramax, Paramount, or 20th Century Fox, for example) produces. Sometimes there are **co-producers**, especially if several people own a company that is working to establish movie projects. **Associate**

CONCEPT
for
A COMMON BOND

Two women in their sixties discover they had the same lover at the same time when they were in their thirties. They set out to find the rogue and along the way experience some unexpected adventures and insights. They also do a little matchmaking for their reluctant twenty-something grandchildren.

Figure 1.1
A concept for a script.

producers work for producers doing whatever jobs producers assign to them, such as looking into **product placement** for a potential film or researching potential investors. Sometimes the associate producer credit is given to someone who performs a special favor for the producer, such as seeing that a script gets into the hands of a particular actor. Producers are not usually on the set during shooting or in the editing room during postproduction, but they may have a representative, a **line producer,** there at all times to make sure everything is progressing on schedule and on budget.

Producers (or line producers) hire **unit production managers (UPMs)** who, in turn, may hire **production coordinators** to help them. A main job for UPMs is the **breakdown** of the script. They read through the script thoroughly, determining all the needs for the movie and making "to do" lists to give to various departments (see Chapter 2). Unit production managers are present during shooting, making sure that everything is in place when it is needed. If one company reneges on delivering a fog machine on Monday, they find another company that can deliver. This type of work is sometimes undertaken by a line producer or an assistant director. The delineation of jobs for the UPM, line producer, and assistant director depends largely on the nature of the producer and director. A producer who is savvy about production may not have a line producer, so the duties of the UPM will be more extensive. A line producer has more involvement with creative elements of a movie, such as casting, than a UPM who mainly deals with crew and equipment. If the director is well known and powerful, an assistant director who knows the director's style may be the best person to do the schedule. And, indeed, the director may have enough

clout to specify who the line producer and UPM should be.

Producers hire **accountants** and other office workers, and they may have a **publicist** on staff to make sure the movie is receiving attention during production so that there is a buzz when it is released. By the same token, a producer will arrange to have a **still photographer** on the set to take publicity photos.

Writing

Writers, like producers, may be involved with movies at a very early stage. A writer can come up with the idea for a movie and pitch it to a producer, or a producer can have an idea and hire a writer to put it on paper. Sometimes movie ideas come from books or other media, in which case the writing is an **adaptation** of another work. Writers work through many stages before the script is finalized. The original idea is usually called a **concept** (or premise or synopsis) and is a brief written account of the basic idea (see Figure 1.1). If someone is interested enough to want more detail, the writer may prepare a **scene outline**—a list of all the scenes in the movie and what happens in each—and/or a **treatment**—a prose description that reads somewhat like a short story.[2] Often the producer uses the treatment to sell the idea and, if successful, will hire the writer to put together the entire script.

Many times writers complete an entire script (see Figure 1.2), and then they (or their agents) submit it to producers and production companies. If the producer likes the script, he or she will **option** it, which involves paying the writer a small fee to own the script for a set period of time, such as a year. During that time period, the producer will have exclusive rights to try to

Figure 1.2

The beginning of a script.

A COMMON BOND

FADE IN:

EXT. CITY STREETS NEAR HOSPITAL - NIGHT

LONG SHOT of an ambulance racing through various city
streets. Some of the opening credits are shown over the
scene.

 CUT TO:

EXT. HOSPITAL EMERGENCY WARD PARKING LOT - NIGHT

We see MARGARET, a woman in her 60s, being lifted from
the ambulance, alert but somewhat frightened. She has an
I.V. and heart monitoring devices attached to her. Her
granddaughter, SUSAN, an attractive woman in her 20s, comes
alongside the stretcher and walks into the emergency room
next to her grandmother. Opening credits continue.

 DISSOLVE TO:

INT. HOSPITAL ROOM - DAY

Margaret is lying in a hospital bed with an I.V. and
electrocardiogram equipment attached to her. She opens
her eyes, and looks around the room.

POV SHOT

She sees CLAIRE, a woman in her 60s, who is reclining in the
other bed in the room. Claire, too, has monitoring devices
attached to her.

 MARGARET
 All this because of a few heart misfirings.
 I wonder what all these gadgets do.

 CLAIRE
 My doctor explained them all to me, but I
 really couldn't understand most of what he
 said. I wonder if we both have the same
 problem.

 MARGARET
 I don't think I really have a problem. My
 heart just started beating funny and my
 granddaughter had me rushed here in an
 ambulance. That ride was enough to give me
 a heart condition.

 (CONTINUED)

get others interested enough that the script can be produced. Generally, a clause in the option contract allows the producer to buy the script from the author for a predetermined amount of money before the option expires. If a producer doesn't have the money to purchase the script by the end of the option period, the rights to the script revert to the author who can then try to get another producer to option it.

Even when a script is sold, it is rarely finished just because the writer has printed out the final page. There are many stages of rewrite. Some-

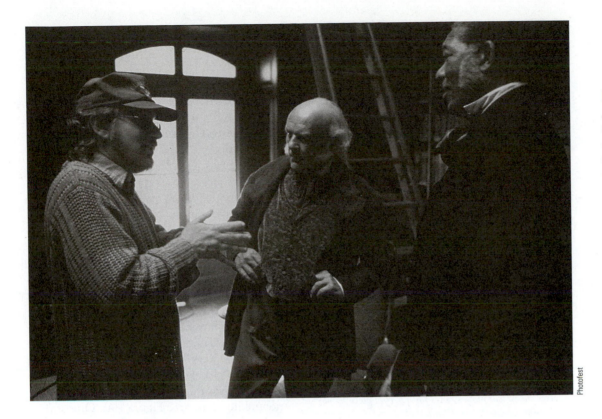

Photofest

Figure 1.3
Steven Spielberg directing Anthony Hopkins and Morgan Freeman on the set of Amistad. *(Photo from Photofest)*

times the original writer handles rewrites, and sometimes other writers are brought in to punch up dialogue, work out the kinks of a difficult scene, and the like. Writers are rarely present during shooting, but that doesn't mean the script doesn't undergo further changes as it is being shot. Directors will have inspirations, and actors will change words to ones that are more comfortable for them. Occasionally a writer (not necessarily the original one) will be brought onto the set to rewrite a scene that isn't working.

Directing

The **director** is the lead person in the moviemaking process—the one who is expected to have the creative vision and bring it to fruition (see Chapter 9). Although producers have the power to fire directors, especially ones who are not adhering to the budget, the director is considered the auteur (author) of the movie and, therefore, is the one who makes most of the decisions (see Figure 1.3). No two directors operate in the same manner, and directors change what they do and how they do it from one movie to another. A director who was previously an art director (such as Alfred Hitchcock) may feel comfortable making firm decisions about the creative "look" of a movie but delegate a

great deal of the technical decision making, whereas a director who rose up through the cinematographer ranks may do the opposite. Directors are involved in the movie at an early stage, overseeing most of the planning. They are the ones who literally call the shots during production, and they work closely with the editor to finalize the movie.

Sometimes one person will be the producer, writer, and director—or handle two of those duties. These people are referred to as **hyphenates** because they have hyphens in their titles: producer-director, writer-director. People usually take on multiple roles because they want more control. Writers who have seen too many of their words changed during production decide they want to direct. Producers are sure they can write something better than what is pitched to them. Directors grow weary of fighting producers for more money. The downside of handling many jobs is that the person doing so can be overworked and wind up not being able to pay enough attention to some aspects of the moviemaking process. Also, because moviemaking is a collaborative process, extra voices often add extra quality.

For large movies, directors have **assistant directors (ADs).** Sometimes there is only one assistant director, but there may be a first AD, a

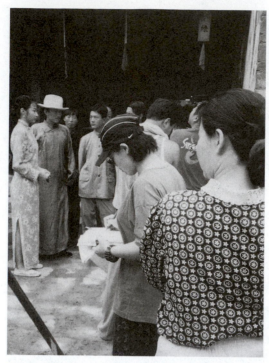

Figure 1.4
A script supervisor makes notes for a period piece movie being shot outside Xi'an, China.

second AD, and even a second second AD. These people handle whatever the director assigns them. Sometimes an assistant director will keep a list of information about all the shots taken during the day. Sometimes the AD will take care of the extras while the director is handling the lead actors. Other times an AD will go off to handle a **second unit**—cast and crew who film material that does not involve the main actors and is in a different location from the principal shooting. Sometimes an assistant director, rather than a unit production manager, will handle paperwork such as script breakdowns and production reports.

The differentiation between the work of first, second, and second second ADs is largely up to the director, but one way to describe the differences is that the first AD is involved with today's work, the second AD looks into tomorrow's work, and the second second AD handles yesterday's work. For example, the first AD's primary job is to run the set by being the communication point person. A first AD will tell the prop person that a specific prop is not on the set as needed or will tell makeup that a particular actor must be ready in 5 minutes. He or she will make sure the crew keeps moving so that the shooting scheduled for the day will be

accomplished. Rarely does a first AD leave the set. The AD communicates through a walkie-talkie and sends assistants to cover needs that are away from the set. The second AD may very well help on the set but also works on a **call sheet** that indicates what time various cast and crew members are to report to work the next day. Likewise, the second second AD is filing the location and performer releases obtained the day before.

In addition to assistant directors, directors may have **special assistants**, usually young people who perform personal as well as professional chores for the directors so they do not get bogged down in minutia while undertaking the myriad duties of directing.

Script supervisors, like assistant directors, work very closely with the director. They are usually seen at the director's side during production taking notes (see Figure 1.4). One of their main jobs is **continuity**. They keep track of such things as the color of tie an actor wears when he leaves to go to work so that 5 days later, when the director is filming the actor at work, he still has on the same tie. They also make sure all the scenes are actually filmed and that any changes made in dialogue during filming are marked in the script. They keep notes about which **takes** are good and which have problems and why. In general they are detail people who are hired to make sure unforeseen shooting problems will not detract from the final product. Often their notes are given to the editor to enable that person to put together the material more efficiently and accurately.

Acting

Actors are, of course, central to any movie. Directors work very closely with actors to obtain the best performance possible (see Chapter 9). The work starts at the casting stage. Although directors may have **casting directors** or hire an independent company to oversee the casting, they play a key role themselves in selecting the talent that will be seen on the screen. Once actors are selected, the director leads them through rehearsals and production.[3]

There are many different categories of actors. At the top of the heap are the **leads**—the people

the movie centers around. Following these are the **supporting roles**—people who are important enough to the story to have a large number of lines. **Bit players** are usually defined as people who have up to five lines, and **extras** are in the background but do not have distinguishable lines. High-budget films sometimes use **stand-ins**—people who stand and move as the main actors would during times when the actors do not need to be present. For example, a stand-in might lean against an automobile bumper while members of the crew set up a particular lighting effect on the car. The actor can be off somewhere learning lines while the stand-in does what is necessary for the crew to complete its work. **Stunt people** are common, especially in action films. A **stunt coordinator,** who may or may not actually perform stunts, oversees the stunt procedures. Occasionally professionals are brought in to help actors—a dialect coach if an actor must speak a particular dialect, a fencing coach if fencing moves are part of the plot. When child actors are involved, a teacher must be on the set so that the children can have schooling. If animals are among the actors, then one or more animal trainers are needed.

Production Design

The "look" of the film is the province of the **production designer.** These people have come to prominence fairly recently. The first movie to have a production designer was *Gone With the Wind* released in 1939, but it was the visual effects laden films of the 1970s that firmly established the position. Prior to that, most movies had an **art director** who was in charge of the look, but the art director's main province was (and still is) the set. Production designers oversee all the visual elements—scenery, props, costumes, makeup, locations—to make sure they are appropriate and consistent and in line with the director's desires.

Because production design functions have grown in size and importance, production designers often have many people reporting to them. One of these is the art director, who, as mentioned previously, deals with sets. Art directors, in turn, have people reporting to them. **Scenic artists** make drawings and models show-

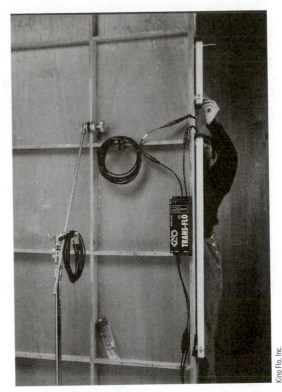

Kino Flo, Inc.

Figure 1.5

A crew member attaches a light to a set. (Photo courtesy of Kino Flo, Inc.)

ing what the set should look like. A set requires construction, and if there are quite a few sets for a particular movie, there may be a **construction coordinator** who handles the flow of construction. For example, if four sets need a special form of luminescent paint, the construction coordinator might schedule all of them to be painted at the same time. Carpenters, painters, plasterers, and even plumbers sometimes are hired to undertake various construction chores. If a great deal of this is being done at a studio shop, then a **shop manager** may oversee the workers. When it comes time to assemble the set in a studio, a **key grip** heads a crew of **grips** who actually erect the sets (see Figure 1.5). Usually at least one painter, called a **stand-by painter,** is present during production to touch up any paint that may get damaged during the course of rehearsal or shooting.

Sets also need decorations such as pillows on the couch and pictures on the wall. **Set decorators** and **set dressers** handle these elements. Sometimes the two terms are interchangeable, and sometimes set decorators specify and find the appropriate decorations and set dressers see that they are placed on the set properly. The

supervisor of the set dressers, if there is one, is called a **lead person** (or, in older movies, a lead man). The production designer usually oversees the set decorations carefully because they are very important to the "look." Fancy, embroidered pillows in a set that depicts the home of a poor migrant worker would look out of place. If the set requires plants or other vegetation, **greenspeople** may be hired to make sure the plants look appropriate for the needs of the script. If there is food on the set, a **food stylist** will make sure it looks appealing and appropriate.

Closely related to set dressings are props. These are overseen by a **property master** who may have a crew of people to make sure all the props are acquired, stored, and in place on the set when and where they are needed. The difference between props and set dressings is that props are necessary for the story, whereas set dressings just add to the atmosphere. If an actor picks up a pillow and throws it across the room, it is a prop. If the pillow just sits on the sofa, it is a set dressing. If the pillow is thrown across the room, the prop master makes sure it is back in place before that scene is shot again.

More and more movies are shot on location rather than in a studio set. **Location scouts,** sometimes overseen by **location managers,** are responsible for finding and securing the best locations. Because the locations must integrate with the other elements of the movie, these people often report to the production designer. When there were no production designers, they reported to the director or the UPM, and that is still the case on some movies today. When a location is chosen, it usually does not have all the elements needed for the movie, so carpenters, set dressers, property masters, and others are needed to enhance the location's characteristics.

Others who are involved with production design are the people who deal with the look of the actors. Costume and wardrobe personnel fall into this category. **Costume designers** sketch the costumes, again something that is carefully watched over for consistency with the look of the film. **Costumers** and **tailors** sew the costumes, sometimes overseen by a **costume supervisor.** The difference between costumes and wardrobe is vague, but costumes are usually something a modern-day person wouldn't wear—a 19th century ball gown or a space suit—whereas wardrobe is more normal clothing. For many low-budget films, actors provide their own wardrobe from the clothes they own.

The role of **makeup artists** and **hairstylists** varies greatly from film to film. If actors need abnormalities or are playing character parts, they may be in makeup for hours before each day's shooting. Often bit players or actors in low-budget films apply their own makeup. In some movies the same people who do makeup also do hairstyling, whereas in other movies they are separated. Sometimes big name stars demand their own hairstylists who do nothing but their hair.

A production designer usually has a **storyboard artist** who draws pictures of setups incorporating all elements—sets, set dressings, props, costumed actors. In this way the production designer can keep track of the overall look. This artist may also draw other graphics for the movie—the sign that goes in the restaurant window, the billboard that the actor drives past. If a set is particularly complicated, a **model maker** may construct a three-dimensional model of it. This may be the same model used for effects (which are discussed later in the chapter).

Picture Creation

The head person who deals with capturing the visual part of the movie is the **director of photography** (often called the **cinematographer** and occasionally referred to as a **videographer**). This person decides, in conjunction with the director, how shots should be lit, and how they should be captured—long shot, high angle, and so forth. The cinematographer may actually operate the camera during production, or a different person, the **camera operator,** may run the camera, be it film or video (see Chapters 3 and 4). The camera operator may have **camera assistants** (see Figure 1.6). For example, during a film shoot, an assistant may load film into a container so that it is ready to be placed on the camera. If the camera is mounted on something complicated, such as a **crane,** someone must operate the positioning mechanisms of the mounting device.

Usually a group of people called **gaffers, electricians,** or **lighting technicians** actually set up

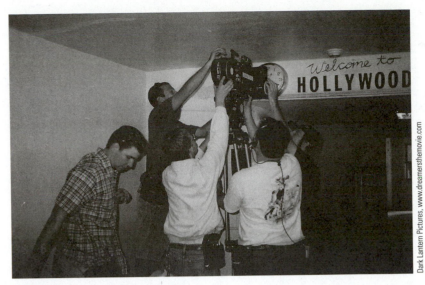

Figure 1.6
A film camera crew sets up for a difficult shot for the movie Dreamers. *(Photo courtesy of Dark Lantern Pictures, www.dreamersthemovie.com)*

the lights and lighting equipment (see Figure 1.7), often under the direction of a **head gaffer** (see Chapters 5 and 6). Another term associated with lighting is **best boy**. This is an old-fashioned term that stems from early movie-making. When a movie went into town to shoot on location, the head gaffer would inquire about who was the most reliable boy in the area. That boy would then be hired to be the head gaffer's assistant. The term has stuck, but on a union shoot today the best boy might be a full-grown man.

Grips are important in the picture creation process, as they are in set construction, because they carry things—lights, cables, camera cases, and so on. The key grip might have a best boy. **Rigging grips** are people who handle lights near the ceiling of a studio.

A relatively new position in the production process is the **video assist operator**. When a movie is shot on film, the film must be processed before it can be viewed. If something is wrong, it cannot be fixed until another day, often a costly process. With video assist, a feed comes from the camera onto a monitor and/or videotape and can be readily viewed by the director or others concerned about the shot.

Sound

Just as there is a production designer to oversee the look of a film, there is often a **sound designer** to oversee the sound of a movie. This person might decide (again in consultation with the director) such things as whether or not to have a particular musical sound that foreshadows the arrival of the villain, what kind of thunder is likely to occur in a particular region, or what tone of popping noise is most likely to evoke laughter (see Chapters 7 and 8).

While a picture is being shot, the main sound people involved are the **boom operator** and the **sound mixer** (sometimes called the **production sound mixer** or **sound recordist**). The boom operator holds the microphone in such a way that it picks up sound but is not in the shot. The sound recordist records what the microphone picks up—mostly dialogue (see Figure 1.8).

Not all sound comes from the set. Sound effects, Foley, ADR, and music are often gathered

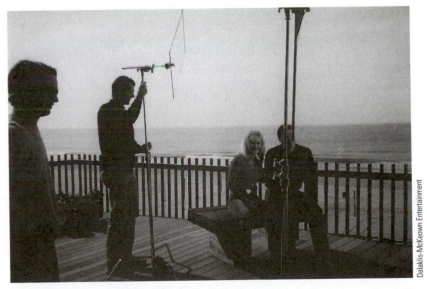

Figure 1.7
A member of a lighting crew adjusts a reflector for a Lifetime cable TV shoot. (Photo courtesy of Dalaklis-McKeown Entertainment)

or recorded away from the sound stage or location and added during postproduction. A **sound effects editor**, working under the director's guidance, decides what sound effects are needed and obtains them, either from prerecorded sources such as CDs or samplers or from a **sound effects mixer** who records at appropriate sources—a bubbling brook, an automobile race, a crowded bar. **Foley** involves the creation of sounds to match particular motions in a picture—the

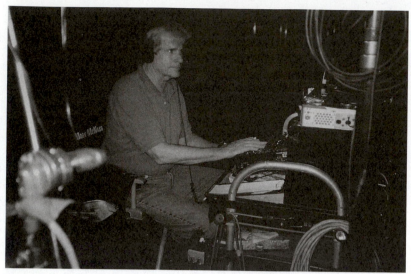

Figure 1.8

A production sound person recording audio for Family Affair.

rustle of a dress, a spoon against a pan, footsteps on wooden stairs. There are **Foley editors** to determine what sounds are needed, **Foley artists** who perform the motions to create the sounds, and **Foley mixers** who record the sounds made by the Foley artists. **ADR** stands for **automatic dialogue replacement** and involves re-recording dialogue that for one reason or another was not properly recorded during the shooting process. An **ADR editor** decides what dialogue needs to be re-recorded. The actors involved re-record the lines in sync with their lip movements, and an **ADR mixer** records the actors. Music is very important to the emotion of a film, so the director and a **music editor** decide where the music should be placed. A **composer** actually constructs the music and may perform it electronically. Other times an orchestra led by a **conductor** performs the music while one or more **score mixers** record it. Some movies, especially low-budget ones, use music that is already recorded. In these cases, a **music supervisor** finds the appropriate music and makes sure it is copyright cleared.

Once all the different elements—dialogue, sound effects, Foley, ADR, and music—are created, they are mixed together by sound mixers who are often called **re-recording mixers** because they are putting together in a unified fashion what all the other people involved with mixing have recorded. This re-recording process is often part of what is considered to be editing.

Editing

In the past all editing was undertaken after all the footage was shot. Now, thanks to digital technologies, some scenes can be edited right after they are shot to make sure they have the effect the director wants. As a result, sometimes **on-set editors** now use laptops to edit in or near the shooting location.

Most editing, however, is still accomplished after all the footage is shot. If the movie was shot on film, a **telecine operator** (see Figure 1.9) transfers the footage to digital video and audio (see Chapter 10) so that it can be put into a computer and edited using a **nonlinear** editing software program. **Editors,** and sometimes **assistant editors,** piece the various shots together (see Figure 1.10), taking into account the script and the ideas conveyed to them by the director (see Chapters 11 and 12). Duties of assistant editors, if there are any, vary. Sometimes they view the footage to find upcoming shots; in other instances they actually edit material. For some projects, editors are divided into **off-line editors** and **on-line editors.** Off-line editors work on relatively inexpensive computers, usually putting the material together at a low resolution and without a large number of effects so that it does not use a great deal of disk space. The on-line editor then uses the decisions made by the off-line editor to make the master of the movie with effects and at a high resolution.

Color timers and negative cutters figure into the editing process, especially if the final project is going to be on celluloid film. **Color timers** make sure the colors on the final product are consistent and in line with what the director wants. When the movie is in digital form, this is accomplished using a computer; at other times, this is part of the film printing process. **Negative cutters** use the decisions made through nonlinear editing to cut and glue the original negative film so that it can be sent to the lab where it is processed and multiple copies are made (see Chapter 14). Even if the final product is to be shown on film, sometimes the negative is not cut. Instead, the movie is edited using a computer and is then projected onto celluloid film through special equipment operated by **film recording technicians.**

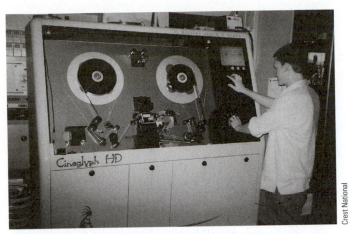

Figure 1.9
A telecine operator working with the equipment that transfers film to video. (Photo courtesy of Crest National)

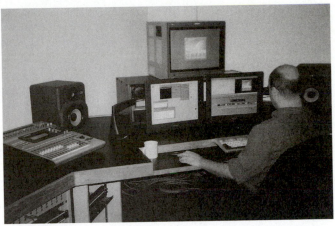

Figure 1.10
An editor working on an Avid nonlinear editing system. (Photo courtesy of Crest National)

Special and Visual Effects

Special effects are created on the shooting stage, such as people being hoisted on wires to appear as though they are flying like Peter Pan. When a large number of such effects are needed, a **special effects coordinator** may be present on the set. If fire is part of a special effect, a **pyro technician** will definitely undertake its execution.

A majority of movie effects are now created in a computer (see Chapter 12), and these are generally called **visual effects** to differentiate them from on-set special effects. This is an evolving field, and methods for creating new exciting effects are being invented regularly. For example, within the last few years it has become possible to transfer movements (such as walking and sitting down) of real humans into a computer and use them to guide the movements of animated characters. Called *matchmove,* this technique created new job categories including **matchmove artists** and even **matchmove supervisors.** Sometimes a **visual effects supervisor** oversees the **visual effects editors**—people who create all the computerized visual effects needed for the movie. Sometimes the various effects are categorized: a **title designer** will create opening and closing credits; a **matte artist** will draw backgrounds; a **3-D computer artist** will create objects; a **graphic designer** will create credits and other effects. When state-of-the-art effects are executed with computers, a **software engineer** may be on the premises to de-bug a program, and a **computer system engineer** may be close at hand to stabilize a computer when it inevitably crashes.

Some effects involve models and miniatures. Real people may be filmed careening down the highway in a car, but when the car plunges over a cliff, what will be filmed is a miniature car being tossed over a model of the cliff. A **miniature designer** makes sure the cliff looks like an extension of the highway scene and that the car has the same features. Model makers then build the cliff and car.

Before computers, effects were undertaken through an optical process that built individual frames of film that meshed foregrounds onto backgrounds. Sometimes this is still done, and **optical supervisors** are involved. A movie can have a variety of effects—some recorded on stage, some the result of models, some created in a computer, and a few others developed optically. These must be joined with each other and with live action in a credible way—a task that is sometimes overseen by a **compositing supervisor.**

Other

Production assistants are also common on a set, sometimes working for the director and sometimes working for others. Production assistants do the little things that need to be done—bring coffee, make extra copies of the script, position props. It is an excellent entry-level position.

One of the most important tasks is feeding the cast and crew. **Craft services** people supply food that is always available on the set—cookies, drinks, fruit. **Caterers** prepare and serve full meals. When shooting on location, **transportation captains** and their crew members are needed

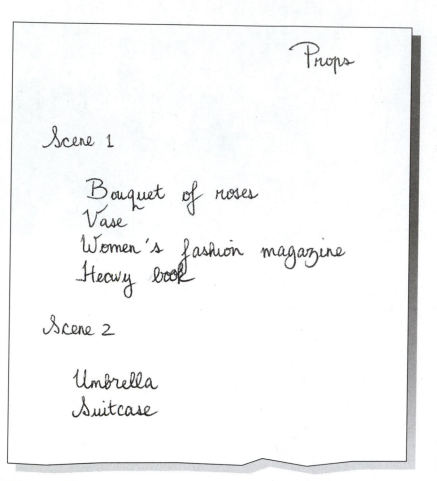

Figure 1.11

A handwritten list that might have been given to the props department. (Artwork by Donny Sianturi)

to take people and supplies to and from the location. Nurses are often in attendance in case someone gets sick. Many times consultants are brought in to advise on specific content—doctors to make sure medical procedures are accurate, a vintage airplane expert to make sure the airplane has the proper characteristics of the era, a World War II historian for a war movie of that time period.

No two movies have the exact same crew positions. Obviously, if there are no animals, there is no need for an animal trainer. But the number of crew positions depends on the complexity of the movie, whether it is union or nonunion, and its budget. Those working with student movies may have the producer and director rolled into one, and another person may handle all the duties given under production design. Sound may be delegated to two people, and the cinematographer might double as a grip. Cater-

ing is probably out of the question. But with a large crew or a small one, you can learn the details of the production process.

The Production Process

Digital technologies are rapidly changing the process of modern movie production. But this process still has many remnants from the older film process that was used, almost unchanged, for some 50 years.[4] Some of the words used in modern moviemaking are the same as those from the past, but the meaning has changed; some of the techniques are very different, but the underlying thinking is the same; and some of today's processes are almost identical to what has been used in the past. Today's moviemakers need to be aware of the past model to better understand their own duties and functions.

The Traditional Film Production Model

For many years movies were made in a serial manner. First the director led everyone through a planning period known as **preproduction**. Various people read through the script, typing or handwriting lists of all the props, sets, locations, costumes, and such (see Figure 1.11). These lists were given to craftspeople, who then prepared the appropriate materials. The director hired the cast and crew and made sure schedules were prepared to determine what scenes of the movie would be shot when.

Then director, cast, and crew entered the **production** phase when all the footage was filmed. The picture was shot with a film camera, and the sound was recorded on an analog reel-to-reel audiotape recorder. Lights were carefully positioned for overall illumination and mood and to make the stars look glamorous. The film was developed in a film laboratory, and a copy (**workprint**) of the original picture footage was made. The sound was transferred to material called **magnetic film** (mag film), which was the same size as the picture film and had the same sort of **sprocket holes** along the side (see Figures 1.12 and 1.13). The original negative

Figure 1.12
This magnetic film stock was used for recording sound so that it could be edited. (Photo courtesy of GCI Group, Inc.)

GCI Group, Inc.

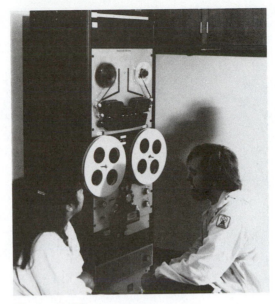

Figure 1.13
Sound was transferred from the audiotape recorded during production to mag stock used in postproduction using this resolving unit.

picture footage and the original sound were temporarily stored.

Then came the **postproduction** phase when director and editor used the workprint and mag film to edit the picture and dialogue. The editor cut out pieces of footage with a glorified razor blade and taped the desired pieces together with a type of adhesive tape (see Figure 1.14). Special equipment called **uprights** or **flatbeds** (see Figures 1.15 and 1.16) enabled the editor to see and hear the film in order to line up shots and make editing decisions. Using marking pens, editors made **rough cuts,** which they often showed to the director, and gradually refined their work into director-approved **final cuts.** Occasionally the director had to make another copy of something from the original footage if some part on the workprint or mag film became so damaged it needed to be replaced. Also, occasionally parts of dialogue that had not recorded satisfactorily had to be re-recorded in a sound studio.

After the picture and dialogue were finished, sound effects were recorded to meet the needs of the story. Also, the director hired a composer to write music to match the mood of the movie, and an orchestra often recorded this music. Then music and sound effects were mixed with the dialogue onto mag film (see Figure 1.17). Credits and what limited visual effects existed were prepared in a film laboratory—the same place that had developed the original film. Once the director was satisfied with all the decisions made with the workprint, the original negative

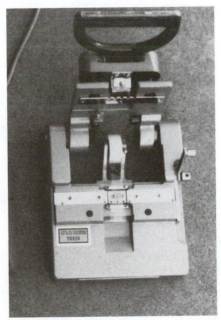

Figure 1.14
One type of film splicer used to cut and tape film. Called a guillotine, it had blades to cut the film and a holder for the tape that was placed over the two pieces of film to be joined for an edit. Once the tape was in place, part of the guillotine was used to punch out sprocket holes in the tape to match the sprocket holes of the film.

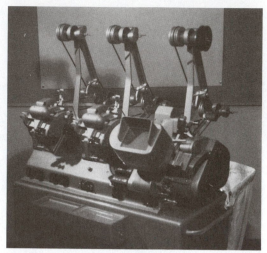

Figure 1.15

An upright film editor. This particular one held the picture on the far right reel and sound tracks on each of the other reels.

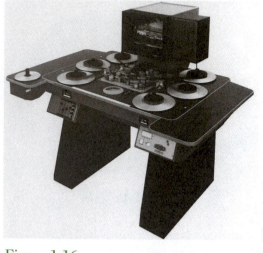

W. Steenbeck and Co.

Figure 1.16

A flatbed film editor. The picture was on the top platters, and sound could be played on the other two platters. (Photo courtesy of W. Steenbeck and Co.)

Ryder Sound Services

Figure 1.17

A bank of mag film players at an old-fashioned sound mixing facility. Some of the reels have music, some have sound effects, some have dialogue. (Photo courtesy of Ryder Sound Services)

was brought out of storage and cut and glued (in a very clean environment) to match the workprint. Then the original cut negative and the mag stock were taken to the film lab where they were married onto one print. Copies that the lab made of this print were distributed to movie theaters and shown to the public.

Much of this serial production was necessary to protect the technical quality of the movie.

Had the original negative been used for editing, it would have been irredeemably scratched by the time it got to the printing stage. Also, due to the nature of the equipment, it was difficult for the director to change a decision once it had been finalized.

The Changing Nature of the Production Process

With digital production, the serial technique is giving way to a parallel process. Digitally recorded material can maintain quality through innumerable generations, and editorial decisions made in a computer can be changed easily. Because a great deal of work can take place in a computer without anything actually being printed, a large number of activities can be happening at the same time. The director can send footage over networks so that many people can access it—the music composer in Vermont, the visual effects house in Hollywood, the producer in New York.

Directors still spend a great deal of time planning a production before they shoot any scenes. Mistakes made on paper or in a computer are much cheaper than mistakes made while expensive actors and technicians stand around doing nothing but waiting for the problem to be solved. But this planning is not all *pre* (before) production anymore. Because activities can take place in a parallel fashion, planning and con-

struction for some parts of the movie can take place while shooting or even editing is under way for other scenes.

Some elements of the production process are similar to the old form. Many movies are still shot on film with sound being recorded separately, but the sound is likely to be placed on a digital recorder, such as a DAT or a hard drive. Many of the same lights are used, although there is a tendency to use cooler fluorescent lamps. More and more movies are being shot with video cameras, especially the **high-definition TV** format called **24P.**

The postproduction process has changed the most. Razor blades, uprights, and flatbeds are no more. Just about every movie is edited electronically using nonlinear software. Scenes are often edited out of order and can be partially finished while awaiting some particular element such as a sound effect. In fact, the separate compiling of picture and discrete sound is evaporating. Digital technology has greatly increased the speed and degree of visual effects. Most movies distributed to theaters are still shown on film, but more and more applications of video exhibition are coming to the fore.

The digital process summarized in this short section will be discussed in more detail throughout the remaining chapters of this book.

Notes

1. This is a paraphrase of a paraphrase that appeared in Steven Kane, "Videocy," *Emmy,* April 1989, p. 12.

2. Many books and Web sites deal with the art of writing the screenplay. For starters try www.screenwriting.com and the Writers Guild site at www.wga.org. Several of the many books on this subject are Michael Walker, *Power Screenwriting* (Los Angeles: Lone Eagle, 2002); Victoria Schmidt, *45 Master Characters* (Cincinnati: Writer's Digest, 2001); William Miller, *Screenwriting for Film and Television* (Boston: Allyn & Bacon, 1998); Syd Field, *Screenplay: The Foundations of Screenwriting* (New York: Dell, 1998); and Linda Seeger and Edward Jay Whetmore, *From Script to Screen* (Stoneham, MA: Focal Press, 1994).

3. Many books cover the subject of acting, including Cathy Haase, *Acting for Film* (New York: Allworth Press, 2003); Tony Barr, Eric Stephen Kline, and Edward Asner, *Acting for the Camera* (New York: Harper-Collins, 1997); and Patrick Tucker, *How to Act for the Camera* (New York: Routledge Press, 1993).

4. Some of the books that detail this older process are William B. Adams, *Handbook of Motion Picture Production* (New York: Wiley, 1977); David Cheshire, *The Book of Movie Photography* (New York: Knopf, 1984); and Edward Pincus, *Guide to Filmmaking* (New York: Signet, 1972).

chapter two
Planning the Movie

An enormous amount of planning is needed for successful moviemaking. People still refer to the planning process as **preproduction**, and, indeed, most of it is done before any footage is shot. But digital technologies are so fluid that planning can be a continuous process that lasts into editing and even distribution. The digital world has greatly enhanced communication; if a director is shooting in Malaysia, the composer can send several examples of potential theme music via DSL lines, cable modems, servers, networks, fiber optics, and Ethernets. Digital technology enables people in various parts of the world to share information and work on the same files, taking care of today's needs and planning for the future.

Planning is also continuous because elements of moviemaking change, and each change can have a ripple effect. You think you have a permit to shoot in a supermarket, but local residents object strongly enough that you have to find a new location. A busy actress you want for a small part may become unavailable when you most need her, and you have to drop the idea of using her or rearrange the schedule to accommodate her. One of your investors backs out at the last minute, and you have to cancel several expensive scenes and rewrite others. Sometimes, because of financial constraints, you can't spend money until a certain date, and then you have to rush to undertake many things at one time. The ideal situation is to plan the movie thoroughly before beginning to shoot, leaving room for some contingencies to accommodate minor changes that you anticipate.

Unfortunately, students often shortchange the planning process. Because the school provides free equipment and the crew consists of class members who are not paid and who have to be there to receive class credit, students do not face the financial reality that professionals encounter. Also, planning can seem boring. Much of it in-volves poring over paper, making sure small details are not forgotten. Although attending to such paperwork may not feel creative, it is what allows for creativity during production for both student and professional productions. The lack of a prop can ruin a whole day's shooting, as can arriving at a local park and learning you can't shoot because you never asked for a permit. Even fellow students do not like to go on a location shoot where there is no time or place to eat. If you aspire to become a professional moviemaker, you need to learn the intricacies of planning. In addition, this knowledge will make you more valuable in the employment market. This is true not only for full-blown movies but also for music videos, commercials, corporate tapes, and other forms of productions.

Finding and Financing the Right Script

Sometimes the script finds the moviemakers rather than the other way around. Many **writers** throughout the country have **screenplays** they would like to have produced, so finding a script is not difficult. Finding the "right" script, how-ever, is another matter. As a student, you will definitely face this dilemma. You probably do not have the money to pay a professional writer for a script, so you need to create something yourself. The script has to be short so you can finish it in a semester, and, even though you might enjoy it, the script cannot involve an 8-week shoot in the Bahamas during which time you cut all your other classes. In the professional world the **producer, director,** or a group of people at a production company find scripts they want to produce by listening to pitches from writers or by hiring writers to compose what they specify.

They are looking for an idea they can sell because these same people must find financing to transpose the written words into moving pictures. The financial arrangements for pictures vary greatly, in part because the business is so risky. For one thing, the money needed to plan, shoot, edit, and even distribute a movie must be spent before anyone knows whether the movie

will be profitable. Although some movies make huge profits, others never recover their costs. As a result, conventional money-lending organizations such as banks rarely fund individual movies. Sometimes consortiums of banks fund a number of movies being produced by different studios—in effect, hedging their bets. Money also can come from individual investors and from deals that can be made for advances from distributors, cable and broadcast networks, foreign systems, and companies wishing to sell ancillary products such as T-shirts or toys based on some character in the picture.

Sometimes money can be raised on the merits of an idea or a best-selling book, but usually it takes more than that. Producers have a better chance of obtaining funding if they **package** elements of the film—that is, if they sign several key people to the project such as a director, a writer, and one or two stars. Having a package creates more interest among investors than does simply having an idea or a script.

Once the script and the money are in hand, the real work of planning can begin. The director usually oversees this process, although the producer may also be highly involved. As discussed in Chapter 1, the moviemaking process can employ an army of people who have specialized skills. For a big-budget movie, most of the people start work during preproduction. But for independent films, student movies, documentaries, alternative videos, and the like, only a few people may be engaged in planning.

Regardless of how many personnel are involved, many duties must be completed or at least considered. These include breaking down the script, scheduling, budgeting, hiring cast and crew, scouting locations, designing and constructing sets and costumes, planning makeup and hair, obtaining props, developing effects, planning sound, checking equipment, obtaining rights, arranging travel and food, and buying insurance. Let's examine each of these areas individually.

Breaking Down the Script

Once the script is written (or is to a point where it does not need a great deal of revision), it can be broken down into various elements so that

Figure 2.1

This is the script format from Screenwriter, a software program that can be imported into some scheduling programs. (Courtesy of Screenplay Systems)

Screenplay Systems

planning can progress smoothly and efficiently. The **unit production manager** (UPM) generally undertakes this chore, but it could also be the province of the producer, **line producer, assistant director** (AD), or someone else.

The person doing the **script breakdown** reads through the script, marking the important elements of each scene, such as main characters, extras, props, set, costumes, and special effects. Not all scripts have the same elements. A movie set in the Old West may need livestock but no vehicles, whereas a 1930s gangster plot might have vehicles but no livestock. Most UPMs use computer software for the breakdown. If the script has been written with software (see Figure 2.1) that is compatible with the breakdown software, they simply import the script into the program and click on words that indicate particular elements.[1] Obviously the computer program cannot determine what actual materials will be needed. Someone must go through the script

Figure 2.2

This scheduling software uses handy icons to denote frequently used breakdown categories. You select words in the script and click on the category. (Courtesy of Screenplay Systems)

and choose the initial breakdown data, highlighting categories using simple codes.

Then UPMs go through the script and, using mouse clicks, indicate what elements belong in which categories (see Figure 2.2). Once these major elements are selected, the computer can generate separate lists, catch errors, and allow changes made in one area to be recorded throughout the script. For example, if a character's name is changed from Maribelle to Mary, the change can be made in one place and it will automatically be changed everywhere else. Although many elements needed for a script breakdown (characters, set) are written in the script, many are not. For example, a scene may take place in a restaurant and mention that the main character is eating quiche. The script will not detail the dishes, utensils, and glasses needed in the scene. The person breaking down the script must recognize these needs and make sure these props are listed.

If you, as a student, do not have access to these computer programs, you can still break down the script the "old-fashioned way" by writing on a copy of the script. You can develop your own shorthand system for this. You might circle characters needed for a scene, underline sets, put stars by special effects, and write a list of props in the margin. Or you could use different colored pens to highlight each category. Figure 2.3 shows a page of a script marked by hand.[2]

The information from the breakdown is used to prepare **script breakdown sheets.** Again,

these can be handwritten or computer generated (see Figure 2.4). Script breakdown sheets are among the most important organizational documents generated for production. They list all the pertinent elements needed at each location. Usually, all scenes at one location are shot at one time, even though some scenes may appear at the beginning of the movie and others may appear in the middle or at the end. In other words, the movie is shot out of sequence. Shooting in this manner saves setup and transportation time, both of which can be costly.

The script breakdown sheet is used to ensure that all people and items needed at a particular location will be available and in place. Most breakdown sheets contain the title of the production, the location, whether the scene is interior or exterior, the time of day the scene is supposed to take place, the scene numbers (taken from the script) to be shot at that location, the number of pages of script for each scene (the importance of this is discussed in the section on shooting schedules), and a brief synopsis of each scene.

If the breakdown sheets are computer generated, the desired categories can be selected depending on the nature of the scene. For example, for a scene with many people, the cast categories might be broken down by **principal actors** (the stars and supporting cast), **bit players** (people with only a few lines of dialogue), and **extras** (people needed for atmosphere but who don't have distinguishable lines). For a scene from a student project, one column for cast may suffice. Most scenes will need an area for props, but only a few scenes are likely to need animals or greenery.

The breakdown sheets are used to generate various lists of what is needed for the production. For example, a list of sets could go to the **production designer** or **location scout,** a list of costumes to the **costume designer,** the props list to the **property master.** A list of scenes in which each actor appears can be used for casting purposes. Figure 2.5 shows samples of three different lists generated from the breakdown sheets.

Computer breakdown programs are particularly valuable for keeping track of the huge number of elements needed for a 2-hour profes-

14.

(CONTINUED)

SCENE 12

EXT. BRIDWELL'S HOUSE - FRONT PORCH - NIGHT

props
Jack-o-lanterns
Halloween decorations
bowl of candy
skeleton

The Bridwell's house is a big old one like Mrs. Oliver's. It's lit eerily and there are big jack-o-lanterns on the porch. The front door is ajar. Spooky organ music plays within and a madman's laugh can be heard inside. The boys know the Bridwells play the holidays to the hilt, but they are still getting a little scared. When David and Scott go up on the porch they hear a terrible cackle. It's MRS. BRIDWELL dressed as an ugly witch.

(David as cat)
(Scott as tramp)
(Mrs Bridwell as witch with green face)

 MRS. BRIDWELL
 Come in, sonny. Why don't any of you
 boys want my candy?

SFX
organ music
mad laugh
scream
thunder

The boys reach for some out of a big bowl when Mrs. Bridwell lets out a shrieking laugh. The boys stand back afraid. Then there is a horrible scream from behind them. The boys whirl around wide-eyed, and a skeleton drops in front of them. There is a sudden flash of lightning from an approaching storm, and the boys scream in terror. They back away from the skeleton, and Mrs. Bridwell's bony fingers touch their shoulders. They whirl back around toward her. Her green face is laughing at them. They shriek in terror and run off the porch. Mrs. Bridwell watches them go, laughing in her own voice now. She enjoyed that one.

FX
lightning

SCENE 13

EXT. STREET IN FRONT OF BRIDWELL'S HOUSE - NIGHT

(Mary Ellen as Indian scout)
(Eric as scientist)
(David as cat)
(Scott as tramp)

Mary Ellen and Eric are coming down the walk toward them. David and Scottie are desperately trying to regain their composure. They don't want it to be known that they were scared. Eric is dressed as a scientist, and Mary Ellen is an Indian Scout.

 ERIC
 Who was screaming?

David and Scottie look at each other and shrug.

 DAVID
 I didn't hear any screams. Did you?

 (CONTINUED)

Figure 2.3
This script is hand marked for script breakdown. Note the marking system: characters circled, locations underlined, costumes in parentheses, and props and effects organized into separate lists.

sional movie. Student films are usually fairly short, so the value of these computer programs is less obvious. However, if you have access to these programs, you should learn to use them. Doing so will make you more competitive in the job market.

Scheduling

The breakdown serves another major function: development of various schedules that organize the planning, shooting, and editing into meaningful, efficient steps.

Figure 2.4

An example of a script breakdown sheet. (Courtesy of Screenplay Systems)

Shooting Schedules

One of the most useful organizational tools is the **shooting schedule** (see Figure 2.6). These forms specify what is to be accomplished each day of production. Because all scenes at a particular location are usually shot together, the script breakdown sheet for each location is used to devise the shooting schedule. However, location is not always the main factor determining the schedule. The availability of a particular actor can be a determinant. If an actor needed in three different locations is available for only 2 days of the shooting schedule, all other cast and crew might be moved to three locations in 2 days to accommodate the actor's schedule. Or, if a department store can be used for location only on Wednesday night when inventory is in progress, the cast and crew might shoot in the park Wednesday afternoon, move to the department store for Wednesday night, and go back to the park on Thursday. Likewise, scheduling might be determined by an expensive piece of equipment. If a helicopter must be rented to shoot two scenes, these (and only these) will be shot in one day, even though they are in different locations.

Generally, however, shooting schedules are set up according to location. Outdoor shoots are often scheduled before indoor shoots because indoor shoots may require sets that can be built while outdoor shooting is under way. Also, if the weather does not cooperate, the

CAST LIST

Character	Scenes
Mike	1, 2, 3, 4, 6, 8, 10, 11, 12, 13, 14, 15, 16, 17, 18, 19, 20, 21, 22, 23, 24, 25
Janette	1, 2, 3, 9, 10, 11, 12, 13, 14, 15, 16, 19
Peter	1, 2, 3, 13, 14, 15, 16, 19
Mary Ellen	1, 2, 3, 13, 14, 15, 16, 19
Ashley	1, 13, 14, 19, 23
Don	1, 13, 14, 19
Frank	1, 13, 14, 19
Elizabeth	1, 3, 5, 7, 8, 17, 19, 24, 25
Policeman	19, 20
Ambulance attendant	19

a

LOCATIONS LIST

Location	Scenes
Back yard	1, 14
Front yard	2, 4
Living room	3, 5, 7
Kitchen	6, 8, 17
Outside the ballroom	10, 18, 20, 24
Inside the ballroom	11, 19, 22, 23, 25
Front porch	9, 12
Classroom	13
Neighborhood street	15, 16
Mike's office	21

b

COSTUMES LIST

Costume	Scenes
Tux	10, 11, 12, 13, 14, 15, 16, 18, 19
Ball gown	10, 11, 12, 13, 14, 15, 16, 19
Maid's outfit	8
Ambulance attendant uniform	19

c

Figure 2.5

Three different lists generated from script breakdown sheets for (a) cast, (b) locations, and (c) costumes.

SHOOTING SCHEDULE

TITLE: Another Chance

DIRECTOR: Danielle Wallace

Date	Time	Scene	No. of Page	Description	Location	Cast	Props, etc.
10/6	9:00 a.m.	7	1/4	Marissa meets Kim	Coffee shop	Marissa Kim Waitress	Coffee cups Tray Apron
10/6	10:00 a.m.	5	1	Marissa and Juan argue	Outside coffee shop	Marissa Juan	Cell phone
10/6	1:00 p.m.	21	3/4	Marissa runs from an unknown attacker	City street	Marissa Juan Policeman 3 Extras	Purse Police uniform Special lighting for lightning
10/6	2:30 p.m.	12	1	Marissa talks to Thelma about Juan	Park	Marissa Thelma 2 children Nanny	Kids' toys Bench Letter

Figure 2.6

An example of a shooting schedule.

schedule can be rearranged to handle indoor shoots. If all the indoor scenes had already been shot, the only option would be to cancel until the weather cleared.

Some people organizing shooting schedules like to include everything from the script breakdown sheet. But this makes for unwieldy schedules. A better schedule is one that includes date and time, scene numbers, location, a brief description, and one or two of the more crucial elements, such as props or cast members needed. Of course, with computer programs all elements can be stored in the computer and the essential ones printed out as needed.

One of the most difficult aspects of formulating a shooting schedule is determining how much time each scene will take. This must take into account many factors, the most significant of which is the length of the scene. A scene that runs three pages usually takes longer to shoot than one that is half a page, which is why the number of pages for each scene should be listed on the script breakdown sheet. Unit production managers can develop a formula for calculating shooting time for movies that consist primarily of talk (for example, eight pages a day). If this is possible, developing the shooting schedule is fairly easy.

However, many productions contain scenes or circumstances that do not fit into an all-purpose formula. A scene with complicated special effects or stunts can take much longer to shoot than one with straightforward dialogue. Scenes with exotic lighting, large crowds, or elaborate camera movement also take longer than average. Often scenes shot at the beginning of the production process, when everyone is becoming accustomed to one another, take longer than those shot later, after the crew has developed a working rapport. This is especially true of student productions in which crew members are learning a great deal at the beginning. Another variable is the director's style. Some directors spend a great deal of time on setup so that everything will be perfect for shooting; others retake scenes from many different angles; still others pride themselves on

Figure 2.7

A computer-generated stripboard. (Courtesy of Screenplay Systems)

setting up and shooting quickly. This is why it is often preferable to have an assistant director who has previously worked with the director rather than the UPM prepare the schedule. The assistant director knows the director's process and can schedule accordingly.

Accurate estimates in a schedule are important for budgeting and for the preparations that must be made for the entire production. Shooting schedules are often modified during production, but they provide the blueprint for how the production can be shot most efficiently.

Stripboards

Many directors like to use computer-based **stripboards** (see Figure 2.7) either instead of or in addition to a shooting schedule. These vertical strips list the locations and other pertinent information needed for each scene. They are helpful because an entire production can be laid out across the computer screen and changed easily. If, for example, you discover you can't shoot at the airport on Tuesday afternoon as planned, you can remove the Tuesday afternoon strip,

place it at some other time, and juggle other strips to readjust the schedule.

The computer program can also be used to print out strips so that they can be manipulated by hand. Some programs bar code the strips so that if they are changed on the board, a light pen attached to the computer can read the changes and resort the electronic data quickly. In the days before computers, UPMs hand made cardboard strips that they mounted on boards in such a way that the strips could be moved easily. Students who don't have access to stripboard software can easily hand make a stripboard.

Production Schedules

Another scheduling aid that some moviemakers use is an overall **production schedule** (see Figure 2.8). This delineates the length of time allotted for various tasks and specifies when they are to be completed. Again, the amount of time needed for each phase varies with the complexity of the movie and the amount of time and money available. In student moviemaking time must be allocated to meet the due date specified by the

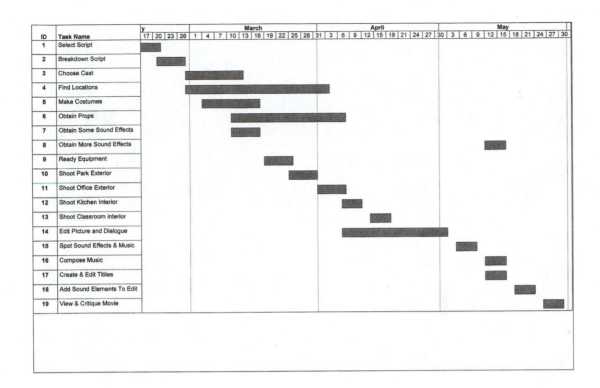

ID	Task Name
1	Select Script
2	Breakdown Script
3	Choose Cast
4	Find Locations
5	Make Costumes
6	Obtain Props
7	Obtain Some Sound Effects
8	Obtain More Sound Effects
9	Ready Equipment
10	Shoot Park Exterior
11	Shoot Office Exterior
12	Shoot Kitchen Interior
13	Shoot Classroom interior
14	Edit Picture and Dialogue
15	Spot Sound Effects & Music
16	Compose Music
17	Create & Edit Titiles
18	Add Sound Elements To Edit
19	View & Critique Movie

Figure 2.8

An example of a production schedule that might be appropriate for a student movie produced in one semester.

professor. Television projects must be completed by their contracted airdates. Films made to be shown in theaters often need to be finished for certain release times—Christmas or the beginning of summer when audiences are likely to be biggest. Corporate videos need to be finished to accommodate the schedule of the client.

Because digital technologies have led to the interweaving of preproduction, production, and postproduction, bits and pieces of tasks sometimes occur at different times. Some elements of planning, such as set construction, may be in the final stages when production begins. With **nonlinear** editing systems, some scenes can be edited while others are still being shot. These overlaps should be delineated on the production schedule. For this reason, one of the forms commonly used for this schedule is a time line.

A major flaw of student productions is not allowing enough time to finish editing. More often than not this is because production runs longer than anticipated. And the main reason production runs long is that planning was not thorough enough. At the end of the semester students wind up fighting each other for access to the editing equipment during the wee hours of the morning. The wise student, who thinks everything through thoroughly during the preproduction stage, can finish early and avoid this fray.

Call Sheets

Daily **call sheets** are another scheduling device. They are posted during production to let people know when and where they should report each day (see Figure 2.9). Formal sheets often are not needed for student productions because much of the shooting occurs during class time or at one set time, such as a weekend. However, call sheets are helpful if a production requires multiple shoots, and certainly they are necessary for professional shoots.

Simple call sheets list all the members of the cast needed for the day and the times they should report for various functions, such as makeup and appearance on the set. More complicated call sheets also specify when caterers are to have meals prepared, when drivers will be needed to move equipment, and when special vehicles or effects must be available. They may also include special instructions for makeup, costumes, or props.

Call sheets are used during shooting, but they can be at least partially prepared during the planning stage. Changes in the shooting schedule can necessitate changes in call sheets, but if the basics have been compiled ahead of time, these alterations can be made fairly quickly, especially if computer programs are used.

Figure 2.9

A sample daily call sheet.

CALL SHEET

Title Action Man Date September 10

Director Marcus Wong Production No. 1

Location Main Street between 17th and 19th Street

SET	SCENES	CAST	PAGES
Chase scene area	8	Toby Cat Man	1/8
Chase scene area	11	Toby Cat Man	1/4
Cyclops Co. exterior	15	Toby Frank Marcia Max	3/4
Cyclops Co. exterior	23	Toby Marcia	3/4

CAST	PART OF	MAKE-UP	SET
Marcus Wrigley	Toby	7:00 AM	8:00 AM
Ted Banner	Cat Man	6:00 AM	8:00 AM
Philip Breecher	Frank	1:00 PM	2:00 PM
Danielle Thompson	Marcia	1:00 PM	2:00 PM
Axias Lapowsky	Max	1:00 PM	2:00 PM

ATMOSPHERE AND STAND-INS **REPORT TIME**

8 bypassers 7:30 AM

CREW **REPORT TIME**

Camera operator	7:00 AM
Boom operator	7:00 AM
Sound mixer	7:00 AM
Makeup person	5:30 AM
Wardrobe person	6:00 AM
Script supervisor	7:00 AM
Electrician	5:30 AM
Grips	5:30 AM
Prop person	7:00 AM
Caterers	Noon

Although script breakdown sheets, shooting schedules, stripboards, production schedules, and call sheets are the primary scheduling forms, other forms can be generated if needed. For example, work orders list the equipment and supplies needed for each day, and worksheets detail the special working conditions to which the production must adhere because of certain provisions in a star's contract. Most colleges have checkout forms students must fill out ahead of time to reserve equipment.[3]

Budgeting

Within the professional world, the budget is the governing force of all movies. Estimates of what the picture will cost must be accurate. Directors who complete a picture on budget or under budget are valued. Those who habitually run over budget are likely to find themselves in unemployment lines.

Budgeting Procedures

Although the usual procedure is for the budget to be derived from a script, sometimes the size of the budget can affect the script. For example, three scenes of the script may take place in Kenya. If the script is budgeted so that the scenes are actually shot in Kenya, a great deal of money will be needed to transport cast and crew to Africa. If the total amount needed for the film cannot be raised, the Kenya scenes might be rewritten so that they can use stock footage of Kenya and other shots, such as close-ups, that do not need the specific location. Often a budget must be derived before you can get any funding, and sometimes there is a constant back and forth between budget and script even after the movie is in production.

In any case, someone must go through the script carefully, figuring the cost of all the elements. Script breakdown sheets and shooting schedules are extremely important in this process, as are computer programs. Any spreadsheet program, such as Microsoft Excel, can be used for budgeting, but budgeting software made specifically for the entertainment industry is worth the investment because it includes the terminology used in the business. In addition, some of these programs interface with scheduling programs.

Budgets for movies are broken down into **above-the-line** and **below-the-line** expenses. Above-the-line expenses are related to a specific film and are creative in nature. They include the costs of writing and acquiring the script, the costs associated with the producer and director, and the salaries and fringe benefits for the actors. Below-the-line costs could be associated with any picture and are more likely to be in the crafts area. They include the pay for crew and the money needed for equipment, tape or film stock, sets, props, costumes, makeup, transportation, food, sound effects, music, and editing. Insurance, legal fees, and licenses are part of the below-the-line costs. They are easy to overlook but can add up to a substantial amount.[4] Overhead also needs to be included and consists of such items as rent and utilities. Overhead is generally figured as a percentage of other costs—usually about 15 percent of the total budget. Movie budgets should also set aside about 10 percent for contingencies, which will take care of overlooked items and will be needed when the production inevitably falls behind schedule.

The organization of a budget can vary from movie to movie. Sometimes all the costs associated with one function, such as lighting, are lumped together, including the salaries of the people who plug in the lights, the cost of renting the lights, and the electricity bill. Similarly, costs for sound, sets, and wardrobe would be together. For other budgets, categories such as crew salaries, utilities, transportation, and insurance serve as the organizing thread. The organization is not nearly as important as the accuracy with which the budget is figured.

Most budgets include a top sheet that lists the major categories followed by several more levels that detail these costs (see Figure 2.10). Software often includes provisions for applying fringe benefits such as health care and insurance to particular items, and sometimes it allows you to try different options. For example, you can see what the total budget would be if you rent props versus buying them or if you shoot with high-end equipment versus more basic equipment. You can usually save parts of one budget

Figure 2.10

This is an example of a budget form that has three levels: (a) the top sheet, which lists all the category accounts; (b) the totals for each particular category (in this case, Props); and (c) the details for each category. Often numbers entered at the detail level on a computer program carry through to all the other levels.

BUDGET

Title: Never Again

Date Prepared: 4/7

Account Number	Description	Total
01	Story and Writers	
02	Producer and Staff	
03	Director and Staff	
04	Cast	
	Total Above-the-Line	
12	Camera	
13	Sound	
14	Script Supervision	
17	Electrical	
20	Set Construction	
21	Set Dressing	
22	Props	
23	Wardrobe	
24	Makeup and Hair	
30	Special Effects	
40	Transportation	
41	Location Expenses	
45	Stock Footage	
50	Licenses	
51	Insurance	
52	Legal Fees	
60	Editing	
61	Postproduction Sound	
62	Graphics	
63	Music	
64	Visual Effects	
70	Dubbing	
75	Publicity	
	Total Below-the-Line	
	Total Above- and Below-the-Line	
	Overhead	
	Contingency	
	GRAND TOTAL	

a

to use as a model for another budget, and you can create as many categories and subcategories as you need.

During the production phase, the UPM (or line producer) prepares regular reports to indicate how much of the budget has been spent.

These reports are sent to the producer along with the **daily production report** (see Figure 2.11), which includes such information as the number of pages of script covered, the minutes of footage shot, the time taken for setups, the people who worked and how much time they worked, and

```
                    BUDGET CATEGORY

    Title:  Never Again

    Date Prepared:  4/7

    Category:  Props

    Account Number:  22

    Account
    Number      Description                    Total

    22.10    Propmaster
    22.12    Assistant Propmaster
    22.20    Fringe Benefits
    22.25    Prop Purchase
    22.26    Prop Rental
    22.30    Insurance
    22.32    Pickup and Return
```

b

```
                    BUDGET DETAILS

    Title:  Never Again

    Date Prepared:  4/7

    Category:  Props

    Account Number:  22
```

Account Number	Days, Hours, or Description	Quantity	Rate	Total
22.10	Propmaster	120 hrs.	$33	$3960
22.12	Assistant Propmaster	100 hrs.	29	2900
22.25	Prop Purchase			
	Clock	1	90	90
	Globe	2	30	60
	Vase	1	45	45
	Boxes of candy	8	10	80
22.26	Prop Rental			
	TV set	1	50	50
	Russian nativity	1	80	80
22.30	Insurance			
22.32	Pickup and Return	2 trips	30	60
		Grand Total		$7325

c

Figure 2.11
A daily production report.

DAILY PRODUCTION REPORT

Title _____ Date _____

Director _____ Production No. _____

Script Supervisor _____ Day _____

First Call _____ First Shot _____ Meal _____ First Shot _____

Meal _____ First Shot _____ Wrap _____ Finish _____

	Scenes	Pages	Minutes	Set-Ups
Total in Script	_____	_____	_____	_____
Taken Previously	_____	_____	_____	_____
Taken Today	_____	_____	_____	_____
Total to Date	_____	_____	_____	_____
To Be Taken	_____	_____	_____	_____

Cast Member	Make-Up	Report on Set	Dismiss on Set	Meals Out	In

Scenes Shot Today _____

Scheduled Finish Date _____ Estimated Finish Date _____

COMMENTS (Explanation of Delays, Cast and Crew Absences, etc.)

the amount of time taken for meals. If too much money is being spent too quickly or if it looks like there will be a budget shortfall, the producer will look at the daily production reports very carefully to exert financial stability.

Budgeting a Student Production

Budgeting for a student movie is quite different from budgeting for a professional movie. Your classmates work for free, the school may provide equipment, you can use the dorm or campus for locations, and you can borrow props from someone's home. Your production can accumulate costs if it is a period piece that requires costumes, if your director decides to rent special equipment such as a dolly to capture certain shots, or if you hire professional actors. Under these circumstances, your producer may want you to draw up an actual budget and keep track of the expenses. Even if a production costs very little, you should calculate what it would cost if it were being produced by a professional company that had to rent equipment. This is good practice for future jobs, and it can show how much the college is contributing to the production budget.

Costs vary greatly from one part of the country to another, from one equipment rental house to another, from one postproduction facility to another, and from one circumstance to another, so you should check out current prices in your area. However, for budgeting practice, you can use the following average costs from a large metropolitan area.[5] Obviously no production needs all the equipment listed, and your director may feel the need for other equipment such as a monitor or walkie-talkie. In addition, students often need to buy their own tape or film. Costs for this vary depending on the format used, but tape is available at electronic discount stores, so you can check the prices fairly easily.

Equipment Costs. Production equipment is usually rented out for a minimum of one day, so all costs listed are daily figures.

Equipment	Per Day
16mm-film camera	$400
35mm-film camera	$800

Video assist system	$400
Prosumer digital camcorder	$250
Professional-grade digital HDTV camcorder	$1,500
Camera tripod and head	$75
Camera dolly	$80
Tungsten light	$25
HMI light	$50
KinoFlo fluorescent light bank	$60
Microphone and fishpole	$30
Wireless lav mic	$50
Portable audio mixer	$35
Nagra digital recorder	$135
DAT recorder	$50

Facilities Costs. Facilities are usually rented out by the hour, so all costs listed are per hour.

Facilities Used	Per Hour
Transfer from film to video	$200
Nonlinear editing suite	$35
Titles and graphics	$25
Visual effects	$50
Audio recording and/or editing	$35
Dubbing	$10

Personnel Costs. Costs for cast and crew are negotiable if the production is shot with a nonunion crew. Unionized cast and crew must be paid wages that at least meet union minimums. Of course, people who are well known or successful can demand much more than the minimum rate. Union contracts are complicated, often taking into account how long people have been in the industry and how many days they have to work in one stretch, but some general minimum figures that should be helpful in developing budgets follow.[6]

Writers are usually hired by the project. If they are hired by the week, the cost is about $4,000 per week.

Writers	Per Project
High-budget feature film	$84,500
Low-budget feature film	$45,000
60-minute TV program	$29,000
15-minute or less project	$10,700

Figure 2.12

A sample budget for a 10-minute student movie.

```
                    SAMPLE STUDENT BUDGET

Above-the-Line
   Story and Writers                              $10,700
   Producer and Staff                              8100
        Producer (5 days at $8000 per week)
           --$8000
        Copying and supplies--$100
   Director and Staff                              8100
        Director (5 days at $8000 per week)
           --$8000
        Copying and supplies—$100
   Cast                                            2400
        2 Principals (16 hours each at $135
           per hour)--$4320
        5 Extras (16 hours each at $12 per
           hour)--$960

                         Total Above-the-Line    $29,300
_____

Below-the-Line
   Camera                                          3240
        Director of photography (16 hours at
           $76 per hour)--$1216
        Camera operator (16 hours at $46 per
           hour)--$736
        Grip (16 hours at $30 per hour)--$480
        *Camera rental (2 days at $250 per day)
           --$500
        *Tripod and head rental (2 days at $75
           per day)--$150
        *4 Tungsten lights (1 day at $25 per
           day)--$100
        *1 HMI light (1 day at $50 per day)
           --$50
        Videotape (1 reel at $8 each)--$8
   Sound                                           1525
        Production Sound Mixer (16 hours
           at $51 per hour)--$816
        Boom operator (16 hours at $34 per
           hour)--$544
        *Microphone and fish pole rental (2 days
           at $30 per day)--$60
        *DAT recorder rental (2 days at $50 per
           day)--$100
        Audio tape (1 reel at $5 each)--$5
   Script Supervision                              560
        Script supervisor (16 hours at $35 per
           hour)--$560
   Electrical                                        0
   Set Construction                                  0
   Set Dressing                                      40
   Props                                             30
   Wardrobe                                           0
   Makeup and Hair                                   10
   Special Effects                                    0
   Transportation (gas money)                        30
   Location Expenses (2 meals)                      100
   Stock Footage                                      0
   Licenses                                           0
   Insurance                                          0
   Legal Fees                                         0
   Editing                                         1288
        Editor (16 hours at $45 per hour)--$720
        *Nonlinear editing suite) 16 hours at
           $35 per hour)--$560
        Videotape (1 reel at $8 each)—$8
```

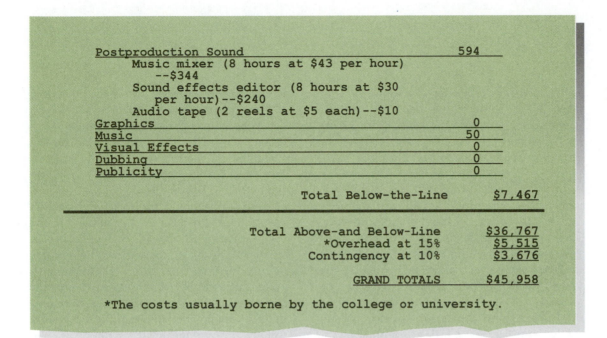

```
Postproduction Sound                              594
     Music mixer (8 hours at $43 per hour)
        --$344
     Sound effects editor (8 hours at $30
        per hour)--$240
     Audio tape (2 reels at $5 each)--$10
Graphics                                            0
Music                                              50
Visual Effects                                      0
Dubbing                                             0
Publicity                                           0

              Total Below-the-Line          $7,467

         Total Above-and Below-Line        $36,767
                     *Overhead at 15%       $5,515
                   Contingency at 10%       $3,676

                        GRAND TOTALS       $45,958

*The costs usually borne by the college or university.
```

Figure 2.12
(Continued)

Directors' minimums vary. They are often pegged to the type and length of the work and sometimes include a guarantee of a certain number of weeks of work. Some minimums are based on days, others on weeks, and still others on total projects. Producers earn the same or a little more than directors. For purposes of simplicity, the sample figures here are per week. ADs and UPMs are included in this category as well.

Directors and Producers	Per Week
High-budget feature film	$13,000
Low-budget feature film	$8,150
60-minute TV program	$16,000
15-minute or less project	$8,000
Assistant Directors	$3,500
Unit Production Manager	$3,700

Major actors are hired for the entire project and set their own rates and working conditions based on what their agents can negotiate. Other performers are paid on a weekly or daily basis. For purposes of simplicity, the minimums given here are per hour.

Actors	Per Hour
Performers	$135
Stunt performers	$85
Bit players	$81
Extras	$12
Stand-ins	$21

Crew members are usually paid by the hour. Here is a representative list. Crew members not given here can be figured at $35 per hour.

Crew	Per Hour
Art Director	$53
Carpenter	$30
Prop Master	$33
Costume Designer	$32
Seamstress	$28
Makeup Artist	$37
Director of Photography	$76
Camera Operator	$46
Production Sound Mixer	$51
Boom Operator	$34
Script Supervisor	$35
Grip	$30
Graphic Artist	$38
Editor	$45
Sound Effects Editor	$30
Music Mixer	$43

Given all this, the actual budget for a simple 10-minute student production might look something like the one shown in Figure 2.12. This budget assumes that the planning can be

accomplished in the equivalent of one 8-hour day, that the shooting will take 2 days (one indoors and one outdoors), and that the editing will also take 2 days. It also assumes that the movie is set in modern times, uses only two principal actors, rents middle-of-the-road TV equipment, does not need elaborate editing or visual effects, and employs cast and crew willing to work for minimum rates. In actual practice, the college or university often bears the costs of the equipment, and there are no personnel costs above the line or below the line. Therefore, out-of-pocket costs can be minimal.

Budgeting usually does not seem important to students because so little actual money is involved. But the professional world places a high value on the ability to read a script, estimate quickly how much it will cost to produce, and determine how to cut costs without cutting content or creativity. For this reason, you should take advantage of every opportunity you have to learn how to budget a movie.

Casting

Choosing people to act in a narrative movie is important because it is the **actors** who convey the story. In fact, **casting** is one of the director's most crucial decisions. Casting comes at a time when a great number of other planning activities are in full swing, but the director should not delegate selection of the cast. Casting errors inevitably hurt the final product. Behind-the-scenes people who cannot handle their jobs can be replaced in the middle of a production, albeit with some disruption, but people in front of the camera are essentially irreplaceable. Some directors feel that casting is 90 percent of directing. As a result, they often spend a great deal of time writing up character traits and preparing for casting sessions (see Chapter 9).

Stilted, unnatural performers detract greatly from a story and sometimes even make dramatic moments inappropriately humorous.

Student productions are especially vulnerable to poor acting, some of which cannot be helped because of budget and scheduling limitations. However, in both student and professional movies every effort should be made to cast people who fit the parts and can be counted on to perform well.

In the professional realm **casting directors** are often hired to screen actors and aid in the overall casting process. These people keep in touch with the talent pool, often going to community theaters and other places to find promising actors. They have close contact with agents and can gather quickly any category needed—pudgy men in their 50s, red-headed teenagers, Abraham Lincoln look-alikes. The UPM supplies the character descriptions (prepared from the script breakdown) to the casting director who then sends out a call to agents for actors to fill the various roles. From the available pool, the casting director may choose four or five candidates for each major role. The director (sometimes in conjunction with the producer, casting director, and others) then makes the final selections. Some directors allow casting directors to be in total charge of casting bit players and extras.

Digital technologies help with the casting process. It is easy for agents (or actors themselves) to make their photos, bios, and some of their work available on the Internet. Those involved in the casting process can avail themselves of this information. Sometimes it is necessary to hold casting sessions in a distant place—perhaps another country. These sessions can be conducted by a local casting person, taped, and then sent over the Internet for the director to view, freeing the director from flying during the busy planning period.

Some productions place ads for **open casting** in trade journals. This means anyone can try out for parts. The main difficulty with this is that so many people show up that selection becomes quite time consuming. Open casting often works well for student films, however. An ad in the school newspaper can draw talented people to fill the parts.

Generally, casting involves a short interview with the actors to enable them to become acclimated to the environment and to determine if they appear to be right for the part. Then they read some of the lines with other actors, usually ones hired for that purpose, but occasionally ones that have already been selected for other parts. Often these short acting scenes are videotaped so they can be reviewed. These videotaped scenes can serve as a **screen test**—a demonstration of how the person will look and sound on video or film. The major roles are cast first; then other people are cast to fit in with the stars.

Student movies usually do not have the luxury or financing to engage in elaborate casting procedures, but you should make every effort to find the best person available for each role. Using your friends and relatives is an accepted but not particularly advisable practice. Generally, directing someone you do not deal with regularly is easier than directing someone you are close to.

One casting problem student productions often have to a greater degree than professional productions is reliability—making sure that all people cast will be reliable throughout the entire production period. If cast members are not paid, they may have little incentive to stay with the project as it becomes more difficult and time consuming. Whoever is doing casting for your project should be honest with actors about the amount of time and commitment the production will require. Using people in your production class as actors is the best way to ensure reliability, but often they do not fit the roles or they are more interested in behind-the-scenes jobs.

After actors are selected, they have to be hired. This involves working out contracts. Lawyers, agents, and personal managers are usually involved in this for well-known stars. The contract stipulates salary, working conditions, placement of credits, size of the dressing room, and anything else that needs to be negotiated. Student producers are wise to have actors sign releases, such as the one shown in Figure 2.13, so that they do not come back at

a later time demanding pay or some other type of recognition.

Hiring Behind-the-Scenes Personnel

By the time the financial go-ahead is given for a movie, several people are already involved in the production. The producer, for example, has been obtaining and selling the script and, in all likelihood, the writer will have completed a draft of the script. A director may be involved in helping to sell the script and in preparing the initial creative visualization.

If the producer is the only person involved in selling the initial concept, he or she will hire a director quickly once the go-ahead is given so that plans can proceed with the director's participation. The director's primary responsibility at this point is to interpret the script and to guide the writer in reworking parts that are weak. During planning, the director will read and reread the script, deciding how best to match the particular character and tone of the screenplay with the appropriate actors, locations, sets, and costumes (see Chapter 9).

Another person who needs to be hired rather quickly is the person who will break down the script—line producer, unit production manager, or assistant director. Usually the next in line for hiring are the production designer, location scout, and **cinematographer** although the director and producer may decide on a different hiring order. The various department heads come next—**art director, costume designer, sound designer, special effects coordinator,** and so forth (see Chapter 1). It is important that the director be very involved in hiring these people because the director will need to lead all of them through the production process.

After the various department heads have met with the director and established their responsibilities, they begin hiring others (**scenic artists, property masters, tailors, sound effects editors**) according to the needs of the movie and the restraints of the budget. People who are not as

PERFORMANCE RELEASE

In consideration of my appearing in the movie

(title or subject)
and for no subsequent remuneration, I do hereby on behalf of
myself, my heirs, executors, and administrators authorize

(producer or production company)
to use live or recorded on tape, film, or otherwise my name,
voice, likeness, and performance for television or film
distribution throughout the world and for audiovisual and
general education purposes in perpetuity.

 I further agree on behalf of myself and others as above
stated that my name, likeness, and biography may be used for
promotion purposes and other uses. Further, I agree to
indemnify, defend, and hold the producer (or production company)
harmless for any and all claims, suits, or liabilities arising
from my appearance and the use of any of my materials, name,
likeness, or biography.

Conditions:

Signature _____

Printed Name _____

Street Address _____

City and Zip Code _____

Phone Number _____

Date _____

involved in planning, such as **grips, gaffers, camera assistants, boom operators,** and **production assistants,** may not be hired until very close to the start of shooting. People involved with editing are usually hired later than others, although many directors like at least one editor to participate in production so that he or she can observe the overall process, view the footage, and perhaps even edit some scenes right after they are shot.

 For student productions the crew is usually determined by the composition and size of the

class. Sometimes the entire class produces one movie, with each person serving one or two functions throughout the whole semester. The choice of the director is a crucial one that you (or your instructor) should consider very carefully. A weak director usually leads to a sub par production experience. In other situations a number of people produce short movies using classmates as crew. Although you can't actually hire your crew in a classroom situation, you should make every attempt to match students' abilities with the jobs that need to be accomplished. This, of course, needs to be tempered with allowing your classmates to try something they have not done in the past to see if they have aptitude in that area.

Finding Locations

Scouting for locations in one of the many tasks related to establishing the movie's look. As discussed in Chapter 1, the production designer oversees the visual elements (under the supervision of the director, of course). Production designers may or may not actually be involved in finding locations, but they do want to make sure the locations chosen serve the overall look appropriately.

Professional companies specialize in finding locations, and many cities and states that want to encourage filmmaking have offices and Web sites with photographs of various sites. The director may hire a location scout (or use the UPM or assistant director or art director) to undertake the initial research of finding a number of appropriate places and narrowing them down to a few choices per scene. Sometimes this person will travel to distant points, take photos of a particular site, and email these back to the director. Since digital technologies allow for easy removal of elements in a picture, a location that has one or two inappropriate characteristics, such as an overpowering tree or a building from the wrong era, can still be considered. In fact, the person searching for locations can use a computer program to remove the offensive element before emailing the photo.

Once a number of possibilities exist for a particular shooting location, the director (often in conjunction with the producer, line producer, UPM, AD, art director, and/or cinematographer) will further narrow the choices. Most directors want to see where they will be shooting so that they can anticipate problems and see whether the location fits their conception of the movie. A chase scene can take place just about anywhere, but a director who wants to give scenes a closed-in feeling will want to look for a certain combination of streets and buildings that can be shot at the appropriate angles. Of course, budget must be considered. The ideal street might be in Rome, but cast and crew cannot be transported there economically. A street in Burbank will have to do.

The director (and often the production designer, sound designer, and director of photography) should carefully survey the locales selected to ensure that shooting will go smoothly. The director should note the name of the person in charge of the facility as well as the name of someone to turn to if unexpected problems arise. If the shoot is outdoors or if natural light is going to be used indoors, the director should look at the facility at the same time of day as that planned for the shoot. In this way problems can be noted that might be caused by shadows or the position of the sun. The cinematographer may want to test the artistic effect of different lenses and different lights. The sound designer will want to listen for noises that may be disruptive such as air conditioning.

Many other important factors must be considered. Where should vehicles be parked? Where can cameras, lights, and mics be placed? How much power is available? Can cables be strung safely? Are there likely to be any interruptions such as a ringing phone? Do any large items (telephone poles, billboards) block the camera's view? The best way to cover all the important points while investigating a location is to develop and follow a location survey form such as that shown in Figure 2.14. Someone must obtain permission, preferably in writing, for shooting at any location. (See Figure 2.15 for a sample location release.) This is true for

Figure 2.14

An example of a form that covers some of the primary points to consider when surveying a location.

LOCATION SURVEY CHECKLIST

Type of material being shot _____

Time of shooting _____

Potential location of shooting _____

 Principal contact person _____

 Address _____

 Phone number _____

 E-mail address _____

Camera:

 Where can the camera be placed?
 What, if anything, is needed in the way of camera mounting devices or platforms?
 What, if anything, is needed in the way of special lenses?
 Will any objects interfere with the camera shots? If so, how can this situation be corrected?

Lighting:

 What types of lights will be needed?
 Where can the lights be placed?
 What light stands or particular light holders will be needed?
 What, if any, special lighting accessories will be needed?
 How can any problems regarding mixing indoor and outdoor lighting be solved?
 In what ways will the sun's position at different times of day affect the shooting?
 What kinds of problems are shadows likely to cause?

Power:

 Is enough power available or will a generator be needed?
 Where is the circuit breaker box?
 Who can be contacted if a circuit blows?
 Which circuits can be used and how many watts can be run on them?
 How many, if any, extension cords will be needed?
 What power outlets can be used?

Sound:

 Are there background noises that may interfere with audio? If so, how can they be corrected?
 Where can the microphones and cable be placed?
 Are any particular microphone holders or stands needed?
 What types of microphones should be used?
 How much microphone cable will be needed?

General:

 Where is parking available?
 If passes are needed to enter the premises, how can they be obtained?

LOCATION RELEASE

The undersigned Owner or authorized representative of the Premises located at:

hereby grants to the Production Company:

its licensees, successors, assigns, and designees, an irrevocable license to enter upon and record the Premises in connection with the production and distribution of the Movie tentatively entitled:

This permission includes, but is not limited to, the right to bring cast, crew, equipment, props, and temporary sets onto the premises. All things brought onto the Premises will be removed at the end of the production period. The Production Company shall leave the Premises in as good order and condition as when entered, reasonable wear and tear excepted. The Production Company shall indemnify the Owner for any loss and liability incurred as a direct result of any property damage or personal injury occurring on the Premises caused in connection with the Production Company's use of the Premises.

The Production Company shall own all rights in and to recordings and depictions made on or about the premises forever and for all purposes. The Production Company shall have no obligations to pay any fee or other consideration for the exercise of the rights granted.

This Agreement may not be modified except by another writing signed by the parties.

Signature _____

Printed Name _____

Date _____

Figure 2.15

A sample permission form for shooting at a location.

student productions as well as for professional ones. Releases should be obtained for use of people's homes, stores, or other commercial buildings.

Many cities require movie producers to pay for permits to shoot in the city. The money is used to help defray any extra costs the city may incur for directing traffic around the production area or adding security. If permits are required, they should be obtained during preproduction so that production is not delayed.

Designing and Constructing Sets

Determining what sets to build is closely associated with location scouting. Theoretically, any movie can be shot totally on location or totally in the studio. During the 1920s, for example, the Germans used the massive studios of UFA (Universum Film A.G.) for all scenes in their films—even those that depicted masses of people in city streets or forests (complete with concrete trees). By doing that they were able to control the lighting, the tonalities that would show on the black and white film, the shape of all the architectural structures, and the relationship of all other elements of art design.

Control is a primary reason for building a set and shooting in a studio. You do not need to worry about the position of the sun. You can shoot long shots at 9 a.m. and close-ups at 4 p.m. without worrying that they won't match when you intercut them. You can place trees where you want them and not where they happen to be growing. You do not need to worry about airplanes flying overhead and ruining the audio of your Civil War picture. You don't have to hurry to finish a shot because classes will be changing and a horde of unwanted students will appear in the background.

A studio set can also be more convenient if you can leave the set up and plan to shoot in the same place for a number of days. Under these circumstances, you can leave everything in place

and do not need to set up and break down every day as you might at a remote location. Another reason for building a set is that you cannot find what you want in the "real world." A *Star Trek* control room does not actually exist anywhere, so you need to build it.

Cost can be another consideration. For student productions, sets are usually more expensive than locations because the material for the sets must be purchased, whereas the locations are usually local and free. On professional features this may not be the case, mainly because the wages of crew and cast are such a large percentage of the budget. The extra time needed on location and the costs that may be associated with transportation and lodging can greatly exceed the cost of a set in a studio.

Sometimes a scene requires a combination of location and set. For example, a TV studio control room might serve as the basis for a futuristic space lab but be augmented by peripheral flats that show additional complicated instruments.

Someone—usually the director, producer, production designer, or unit production manager—must decide which scenes need sets and which need locations. These decisions are made tentatively after the script is broken down. The location scout may be looking at city photos for available Victorian dining rooms while the art director is planning and determining costs to build one. The director would decide what to do after they both complete their research.

Once the decision to build a set has been made, the **set designer** draws up the plans, keeping in mind the overall feel of the picture decided on by the director and art director and the lighting and shooting requirements the cinematographer might impose. Computer programs can help with set designing, allowing for previsualization and testing of "what ifs" (see Figure 2.16). Some programs allow a set designer to "build" a set with computer graphics. Then the set designer, director, and others can "walk through" the computerized drawing as though they were looking through a camera. **Aspect ratios** or lens **focal length** can be changed with the click of a mouse. Computer programs allow for very accurate measurements that can

a b

Figure 2.16

Computer programs make it easy to alter elements. If you had designed the set as in (a) and then decided there wasn't enough room for the action, you could easily redesign it (b) with a few mouse clicks to make it roomier.

sometimes be transferred to machinery that cuts the wood or other material. Another approach to set building is to construct a model. Often this miniature construction points up problems that will occur when the large set is built.

Once the director approves the set design, it can be built. Construction must be started well in advance of the shooting date because building a set can be a long, multistep process. **Flats** must be built before they can be painted, must be painted before pictures can be hung on them, and must be erected before major pieces of furniture can be placed in front of them. The sturdiness of the set must be considered. A door that is not used can be rather flimsily built, but one that is going to have characters using it must be sturdy and well braced so that it looks real. Also, set builders must keep the safety of the actors in mind at all times.

Set decorations need to be considered as part of the set design. These items, such as flowerpots, ashtrays, pillows, and lamps, add atmosphere. Someone may need to do research, especially if a movie is a period piece, to make sure the set decorations are consistent with items that were available at the time and place the movie is supposedly taking place.

A set can be expensive if everything is bought new. Students rarely need to do this; you can raid the dorm (with permission!) or your own bedrooms. Even professionals usually deal with secondhand or rental stores or find flats and set pieces among those stored at the studio.

Digital technologies can provide an alternative to traditional set building. Increasingly, computers are being used to create the sets themselves. These **virtual sets** are computer-generated graphics that are placed behind the actors, who, while they are performing, do not have an actual set surrounding them. Computerized sets, or parts of them, can be reused in different films. Elements of a set can be modified and reshaped; new elements can be added, cut, and repositioned; and perspective can be changed and objects can be resized.

However, whether the set is made of pixels or plywood, a great deal of time, thought, skill, and hard work goes into it. The whole process must be considered carefully because the set can be the major element in creating the atmosphere for the scene.[7]

Designing Costumes, Wardrobe, Makeup, and Hairstyling

The extent to which costumes, wardrobe, makeup, and hairstyling need to be considered during the planning phase depends on the nature and scope of the picture. Many student directors give little thought to these elements. Actors wear their own clothes and handle their own hairstyling and makeup, if any. The main consideration is making sure actors wear the same clothes and makeup in all scenes that supposedly occur close to each other in time. Actors should also keep the same general hairstyle. One student actor decided to shave his beard about three fourths of the way through a production. Shooting had to be halted for 2 weeks while he

grew his beard back. If your student production is set in a different era, you will need period costumes. If some characters have an unusual look or are much older than the actors actually portraying them, you will need special makeup.

Professional productions pay more attention to these elements. Even if a movie is set in modern times, the wardrobe of the stars is usually specially designed so that it flatters the stars and fits the overall mood of the picture. Period pieces require a large staff of people fitting and sewing costumes for many months before production begins. People involved with period hairstyling also can be busy during these weeks, researching the styles of the period and buying and styling wigs. Unusual makeup, such as a hand with six fingers or a burned face, must be considered in advance so that all the necessary supplies are available.

For movies that do not require anything unusual, makeup artists and hairstylists do most of their work during production. They are there to enhance the actors and to make sure face and hair look the same from one day to the next if that is what the shooting schedule requires.[8]

Obtaining Props

A list of essential **props** can be culled from the script breakdown, but a prop master, or someone filling that duty, must make sure all are obtained and fit the director's overall vision of the movie. The person buying or borrowing props may look for set decorations as well.[9] Props are usually thought of as items required by the plot (for example, the flowers the hero gives to the heroine to win her heart). Set decorations add to the overall feel of the scene but are not integral to the plot (for example, the vase of flowers sitting on the coffee table). The line between the two often becomes blurred. If a scene is shot in a garden in September, but the story is set in May, someone may need to buy artificial spring flowers.

Some props are actually a source of income for the production company. **Product placement** has become quite common in movies. The companies owning the diet soda that the star consumes, the running shoes adorning feet in a chase scene, or the toy that the child holds tightly all may have paid to have their products used in the movie.

Once sets, costumes, makeup, hair, and props are designed for a particular scene, a **storyboard artist** puts them all together to see if there are integration problems. Does the dress the lead actress will wear clash with the sofa? Will the blond actor's hair disappear when he steps in front of the mostly yellow painting? Will the vase get in the way when the child runs across the room? As with everything else, it is much better to solve problems when they are on paper or in a computer than when they are on a stage with expensive actors and crew members standing around.

Developing Effects

On-set special effects fall into a number of areas: a blood packet that explodes in the mouth of someone who has been socked in the jaw could be considered makeup, a sleeve that rips off could be part of a costume, a chair that breaks in half could be designed into the set, and a fog machine might fall in the province of the cinematographer. What is important is that someone makes sure all items needed for special effects are ordered and in place for production. A special effects coordinator often reads the script and plans for the on-stage effects. This can be something many people wouldn't think of as a special effect, such as water running from a faucet in the kitchen sink. But if the kitchen set is built without water and washing hands is integral to the plot, someone has to figure out how to create or simulate running water.

Of course, visual effects can be created in computers and then intermingled with the live footage. Similarly, some effects are created using models. All of these effects need a great deal of careful planning and are usually started before live production begins because they take a fairly long time to create. For an effects laden movie, a **visual effects supervisor** may be an important member of the planning team, even to the ex-

tent of creating some of the visual effects before the art director starts to work on sets so that the sets can match the needs of the effects. Regardless of the order in which the work is completed, effects must be very carefully coordinated with what will be shot. For example, tiny models or computer-generated images of the main characters must wear the same color clothes as the people in the live action scene.

Planning Sound

Although most sound is a product of shooting and editing, it can certainly be planned earlier. The sound designer should read the script and determine what dialogue can be captured during shooting and what will need to be recorded in an **ADR** session after filming. If circumstances that will inhibit the proper recording of audio are identified early, such as a noisy environment or a stunt performance where a microphone might cause a safety problem, audio operators will not try for usable sound but will record a **scratch track** that the talent can use later to record the dialogue in a studio environment.

The preproduction period is not too early to start collecting sound effects that will be used during postproduction. Some of these can be from prerecorded sources such as sound effects CDs; other can be created digitally. Combining and manipulating digitally created noises often leads to unique audio elements that add to the film. As with picture elements, sounds can be sent over the Internet for the director to review, regardless of where he or she is located.[10]

Acquiring and Checking Equipment

All equipment should be purchased, rented, or obtained in some other way during the planning period. It should then be carefully checked out to make sure it will work properly. For both professional and student productions, equipment taken to a location should be connected and operated somewhere close to a maintenance facility so any problems can be corrected.

Check batteries to make sure they are fully charged. Examine lenses for scratches or focus imperfections. Lubricate tripods, if necessary, so they operate smoothly. Check that lights focus properly and that extra lamps and extension cables are readily available. Make sure the viewfinder is accurate by framing something with it and seeing that the framing is the same when the image is recorded. Test cameras, microphones, and headsets to make sure they work. Check connectors and cables carefully both visually and in operation because they are likely to cause trouble. By all means make sure you have purchased the film or tape stock you will need to capture your movie.

Obtaining Rights

Some movies contain elements that involve rights clearance. For example, if the plot calls for a radio to play or one of the characters to sing "I Want to Hold Your Hand," rights to that Beatles song must be cleared. Clearing music is not easy. The first step is to find out what company published the music and ask that publisher for a synchronization license, which usually costs money. The publisher may also require that you receive permission from the performer, the record company, and/or the composer. Gaining all these permissions can be time consuming.

It is easier to use **copyright**-cleared music from one of the many stock libraries that exist solely for this purpose. The music is not always distinctive, but it often can fill the need.[11] Using music that is so old that it is in the **public domain** is another solution. Music can also be specially written for the scene, but this often costs more than obtaining the rights. Students can sometimes obtain original music economically by talking to friends in the music department who are eager to experiment with music for movies.

Film or tape footage is another item that often needs clearance. One example would be a news story that is an integral part of the plot.

You cannot simply tape Dan Rather off the air and include that in a production. You must seek permission from CBS. Sometimes, rather than shooting at a location, a movie will incorporate a few shots that establish the location; for example, shots of an airplane taking off will establish the location as an airport. Many movies contain shots of airplanes taking off that could be used, but rights again must be cleared. A number of companies supply copyright-cleared stock footage, including news clips. They charge for the footage, but using them is usually cheaper and more convenient than trying to clear rights.[12]

Photographs, artwork, pictures from books, and sometimes even sound effects must also be cleared through the appropriate contact(s)—publisher, artist, author, photographer, museum, or record company. Figure 2.17 shows a sample letter requesting permission to use a copyrighted work. Finding the address of the appropriate contact often requires some research, but the Internet makes this much easier than it used to be.

If a movie is going to have a sequel or a TV movie may become a series, you should be sure to get rights for future uses so you do not need to go back repeatedly. Archive everything you get clearance for (and also material created specifically for the movie) so you can remember it at a future time.

Arranging Travel and Food

Someone must attend to the creature comforts for members of the cast and crew. For any shoot that will last more than 4 or 5 hours, someone should have snack food available and locate in advance the nearest restaurant and restrooms. At a more complex level are arrangements for air travel, ground transportation, overnight accommodations, and meals in some exotic country. If the travel is to be extensive, perhaps to several different countries, the unit production manager (or someone else) can enlist a travel agent to make the arrangements.

However, the plans cannot be handled like a simple tourist travel plan. Such a shoot often involves shipping an extensive amount of expensive equipment, and stars may require extra security. If the movie falls behind schedule during production, many of the transportation arrangements made may need to be changed.

Usually, someone goes to the location ahead of time to check whether equipment can be rented and to try to line up some crew members and extras. This will cut down on transportation costs. This person can also check out local hotels, restaurants, and **catering** services so that cast and crew can be adequately cared for within the limits of the budget.

If the film is shot locally, lodging is not a problem because everyone can go home at night. But transportation for people and equipment still is a consideration. A student producer must make sure enough cars are available to transport everyone and everything to the location site. Also, provide everyone with maps and phone numbers for the location.

For shoots that last all day, at least one meal must be provided. One way to handle this is through caterers. In cities that host a great deal of video and film production, companies specialize in catering to casts and crews at location sites. Usually, the UPM hires the catering company and makes sure it is kept up to date on when and where the cast and crew will be for lunch. Catering has definite advantages, especially if the shoot is at a remote location. People can get back to work more quickly if the food comes to them than if they have to drive a long distance to a restaurant. A variation on catering often used by students is sending one of the crew members to the nearest fast food place to buy lunch for everyone and bring it back to the location.

On the professional level, many union regulations govern meal breaks. The production company must follow them strictly or face fines and legal grievances. Requirements vary according to the particular working arrangements for cast and crew, but generally no one can work for more than 6 hours without at least a 30-minute meal break. Some contracts stipulate the quality of the food that must be provided—a soft drink and a bag of potato chips won't do.

Students are not encumbered with union regulations, but a student producer should still

Date

Name
Licensing Department
Music Publishing Company
Street Address
City, State, and Zip Code

Dear Person's Name:

I am producing a movie entitled <u>Name of Movie</u> for which I would like to have one of the characters sing the song "Name of Song" composed by Name of Composer. I would like to acquire a non-exclusive synchronization license for this musical composition.

I would like permission to use this material for broadcast, cablecast, or other means of exhibition throughout the world as often as deemed appropriate for this movie and for any future revisions of this movie. Your permission granting me the right to use this material in no way restricts your use for any other purposes.

For your convenience, a release form is provided below and a copy of this letter is attached for your files.

Sincerely yours,

Your Name

I (We) grant permission for the use requested in this letter.

Signature _____

Printed Name _____

Title _____

Phone Number _____

Date _____

Figure 2.17
A sample letter asking for permission to use a copyrighted work.

make sure people have time to eat. An empty stomach makes for a grouchy disposition.

Buying Insurance

Moviemaking is subject to a great deal of risk. During the planning phase, the producer should make sure that adequate insurance is purchased to cover any mishaps. One risk is that the movie will not be completed because the money runs out. To cover this risk, Hollywood has developed a special type of insurance, called a **completion guarantee.** Of course, like any insurance, a completion guarantee costs the production company money in terms of a premium, usually a percentage of the estimated cost of the picture. The company that provides the money for the completion guarantee states that if its money is needed to finish the movie it can take over the production, which usually means firing the director and hiring someone who can finish the job economically.[13]

Producers often buy error and omission insurance that covers them if they accidentally neglect to obtain copyright permission for something that needs such clearance or misstate information in something that is supposed to be factual. Liability insurance is a must, especially if the picture is to be shot on location. This insurance covers damage to people's homes or other sites used as locations, as well as harm to people. Someone on the production crew should be assigned to take before and after pictures of a location in case the owner of the location files a damage suit. Insurance is also needed to cover theft or breakage of equipment, props, set pieces, and the like. This insurance is often quite expensive or else it doesn't cover much. The producer must decide on the breadth and depth of the insurance coverage in relation to its cost.

Vehicle insurance is a must for all cars and trucks that will be moving equipment or people during a production. Many other specialized forms of insurance exist—for example, a particular star or a particular prop can be insured. Insurance can even be taken out against inclement weather, but these special insurance plans are expensive and usually not worth the cost. Nothing is fail-safe.

Notes

1. Screenplay Systems used to own Movie Magic Screenwriter, Scheduling, and Budgeting. However, in 1999 it sold Scheduling and Budgeting to Creative Planet, which then sold it to Entertainment Partners. Screenplay Systems retained Screenwriter. The two programs are still closely tied together. Information about Movie Magic Technologies can be found at www.moviemagic-technologies.com. Screenplay Systems Web address is www.screenplay.com. Information about scriptwriting software can also be found at The Writer's Computer Store at www.hollywoodnetwork.com/writerscomputer.

2. We would like to thank filmmaker/screenwriter Mark Chodzko, author Carol Carrick, and Phoenix Films for allowing us to use the material dealing with *Old Mother Witch*.

3. For a variety of forms, see Richard Gates, *Production Management for Film and Video* (Stoneham, MA: Focal Press, 1995); Dale Newton and John Gaspard, *Digital Filmmaking 101* (New York: Edmond H. Weiss, 2001); Steve R. Entwright, *Pre-Production Planning for Video, Film, and Multimedia* (Stoneham, MA: Focal Press, 1996); and *Producer's Masterguide* (New York: Producer's Masterguide, 1995).

4. Sometimes insurance, legal fees, and licenses are considered to be above-the-line rather than below-the-line costs.

5. These rates are based on a number of rate cards, including those of Alan Gordon Enterprises, Birns and Sawyer, Creative Video, Edit House, Sight and Sound Studios, and Shokus Video.

6. These figures are based on those given in the CD-ROM *Paymaster* (Burbank, CA: Entertainment Partners, 2002-2003). The Web address is *www.ep-services.com*. A low-budget movie is one below $500,000; a medium-budget movie is between $500,000 and $1.5 million; a high-budget movie is more than $1.5 million. Some things other than direct salary considered in union contracts are meals, rest breaks, wardrobe allowance, overtime, and travel allowance.

7. For more on set design, see Peter Utz, "The Joy of Sets," *AV Video*, May 1995, pp. 90–93; and "Virtual Sets: Tie to Push the Button?" *Electronic Media*, 15 June 1998, p. 10.

8. For more on costumes, makeup, and hairstyling, see Janet Literland et al., *Broadway Costumes on a Budget* (Colorado Springs, CO: Meriwether, 1996); Margit Rudiger and Renate Von Samson, *388 Great Hairstyles* (New York: Sterling, 1998); and Penny Delamar, *The Complete Make-Up*

Artist: Working in Film, Television, and Theatre (Evanston, IL: Northwestern University Press, 1995).

9. Many directories exist to help production people find props, costumes, locations, equipment, and so on. Some of them are *The Source Book* (Pasadena, CA: Debbies Book, 2002); *The Industry Flip Book* (Los Angeles: Generation, 1998); and *Motion Picture TV and Theatre Directory* (Tarrytown, NY: Motion Picture Enterprises, 2002).

10. "Voices on the Wire," *TV Technology,* 22 September 1999, p. 68.

11. A list of music libraries can be found in "Sound Trackers," *Hollywood Reporter,* 23–29 April 2000, p. S-16.

12. A list of stock footage providers can be found in "UnCommon Stock," *AV Video,* March 1995, pp. 159–172. Some companies put out CD-ROMs that index their offerings.

13. "The Risk Business," *Hollywood Reporter,* 25 June 2001, pp. S-1–S-2.

chapter three
Cameras

Many moviemakers who use digital technologies for planning, editing, and other processes still use film cameras to capture original images. However, an increasing number, both students and professionals, are using digital camcorders. Advocates of both film and video argue the merits of each. Video is cheaper because tape is less expensive than film and because tape does not need to be processed as film does. The argument goes like this: if you have less financial risk, you can take more creative risk. If you are a student on a limited budget, you will appreciate the fact that you can learn and experiment with video without overtaxing your bankroll. Some digital video camcorders are very small and portable, enabling you to shoot in places where it would be difficult to position a film camera. However, because video is inexpensive, moviemakers sometimes shoot too much and then have difficulty sorting through all the footage and editing it.

Another advantage of video is that you can see your footage right away. You do not have to wait for processing to discover your mistakes. If you see the errors immediately, you can reshoot when it is still inexpensive and convenient to do so rather than after you have moved from the location. Other people can avail themselves of the footage faster too. Material shot in the morning can be in the editor's hands by lunch, even if the editor is in another city, because digital video can be sent over the Internet through high-quality phone lines.

Digital footage also meshes easier with other digital processes. Film footage must be transferred to video before it can be placed in a computer for editing, whereas digital video footage can skip the various transfer stages. It is also easier to integrate digital footage with visual effects created in a computer, again because the interface is relatively uncomplicated.

On the other hand, film has been around longer and is better understood by veteran cinematographers. Some people like the "film look" and feel that video images are too harsh. Video still does not have the technical quality of film, although it has come a long way in a few short years. Thirty-five millimeter film is a world standard that can be found anywhere, whereas video forms come and go, making it difficult to archive material in a form that will stand the test of time.[1]

Because the video image is different from the film image, some movies are now shot partly with video and partly with film (see Figure 3.1).[2] If a sharp, saturated look is called for, that is easier to conjure with video than with film. When very bright and very dark images must be discerned, that is a job for film. Video can be used for material that is going to be intermixed with computerized visual effects, and film can be used on a studio set. In this chapter we will look at characteristics of both video and film cameras and discuss their similarities and differences.

Formats

Film **formats** have been standardized for many years, but new video formats are introduced regularly. Film formats are determined primarily by the actual width of the film in millimeters. However, it is possible to have two formats of the same width (Super 8 and regular 8mm, for example), so film formats are also based on the differences in image area, perforations, and sound tracks. Video formats are based on factors such as tape size, the method used to record the video signal, and the speed at which the tape moves through the recorder.

Film Formats

The original motion picture format, invented by Thomas Edison and George Eastman in 1889, was **35mm**, which is basically the same film format used today for most theatrical motion pictures. Perforations (**sprocket holes**) along the sides of the film, the area of the film

available for the image (the **frame**), a film speed of 24 frames per second, and the sound tracks were soon standardized. In the 1920s Eastman Kodak introduced a new format, **16mm**, which was intended to encourage amateur filmmaking. This format proved to be too costly for most amateurs, but it became the choice for many educational and training films.

Super 8 was introduced in 1965, and was a variation on **8mm,** which had been around since the 1930s. Both formats used film that was 8mm wide, but by repositioning sprocket holes and making them smaller, Super 8 had a larger image area. In the same way, **Super 16,** introduced in early 1970s, provided more image space by eliminating sprocket holes on one side of the 16mm frame. Formats larger than 35mm (primarily **70mm**) have also been developed to improve the quality of theatrical films. Because 70mm is so expensive, it is usually reserved for big budget epic productions that can truly take advantage of the more dynamic image (see Figure 3.2).[3]

Obviously, the different formats require different cameras because they must be able to hold different sizes of film (see Figure 3.3). In film, the producer selects a format based on the cost and the ultimate place of exhibition. The larger the format, the more image resolution and the more expensive the production. Theatrical motion pictures use 70mm and 35mm. The less expensive 16mm format and its sister Super 16 format are used for productions that do not call for the large-screen image, such as music videos. Because of the enormous cost associated with theatrical film formats, student moviemakers, if they work in film at all, usually work in 16mm or Super 8. However, Super 8 has been largely superseded by video camcorders, and it is becoming increasingly difficult to find places to purchase or process 16mm.

Analog Video Formats

The original video format introduced by Ampex in the 1950s used 2-inch tape and a very large recorder that was never attached to the camera. Formats in this unattached configuration (1-inch, ¾-inch **U-matic**) continued to be introduced

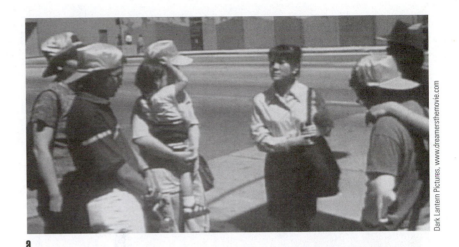
a

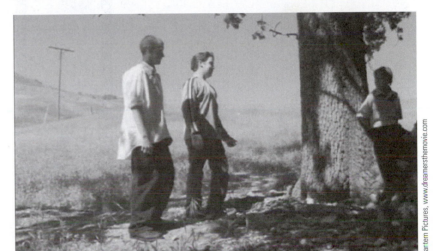
b

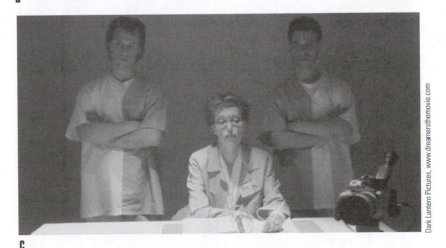
c

Figure 3.1

The movie Dreamers *used three formats: Shots from a tourist's perspective (a) were shot on video; the main character's youth (b) was shot on 16mm; and shots related to the movie business (c) were shot with 35mm. (Photos courtesy of Dark Lantern Pictures, www.dreamersthemovie.com)*

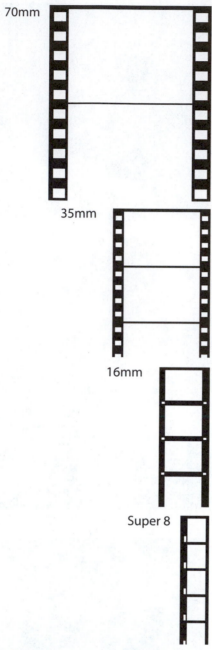

70mm

35mm

16mm

Super 8

Figure 3.2
A comparison of different film formats.

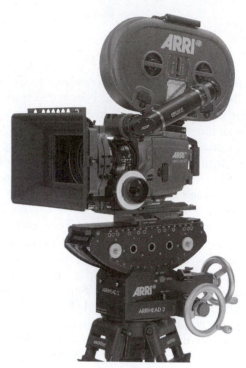

Arri Inc.

Figure 3.3
An Arri 35mm camera. (Photo courtesy of Arri Inc.)

Most of the formats introduced during the 1980s and early 1990s (**VHS, Super VHS, Betamax, Betacam, M-format, Video-8, Hi-8,** and so forth)[4] were **analog** rather than **digital**.

Analog recording produces a continuous electrical signal with a shape that is defined by the video wave it is representing. Digital equipment records the video information as a series of discrete on and off pulses in the form of zeros and ones (see Figure 3.4). The digital technique produces superior picture quality and also allows taped material to be copied without losing quality. This is because the on and off pulses of digital can be repeated without degradation, whereas the shape of the analog signal changes slightly as it is dubbed from one recorder to another. If you have ever seen a fourth-generation VHS tape, you have seen the degradation process of analog recording.

Digital Video Formats

Sony introduced the first digital recording format, **D1**, in 1986, a very expensive system that used ½-inch cassette tape and separated camera and recorder. A number of formats followed

through the 1970s but were rarely used for moviemaking.

In the early 1980s manufacturers (primarily Sony and Panasonic) introduced **camcorders.** These small, portable configurations combined camera and recorder and became very popular with consumers, who used them for home movies, and with students and independent moviemakers, who used them for their projects.

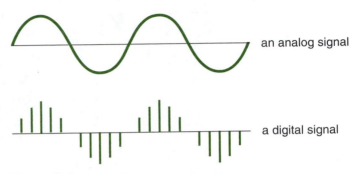

Figure 3.4

The difference between analog and digital. The analog signal is continuous, and the digital signal samples the sound wave.

(**D2, D3, DCT**), some of which were compressed. **Compression** is a digital technique for placing more information in less space. Much of the information in a particular shot does not change over the course of that shot. For example, if two people in a long shot are standing in front of a building having a conversation, the building does not change; only the gestures of the people will change. In the digital domain, the building does not need to be recorded over and over for each frame as it does for analog recording because the discrete on and off pulses remain the same and can be referenced to the first frame. The only information that needs to be recorded is that related to the two people. This means the information about the shot can take less tape space than would be required if the building were recorded over and over. The ability to compress is another way digital technologies differ from analog.

In the 1990s, a number of digital camcorder formats emerged. In 1993 Sony introduced a ½-inch **Digital Betacam** format, and in 1995 both Sony and Panasonic came out with ¼-inch digital formats: **Mini-DV** and **DVCAM** from Sony, and **DVCPRO** from Panasonic. The main difference between Mini-DV (sometimes referred to simply as **DV**) and DVCAM is the size of the tape. Although both are ¼-inch tapes, the DV container is smaller (about 2¼ in. x 2 in.) than the DVCAM container, which is about 3 x 5 inches (see Figure 3.5). The DV camcorders can be very portable, in part because the tape container is so small. The DV tape works perfectly in a DVCAM recorder, but a DVCAM tape, of course, cannot fit in the smaller DV camcorder. The DVCPRO format uses the larger tape container, but it is not compatible with DVCAM or DV because of the type of tape it uses and because of internal machine differences. Digital video camcorders are rapidly replacing analog formats and at present are the cameras of choice for student moviemaking (see Figure 3.6).[5]

High-Definition Video Formats

All of the formats discussed here, whether analog or digital, were made with **standard definition**

Brian Gross

Figure 3.5

A small DV tape next to the larger DVCAM tape. (Photo courtesy of Brian Gross)

Brian Gross

Figure 3.6

A Mini-DV camcorder. (Photo courtesy of Brian Gross)

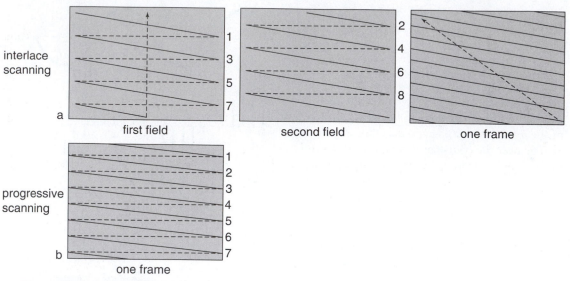

interlace scanning

a　　first field　　　second field　　　one frame

progressive scanning

b　　one frame

Figure 3.7

The difference between interlace and progressive scanning. (a) For interlace, the odd field lines (1, 3, 5, and so on) are scanned, moving left to right across each line. At the end of a line, the signal goes into a blanking mode and quickly retraces back to the left edge to begin scanning the next line. This continues until all the odd-numbered lines in the first field (half of the picture) are scanned. Then the signal goes into the vertical blanking mode while it moves back to the top of the picture to begin scanning the even-numbered lines that make up the other half of the picture. The scanning process for each field takes 1/60 of a second. Combining the two fields produces the full video frame in 1/30 of a second. (b) For progressive scanning, the lines are laid down one after the other to form an entire frame.

television (**SDTV**) in mind—the form of television that has been used since TV's early days. In the United States this is called **NTSC** after the National Television System Committee, which designed it. It is a system that has 525 lines for each frame of video and shows them at a rate of 30 frames per second. The lines are **interlace scanned;** that is, odd lines (1, 3, 5, 7, and so on.) are projected followed by even lines (2, 4, 6, 8, and so on). **PAL** and **SECAM** exist in other parts of the world. These systems have 625 lines shown in an interlaced fashion at 25 frames per second; they differ in how they handle color. They are easier to transfer to film because the 25 frames per second is close to the 24 frame per second rate of film.

High-definition television (HDTV) has been under development since the 1970s, and cameras to accommodate it have come and gone. HDTV has suffered from numerous political problems, and there were so many different HDTV formats proposed that camera manufacturers did not know what path to follow. All systems proposed more lines on the screen than SD, but the number varied—720,

1080, 1125, to mention a few. Originally HDTV was based on analog technology, but now it is digitally based. Early HDTV systems used interlace scanning, but computers have now been developed with **progressive scanning** wherein all the lines are placed on the screen sequentially (see Figure 3.7). Some of the HDTV formats adopted progressive scanning, but others stuck with interlace scanning. So, although cameras exist, they are not standardized with regard to television production and distribution.

A standard, **24P,** has emerged for moviemaking, however. This is a digital camera with 1080 lines and progressive scanning that operates at 24 frames per second, the same speed as a film camera. Its signal, as is, cannot be sent through the television airwaves, but it is an excellent format to use to combine with film or computer-generated visual effects. It has a **refresh rate** of 72, meaning that each frame is shown three times (24 x 3 = 72), giving even greater stability to the picture. The 24P format received a big boost because George Lucas used it in the 2000s to shoot the new *Star Wars* episodes (see Color Plate 8). Sony developed the

camera, called CineAlta (see Figure 3.8), and Panavision modified it slightly so the colors would look more like those shot on film.[6]

All the high-definition formats have higher resolution than the standard definition formats. The **resolution** of an image is determined by the number of **pixels** that can be seen across the screen (**horizontal resolution**) times the number of pixels that can be counted going down the screen (**vertical resolution**). We have already mentioned that the NTSC system has 525 lines down the screen. NTSC's vertical resolution is not quite 525, however, because some of the lines are used for the vertical blanking (review Figure 3.7). The vertical resolution is actually about 480 lines. Horizontal resolution depends to some degree on the quality of your TV set, but over the air signals have a horizontal resolution of about 300, so the overall resolution is 300 by 480. Here are the resolutions of some of the formats we have been discussing:

VHS – 200 by 480
Hi-8 – 400 by 480
MiniDV – 720 by 480
24P – 1920 by 1080
35mm film – 4000 by 3000

As you can see, the 24P HDTV format is more than double the resolution of standard TV formats, but only about half that of film. Resolution affects how well fine details show up when projected onto a large screen. This is one reason film is still the desired medium for theatrical projection.

Aspect Ratio

The basic shape of a film or video frame is referred to as its **aspect ratio.** It is the ratio of the width of the frame to its height. In film, the most popular early aspect ratio (3 units of height to every 4 units of width) was eventually adopted by the Academy of Motion Picture Arts and Sciences as the standard for theatrical films. This **Academy ratio,** also expressed as 1.33:1 (a square would have an aspect ratio of 1:1), has been the aspect ratio for standard 8mm, 16mm, and 35mm film.[7] Although 1.33:1 was an arbitrary

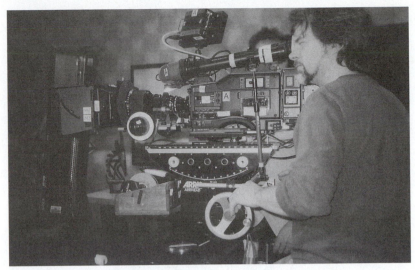

Figure 3.8

The CineAlta camera 24P high-definition camera in use.

frame configuration, the television industry also adopted the mildly rectangular 4:3 aspect ratio when it standardized its frame shape.

Partly in an effort to lure television viewers back to movie theaters in the 1950s, the motion picture industry developed several **widescreen** aspect ratios to produce a larger, more powerful film image. One method was to mask off the top and bottom of the typical 35mm film frame, a procedure that created the commonly used widescreen aspect ratios of 1.85:1 in the United States and 1.66:1 in Europe. Another method involved the use of an **anamorphic lens** to squeeze the widescreen image optically into the film frame, and then unsqueeze it onto the movie screen with an anamorphic lens on the projector. The anamorphic widescreen process created an extremely elongated rectangular frame, with an aspect ratio of 2.35:1 for the Panavision process.[8]

Occasionally, widescreen films are shown on standard definition television (or released on videotape or disc) in the **letterbox** format, which masks off the top and bottom of the frame and displays the entire widescreen image within television's 1.33:1 aspect ratio. More commonly, this translation of aspect ratios involves some loss (or even reframing) of the original film image, a process referred to as **panning and scanning.**[9]

The aspect ratio for digital HDTV is 16:9, which is about 1.78:1, so it is much closer to the widescreen formats than standard definition (see Figure 3.9). Most digital format cameras have the option of shooting either 4:3 or 16:9.

chapter three

1.33:1 Academy aperture

Figure 3.9

A variety of aspect ratios.

4:3 standard TV ratio

1.66:1 European standard widescreen

16:9 HDTV ratio

1.85:1 American standard widescreen

anamorphic 2:1 squeeze, 2.35:1 when projected

Stock

Selecting a film or videotape stock begins with the format you choose for your production. A 35mm film camera requires 35mm film, and a ½-inch VHS VCR requires the right ½-inch videotape cassette. But the choice of a film stock has far greater impact technologically and aesthetically than does the choice of videotape. The film stock itself produces the image, so the selection of a particular type of film profoundly affects the picture.

Film Stock

Motion picture film is composed of a thin layer of light-sensitive silver halide grains suspended in gelatin, the emulsion. The layer of **emulsion** is supported by a flexible, transparent **base** of acetate. Film is threaded in the camera so the emulsion is toward the light source; the lens focuses light onto the emulsion, and a photochemical reaction occurs. The areas of the photograph (each frame of the motion picture film is an individual photograph) that receive the most light will appear darkest when the film is developed (chemically processed and stabilized) in the laboratory. Raw (unexposed) film should be stored in the refrigerator; film stored for 6 months or more should be stored in a freezer. Always allow stored film to warm up for about an hour before using it. Once the film is exposed, it should be processed as quickly as possible, and processed film should be stored at room temperature.

For one type of film, called **negative** film, the image must be printed on another piece of film to produce a **positive** image with correct photographic tones (that is, black as black and white as white). Another type of film, called **reversal**, requires additional processing in the laboratory to convert the film (the original film run through the camera) into a positive image. After processing, reversal film can be viewed (or projected) without the need to make a print. Color film stock uses three layers (yellow, cyan, and magenta) of photosensitive dyes to produce all the colors in the visible spectrum.

You can also select film stock based on the light you will be using. If you want to shoot

Kodak 16 mm Film Stock			
Number	Type	Daylight ASA	Tungsten ASA
7245	Color Negative	50	12 with blue filter
7248	Color Negative	64 with orange filter	100
7274	Color Negative	125 with orange filter	200
7246	Color Negative	250	64 with blue filter
7277	Color Negative	200 with orange filter	320
7279	Color Negative	320 with orange filter	500
7240	Color Reversal	80 with orange filter	125
7239	Color Reversal	160	40 with blue filter
7250	Color Reversal	250 with orange filter	400
7251	Color Reversal	400	100 with blue filter
7231	B&W Negative	80	64
7222	B&W Negative	250	200
7276	B&W Reversal	50	40
7278	B&W Reversal	200	160

Figure 3.10

Kodak's line of 16mm film stock.

where there is not much light, you need to buy a **fast film stock** (one more sensitive to light) that has a high **exposure index** (**EI**) or **ASA** (for example, ASA 400). Or you may want a **slow film stock** (with a lower EI, such as 50) to produce a sharper, less grainy image. Film stock is also **color balanced** (designed to produce the correct colors in different types of light) for artificial (**tungsten**) light or for **daylight**. Finally, even similar film stocks from different manufacturers (like Kodak, AGFA, and Fuji) have different **tonalities**—the range of colors (or black and white) that they reproduce (see Figure 3.10).[10]

Videotape

In video, almost all these choices are predetermined by the recording format and the quality of the camera. Whether to shoot in black and white or in color is not determined by the selection of videotape, because all videotape can record either color or black and white. The quality and sensitivity of the camera determines the ability to produce an image in low light as well as the overall sharpness and quality of the image. Given the same camera and VCR, the choice of one videotape over another has only a minimal effect on image quality and almost no effect on the cinematographer's artistic control of the image.

Videotape is composed of a polyester base coated along one side with a thin layer of metal oxide. More expensive videotapes usually (but not always) provide some slight gain in image quality and color rendition and a reduction in **dropouts** (loss of signal due to imperfections in the tape's surface). Videotape can, of course, be recorded over and used many times. However, because videotapes show wear after being used only a few times, most professionals would never consider using "used" tape stock for an important shoot.

Although this reuse capability is a definite advantage, especially in terms of cost, it is also possible to erase or record over something that you meant to save. Most cassettes have some temporary means of preventing an accidental re-recording, such as small tabs that can be moved to a different position or broken off from the cassette housing to protect the tape from erasure or re-recording. If you change your mind later and want to record on a tape after you have broken off the recording tab, you can place a piece of masking tape over the hole.

Tape may not remain as the main recording material for video. Recordable **DVDs** (**digital versatile discs**) could supersede it, and some cameras now record directly to hard drives. Both discs and hard drives have potential for higher resolution than videotape.

Brian Gross

Figure 3.11

A core (right) and a daylight reel. (Photo courtesy of Brian Gross)

Michael Swank

Figure 3.12

A threading pattern for film. (Artwork by Michael Swank)

Camera Construction

Film camera construction leans toward the mechanical, whereas video cameras are primarily electronic. This relates, at least in part, to the fact that film cameras were developed in the late 1800s, and video cameras were a product of the mid-1990s. But the principle is the same. When the camera is pointed at a scene, the lens gathers the light reflected from that scene and focuses it on an **imaging device**. Film stock is the imaging device in a film camera. In a video camera it is a solid-state element known as a **charge-coupled device (CCD)**.

Film Cameras

Film stock comes loaded on either a **core** or a **reel** (see Figure 3.11), which is placed on a feed spindle inside the camera. It is important that the stock not be exposed to light, so film is usually loaded in a dark room or with a special black changing bag that keeps out light. The stock is threaded through the various gears, wheels, and pins of the camera, which hold it in place and move it past the lens opening to a take-up spindle (see Figure 3.12). The camera is then sealed shut.

A motor, operated either by battery or house current, powers the camera in such a way that the film stock stops very briefly behind the lens opening so that light coming through the lens can strike it and create the chemical reaction that eventually results in a processed image. While the camera is pulling the next frame into place, a **shutter** closes behind the lens opening and momentarily blocks the light. It then swings out of the way so the next frame can be exposed. This happens over and over at the rate of 24 frames per second. Some cameras have provisions for filming slow motion or fast motion. The motor moves the film more quickly or more slowly but the process is the same.[11] After the film is exposed in this manner, it is taken out of the camera (again, in the dark) and sent to a film lab for processing.

Film projectors operate in much the same way. The processed film is threaded through the projector, and each frame stops momentarily behind the lens. Light from a bulb in the projector

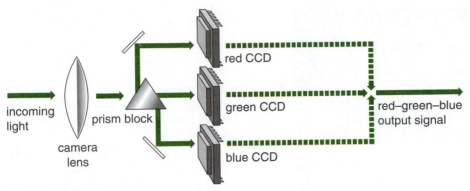

Figure 3.13

A prism block separates the light coming through the lens into its red, green, and blue components. Those three signals are then sent to the appropriate red, green, and blue CCDs. Eventually, the encoder recombines the three separate color signals to produce the full-color image.

is used to project the frame onto a screen. This, too, happens at the rate of 24 frames per second, which, to the human eye, looks like continuous movement.[12]

Video Cameras

Video creates the illusion of movement in a different way. Again, light comes through the lens, but it does not strike the videotape. It strikes the CCD sensors, which transform the incoming light into electrical signals that can be recorded on videotape. A CCD sensor is a solid-state device (a chip) that contains an array of individual light-sensitive pixels. When the image is focused on the sensor, each pixel builds up an electric charge containing color (chrominance) and brightness (luminance) information.

Chrominance contains two components, hue and saturation. **Hue** is the specific tint of the color (for example, yellow, brown, red); **saturation** is the intensity or purity of the color (for example, a highly saturated deep blue, a lightly saturated pale blue). **Luminance** is the degree of darkness or lightness of the image (color or black and white), and it has an effect on the **brightness** of a color (see Color Plate 1). Usually there are three CCDs, one for each primary color—red, blue, green (see Color Plate 2). The color is broken down (in proportion to the amount of each color in a scene) with a **prism block** behind the lens (see Figure 3.13).

The information captured on the CCDs is stored momentarily in a storage area in the chip until it is read out to create the video signal. The video frame does not exist as a single, discrete frame like a motion picture frame. It is a moving dot that travels electronically and eventually lights up phosphors on the TV screen one pixel at a time, line by line.

Within camcorders, the video signal can go directly to the recorder that is part of the overall camera. If the recorder is digital, the information is recorded as 0s and 1s that correspond to the electrical charge on the CCD. If it is analog, it is recorded as a continuous electronic signal. Sound as well as picture can be recorded on the tape (see Chapter 7).

Time Code

Time code is a numbering system that provides an address number for each frame of video. Most video systems record SMPTE[13] **time code** on the tape. This is a numbering system that provides an address number for each frame of video. For example, 01:02:15:10 would mean the tape was at 1 hour, 2 minutes, 15 seconds, and 10 frames. For some video formats, the time code is laid on one of the audio channels. For others, it is laid on the vertical blanking interval or on a special section of the tape specifically reserved for time code. Still other camcorders do not come equipped with the components for recording time code in the field, but it can be added in postproduction. Time code is most useful for editing (see Chapter 10).

Time code can also be recorded on audiotape (see Chapter 7) or film stock, and it can be shown on a slate. In this way everything that was recorded at the same time will have the same

Figure 3.14

A slate with a clapper and electronic time code. (Photo courtesy of Denecke, Inc.)

Figure 3.15

The proper way to look through a film camera eyepiece. (Photo courtesy of Dark Lantern Pictures, www.dreamersthemovie.com)

number and can be easily synced at some later date. Time code comes from a **time code generator** built into a camera or some other equipment or stands alone. In the case of film, the time code is recorded on magnetic material placed by the perforations on the stock and then printed there when the film is processed. As the film is transferred to video for editing, a **time code reader** picks up the numbers from the film and records them along with the picture.

A **slate** is a device that is held in front of the camera before the action of a particular shot begins. It gives such information as the name of the production, the director, and the scene that

is being recorded (see Figure 3.14). The slate does not need to show time code to be useful, but having time code on it will enhance the syncing process.

Other code numbers, such as **Keykode, Mr. Code, edge numbers,** and **Aaton dots,** are part of the film process and are used for **editing** and for cutting the original negative so that copies of the film can be made at a laboratory. These will be discussed in later chapters.

Viewers

Obviously, camera operators need to be able to see what they are recording. Film cameras have an **eyepiece,** a small viewer through which the camera operator looks to see the image as framed with the lens. To prevent unwanted light from seeping in and to see the image properly, you need to keep your eye up against the viewer (see Figure 3.15). This makes it difficult for people to wear glasses while peering through the viewer, but most eyepieces have a **diopter** that can be used to adjust the viewer to compensate for nearsightedness and farsightedness. The small eyepiece also makes it so only one person at a time can see the image. Cinematographers like this feature, but directors who want control over what is shot don't.

To aid the directors, **video assist** has been added to the repertoire of filming. A tap is taken off the film camera right behind the lens, and this image is sent to a video monitor. The director (and others) can stand by the monitor and see exactly what is being shot and make suggestions and corrections. Material shown on the monitor can also be recorded onto tape and then viewed as desired.

Television cameras have **viewfinders** that display an electronic image of what is coming through the lens to the CCDs. Some viewfinders are very tiny—the size of a film eyepiece. Others, such as those on studio cameras, are quite large so that the image can be easily seen while standing in back of the camera operating its controls. In between are viewfinders (usually LCD screens) that pop out to the side of the camcorder and even flip around so people being recorded can see themselves. Camcorder view-

finders usually display not only the picture but also information about the status of the camera—how full the battery is, how much tape remains, what filters or light settings have been selected. The viewfinder can also be used to see what has been recorded on the tape when it is played back.

When a separate monitor is set up on a video shoot (see Figure 3.16), it is usually not referred to as video assist, but if more people need to see what is being shot than can see it on the viewfinder, a monitor feed can certainly be taken from the camera with ease. Many cameras have connections that allow them to show images, including those recorded on tape, on a regular home TV set. Using your TV is a particularly effective way to log what you have shot and make some initial editing decisions.

Basic Camera Features

Each camera model (video or film) has slightly different features, so you should always read the manual for the particular camera you are using. However, some general features relate to the operation of most film or video cameras, and we will describe them here. We have already discussed some of these functions, such as the ability to shoot 16:9 or 4:3 aspect ratios, and other features are addressed in the section on lenses later in this chapter. Audio applications of cameras are covered in Chapter 7.

Power

Generally cameras (film or video) require electrical power in order to function.[14] One form of power is **DC**, which comes from batteries inserted into the camera or carried in an external battery belt or shoulder pack. Most cameras have some type of adapter (or power unit) that allows the camera to use **AC** current from the wall, and many consumer-grade cameras provide car battery adapters that plug into the cigarette lighter. There often is a switch on the camera for selecting the type of power (AC or DC) a camera is to receive; another switch turns the power on or off. In some cameras the on/off switch has a **standby** position that allows the

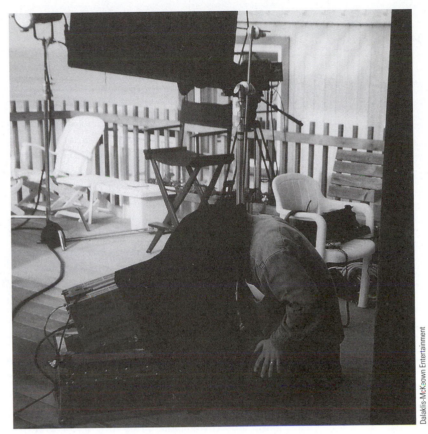

Figure 3.16
Producer-Director Greg Hodson checks out a shot for a Lifetime cable TV shoot. The black cloth over his head enables him to see the image on the monitor when it is in bright outdoor light. (Photo courtesy of Dalaklis-McKeown Entertainment)

Dalaklis-McKeown Entertainment

camera's circuitry to preheat or warm up without using full power.

Some rechargeable batteries develop a "memory" problem if they are not handled properly. If a camera is used only for a brief time and then the battery is removed and placed in the charger, eventually it will not be able to accept a full charge. This can be avoided by being sure the battery is fully drained before recharging. Most cameras have some sort of indicator to let you know the battery is running low. Some batteries have their own charging units; others can be recharged using the AC adapter.

Recording Controls

Camcorders and film cameras are designed for use by a single operator and have a triggerlike switch for starting, stopping, or pausing. A strap near the front of the camera or lens provides support for holding the camera by hand and also places the hand close to the switch and any

controls that may be needed for focusing or zooming the lens.

A film camera only starts and stops, but a camcorder has all the controls of any VCR—play, record, pause, fast forward, rewind, and stop. Of course, a film camera does not need many controls because you cannot view the footage after you shoot it. Film cameras do have dials that show you how many frames or feet you have shot.

Most recorders also have some sort of metering system so you can evaluate the quality of the signal you are recording. The most professional VCRs have a number of separate meters—one for video and one for each of the audio channels. Others have only one meter, but it can be switched to show either video or audio. Sometimes this same meter indicates the amount of charge in the battery. VCRs have a variety of recording inputs and outputs for video and audio. The video output is most commonly used to connect the camera to a monitor. The audio inputs are used primarily for microphones (see Chapter 7).

Color Rendition

Video cameras have a number of controls to adjust the picture for proper color rendition. With film, color is controlled mainly by the choice of film stock. But with video cameras, a filter wheel or a switch permits selection of filters appropriate for various lighting conditions, such as sunlight or artificial light.

A closely related function, **white balance**, enables the camera operator to make more subtle adjustments in the camera's ability to record white correctly, even in situations in which the lighting has a different hue—more red at sunset, more blue in August than in December. Most cameras sense whether the camera is being used indoors or outdoors and adjust white balance automatically, but the more subtle adjustments require operator control. To white balance, you fill the frame with something white and push the white balance button. That sets the camera circuitry to recognize white, and all other colors can be set accurately from the white setting. Or, if you want to be creative, you can white balance on some other color such as yel-

low. This will fool the camera circuitry into thinking yellow is white and change all other colors accordingly.

Gain

The signal strength (brightness of the picture) of many portable video cameras can be increased electronically by boosting the **gain.** Although this allows the camera to operate effectively at lower light levels, it creates more video noise (comparable to increasing the grain in a film image). Usually, a two- or three-position switch on the camera boosts the gain in large increments, such as +9 **decibels** (**dB**) or +18 dB.

Most consumer cameras are equipped with an **automatic gain control** (**AGC**) option that continuously adjusts the signal gain as the picture changes. In situations that call for a great deal of camera movement and different light levels, problems arise because the AGC is constantly compensating for varying levels of brightness and darkness. Being able to turn off the automatic gain control is a valuable asset.

Shutter Speed

Many video cameras also contain an electronic **shutter** switch for different high-speed shutter settings. The shutter reduces exposure, which sharpens detail and helps eliminate blurring in shots with fast action (such as a racing car). This shutter should not be confused with the shutter in a film camera, which shuts out light as the film is moving.

Other Features

Many consumer camcorders can insert the date and time on a recording, and some models can insert titles into a shot. Another switch may record an index search pulse to help locate that position during playback. Also, digital technology has made it possible to generate a number of in-camera visual effects, such as wipes, still frames, pictures in a picture, and fades in or out. These are fine for recording vacations and parties, but moviemakers rarely use these add-ons. Titles and effects are better done in the editing suite. Once you have the camera set for the way

you want it for a particular shot, some cameras have a switch that memorizes all the settings so you can use them again for some other shot.

Lenses

Everything that is filmed or taped passes through the **lens,** so it is a very important part of the camera assembly. In fact, in some ways a camera is only as good as its lens. Given the clarity possible with high-definition television, good lenses have become even more important.[15]

Lenses gather light reflected by a subject and concentrate it on the imaging device. A **lens hood** is often mounted on the front of the lens to keep stray light from hitting the lens surface and causing unwanted glare. A lens hood also may help protect the lens surface during transport.

Lenses consist of curved glass elements that turn the image upside down at the **optical center** of the lens and then focus it at a point where it begins its electronic or photochemical journey to being recorded. In a film camera, this focus point is the film itself; in a video camera, it is the CCD chip.

Focal Length

Most lenses on TV cameras and camcorders are **zoom lenses** (more properly called **variable focal length lenses**), capable of capturing close-ups, wide shots, and everything in between. Other lenses, called **fixed lenses** (or **prime lenses**), are capable of capturing only one perspective. If you frame a close-up with a fixed lens, you cannot keep the camera in the same position and change to a wide shot unless you change to a different lens.

With a zoom lens you can make this change, either while you are taping or between shots. To do so you must move elements within the lens by turning a barrel on the lens. This barrel can be turned by hand, but more often the barrel is turned remotely by a servo-controlled motor (see Figure 3.17). A switch on the camera allows the operator to activate and deactivate the zoom and to control its speed. The motor allows for a smoother zoom than can be accomplished by hand.

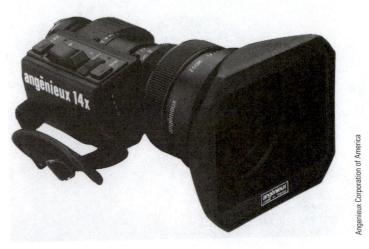

Angenieux Corporation of America

Figure 3.17

A zoom lens with servo-control mounted on the left. Note the lens hood, which keeps stray light rays from the lens surface. (Photo courtesy of Angenieux Corporation of America)

All lenses, zoom or fixed, have measurements that designate their **focal length.** One fixed lens may be a 25mm lens, whereas another is 50mm. A variable focal length lens may have a range of 10mm to 100mm. The focal length is the distance from the optical center of the lens to the point in the camera where the image is focused. The longer the focal length, the more the shot is magnified. A 50mm lens will show greater detail, but less of a scene, than a 25mm lens. A zoom lens that is in the 100mm position will have a tighter shot than when it is in the 50mm position.

Zoom lenses often have a designation that specifies the ratio of the closest shot to the widest shot. For example, some lenses are 5:1, whereas others are 10:1. If the widest shot on a 5:1 lens is 20mm, the tightest shot will be 100mm. If the widest shot on a 10:1 lens is 20mm, the tightest shot will be 200mm. The bigger the ratio, the greater the zooming range—and the greater the cost of the lens.

Lenses or zoom lens positions that show shots that appear to be magnified are usually referred to as **telephoto;** those that show views roughly as the eye sees them are **normal;** those with a view wider than the human eye's are called **wide-angle.** The normal lens creates the most natural perspective. The telephoto makes things appear bigger, but it also foreshortens them so that they appear to be closer to each other. If the objects are moving, they will appear to move more slowly than they actually are. The

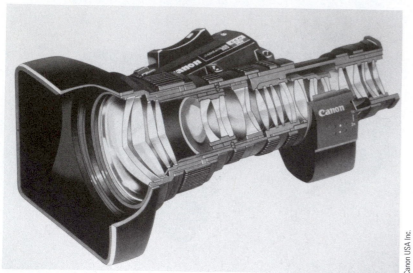

Figure 3.18

A cutaway of a zoom lens showing the many different elements within. (Photo courtesy of Canon USA Inc.)

lenses to use. They are more expensive, mainly because they have more elements than fixed lenses (see Figure 3.18). They need more light, because light dissipates as it goes through these dozen or so elements. They cannot be manufactured to provide an optimum picture at all focal lengths. However, zoom lenses have the obvious advantage of changing magnification easily. They are also likely to deliver more consistent color than prime lenses. Color rendition changes slightly from one lens to another, so if a 25mm lens is removed from a camera and replaced with a 50mm lens, the color recorded may change slightly. Prime lenses, however, need less light than zoom lenses and produce a sharper image because focus quality shifts in various areas within the zoom range. In general, prime lenses surpass zoom lenses in quality.

Focus

A lens has a ring for controlling **focus**, with numbers on the ring that give distance in feet (and inches) and meters. When something is in focus, it looks sharp and clear; when it is out of focus, it appears fuzzy and ill defined. When you look in the viewfinder while turning the focus knob, you usually can discern when the picture is in focus. However, a good practice is to look at the focus ring to make sure it reads a distance about the same as the actual distance to your subject. If you are 10 feet from a subject and your focus ring reads 3 feet, something is wrong with the optics. If focus is crucial, you can run a measuring tape from a mark on the camera that shows the location of the camera imaging device to the subject and set the focusing ring to correspond to the measurement.

Many cameras have **automatic focus** in that they discern the distance from the camera to the object and adjust the focus accordingly.[16] However, the automatic focus can be fooled. If the object you want in focus is at the right of the frame and another object is more to the center, the lens may focus on the wrong object. As with many of the other automatic features of cameras, auto focus is often best turned off.

The focusing mechanism for a fixed focal length lens is quite simple. It merely moves the lens elements closer to or farther away from the

opposite is true of a wide-angle lens. It makes things appear smaller, farther apart from each other, and faster than normal if an object is approaching or receding from the camera position.

In effect, a zoom lens can be thought of as a lens having the characteristics of all the prime lenses that it can mimic within the extremes of its zoom range. It is so easy to go from wide-angle to telephoto that operators sometimes do not weigh the advantages or disadvantages of a particular focal length setting. For example, an extreme telephoto shot can seem close to the subject and can fill the screen with detail, but at the cost of foreshortened depth, difficulty in holding the camera steady, and a touchy focus because of the shallow depth of field. At the other extreme of the zoom range (wide-angle), the opposite may be true. For example, although there is depth, the amount of detail needed to understand what is happening may not be discernible.

Zoom lenses often have a **macro** setting that allows the lens to focus on an object very close to the front element of the lens. A knob or some other control allows you to select the macro position for the lens to create a screen-filling close-up of a small object, such as a coin or a fingernail. Digital cameras sometimes provide a digital zoom that extends the range of the optical (mechanical) zoom through digital means, usually with some loss of image quality.

Although zoom lenses are standard on most video cameras, they are not always the best

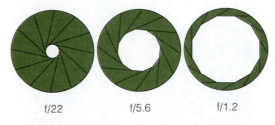

f/22 f/5.6 f/1.2

Figure 3.19

The thin metal blades of the lens iris open or close the aperture to different f-stops. The smaller the opening, the larger the f-stop number (and the less light the lens will allow to enter the camera). Lens speed is based on how much light a particular lens will let in at its maximum aperture. Thus, a lens with a maximum aperture of f/1.2 is faster than a lens with a maximum aperture of f/2.

imaging device. When the object to be placed in focus is close to the camera, the elements should be far from the imaging device. If the shot is focusing on a distant object, the elements should be closer to the film or CCD.

To focus a zoom lens properly, zoom in all the way (the most magnified or telephoto setting), focus, then zoom out to frame the shot. This focusing technique allows you to zoom in or out during the shot without losing focus on the subject. This type of focusing sets what is referred to as the zoom lens **front focus** because it changes the glass elements at the front of the lens. Zoom lenses also have a back focus, which should be adjusted only by a qualified camera technician. If the lens is jarred, this back focus can come out of adjustment, causing a fuzzy picture.[17]

Aperture

In addition to the focus ring, lenses have a ring that determines how much light is let into the camera. This ring controls the size of the **aperture**—the opening in the lens that allows light to pass. The aperture has an adjustable **diaphragm** or **iris** that opens and closes to let in more or less light. The degree to which the aperture is open is measured in **f-stops**, and these numbers appear on the aperture ring.

F-stops can be confusing if for no other reason than that they are depicted by rather strange numbers: 1.4, 2, 2.8, 4, 5.6, 8, 11, 16, 22. These seemingly unrelated numbers are the product of a mathematical formula that calls for multiplying each preceding number by the square root of 2. In this relationship, each f-stop doubles or halves the amount of light of the f-stop next to it. This relationship adds to the confusion because the larger the f-stop number, the smaller the aperture. In other words, there is an *inverse relationship* between the two. An f-stop of 8 will let in half as much light as an f-stop of 5.6; an f-stop of 11 will let in twice as much light as an f-stop of 16 (see Figure 3.19).

Some lenses may include a **t-stop** scale. T-stops are more accurate than f-stops because they take the particular lens into account. All lenses lose a certain amount of light within the lens itself, depending on the quality of the lens and its coatings. T-stops denote the actual amount of light *transmitted* (thus the *t* in t-stop) through a particular lens.

Lenses are rated according to their lowest f-stop number—the greatest amount of light they can let in. An f/1.4 lens is considered a fairly **fast lens** because it can open up wide enough to let in a good deal of light. An f/4 lens is a **slow lens** because it can let in much less light.

As with focus, many cameras have an **automatic iris** that adjusts to the amount of light hitting the image plane and sets the f-stop accordingly with a small motor that opens and closes the iris. Again, this is fine as long as you want average exposure. But if you want the scene to look dark, or if you have a scene with a bright background and a dark foreground, you may need to turn off the automatic iris.

Some situations require sacrificing overall exposure for the sake of correctly exposing the most important element in the frame. One way to make sure that your light reading is correct under these circumstances is to zoom in on that element and look at the automatic iris reading. Then zoom back out to your intended composition, and set the iris manually for the f-stop reading you had when you zoomed in. This is especially helpful if you have a person standing in front of a bright background. The automatic iris might expose for the bright background when what you want to be able to see is the person's features. If you have zoomed in and set the iris for the person's face, the face will be the element that is properly exposed.

Depth of Field

Depth of field is the distance (the range, really) through which objects will appear in sharp focus in front of and behind the point at which the

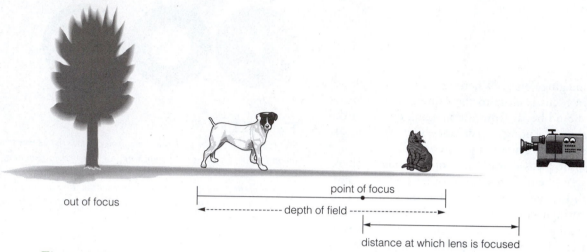

out of focus

point of focus

←-------------------- depth of field --------------------→

distance at which lens is focused

Figure 3.20

Depth of field and the one-third principle.

camera is actually focused. The depth of field varies according to the aperture, the focal length of the lens, and the distance of the camera from the subject. The longer the focal length of the lens and the wider the aperture, the shallower the depth of field will be. Thus, wide-angle (or short focal length) lenses give a greater depth of field than telephoto (or long focal length) lenses. Generally, the closer the subject is to the camera, the less the depth of field will be.

When two characters or objects are lined up at different distances from the camera, it sometimes may be necessary to split the focus to keep both subjects in clear, sharp view. This is not done by focusing on a point midway between the two; rather, it is done by focusing on a point one-third the distance behind the front subject. In other words, focus will be sharp for an area one-third in front and two-thirds behind the point of focus (see Figure 3.20).

Focal length affects depth of field because wide-angle lenses have a greater natural depth of field than telephoto lenses. They are designed to capture large, deep scenes. The smaller the aperture (and the larger the f-stop number), the greater the depth of field. A lens set at f/22 will create a greater depth of field than one set at f/2.8. This characteristic can be used to highlight certain objects in the frame by having them, and only them, in focus. Most lens manufacturers and many publications such as the *American Cinematographer Manual* publish depth-of-field charts that give the depth-of-field characteristics for lenses of different focal lengths under various conditions.[18]

As you can see, the various lens characteristics are interdependent. Sometimes it is difficult to remember the best combination after you have found it, but there is computer software that can remember your focal length, f-stop, and focus and replicate it at a later time. This can be helpful if you need to reshoot a scene on a different day or if you have an actor who plays two parts that are on the screen at the same time but are recorded at different times.

Camera Supports

Many elaborate pieces of equipment have been designed to support cameras, including stands and clasps for holding a camera on an airplane wing and platforms that mount on the side of a speeding car. But the types of supporting devices most common in electronic moviemaking are the tripod and the human shoulder. Less common, mainly because of their cost and size, are the dolly and the crane.[19]

Handheld Cameras

Small lightweight cameras can be placed on the shoulder and hand held, even by people who are not especially strong. However, it is difficult to hold them steady for any long period, especially if you must walk or move in any other way. The result is often jerky pictures that are likely to cause motion sickness in anyone who watches them.

Some camcorders have a feature called **image stabilization**, which digitally magnifies part of

Figure 3.21
A small Steadicam JR™ made for lightweight consumer camcorders. (Photo courtesy of Cinema Products Corporation)

Figure 3.22
A lightweight tripod. (Photo courtesy of Miller Fluid Heads)

Figure 3.23
A fluid head that allows smooth, fluid pans and tilts. (Photo courtesy of Miller Fluid Heads)

the image and tracks the image if the camera moves. In effect, it keeps the picture stable even though the operator's hands are moving slightly. Image stabilization cannot handle large variations in movement, but it is a worthwhile feature to look for if your movie calls for a fair amount of handholding.

Another aid to stable handholding is a **shoulder mount** attached to the camera so that it rides comfortably on the shoulder. More elaborate **body braces,** such as a **Steadicam** can also help the operator reduce unwanted camera movement. The Steadicam JR, a scaled down version of the original Steadicam, was designed specifically for lightweight consumer camcorders (see Figure 3.21).

Tripods

The **tripod** is a three-legged device for supporting a camera. The lengths of its legs are adjustable so that the tripod can be level even if the surface on which it is resting is not (see Figure 3.22). Most legs will adjust so the camera can rise from 2 to 3 feet off the ground to slightly above eye level. If a camera needs to be lower, you can use a **high hat,** a board attached to very short legs. Tripod legs have spikes or pads on the bottom so they can rest firmly on the ground or a floor. Sometimes wheels are attached to the legs to make the whole unit mobile.

Mounted on top of the three legs is a tripod **head,** a device with a handle that allows the camera to pivot smoothly (see Figure 3.23). A screw on the head attaches it to the bottom of the camera. Some heads (usually inexpensive ones) are referred to as **friction heads** and use

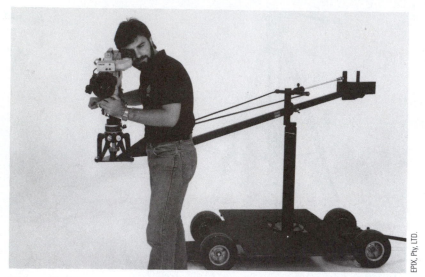

Figure 3.24

This dolly has a jib-arm, but the camera could also be mounted on the pole in the middle of the dolly. The wheels could be placed on a track so that the dolly would move consistently each time the shot is repeated. (Photo courtesy of EPIX, Pty, LTD.)

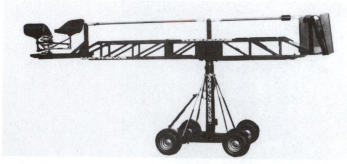

Figure 3.25

A crane. Note that it has space for mounting the camera and for the operator. (Photo courtesy of Matthews Studio Equipment, Inc.)

the resistance created by surfaces touching each other to provide smooth movement. More expensive **fluid heads** have adjustable hydraulic resistance that allows for easy, smooth camera movements. Both types have levers or screws that control the amount of freedom the camera has; heads can be locked down so they do not move at all, or they can provide varying degrees of movement.

Dollies and Cranes

Professional **dollies** are wheeled carts that come in various sizes, from about the size of a wagon to the size of a small truck. They are usually motorized and have pneumatic wheels that can be mounted on tracks (which sometimes come in a suitcase) for extra smoothness. There is a pole in the middle on which the camera is mounted, or sometimes they have **jib-arms** that can be used to swing the camera out (see Figure 3.24). Usually, one person drives or pulls the dolly while another operates the camera. They are excellent for moves that involve going forward and backward. Talented students often concoct homemade dollies from wheelchairs, grocery carts, and the like.

Cranes are large pieces of equipment, like the phone company's cherry pickers, that can move the camera from very low to very high above the set (see Figure 3.25). Many cranes can also move forward, backward, to the side, and in arcs. Several people may be required to move a crane from one position to the next. Cranes are expensive and are not used frequently, so they are usually rented.

Connectors

When a signal leaves one piece of equipment and goes to another, it travels through cables and connectors. The main connectors used for cameras are those that take the video signal to a monitor or some other piece of equipment such as a computer. Cables and connectors also transport audio signals (see Chapter 7).

The video connectors you are likely to encounter are BNC, S, RCA, and FireWire (see Figure 3.26). **BNC connectors** are most likely to be seen on older monitors. **S-connectors** are newer and usually take signals from cameras to monitors, including video assist systems. **RCA connectors** can carry either video or audio, but not both at the same time, and are very common in consumer equipment. Digital cameras usually include one or more of these analog connections so that the digital signal can be displayed on analog equipment. Digital cameras also include **FireWire** connections, or IEEE 1394, which enable a digital signal to be copied from one piece of equipment to another. For example, if a camera has a FireWire output, its sig-

nal can be copied into a computer with a FireWire input.

Care of Equipment

All equipment and supplies mentioned in this chapter should be handled and stored carefully. They represent an investment on the part of an individual, a school, or a company. Careless handling shortens their life and causes unnecessary operating problems.

One good rule is *never force anything*. If a connector won't slide into its receptacle easily, you probably do not have it lined up correctly. If you force a knob on a tripod, you may strip the threads. If a lens ring is binding or feels excessively loose, you are going to make things worse by forcing it. Driving a lever, switch, or dial against the end of its movement range will damage the equipment.

You should also protect equipment while transporting and storing it. Whenever possible, store and carry cameras and their lenses in sturdy, well-padded cases that hold the equipment securely in place so that it will not bounce around. If possible, store and carry tripods in sturdy cases. Before putting a tripod in the case, be sure that all levers are locked, the legs are bound together, and the handle attached to the head is positioned so that it cannot be damaged. Similarly, monitors and other pieces of equipment should have their own cases.

Even with cases to protect the equipment, everything should be moved as gently as possible. For cases that have wheels, use an elevator or handicapped ramp if available. If necessary, simply pick up the case and carry it a short distance.

Extreme heat or cold is not good for most equipment, and electronic gear must be protected from moisture. Keep lenses away from areas of high heat because the cement holding the elements in place may melt. Store tape and film in a cool place. Never leave film or tape in a parked car where the temperature can reach high levels. Dirt is also an enemy of electronic components. Keep equipment and supplies off the ground, especially if the area has sand or loose dirt.

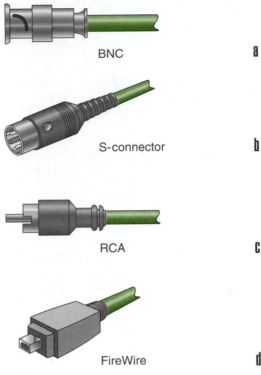

Figure 3.26

Some basic video connectors: (a) a BNC connector, (b) an S connector, (c) an RCA connector, and (d) a FireWire connector.

Lenses should be kept spotlessly clean. Although it is possible to clean a lens, doing so too often is not recommended. Anything touching a lens, even a cleaning cloth, can scratch it or wear down its antireflective coating. Fingerprints are especially bad for lenses. They produce a smear on the picture, and the oil from fingers can etch the lens over time. If the lens becomes dirty, remove dust gently with a camel hairbrush. Next, place a drop of special lens cleaner on a special nonabrasive lens tissue and rub it lightly over the lens surface in a circular motion.

One of the surest signs of professionalism is the respect with which a person treats equipment.

Notes

1. Frank Beacham, "A Production Standard for the Ages," *TV Technology,* 15 June 1998, p. 37; "Filming Without the Film," *Los Angeles Times,* 11 July 2002, p. 1; "The High-Definition Debate," *Hollywood Reporter,* 5–7 April 2002, p. 18; and "Cinematographers Find a Friend in Tape," *TV Technology,* 7 February 2001, p. 12.

2. The authors would like to express their appreciation to Ann Lu, writer and director, and Neal Fredericks, cinematographer, for providing us with the various photos from *Dreamers,* distributed by Pathfinder Home Entertainment.

3. Film formats have never been quite as standard as this discussion suggests. The number of perforations per frame has varied from two to six, and at different times in film history ultra-large-screen film formats have been introduced with film widths of 62mm, 63mm, and 65mm. The IMAX format uses several frames of 35mm film placed sideways. The Cinerama format initially required three cameras at a frame rate of 26 frames per second. In fact, much of the experimentation with large-screen formats involves increasing the frame rate to a speed higher than the customary 24 frames per second standard. By increasing the filming and projection speed to 48 fps or 60 fps, much higher image quality can be achieved in terms of sharpness and clarity.

4. In reality there have been and are many more formats than are discussed here. Formats using 1-inch tape have come and gone several times. In the 1960s, a ½-inch reel-to-reel format was developed by Sony, and a ¼-inch reel-to-reel was developed by Akai. A number of cartridge-based formats were introduced in the 1970s and 1980s that didn't last long. A ½-inch cassette format called ED-Beta was developed by Sony in the late 1980s to appeal to the education market, but this market latched on to other formats and the ED-Beta was discontinued. An improved version of the M-format, M-II, existed for a while.

5. Some good general articles that cover the various formats are "HDTV, 24p Cameras Steal the Spotlight," *TV Technology,* 20 March 2002, p. 56; "A Wide-Angle View of HD Cameras," *TV Technology,* 10 August 1998, p. 20; "Zooming in on Camcorders," *Consumer Reports,* October 1998, pp. 22–25; "Panasonic, Sony Unleash Rival DVCs," *TV Technology,* 22 March 1996, p. 1; and "Sony Moves to All Digital Camcorders," *TV Technology,* 1 November 2001, p. 1.

6. Panasonic developed a 24P camera that has 720 lines of vertical resolution, but it has not received the acceptance of the 1080 camera. For more on 24P, see "Prime Mover," *Hollywood Reporter,* 30 March–1 April 2000, pp. S-6–S-7.

7. Super 16, because it has only one side of perforations, has a wider frame with an aspect ratio of 1.66:1. If you want to shoot 16mm and blow up the picture to widescreen, you are better off shooting in Super 16 than regular 16. There is also a 35mm format that is only three perforations long rather than four, so the aspect ratio is close to 1.85:1. This format reduces the size of the frame and saves about 25 percent of the cost of film stock.

8. There are actually far more aspect ratios in film. Between the two extremes, the 1.33:1 Academy ratio and the Cinerama 3:1 ratio, are nine sizes. For a good historical summary of different aspect ratios, see Lenny Lipton, *Independent Filmmaking* (New York: Simon & Schuster, 1983), pp. 182–183.

9. Bruce Elder, "Widescreen Fever: Letterboxed Films Find Passionate Following in the Laserdisc Age," *Video,* September 1991, pp. 53–54.

10. Film manufacturers continue to improve the speed and the resolution of their film stocks. See, for example, Tony Harcourt, "The Features and Benefits of T-Grain Emulsion," *In Camera,* Summer 1995, pp. 28–29; and "Know Your Vinegar," *Hollywood Reporter,* 14–20 July 1998, p. S-9.

11. The motor makes the film travel through the camera faster for slow motion and slower for fast motion. The logic behind what seems to be a contradiction has to do with projection. When film that has been shot fast (say, at 48 fps) is projected back at 24 fps, each second of film shot will take 2 seconds to be projected. When film is shot slowly (for example, at 12 fps), one second of this film would be projected in one half of a second.

12. Early researchers credited this phenomenon to the so-called persistence of vision, the capacity of the human eye to retain each image (each projected frame) for a fraction of a second. Coupled with the Phi phenomenon, a response observed by Gestalt psychologist Max Wertheimer, the sense of motion on the screen is possible. Scientists, however, are still debating precisely how this process actually works. The illusion of movement created by a series of projected still pictures is the result of complex physiological and psychological factors. If the film projection rate is too slow, 8 frames per second, for example, the image appears to flicker. When the speed is increased to 16 or more frames per second, the viewer no longer perceives the flickering.

13. SMPTE stands for Society of Motion Picture and Television Engineers, the group that set time code standards.

14. Some film cameras have wind-up motors.

15. Michael Grotticelli, "New Lenses Key to HDTV Acquisition," *TV Technology,* 8 May 1997, p. 114; "Choosing the Right Camera and Lens," *Video Multimedia Producer,* November 1998, p. 67; and

"To Focus and Project," *Sound and Video Contractor,* January 2002, p. 24.

16. Three main types of auto-focusing systems are used in camcorders today: range finding, phase detection, and blur reduction. For an excellent discussion of the pros and cons of the various systems, see David Ranada, "Inside Optics: How Camcorders See," *Video,* October 1990, pp. 38–43. One offshoot in auto-focusing, "fuzzy logic," was designed to avoid the "hunting" typical of the earlier auto-focusing systems. When confronted with multiple subjects, many older auto-focusing systems went back and forth, in and out of focus. In contrast, a fuzzy logic system surveys many objects at different distances, chooses a compromise setting, and stops grinding back and forth.

17. This is tied to depth of focus, a concept that is often incorrectly confused with depth of field. Depth of focus refers to the distance between the back of the lens and the target of the camera. If this distance is changed, the depth of focus is changed, and the picture will not focus properly. The focus can be adjusted by setting the lens at infinity and zooming in on a distant object. Then adjust the distance between the lens and the CCD (the back focus) so that the image is sharp. When you zoom out, the image should stay sharp. If it doesn't, adjust the back focus in the zoomed-out position until the picture is sharp. Now zoom in. The picture should be sharp. Continue to do this until both the zoomed-in position and the zoomed-out position yield a focused picture.

18. Internet sites that provide depth-of-field charts include *www.outsight.com, www.bep.co.uk/photo,* and *www.johnhendry.com.*

19. For articles on camera mounts, see "The Pros and Cons of the Tripod," *TV Technology,* February 1993, p. 36; and "Sachtler Supports Cameras Around the World," *TV Technology,* 22 September 1999, p. 88.

chapter four
Approaches to Image Capturing

A director must decide not only what to shoot but how to shoot it. The distinction here is between what is put in front of the camera and how the camera itself is used to record and manipulate the scene being shot. Film scholars have adopted the French theatrical term **mise-en-scène** to describe the director's control of the lighting, sets, locations, props, makeup, costumes, and blocking.[1] This concept is useful in defining more clearly the role of cinematography.

The director can make decisions about the mise-en-scène while undertaking planning or during the shooting phase (the last-minute blocking of the actors or adjustment of the lights) but before the camera comes into play. In effect, the mise-en-scène is what is visible through the viewfinder before shooting—the way the scene is staged for the camera. Once the director decides on the mise-en-scène, attention moves to how best to capture it with the camera. At this point the director and cinematographer must make a number of choices about composition.

Shot Determination

Interpreting the mise-en-scène involves determining how much of that scene to include within the shot. One of the special powers of the camera is its capacity to force the audience to see what the director wants the audience to see. This situation is quite different from real life or from a stage play, where the observer is free to choose the point on which to concentrate. At a play, part of the audience may be watching the French maid; the rest may be watching the English butler. When a camera is used to interpret that scene, the viewer can virtually be forced to see a single area of the scene, such as the maid's eyes.

Of course, the director may also use elements of the mise-en-scène to direct the audience's attention, whether in a movie, at a stage play, or even in real life. The lighting, blocking, costumes, makeup, set design, and dialogue all direct the viewer's eye. But the camera directs the audience's attention in a more obvious and powerful manner.

The Basic Shots

Selecting what is to be seen in the frame is one way the camera can be used to direct attention. This capacity distinguishes a film from a play, where the frame is the entire proscenium arch. In the theater you buy the frame through which you are going to see the play when you pay for your seat. The cheaper the seats, the longer your "shot" of the stage. Shots are constantly changing in a motion picture. You see a variety of **long shots (LS)**, **medium shots (MS)**, and **close-ups (CU)**. Defining these terms is not always easy, but generally a close-up isolates the subject from the surroundings, a medium shot includes the subject but also some of the surroundings, and a long shot emphasizes the surroundings and the subject's place in relation to them (see Figure 4.1) However, to some extent these terms are relative to each other. The medium shot in Figure 4.1 might serve as a long shot in another circumstance. For example, used as a long shot, it could be followed by a medium shot of the man's head and chest and a close-up of his face. Perhaps the simplest way to describe different shots is in terms of a spectrum, with an extreme long shot as the widest shot and an extreme close-up as the nearest shot. All other shots are spread somewhere between the two extremes.

Another common way to describe a composition is according to the number of people in the shot; for example, a two-shot has two people, and a three-shot has three people. Terms such as *head shot, head-and-shoulders shot,* and *full shot* are fairly self-descriptive, but none of these terms is exact. (Figure 4.2 shows some standard shots.) Given that there are many ways to describe a composition and that your medium shot may be somewhat different from what your friend means by a medium shot, the

a

real translation often lies in the camera viewfinder. The director can look through the viewfinder (or at the video assist) and say, "That's what I want."

Subjective Shots

Another type of composition injects a subjective element into the composition. A shot in which the lens of the camera becomes, in effect, the eye of a character in the film is called a **point-of-view (POV) shot.** We are all familiar with a novel that is narrated by a character such as the hard-boiled detective. Narration from the viewpoint of a character within the story is more difficult in film and video. Nothing within the shot itself tells you that this is what James Bond sees. But a close-up of Bond's eyes (and a slight widening of the pupils) can be followed by a POV shot that approximates the height, angle, and direction of Bond's gaze.

Sustaining this for an entire film, however, greatly reduces a director's storytelling flexibility and can be almost silly. Robert Montgomery's film *The Lady in the Lake* (1946) tried, and not very successfully, to create a visual equivalent of first-person narration (like the hard-boiled detective novel on which it was based) by using POV shots for the entire picture. We see the detective's hands reaching into drawers or his pipe poking into the shot as if the camera were located precisely at eye level and the pipe were in our (his) mouth at the bottom of the frame. The detective in *The Lady in the Lake* is seen only occasionally, in a mirror or window reflection. Most filmmaking uses POV shots far more sparingly (see Figure 4.3).

The **over-the-shoulder (OS) shot** (see Figure 4.4) is also executed from a particular position. This shot literally looks over the shoulder of one character toward another character or object. An OS shot is a typical way of shooting two people talking. For example, a man might be seen from over a woman's shoulder. A reverse angle shot would then show the woman from over the shoulder of the man. Over-the-shoulder shots have a subjective element. We are seeing from approximately the same angle as the character whose shoulder we are looking across.

b

c

Figure 4.1

(a) A long shot, (b) a medium shot, and (c) a close-up.

Figure 4.2

Other common shot descriptions: (a) a two-shot; (b) a full shot; (c) a head-and-shoulders shot; and (d) an extreme close-up, sometimes called a choker close-up. (Photos (a), (b), and (c) from Len Richmond's Merchants of Venus, courtesy of Amazing Movies, Dianna Ippolito, photographer)

Lens Selection

Another aspect of composition concerns the choice of **lens** or the setting of the variable focal length **zoom lens** (see Chapter 3). This choice can determine how something appears in terms of physical and psychological distance. It can also direct attention by selecting what will and will not be in focus. As more and more shooting moves out of the studio and into the environment, the manipulation of lenses becomes quite important. In the real world, things are often more crowded and cramped than they are on a sound stage, so the lenses need to be used to convey distances that may not actually exist.

Focal Length Characteristics

The **normal lens,** so called because it shows things much as the viewer's eyes see them, might be the least manipulative and most realistic of the various lenses. It introduces the least distortion into the scene.

The **telephoto lens** (or **long lens**) tends to compress the perceived distances between the foreground and background within the shot. A television commercial in which the auto execu-

tives demonstrate their faith in the brakes of their company's luxury sedan actually demonstrates their faith in the power of an extreme telephoto lens. This lens makes the car that is screeching to a halt near their legs seem much closer than it really is. In general, the long or telephoto lens may be the most obvious lens in the sense of calling attention to itself. It can draw the viewer into the scene, creating intimacy and involvement. An extreme telephoto lens can so distort perspective relationships that the result is an almost surreal, dreamlike quality. This lens can also give a voyeuristic feeling, almost as if the spectator is eavesdropping on the scene. *Mississippi Burning* was shot largely with a telephoto lens to give a closed-in feeling that evoked racial tension.

On the other hand, an extreme **wide-angle lens** (or **short lens**) calls attention to itself by distorting the image, albeit in the opposite way. It can create a feeling of size and scope by giving a wide horizontal field of view. This characteristic can be used to delineate relationships between characters in a film. Orson Welles's classic film *Citizen Kane* is noted for its extensive use of extreme wide-angle lenses to emphasize the physical and psychological distance between its characters (see Figure 4.5).

The object is to choose the focal length that fits the sense of the scene you are shooting. What kind of relationships do you want to emphasize through size, distance, and perspective? Do you want to distort or call attention to the way the mise-en-scène is being manipulated?

Figure 4.3

A point-of-view shot of a person framing a picture for a film shot. (Photo courtesy of Dark Lantern Pictures, www.dreamersthemovie.com)

Figure 4.4

An over-the-shoulder shot. (Photo courtesy of Dark Lantern Pictures, www.dreamersthemovie.com)

Depth of Field

By manipulating the **depth of field**, the director has yet another way to direct the spectator's attention within the frame (see Figure 4.6). A large depth of field allows the viewer's eyes to roam throughout every plane of action, all of which will be in focus. Some directors, like Orson Welles and Jean Renoir, are noted for using deep focus in their films. This technique can be more realistic because it approximates the way we see. It also allows the viewer to seek out an area of interest in a composition with many layers.

A shallow depth of field (or shallow focus) isolates a subject in one plane and throws all other planes out of focus. In the heyday of Hollywood studio production, a shallow depth of field was often used to isolate the studio's major star from any visual distractions in the foreground or background. Using a shallow depth of field also makes it possible to shift the point of focus during the shot. This technique, as it is seen on the screen, is known as **rack focus.** It is the result of **pulling focus** (that is, changing focus) during the shot (see Figure 4.7). For example, a shot might begin with the star in sharp focus in the foreground, but as the focus is shifted, the star blurs out of focus while a character in the background comes into sharp relief.

Photofest

Figure 4.5

In this breakfast scene from Citizen Kane, *the husband and wife are made to look fur- ther apart than they are to emphasize alienation. (Photo from Photofest)*

Camera Angle

The angle of the shot can also affect composition. A camera can be placed above or below the scene, creating a **high-angle shot** or a **low-angle shot**. The standard (or conventional) meaning attached to these shots deals with the relative dominance of different viewing angles. A shot looking down usually diminishes or weakens the subject (or character), whereas a shot looking up tends to ac- centuate the power or dominance of the subject. In Orson Welles's *Touch of Evil* the corrupt and corpulent border police officer, played by Welles himself, is consistently shot from extreme low an- gles, making him grotesquely sinister and power- ful at the same time.

These are examples of extreme angles, how- ever. The normal camera angle in narrative

Figure 4.6

(a) A shallow depth of field from Dreamers *and (b) a deep or large field in Jean Renoir's* Rules of the Game. *(Photo (a) courtesy of Dark Lantern Pictures, www.dreamersthemovie. com; photo (b) from Janus Films)*

a

Dark Lantern Pictures, www.dreamersthemovie.com

b

Janus Films

Figure 4.7

(a) The man in the fore- ground is in focus. Pulling focus (b) brings the man in the back- ground into focus and throws the man in the foreground out of focus. (Photo courtesy of Video Producer: A Video Pro- duction Lab *by Herbert Zettl and Cooperative Media Group, published by Wadsworth)*

a

Video Producer

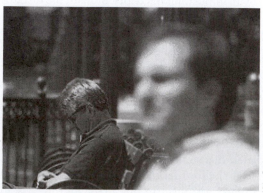

b

Video Producer

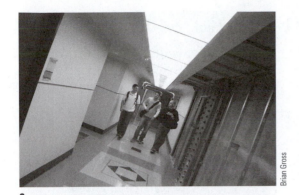

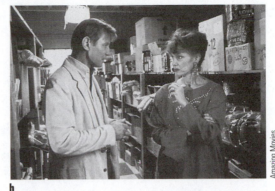

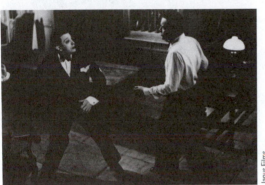

Figure 4.8
Different camera angles: (a) a canted shot; (b) a two-shot from the conventional chest-high angle in Merchants of Venus; *(c) a high-angle shot; and (d) a low-angle shot from Jean Renoir's* Rules of the Game. *(Photo (a) courtesy of Brian Gross; photo (b) from Len Richmond's* Merchants of Venus, *courtesy of Amazing Movies, Dianna Ippolito, photographer; photos (c) and (d) from Janus Films)*

motion pictures is chest high, not eye high, a practice that does not match the viewer's everyday visual experience (unless the viewer is very short). This angle does match the viewer's experience of watching motion pictures—a chest-high camera angle is the norm, the conventional angle for shooting "larger-than-life" film stars. Consequently, eye-height angles (as in shoulder-mounted camera work) look like high angles even though they are totally realistic in terms of our normal viewing experience. A **Steadicam** (see Chapter 3) allows stable, handheld, mobile shooting at angles lower than eye height.

The framing of a shot may also be manipulated by the degree to which the framing is level with the horizon. A **canted shot,** or **tilted shot,** is unusual and disorienting and can be unsettling to the viewer. A POV shot that suggests someone is drunk or drugged frequently uses this composition, but it is wrong to suggest that a canted frame always means something is askew or out of kilter. The meaning of a canted frame, or for that matter a high-angle or low-angle shot, is derived from the context of the film, not from some dictionary of camera aesthetics. (The photos in Figure 4.8 illustrate different camera angles.)

Composing Within the Static Frame

Some shots that the director composes are relatively static because the camera does not move very much. A number of conventions, or so-called rules, have evolved regarding the composition of a shot within a static frame. These involve elements such as balance, depth, relative strength of various planes of the shot, and the space on and off the screen.

Manipulating the Mise-en-Scène

Before the camera rolls, the way the event is staged for the camera has a profound effect on how the composition directs the viewer's eye. The director's storytelling technique is based on

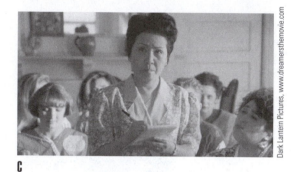

a

c

b

Figure 4.9
(a) The diagonal lines add to the interest of this shot of Prunella Gee and Michael York; (b) the two people in the center of this scene from Dr. Zhivago *create a mass that is dominant in the frame; (c) the woman standing facing the camera stands out from the others. (Photo (a) from Len Richmond's* Merchants of Venus, *courtesy of Amazing Movies, Dianna Ippolito, photographer; photo (b) © 1965 Metro-Goldwyn-Mayer, Inc.; photo (c) courtesy of Dark Lantern Pictures, www.dreamersthemovie. com)*

a subtle interplay of lighting, blocking, costumes, and setting and the way the camera emphasizes those elements.

In a culture that reads left to right, the left side of the frame is probably more powerful than the right. To counterbalance this tendency, it may even be useful at times to place an object (or character) of greater size on the right side of the frame. Usually, the element that has the greatest mass or that takes up most of the composition will draw the most attention.

However, the placement of objects or characters within the scene is not the only way to attract the viewer's attention. The most brightly lit object (or person) in the composition also tends to dominate the frame. The colors of costumes, props, or the set itself can create a visual emphasis.[2] In Robert Altman's *The Player,* the appearance of Cher in a bright red dress at a formal social gathering, where everyone else is wearing black or white, absolutely guarantees that she will be noticed. During the liquidation of the Warsaw Ghetto in Steven Spielberg's *Schindler's List,* a young girl in a red coat is the only visible color in an otherwise black and white scene. The red coat is glimpsed again later in the film as the camera pans across a pile of discarded clothing, indicating that the girl is dead.

The different lines of interest established within the composition have a dramatic effect on how the viewer sees and interprets the image. Diagonal lines across the frame are often more dynamic than horizontal lines. Horizontal lines make people feel comfortable, and vertical lines convey strength. Shooting a group of choir boys in a circle rather than in a straight line may create a feeling of tranquility.

The **blocking** of actors is one of the director's most basic tools for focusing the audience's attention. An actor closer to the camera is more dominant than one farther away. A performer facing the camera tends to grab the spectator's attention more than someone turned three-quarters, in profile, or away from the camera. A person in motion tends to attract the viewer's eye more than a person who is stationary. Similarly, an actor who is standing while the other actors are seated (or vice versa) receives greater emphasis. A performer alone, away from others in the composition, tends to attract more attention, as does an actor on whom all the other actors seem to be focusing their attention. Someone entering the scene usually is noticed more than someone leaving the scene.

Ultimately, the director's dramatic objective for a given scene determines the way the event is staged for the camera. What are you trying to emphasize? What do you want the audience to see? The answer to these questions lies somewhere between the manner in which the viewer's attention is directed by the mise-en-scène and the way in which the camera interprets the mise-en-scène (see Figure 4.9).

Balance

Unbalanced compositions are considered more interesting than **balanced** compositions. When subjects within the frame are balanced so that the relative "weights" on the left and the right or on the top and the bottom are equal, the composition appears stable and solid but also tends to be flat and lacking in depth. Unbalanced compositions are more dynamic and visually active and can be used to create a sense of instability or tension. One reason for this is that what is in the "heavy" (or weighted) half of the frame tends to draw the items in the "light" half of the frame toward it.

The real objective, of course, is not to create individual shots suitable for framing on the wall but to create a composition that is appropriate for the subject at hand. Sometimes a perfectly stable and relatively flat composition is exactly right. For example, George Cukor used many balanced frames in his film *Adam's Rib* to convey equality between Spencer Tracy and Katharine Hepburn (see Figure 4.10).

Closely related to the concept of balanced-unbalanced compositions is the **rule of thirds,** which states that you should try to avoid breaking the frame in half (top and bottom or left and right) because such compositions tend to be overly balanced and flat. Breaking the frame into thirds tends to create less symmetrical and more active compositions. Because the lines of interest are more on the diagonal, the viewer's eyes may be drawn more powerfully across the frame, and a sense of depth may be enhanced by the more angular, less even composition (see Figure 4.11). Of course, following this rule is difficult if you are trying to shoot for both **standard definition** (square) and **high-definition** (widescreen) formats because the thirds will be in different places.

Creating Depth

A director can accentuate the sense of depth in a static shot in a number of ways. For example, giving a frame a definite foreground, middle ground, and background provides a sense of depth (see Figure 4.12). A shot of a person (foreground) placed in front of a wall (background)

Figure 4.10

A balanced and relatively flat composition from Adam's Rib. *(© 1949 Turner Entertainment Co. All rights reserved.)*

Figure 4.11

A shot from Married… with Children *provides a good demonstration of the rule of thirds. A strong diagonal line of interest flows from the kneeling shoe salesman in the lower left third to the woman trying on shoes up to the reaction by coworker Al Bundy in the upper right third. This picture also demonstrates how the sense of depth can be enhanced by having objects in different planes throughout the composition. (Photo courtesy of Columbia Studios)*

does not appear to have much depth, but if a middle ground figure, such as a bush or even a shadow, is added between the person and the wall, the frame will assume more depth. Overlapping foreground objects with middle ground or background objects enhances the sense of

Figure 4.12

With Prunella Gee and Michael York in the foreground, the foliage of a bluff in the middle ground, and a harbor in the background, this shot has great depth. (Photo from Len Richmond's Merchants of Venus, *courtesy of Amazing Movies, Dianna Ippolito, photographer)*

Figure 4.13

The frame of this shot is opened up because Beverly D'Angelo is looking off-screen and also holding a cup toward something that is off-screen. (Photo from Len Richmond's Merchants of Venus, *courtesy of Amazing Movies, Dianna Ippolito, photographer)*

depth even more. Variations in size of objects within the frame or in their position within the picture plane can also serve as depth cues, as can color and brightness.

Unbalanced compositions and strong diagonal lines in the composition tend to increase the

depth cues and draw the viewer's eyes back into the frame. A director must take care, however, to keep background objects, such as potted plants and telephone poles, from appearing to grow out of a person's head.

On-Screen/Off-Screen Space

Another important element of composition involves the director's use of space outside the frame of the film or television image. The frame limits what we can see of a scene, but a director can choose to open up the frame by having actors leave and reenter the frame or by framing shots that make us more aware of the space outside the frame. We may see only the front half of the dog in the frame, but we are at least subliminally aware that the rest of the dog exists just outside the frame.

The **off-screen space** in film or video is more "real" than in a stage play. When actors go offstage (out of the frame imposed by the proscenium arch), we do not expect to follow them. In film or television, the frame is more like the frame around a window. Viewers have the sense that if the camera moved just slightly forward and more to the right they could see through the window and continue to watch the characters who just went out of frame. By having a character simply look off screen, the director to some extent can open up the frame and heighten the use of that off-screen space (see Figure 4.13).[3]

The Edge of the Frame

Even if a director tries to open up a frame, it does have limits because only a certain amount can be shown. Deciding what to put toward the edge is challenging if the movie is going to be shown in both the rectangular 4:3 **aspect ratio** and one of the **widescreen** formats. If you want to place an actor at the edge of the frame to convey isolation, and you do this so the actor is at the edge of the 4:3 frame, that actor will be about a third of the way into a 16:9 frame. Conversely if you frame for widescreen, the actor may not be there at all for a 4:3 ratio unless the frame undergoes **pan and scan** (see

Figure 4.14
Photo (a) shows a composition with too much headroom; photo (b) shows a more typical or conventional amount of headroom. Photo (c) does not give the man on the bicycle enough leadroom; photo (d) is better. (Photos courtesy of Video Producer)

Chapter 3). As the widescreen aspect ratio becomes more common for TV and film, the problems associated with the edge of the frame will diminish.[4]

The sides of the frame create another kind of limitation, however, particularly in shots in which a person is the subject. A viewer usually perceives that something is wrong if the framing of a person does not leave enough (or leaves too much) **headroom** between the top of the frame and the top of the person's head. **Noseroom,** sometimes called **look space,** refers to the space to the sides of the frame and the direction a person is looking within the frame. If the person is looking to the left, placing him or her on the right side of the frame leaves noseroom to the left and focuses attention in the direction

the person is looking. If a person looking left is placed on the left side of the frame (with his or her nose virtually touching the left side of the frame), attention focuses on the empty space behind.

These same general principles apply when a person is moving in the frame and the camera is following the action. The convention is to provide **leadroom** in the direction the person is moving. In a chase sequence, however, allowing the people being pursued to bump up against (or move closer to) the side of the frame in the direction they are moving may help create the sense that they are hemmed in and about to be overtaken. The photos in Figure 4.14 illustrate proper and improper use of headroom and leadroom.

The Moving Frame

Most of the concepts we have talked about in this chapter thus far would apply equally well to still photography or painting. The mobility of the camera itself, however, is one of the distinguishing characteristics of film and video. When the camera moves, the framing of the scene moves with it. A composition that was unbalanced one second may be balanced the next, or a shot that was high-angle can become straight-on. A medium shot can become a close-up, or the foreground can become the background. A camera moving in toward a character gives that character more impact or emphasis.

Camera Movements

Tripods, cranes, dollies, and the human body allow cameras to move (see Chapter 3). Camera movement is needed to follow moving people or objects, but it also provides different psychological feelings. The major camera movements are the pan, tilt, dolly, track, and crane. A **pan** is a left to right movement of the camera but not of the mounting device. A **tilt** involves moving only the camera up or down. Moving the camera and the supporting device in or out is called a **dolly,** and moving both of them left or right is called **tracking.** An up and down movement of the camera and the supporting device is called a **crane** (also referred to as a **boom**). Other movements, such as an **arc,** are used from time to time, and you can make several movements at once—for example, a camera can dolly in, pan left, and crane up all at the same time.

In general, when just the camera moves, the feeling projected is one of an onlooker. When the camera and its mounting support—crane, tripod, human shoulder—move, the feeling projected is one of a participant. Take, for example, the difference between a pan and a track. Both are side-to-side movements, but for the pan only the camera moves left to right, a movement that produces an effect similar to someone moving his or her head from side to side as someone would who was observing the scene. Tracking, on the other hand, moves the camera and tripod and produces a feeling of someone walking or running alongside whatever is being photographed, a much more involving type of shot. The movement of the background is also very different with a pan and a track. For the pan, the background moves at an angle; for the track, it stays parallel. Similar differences in feeling and background occur with a tilt, which involves swiveling the camera up or down, and a crane, which moves the entire camera and supporting mechanism up or down.

Zooming

In a **zoom** the elements of the lens move, magnifying or reducing objects in a way that the human eye cannot. With a dolly, the camera and the camera support move together into and through the space in the scene, creating a greater sense of what that particular space is like. A zoom in tends to flatten things out and bring everything in the composition closer. A dolly makes objects on screen appear to move out of frame as the movement occurs, forcing the viewer to experience the space at a more visceral level.

Students tend to rely too much on the zoom. Don't use it as an excuse for not putting the camera in the proper place for the appropriate field of view. Instead of zooming, place the camera closer to the scene (or farther away) and then compose the shot. Don't use a zoom as a substitute for a dolly because they have a different psychological feel. Constant zooming during shots can create a feeling of uncertainty (if not vertigo). Professionals use the zoom sparingly and carefully. They sometimes use it in a situation in which the artificiality of the zoom lends some particular meaning to the shot. They also use it in a situation in which a dolly is impossible or too expensive (as in *K19: The Widowmaker* when a zoom in on a submarine emphasizes its isolation in a vast ocean). Like any shot, a zoom should have a purpose.

Time

Any camera movement also involves a time element. Moving the camera takes time, and a director who chooses to use elaborate camera moves generally tends to emphasize the mise-en-scène (as opposed to editing) to tell the story. Moving back from a close-up to a two-shot usually takes longer than cutting directly from a close-up to a two-shot.

Camera movements can be slow or fast or any speed in between. Many directors have used the rhythmic quality of camera movement as a powerful, expressive tool. Abrupt, quick movements create a different feeling than long, majestic ones. Even a brief look at music videos provides many examples to illustrate the importance of time in camera movement.

Camera movements are most frequently based on the movement of the characters within the frame. But a director may also use camera movement to create a sense of expectation or suspense unrelated to the characters. A camera movement can also change our focus to some object or some part of the mise-en-scène that the director wants to emphasize.

Color and Tonality

Manipulating the filmed image through the choice of film stock is strikingly different from capturing an image on videotape. A black and white **slow film stock** (one less sensitive to light) records a richer range of grays and a sharper image than a **fast film stock** (one more sensitive to light), which tends to yield grainier images with more contrast. Different color film stocks, and even different stocks from different manufacturers, offer perceptibly different tonal qualities (one stock may emphasize the reds and yellows, another the blues and greens). And the lab can further manipulate all these differences when the film is processed and printed.

There is no such thing as color videotape or black and white videotape. In video, the same tape can be used to record both. In most cases it is easier to obtain black and white in postproduction than in production because most video cameras do not allow the user to shoot in black and white. Tonal quality gradations are also best handled in postproduction.

Black and White or Color

Color is the norm for commercial production in film and video, so the absence of color calls attention to itself. Television advertisers recognize the attention-getting value of a black and white commercial. Some commercials extend this idea even further by colorizing the product in postproduction (the pink cherry cola can or ravishing new red hair rinse) to highlight the product in an otherwise black and white environment.

More commonly, black and white is used to evoke the past. Both film and television began as black and white media, with color becoming the standard as the technology evolved. Woody Allen's comic "documentary" *Zelig* uses black and white in much the same way, suggesting not only the past but old movie newsreels as well. In fact, one of the clichés of student moviemaking is the use of black and white to cue flashbacks in a color film. Director Martin Scorsese seemingly inverts this cliché in his black and white film *Raging Bull.* The only color material in this film consists of flashbacks to the La Motta family's faded color home movies.

Black and white may be more appropriate than color for certain subjects. Movies meant to be somber or earthy may convey this mood better if shot in black and white. This is true for Steven Spielberg's *Schindler's List* with its somber holocaust subject matter. Many music videos have experimented with ways black and white (or black and white in combination with color) can be used to enhance the mood or meaning of a particular piece of music. Oliver Stone's *Natural Born Killers* switches between black and white and color within the same scene, mimicking the intercutting of color and black and white in many music videos.

Color Considerations

Much has been written about the aesthetics of color.[5] Even beyond the theorizing of the artists and scholars about the power of color to evoke specific emotions, most of us accept a number of cultural conventions about color. Whether we are buying fabric or talking to an interior decorator or housepainter, we have a tendency to describe certain colors (reds and yellows) as emotionally warm and other colors (blues or greens) as emotionally cool. One theory holds that warm colors make items appear large, close, heavy, and enduring, whereas cool colors make items appear small, far away, light, and temporary.[6]

Certain colors seem to go together, and others seem to clash. Mixing colors opposite each other on the **color circle,** such as green and red, creates color contrast. Working with colors on the same side of the color circle creates color harmony. (See Color Plate 3.) Advertisers go to great lengths to determine what color of packaging encourages us to buy their products.

In moviemaking many decisions about color are made during the planning stage. The director, in conjunction with the production designer, decides which colors are appropriate for the sets, costumes, props, and even makeup. Color can emphasize or deemphasize any element of the mise-en-scène.

The camera can also be used to alter the emotional content of the shot with subtle shifts in color tonality. Think of the warm and homey glow of the typical hamburger chain's television commercials, or the way beer commercials tend to be shot in the orangish light of late afternoon (after work when the world is beautiful). In Robert Altman's western *McCabe and Mrs. Miller* the Golden West comes to life visually on-screen. A dreamlike golden tone pervades most of this film, a technique that further heightens the contrast with the cold blue death of McCabe in a snowstorm at the end. Warren Beatty's film *Dick Tracy* uses vibrant primary colors to emphasize the story's comic book origins.

In filmmaking these effects can be produced to some degree in the laboratory as the film is being processed or printed. With video, similar effects can be created during digital postproduction. In both film and video, color effects can be enhanced by placing a filter on the lens to warm (orange or reddish) or cool (blue or green) the image (see Color Plates 6 and 7). Other types of filters can alter the contrast range of a shot or diffuse and soften the subject being photographed (see Chapters 5 and 6 for more on filters).

The same scene or subject can read in very different ways, depending on shot composition, framing, camera movement, and manipulation of the color and tonality of the image. The power to interpret the mise-en-scène with the camera is basic to the art of moviemaking. Choosing and controlling the type and quality of the shot is one of the most important decisions confronting the moviemaker, student and professional alike.

Shooting to Edit

The camera can move from a medium shot to a close-up (or the actor can move toward the camera and change a medium shot to a close-up), but this change of view is normally created through editing. The eventual editing of the shot has a profound effect on the composition, framing, and movement created by the camera (see Chapter 13 for aesthetics of editing).

Shot Selection

A **shot** begins the moment the camera starts recording the subject and ends when it stops. It can be long or short, but eventually it will be joined with other shots during editing. In narrative moviemaking, the basic building block in the construction of the story is the **scene,** a unified action occurring in a single place and time. A scene is usually composed of a series of shots, though an entire scene can be one continuous shot. To provide complete coverage of the scene, the director usually shoots more shots than will actually be used in the final edited version. At the simplest level, the objective is to provide a

variety of shots of the physical action and dialogue in the scene (see Figure 4.15).

Imagine a simple one-minute scene in which a man and a woman eat breakfast while talking at the kitchen table. To ensure adequate coverage of this scene and to make certain that the needed shots will be available during editing, many directors begin by shooting a **master shot,** a fairly long shot showing both characters at the table as they play out the scene in its entirety. If used in the edited version of the motion picture, this one master scene shot would present all the dialogue and action within a single shot—a one-shot scene. A director using the master scene shooting method would then begin to provide coverage of the scene with shots from a variety of angles and perspectives: close-ups of each actor delivering lines, two-shots, reaction shots of one character listening to the other talk, and **cut-ins** to some essential detail within the scene (for example, a piece of burned toast). Perhaps the last element in providing complete coverage of a scene is to shoot **cutaways,** shots of related details that are not actually part of the scene (such as the kitchen clock on a wall off-screen).

In the editing room these different shots will be cut together to build up the scene—beginning, perhaps, with a master shot of both actors, then cutting to a close-up of the clock, a two-shot of the woman talking, and a CU of the man listening. It is important that the director select shots that can be edited according to the action, dialogue, and dramatic needs of that particular scene. Sometimes, for complicated scenes, the director may shoot two master shots from different angles, or a master shot where the camera moves, or no master shot at all. Directors always select shots with an eye to how they might be edited later.

Shot Duration

The director must also decide how long to shoot each shot. The dialogue or the movement of the actor within the scene often dictates the length or duration of a shot. Moving the camera (because it takes place in time) can also determine shot duration. In addition to the composition, framing, and use of camera movement, the du-

a

b

c

Figure 4.15

In this scene from Merchants of Venus, *two policemen confront Nancy Fish, who plays a business owner. Director Len Richmond filmed the master shot (a) of the three people. Because a heated argument transpires between the owner and one of the policemen, he shot the two of them (b). At the end of the scene, the owner becomes ill, so he also filmed her by herself (c). (Photos from Len Richmond's* Merchants of Venus, *courtesy of Amazing Movies, Dianna Ippolito, photographer)*

ration of the shot deeply affects how we see and understand it. The viewer can absorb more during a shot of long duration than during one of short duration.

On the purely technical level, providing extra time at the beginning and end of a shot for identification and editing purposes is important. In film and video the first few feet are needed to **slate,** or identify, the shot. In filmmaking the first few frames of the shot often contain overexposed frames (or *flashframes*), which are created while the camera is getting up to speed. Having a little more *head* or *tail* on each shot can prove invaluable in the editing room because it allows for options, both technically and aesthetically.

The Long Shot, Medium Shot, Close-Up Pattern

The most conventional way to put together a scene is to begin with an **establishing shot,** a shot that sets the scene and establishes the location. This often is a long shot (the apartment building), but it could be something like a sign (Mastroianni's Cafe) that tells us where the scene is taking place. Next, we move into the scene from long shots to medium shots and finally to close-ups.

If the angle of view does not change sufficiently between the LS, MS, and CU, the shots will appear to jump when they are edited together. The conventional way to avoid this problem is to vary the angle of view at least 30 degrees from the previous shot (the so-called **30-degree rule**). Some critics have argued that the LS–MS–CU pattern is the most psychologically correct way to construct a scene because it is similar to the way our minds work.[7] When we walk into a dance in a large ballroom (establishing shot), we tend to survey the entire room (the long shot) until we spot a group of friends (the medium shot) and move over and begin talking to them (the close-up). The establishing shot, long shot, medium shot, close-up pattern draws us into the scene. We gather more and more information as the shots move closer and closer.

This pattern can also be reversed. Beginning with a close-up can create questions. Who is this character talking to? Where are we? Moving from close-up to the medium shot and long shot can answer these questions as each shot provides additional information about the scene. Again, there is nothing inherently right or wrong about any pattern, but unless the director selects the shots during the shooting phase of production (shooting to edit), they will not be available when the editing begins.

Shooting for Continuity

Technically, a single shot maintains **continuity,** a sense that the space we see in the shot and the time of the shot are continuous and uninterrupted. In conventional moviemaking continuity most often becomes an issue in the scene. Usually, scenes take place in a single location and in a continuous segment of time. This arrangement would not be a problem if the scene were shot with a single run of the camera. But because most scenes are composed of a variety of shots taken at different times and from different angles, continuity is often difficult to maintain during editing.

On the set of a typical Hollywood film, continuity is almost an obsession. Crewmembers such as the **script supervisor** are constantly checking for continuity errors. Some of the most common gaffes involve costumes or props: the tie that changes color from one shot to the next or the glass that is almost empty in the first shot but full in the next. Even something as simple as changing light values (when shots taken at different times of the day are edited together in what is supposed to be a continuous sequence of time) can violate continuity. This kind of error involves the mise-en-scène, but unless a director is consciously shooting to maintain continuity, the placement of the camera can also create problems.

Perhaps the most common technique for shooting to maintain continuity involves the **axis of action,** or the so-called **180-degree rule.** In any shot, whether it contains two people talking or a single person walking down the sidewalk, the principal axis of the action is identifiable. It is the imaginary line between the two people talking or the **screen direction** established by the walking character or moving ob-

ject. If the camera is placed on one side of this imaginary line (anywhere within the 180-degree arc on the same side of the line), spatial continuity will be maintained (see Figure 4.16). A shot that crosses the line would, when edited, flip-flop character A and character B to opposite sides of the screen. Similarly, crossing the axis of a walking character or moving car would make the person or car appear to reverse screen direction on the cut.[8]

Maintaining a constant screen direction also extends to the line of action established by a character looking off-screen. Imagine, again, two characters talking. We see character A in a close-up talking to character B, who is off-screen. In the next shot we see a close-up of character B responding to character A, who now is the one off-screen. Unless there is an **eyeline match** between the two shots, character A and character B will not appear to be talking to each other and might even appear to be distracted by something else off-screen (see Figure 4.17).

A radical change in the speed of a character or object (a car, for example) from one shot to the next also can violate continuity. The first few steps people take when they are getting up to walking speed (almost always near the beginning of the shot) are appreciably slower than when they are already at full walking speed. If you cut together two shots of people walking down the street, you want their relative speed (and gait) to match up as you edit from one shot to another. A **match cut**—a cut that maintains a continuous sense of space and time from one shot to the next—can be extremely difficult to make unless the director has shot the material with an eye to editing.

The time-tested method of ensuring footage that can be match cut is to have **overlapping action** during shooting. Imagine two shots that are going to be match cut. A character (from an angle in the hall) comes up to a door and opens it. The next shot shows the character entering the doorway and coming into the room from an angle inside the room. To overlap the action during shooting the director should shoot the entire action (walking up to the door, opening it, and walking into the room) in both shots. By overlapping the action in this manner, the director provides the editor with an almost infinite

a

b

c

Figure 4.16

Anywhere within the 180-degree arc established from camera view 1, the two people (A and B) will maintain the same spatial relationship—A on the left and B on the right. Crossing the axis, however (as in camera view 2), will reverse, or flip, A and B to the opposite sides of the screen.

a

b

c

Figure 4.17

Once the eyelines have been established in one shot (a), the eyes must maintain those directional lines in subsequent shots to match. The woman in photo (b) illustrates correct eyeline match as she is looking in the correct direction for the man established in photo (a). If the woman is supposed to be listening to the man, the eyeline match is wrong in photo (c) because she is looking away from him (and his eyes). The implication of cutting from shot (a) to shot (c) is that she is not really listening to him or that she has been distracted by something off-screen in the other direction.

number of cutting places for matching the two shots.

Of course, continuity entails much more than the placement of the camera. It also depends on how the director stages the mise-en-scène for the camera and the way in which the editor puts the material together in post-production.

Now That You Know the Rules…

Now that you know the rules… go ahead and break them. Cross the line. Shove someone's nose up against the edge of the frame. Forget chest-high shooting and try other angles. Break the frame into halves instead of thirds. The "rules" presented in this chapter are violated frequently, and usually for good reason. They are broken because doing so serves the needs of the story or will, in some way, affect the perceptions and emotions of the audience. If you are a student, school is an excellent place to experiment. Use your creativity and imagination and try some new techniques. It is a good idea to also record material in the tried and true fashion in case your ideas don't work, but don't be afraid to go out on a limb. If you are shooting on film, experimentation can be expensive, but if you are shooting on video, try whatever comes to your mind—tape is cheap.

Professionals know that in actual practice composing a shot is more intuitive than analytical.[9] Through composition of the image within the frame, the director can choose to highlight, modify, shade, reinforce, or even undercut almost any element in the scene. Whether the composition of a shot is good or bad depends more on what the director is trying to accomplish with a shot than on some abstract principle of pictorial composition.

Color Plates

Color Plate 1

The actual properties of the color video image are based on the hue (the specific color), on the strength or purity of the color (its saturation), and on the brightness information (luminance), which indicates the amount of light being reflected or given off. In the development of NTSC color video, the chrominance information (hue and saturation) was designed so that it could be added onto an existing black and white signal (the luminance information). This maintained compatibility with existing black and white television receivers, which could simply ignore the color information of a program broadcast in color.

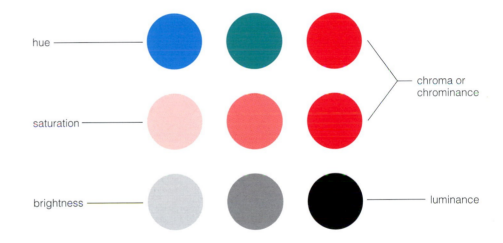

Color Plate 2

Additive color mixing. In video all colors can be produced by mixing together various quantities of the three primary colors (red, green, blue). Where the primary colors overlap, they produce the secondary colors cyan, yellow, and magenta. Magenta, for example, results from mixing red and blue. A mixture of the three primary colors produces white.

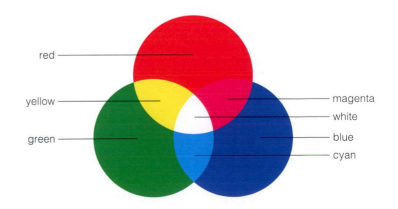

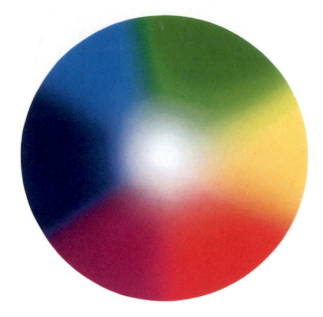

Color Plate 3

This color circle shows the colors of the visible spectrum as they gradually merge into each other. The primary colors (red, green, blue) are on the opposite side of the color circle from their complementary colors (cyan, magenta, yellow).

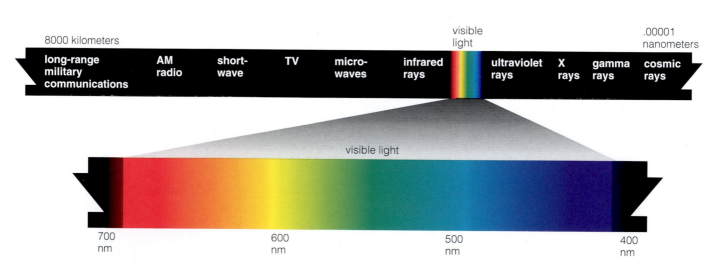

8000 kilometers

visible light

.00001 nanometers

| long-range military communications | AM radio | short-wave | TV | micro-waves | infrared rays | ultraviolet rays | X rays | gamma rays | cosmic rays |

visible light

700 nm

600 nm

500 nm

400 nm

Color Plate 4

Electromagnetic spectrum wavelengths. The human eye can see only a small part of the visible spectrum, ranging from the short violet wavelengths to the longer orange and red wavelengths.

Color Plate 6

Color conversion filters. The orange 85 filter (left) is used to convert 5,500-degree Kelvin daylight to 3,200 degrees Kelvin for use with a tungsten-balanced film stock or electronic imaging device. The blue 80A filter (right) is used for shooting daylight-balanced film (5,500 degrees Kelvin) under lights that are balanced at 3,200 degrees Kelvin.

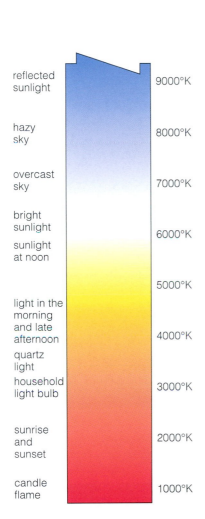

reflected sunlight — 9000°K

hazy sky — 8000°K

overcast sky — 7000°K

bright sunlight — 6000°K

sunlight at noon

— 5000°K

light in the morning and late afternoon — 4000°K

quartz light

household light bulb — 3000°K

sunrise and sunset — 2000°K

candle flame — 1000°K

Color Plate 5

The color temperature of some common light sources.

a

b

Color Plate 7

(a) Shooting in sunlight (5,500 degrees Kelvin) with film or with an electronic imaging device balanced for 3,200 degrees Kelvin produces a bluish image.
(b) With the orange 85 color conversion filter in place, the daylight is converted to a color temperature that more correctly matches the imaging system.

Color Plate 8

George Lucas shot the 2002 Star Wars Episode 2: Attack of the Clones *with a CineAlta 24P high-definition camera. He also had the film edited while it was still being shot, and an enormous amount of it was computer generated. The lighting of live foregrounds and computer-generated backgrounds had to mesh. (Photo from Photofest)*

Color Plate 9

This scene from Immortal Beloved, *Bernard Ross's film about the life of Beethoven, is an excellent example of Rembrandt lighting (often called chiaroscuro lighting). The face and arms are selectively lit, and other areas remain in darkness. (Photo from Photofest)*

Color Plate 10

There were many unique sound elements in Chris Columbus's Harry Potter and the Sorcerer's Stone, *starring Daniel Radcliffe, including the noises the owls made, which were louder than real owl noises. Lighting was used to create a dark, mysterious mode consistent with wizardry, and visual effects were constructed in many layers. (Photo from Photofest)*

Notes

1. See, for example, David Bordwell and Kristin Thompson, *Film Art: An Introduction* (New York: McGraw-Hill, 1993), pp. 145–184; and James Monaco, *How to Read a Film: The Art, Technology, Language, History and Theory of Film and Media* (New York: Oxford University Press, 1981), p. 148.

2. Bob Fisher, "Through the Looking Glass," *Emmy*, June 1999, pp. 34–36.

3. Noel Burch, *Theory of Film Practice*, trans. by Helen R. Lane (New York: Praeger, 1973), pp. 17–31.

4. "Finding the Art in HDTV," *Broadcasting and Cable*, 25 June 2001, pp. 26–28.

5. Monaco, pp. 96–98; R. T. Ryan, *A History of Motion Picture Color Technology* (New York: Focal Press, 1977); Raymond Durgnat and Vincent LoBrutto, "Three Moods Prevail in *Dead Presidents*," September 1995, pp. 59–66.

6. Herbert Zettl, *Sight-Sound-Motion: Applied Media Aesthetics* (Belmont, CA: Wadsworth, 1990), pp. 66–68.

7. André Bazin, *What Is Cinema?* trans. by Hugh Gray (Berkeley: University of California Press, 1971), pp. 23–40.

8. Frank Beacham, "The Art of Crossing the Line," *TV Technology*, October 1991, pp. 30–31.

9. "Are You Serious About No Catering Truck?" *Los Angeles Times*, 30 July 2001, p. F-1.

chapter five
Lights and Filters

L ight is the key to recording an image on film or videotape. Whether the light record is created photochemically or electromagnetically, the **cinematographer's** first concern is to determine if there is enough light to record the image. The cinematographer's attention next shifts to how the light can best be shaped to fit the dramatic needs of the story. Thus, creative control of the image involves not only the means to measure the light accurately but also the means to control it. This chapter deals with the tools needed to accomplish those tasks.

Measuring the Light

To obtain the correct exposure, the amount of light reaching the film emulsion or electronic imaging device must be carefully governed. Too much light will result in an overexposed image; too little light will result in an underexposed image. The adjustable diaphragm in the lens (see Chapter 3) is used to obtain the correct exposure setting. To calculate that setting, a **light meter** is used to measure the amount of light falling on or reflected by the subject. A needle on a scale or dial can present this information, but many modern light meters produce a digital readout of the light reading.

Incident Meters

An **incident light meter** measures the amount of light falling on a particular person or area of a set. Commonly used incident meters, such as the Spectra and Sekonic, have a plastic hemisphere (which looks like half a Ping-Pong ball) over the light-sensitive cell on the meter (see Figure 5.1). To use an incident meter, hold it next to the subject with the light-collector bulb pointed at the camera position. The intensity of the light reaching the hemisphere creates a light reading that can be measured. Usually, the top half of an incident meter swivels so that the person taking the light reading can read the scale without casting a shadow over the light-sensitive photocell.

An incident meter is generally considered the standard meter for professional cinematography. It is accurate, easy to use, and highly reliable. Because it measures the light hitting a *specific* area, it is not fooled by reflected light. Therefore, it gives an objective light measurement from scene to scene. An incident meter is especially helpful when setting lights to a particular intensity for more than one camera setup.

Reflected Light Meters

A **reflected light meter** measures the amount of light reflected by the subject, providing an overall light reading for the entire scene. It gathers light from a relatively wide angle of view, creating a light measurement that is the average of the range of brightness levels within the scene. Although it can be a separate unit—and, in fact, some incident light meters can be adapted for use as reflected light meters (see Figure 5.2)— a reflected light meter is usually built into a camera. As such, it measures the light coming through the lens (usually a zoom lens) and can automatically adjust the iris to the proper setting. Because it is behind the lens, the reflected light meter will compensate for any light lost to filters or to the many elements within the lens itself.

Some cameras use a **zebra stripe** pattern visible within the viewfinder to show areas at the upper limit of the camera's exposure range.[1] Others blink the words *low light* in the viewfinder when there is not enough light for an acceptable image. Automatic exposure systems are extremely easy to use, which is one reason they are virtually standard on consumer-level cameras. They can be invaluable in situations in which the light cannot really be regulated or when shooting entails rapid, uncontrollable shifts in exposure levels, as in sports or documentaries.

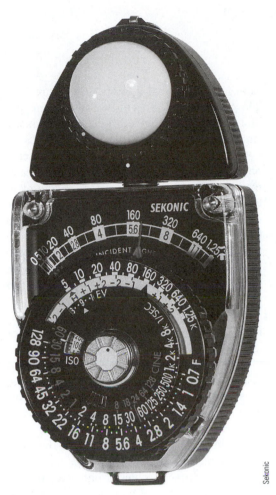

Figure 5.1
One of the workhorse incident light meters that has been used for moviemaking for many years. (Photo courtesy of Sekonic)

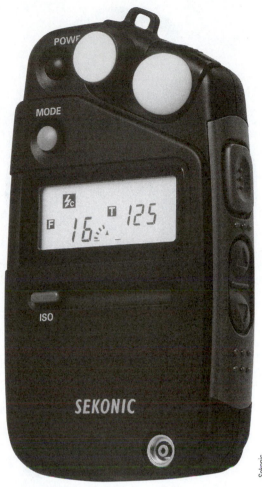

Figure 5.2
This meter can be used for both reflected and incident light readings. (Photo courtesy of Sekonic)

Spot Meters

A **spot meter** (see Figure 5.3) is a reflected light meter with a narrow angle of acceptance, often as little as one degree. Instead of averaging brightness across the entire scene, it provides a reading of a small, individual spot within the composition. A spot meter usually is shaped like a small camera. It has a pistol grip, eyepiece, and viewfinder to enable the operator to target the exact spot (usually designated by a small circle in the viewfinder) being measured. This is particularly useful when you are comparing brightness levels of different parts of the scene. Although they are reflected meters, spot meters can provide the same information as incident meters because they read light for small areas. In

this way they combine the best features of incident meters and reflected meters.

Getting Correct Exposure

Light meters are simply tools. They cannot think, nor can they know what you are trying to expose for within a shot. The brightness levels in a particular shot might range from f/2.8 to f/22 (or beyond), and this can pose problems for any type of light meter. In-camera meters try to solve this problem either by averaging the light readings from the entire scene or by metering a smaller area in the center of the frame, which is called **center-weighted metering.** It is also possible to use a handheld meter to take readings of

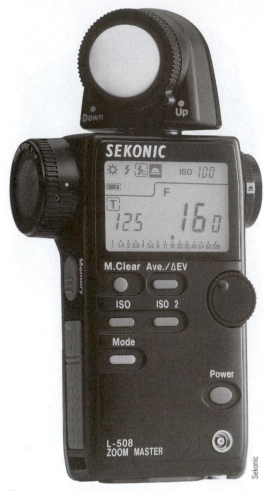

Figure 5.3

A spot meter with a digital readout. (Photo courtesy of Sekonic)

different areas within the frame and then work out the average mathematically. What is important is interpreting the light readings to suit your purpose.

Problems with Automatic Metering Systems

Certain lighting situations can easily fool reflected light meters, whether they are handheld or built into an automatic metering system in the camera. Strong backlighting causes the most common problem. A shot of the face of a person who is standing in shade that is in front of a bright, sunny background can result in a reading that greatly underexposes the face. The meter averages the light for the entire scene, not just the face, and produces a reading that over-

values the bright background (see Figure 5.4). The opposite could occur in a shot of the face of a subject standing in bright light against a large dark background.[2]

Using a spot meter or an incident meter is one way to get a correct reading of the area of the frame you are trying to expose. A zoom lens with an in-camera metering system can also be used as a kind of spot meter. By zooming in and filling the frame with the person's face, you can obtain the correct exposure setting. Then you must manually override the automatic exposure system (if that is possible with your camera) or change the lighting setup (if that is possible).

Some cameras have a backlight control button that opens up the iris one f-stop (or more or less) to compensate for strong backlighting. Other cameras have an exposure lock that enables you to lock in a particular f-stop setting, thus overriding the automatic iris system. Another technique for obtaining correct exposure is to **bracket** your shots. Provided you can manually adjust the iris, you simply shoot the scene with several different f-stop settings.

Because different types of light meters have different strengths and weaknesses, it is probably wise to supplement an in-camera reflected meter with a handheld incident meter. When working outdoors, many cinematographers prefer a reflected light meter. They usually choose an incident meter when working indoors, where the lighting can be totally controlled. You might also consider bringing along your still camera. You are probably quite familiar with its built-in metering system and can use it to back up your light readings on the set, as well as to provide stills of your production.

Footcandles, F-Stops, and EI

Most light meters are calibrated to produce readings in either footcandles or f-stops or in both. A **footcandle** is an international unit of illumination.[3] It represents the amount of light falling on a sphere 1 foot from a light source of 1 candlepower. In effect, a footcandle reading on a light meter is a measurement of light intensity.

If the light meter provides an **f-stop** reading, it must have some means of translating the light

intensity in the scene to a lens f-stop that is accurate for the particular camera being used. When metering for film, this usually means that it is necessary to set the **exposure index (EI)**, or **ASA,** of the particular film stock being used (see Chapter 3). A film stock with an EI of 400, for example, is twice as sensitive to light as a film stock with an EI of 200. Thus, the proper f-stop depends not only on the amount of light available but also on how sensitive a particular film stock is to light. With exactly the same light (that is, the same footcandle reading), an EI of 100 might require an f-stop of f/8, whereas an EI of 200 would require f/11. Each f-stop change (from f/2.8 to f/4, f/5.6, f/8, and so on) cuts the light that reaches the film in half. The EI is set either by slipping a slide in front of the photosensitive cell or by turning a dial similar to the type used to set the film speed on a still camera.

Calculating the exposure index for a video camera is more complicated. The light sensitivity of a video camera cannot be boosted by changing the imaging device (as in buying a roll of faster film). Its responsiveness to light is, in effect, built in to that particular imaging system, usually the CCD sensors. Of course, many video cameras can boost the image signal electronically (a 6 dB increase in gain approximately doubles the exposure index). At the normal setting, however, most video cameras have an exposure index that is in the range of 100. With the proper video test equipment, determining the effective EI rating for any video camera is not difficult.[4]

Contrast Range

Contrast refers to the varying levels of brightness and darkness within a particular scene. A high-contrast scene would have extremely bright and dark areas with almost no gradations in between. In comparison, a low-contrast scene would be relatively flat, with the brightest and darkest areas of the scene at roughly the same luminance level. Normal contrast would exhibit a rich, full range of brightness levels between the darkest and brightest parts of the scene.

By taking a light reading of the brightest and darkest areas of the scene, it is possible to calcu-

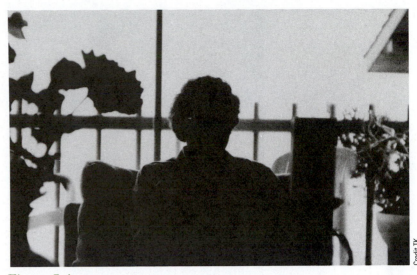

Figure 5.4

A lighting situation such as this easily fools an automatic iris. The iris will close too much because of the large amount of light in the scene's background. A center-weighted light meter offers some correction. Other cameras have backlight compensation systems that increase exposure to make up, at least in part, for strong backlight.

late the **contrast range,** the ratio of the brightest value to the darkest value. For example, if the brightest area in the scene is 8 times brighter than the darkest area of the scene, the **contrast ratio** for that scene would be expressed as 8:1 (a range of light three f-stops wide). A 16:1 contrast ratio would produce a range of light roughly four f-stops wide. Calculating the contrast ratio is relatively simple with a spot meter, but any reflected light meter can be used for this purpose by moving in closer and measuring the amount of light reflected by different objects across the scene.[5]

All film stocks and electronic imaging devices are limited in the range of brightness they can accurately reproduce. That range or **latitude** is designed into a particular film stock or video imaging system, although the contrast ratio in film is frequently altered during the developing process. Negative film stock has greater latitude than reversal film stock, and film generally has greater latitude than electronic imaging systems. A shot exceeding the latitude of a particular imaging device will create areas of brightness or darkness in which all distinguishing details are lost. Thus, measuring the range of brightness within a scene is important not only for obtaining correct exposure but also for creatively manipulating the lighting for a scene.

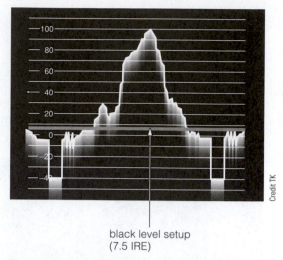

Credit TK

black level setup
(7.5 IRE)

Figure 5.5

The display on the waveform monitor allows the picture to be represented on a luminance scale. The bright areas in the picture register near the top (near 100 IRE). The monitor displays the darkest areas at the bottom, where the black level (7.5 IRE) is normally set. This is often called the pedestal level. If image brightness exceeds 100 IRE or falls below 7.5 IRE on the waveform monitor, the image will be distorted.

Using a Monitor to Help Evaluate Exposure

Having a television **monitor** on a set can be somewhat helpful in evaluating exposure. The viewfinder of a video camera can show how light or dark a scene is, and a stand-alone monitor, such as the one used with **video assist** (see Chapter 3), can do the same.

However, a monitor can sometimes cause problems when used for image evaluation. It is seldom a satisfactory substitute for a light meter because the actual quality of the image being viewed depends on how accurately the monitor is calibrated. For example, if the brightness control of the monitor is set too high, an image that looks all right on the monitor may actually be too dark. With portable gear that is constantly knocked around in transit, image reproduction is seldom trustworthy. A light meter provides a comparable measurement of light values from one lighting setup to the next. Trying to use a monitor for this purpose is haphazard at best. Without the numerical values provided by a light meter, trying to match lighting setups can be total guesswork.

Using a Waveform Monitor to Evaluate Exposure

A **waveform monitor** is a far more accurate way of measuring and evaluating lighting. This piece of equipment is standard in any television studio, and it is also available in portable versions for use in the field. These portable units can operate on either DC (batteries) or regular AC power.

When a video signal from a camera is looped through a waveform monitor, the monitor's screen presents a graphic representation (see Figure 5.5) of the signal (the waveform). That signal is superimposed on a scale divided into 140 IRE units (IRE refers to the Institute of Radio Engineers). The picture information falls in the area between zero IRE units (the darkest area of the scene) and 100 IRE units (the peak white area of the scene). The blackest areas of the scene are actually set slightly above zero, at 7.5 units. The negative area at the bottom of the scale (between zero and –40 IRE units) displays information about the technical aspects of the signal, such as the vertical blanking interval (see Figure 5.6).

The waveform monitor provides more information about the brightness and contrast range of a scene than any light meter can. The area between 7.5 and 100 IRE units provides information that you can use to adjust the camera's imaging system (20 IRE units equal approximately one f-stop, hence a latitude of approximately five f-stops). Any area of the scene exceeding 100 IRE will be overexposed, and any area of the scene below 7.5 will be too dark to render visible detail. Obviously, this information can be used to set up and adjust lights. The waveform monitor displays the exposure levels for every point in the scene, like a full-frame spot meter. It also shows precisely which areas of the scene are above or below the contrast range the camera is capable of reproducing.

Some of the more professional video cameras display a crude waveform in the viewfinder, but this does not present the same kind of detailed information as a waveform monitor. Few schools have portable waveform monitors set aside for student use. The waveform monitor is

a

b

Figure 5.6

The two fields on the waveform monitor show the waveform (a) of the metal videotape reel (b). Notice how the dark black cutouts in the videotape reel are mirrored in the two rectangular areas just above the 7.5 IRE line on the waveform monitor. The hole in the center of the videotape reel is less distinct on the waveform monitor because it is reflecting some light. It is not as black as the rectangular cutouts beside it. (Photo (b) courtesy of Maxwell Corporation of America)

usually mounted in the studio and used primarily by the college's video engineer. But as sophisticated location lighting becomes more commonplace in video, students will need increased access to portable waveform monitors and the training to use them properly.

The Color of Light

Thus far we have been concerned primarily with different ways to monitor and measure light intensity. The color of light in the scene is also an important concern for the cinematographer. Different light sources produce different colors. Being able to measure and compensate for those color variations is as much a part of quality image making as controlling exposure.

The Electromagnetic Spectrum

Our eyes can see only a small portion of radiated energy in the **electromagnetic spectrum.** Electromagnetic energy is measured according to **wavelengths** and ranges from the microscopically small wavelengths of cosmic rays to electrical power waves several miles long. Visible light is only a tiny portion of that spectrum, ranging from the shorter violets to the longer blue, green, yellow, and red wavelengths. The wavelengths just below and above the visible spectrum, X rays and infrared, cannot be seen by the eye but can be recorded on special film (see Color Plate 4).[6]

Our eyes see different wavelengths as different colors. White light is composed of all the visible wavelengths. When white light falls on an object like a red flower, it reflects the red wavelengths and absorbs the other wavelengths (primarily the greens and blues). If the color of the light illuminating that flower is changed, our perception of that flower's color will also change. The way we perceive colors is based on both the particular wavelengths (colors) of light illuminating an object and the wavelengths of light that the object absorbs. This fact has important implications for cinematography. It means that a filter can be used to modify the light by

absorbing certain colors and letting other colors pass through.

The Kelvin Scale

What we perceive as the white light of the sun is actually made up of roughly equal parts of red, green, and blue light.[7] The color of sunlight is constantly changing, according to the time of day or the way that light is reflected through clouds or smog in the air. As the sun sets toward the horizon, the longer red wavelengths and denser atmosphere create a redder color. If the noonday sun is reflected through a cover of clouds, the light may seem almost blue.

A **color temperature** scale was developed to provide a precise and accurate measurement of different colors of light. This scale is expressed in degrees **Kelvin (K)**. As a theoretical black body source is heated, it will give off light. Imagine a chunk of iron heated over a powerful flame. As the metal begins to heat, it will start glowing red. As it gets even hotter, it will turn orange and then white and finally blue-white.

These changes can be measured on the Kelvin scale. The sun at noon, for example, has a color temperature of about 5,500 degrees Kelvin, whereas the color temperature at sunrise could be as low as 1,800 degrees Kelvin. This can be a little confusing because we tend to think of red light as hot and blue light as cold. But in terms of color temperature, the lower the color temperature, the redder the light; the higher the color temperature, the bluer the light (see Color Plate 5). A special type of light meter, called a **color temperature meter**, registers the specific color of light in degrees Kelvin. It also specifies the type of filters that should be used to obtain a particular color temperature (see Figure 5.7).

Tungsten and Daylight-Balanced Light

Our eyes (and brains) have the ability to compensate for large changes in the color of light and still see seemingly accurate, believable color. Film and video cameras cannot do this, however. Color film stocks and electronic imaging

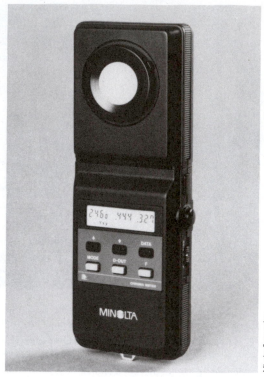

Figure 5.7
A color temperature meter with digital readout. (Photo courtesy of the Minolta Corporation)

devices can only produce correct colors within a relatively limited range on the Kelvin scale. This is accomplished in film and video in a somewhat different manner, but the basic principles are the same.

In film, you can compensate for color changes by purchasing a film stock that is **color balanced** for use in either **daylight** (5,500 degrees Kelvin) or **tungsten** light (3,200 degrees Kelvin). When used with lights rated at 3,200 degrees Kelvin, tungsten-balanced film will produce correct colors. If that same stock is used outdoors, color rendition will be skewed by the much bluer 5,500 degree Kelvin color temperature of the sunlight. Using tungsten-balanced film stock outdoors requires a **color conversion filter** such as a Wratten 85 or 85B filter. These orange filters effectively convert the more bluish sunlight outdoors to the color balance of the tungsten film. Conversely, a daylight-balanced film stock can be used outdoors without a filter. But using that same daylight-balanced stock in the more reddish tungsten light requires a blue filter, such as a Wratten 80 or 80A, to obtain the correct color balance (see Color Plates 6 and 7).

Video does not have daylight-balanced CCD sensors. Video imaging systems are balanced for tungsten light. Using a video camera outdoors in daylight requires the same type of orange 85 filter used in film, but because it is built into the camera, it is not easy to see. Some video cameras have a built-in **filter wheel** that enables the operator to dial in the correct filter for a variety of lighting sources. Such cameras typically have a setting for tungsten lights at 3,200 degrees (actually no filter), a setting for daylight (5,500 degrees), and perhaps an intermediate setting at 4,500 degrees. Some cameras may have only two settings, one for daylight and one for artificial light. These are often represented by graphics of the sun and a lightbulb. Many video cameras sense whether the camera is being used in artificial or outdoor light and automatically set the filters accordingly. It is beneficial for the operator to be able to override this automatic feature, however.

Small-Scale Color Corrections

The human eye can detect changes in color temperature as small as 100 degrees Kelvin. For this reason, you often must correct for slight variations in color that are much smaller than the broad changes made by color conversion filters such as the orange Wratten 85 filter. Another category of filters, called **light-balancing filters** or **color-compensating filters,** has been designed for this purpose. They are used on the film camera to compensate for subtle shifts in color temperature.

Generally, these filters are paler in color than the heavier color conversion filters used to correct between sunlight and artificial light. Their colors tend to fall at either the blue end or the red end of the color spectrum. Cinematographers often use them to warm up (a yellow to red filter) or cool down (a blue to purple filter) a particular light source.

In video, obtaining this kind of small-scale color correction is much easier. In fact, it is precisely the type of color correction produced by **white balancing** (see Chapter 3). Once the camera is set for tungsten light or daylight, white balancing fine-tunes the color, adjusting the camera precisely to the color temperature of any light

source. You do this by pointing the camera at a white surface such as a piece of white paper or a white T-shirt. Zoom the lens in to fill the frame with the white surface, and then activate the white balance control on the camera. A microprocessor in the camera automatically adjusts the imaging device to produce an accurate white in that light. In effect, the automatic white circuit knows what white is (almost equal amounts of red, blue, and green), and white balancing simply adjusts the system to reproduce white at the specific color temperature of the light in a scene.

You can also use the white balancing circuit to produce the kind of warming and cooling effects created by light-balancing filters. By white balancing the camera on a colored card rather than a white one, you tint the entire scene. When you do this, you are in effect lying to the white balancing circuit of your camera. White balancing on a light blue card, for example, produces a color tint toward the opposite end of the color spectrum (that is, a warmer orange), whereas balancing on an orangish card produces a cooler, more bluish tint. You may need to experiment a little to get the effect you want, but you can check the results immediately with an accurate color monitor.

To obtain comparable control of small color variations in film requires a color temperature meter and a case full of finely graded light-balancing filters. And the color correction still would not be as accurate as the white balancing process in video cameras.

The Vectorscope

In video, a **vectorscope** is used to monitor the color information in the video signal. It is used primarily to match the color between cameras in multicamera productions and to analyze and adjust color during postproduction.

The screen of a vectorscope presents a graphic display of the color information in the video signal. It shows the **hue** (the specific tint, such as blue, yellow, or orange) and the **saturation** of that hue (the degree to which the color is mixed with white light). A royal blue, for example, contains less white light than a baby blue. In other words, the royal blue is more saturated

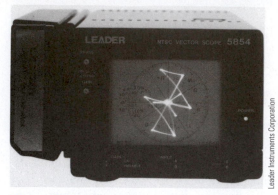

Leader Instruments Corporation

Figure 5.8

A small battery-powered vectorscope. (Photo courtesy of Leader Instruments Corporation)

(less diluted) than the baby blue. Portable vectorscopes (see Figure 5.8) are used in the field to analyze the color characteristics of various scenes, but a vectorscope is generally less valuable than a waveform monitor as a location production tool.[8]

Filters for Film and Video

In addition to the filters used to correct color balance and color temperature, many other filters change the image in a variety of ways. Generally, the effects of various filters are achieved by placing the filters on camera lenses, but with nonlinear editing systems, many of these effects can also be achieved during postproduction (see Chapter 11).

Types of Filters

Among the most common filters are **neutral density filters.** They reduce the intensity of the light reaching the imaging system without altering the color of the light in any way. Designed primarily to bring the light down to a level that the camera can handle, they are most commonly used for shooting in very bright light. Neutral density filters are calibrated according to their density, the amount of light they block. An ND-3 filter, for example, reduces the amount of light transmitted through it by one f-stop, an ND-6 by two f-stops.

A **graduated neutral density filter** is a special type of neutral density filter that darkens only part of the frame, usually the top. This is helpful on bright sunny days when the sky is too bright to allow correct exposure of the foreground. If

you expose for the foreground (probably the most important area of the shot), you will overexpose the sky, hence the graduated neutral density filter. Such filters have a clear area that gradually becomes a neutral density gray. You align the neutral density half of the filter with the sky at the horizon, which allows proper exposure of the sky and clouds without affecting exposure at ground level in the foreground.

Neutral density filters reduce all wavelengths of light equally, so they do not change the color temperature of the light transmitted through them. This neutrality means they can be combined with many other types of filters. An 85ND-6 filter combines the orange 85 color correction filter with a neutral density filter that reduces the light transmission by two f-stops. Many video cameras contain this type of combined neutral density–color conversion filter. Cameras that have an icon for clouds and another for the sun usually have a plain 85 filter for the former and a combined 85–neutral density filter for the latter.

Several types of filters eliminate haze. A **haze filter** is particularly useful for eliminating the bluish cast often seen on overcast days. The **ultraviolet (UV) filter** performs a similar function by blocking out ultraviolet rays. Outdoors, many photographers simply leave a UV filter on their camera at all times. It is clear and has no effect on regular light frequencies. In black and white photography, a pale yellow **sky filter** usually corrects the overexposure and loss of detail caused by haze.

Polarizing filters may also help eliminate haze and darken a blue sky, but their primary use is to minimize reflections from water or glass. The amount of polarization depends on the angle of light between the camera lens and the surface of the glass or water. Shooting at about a 30-degree angle to the reflective surface and then rotating the filter for maximum absorption of glare usually yields the best results.

Diffusion filters have a rippled surface or an extremely fine, netlike pattern that scatters (diffuses) the light and creates a softer, less detailed image. In the heyday of the Hollywood studio system, cinematographers would often put a fine silk mesh over the lens to photograph the movie's female star. This reduced wrinkles and

other blemishes and produced the same effect created by diffusion filters—a softer, more dreamlike, and romantic image. The amount of diffusion a filter provides depends on its grade (how dense it is) as well as the lighting, contrast, and size of the subject in the shot. In general, long shots require less diffusion than close-ups. **Star filters** are a special kind of diffusion filter. A grid of parallel lines etched into the filter surface turns any bright point of light in the scene into a bright star pattern.

Fog filters break up the light like diffusion filters but scatter that light from the bright picture areas into the shadow areas. The result is a light fog effect that tends to lower contrast and soften the shot, creating a mysterious, foreboding feeling.

Not surprisingly, **low-contrast filters** reduce contrast and color saturation. They are among the most useful filters for exterior shooting and are frequently credited with creating a film look in video. On a bright sunny day, the direct sun casts extremely hard shadows. It also produces a much greater range of brightness levels in the scene. As a result, the camera cannot properly expose the shadows and the highlights. This is where a low-contrast filter is most useful. It uses light from the highlights within the scene, scattering the light to brighten up the shadow areas, usually without reducing sharpness. This can be invaluable in any high-contrast lighting situation and can be particularly helpful in video.

Soft-contrast filters also reduce contrast but preserve a darker shadow area than low-contrast filters. They diminish the highlights without lightening the shadow area. The bottom line for both low-contrast and soft-contrast filters is reducing the contrast range. Whether you do this by brightening the underexposed areas of the shot or by darkening the overexposed areas is less important than the fact that you have reduced the contrast range to a level the imaging system can handle.[9]

Mounting Filters

Filters are normally made out of either gelatin or glass. **Gelatin filters** are the least expensive and come in small sheets that you can cut to the proper size for the camera lens or filter holder.

Glass filters may have a gel cemented between two sheets of optical glass, or they may have dyes laminated between two sheets of optical glass. The least expensive glass filters have dyes added directly to the glass during manufacturing. Some "glass" filters are actually made out of plastic.

Glass filters normally mount in front of the lens and must be of the proper size and type for a particular piece of equipment. Some glass filters screw directly into threads on the front of the lens and must be sized exactly to the diameter of that particular lens. Others mount on the lens with a special adapter ring and are held in place by a lens hood or matched retaining ring. You can also mount glass filters in a **matte box**, sometimes called a **filter box**. It is an adjustable bellows that attaches to the front of the camera body and extends beyond the lens. Squares of filter glass simply drop into the matte box, an arrangement that offers several advantages. Filters used in a filter box are cheaper because they do not have to be mounted (and threaded) on a specific lens. A matte box makes it easy to stack multiple filters, to drop in a cutout for such effects as binoculars, or to use the same filters with different cameras (because the filter does not have to screw into a particular lens size). Plastic filters are used most often to cover windows. They come in large rigid sheets that can be cut to fit the shape of the window.

You can mount gelatin filters in a variety of ways. With a matte box you cut the filter to the proper size, place it in a holder, and mount it at the rear of the matte box. It is also possible to attach gelatin filters to the front of the lens with an adapter and retaining ring. Some film cameras have a filter slot behind the lens. A gelatin filter is cut to fit into a small metal holder and then inserted in the filter slot behind the lens. You can also place large sheets of gelatin filter over windows or fit them into holders on the front of lighting instruments to change the color temperature in mixed lighting situations.

Compensating for Filters

As we have already seen, filters work by absorbing certain wavelengths of light and transmitting others. This means that obtaining proper exposure usually requires some iris adjustment. A

Mole-Richardson, Hollywood, U.S.A.

Figure 5.9

A tungsten-halogen bulb in a highly portable lamp housing. (Photo courtesy of Mole-Richardson, Hollywood, U.S.A.)

camera with a built-in light-metering system automatically compensates for the amount of light absorbed by a filter. When working with a separate meter, however, you must change the exposure according to the amount of light the filter prevents from reaching the imaging system. The degree of exposure compensation required for different grades of filters is usually expressed as a **filter factor,** a number based on the amount of light transmitted through the filter.[10]

The filter manufacturer normally supplies exposure compensation tables and an explanation of the filter grading system. Film manufacturers also indicate how filters change the EI or ASA. For example, one Kodak color negative tungsten-based film has an EI rating of 300 without a filter but an EI of 200 when it is shot with the orange 85 filter required for daylight shooting.

Care of Filters

Because filters sit directly in the light path (either in front of the lens or behind it), they should be treated with the same care as a lens. Gelatin filters are so soft and easily damaged that they should be handled only by their edges and cleaned with a camel-hair brush. Fortunately, gelatin filters are inexpensive and if damaged should simply be replaced. Fingerprints can scratch or smudge glass or plastic filters. Carry them in a protective case

and keep them immaculately clean. Once damaged, they cannot be repaired.

It makes no sense to shoot with a high-quality camera and lens and then degrade the image they create by using a damaged filter. A clear glass filter (or a UV filter) is one of the least expensive ways to protect the costly lens on your camera. Mounted in front of the lens, it will shield the irreplaceable lens surface from scratches, water, and dirt. If it is damaged, you simply throw the $10 glass filter away, something you would not do with an expensive zoom lens.

Artificial Lighting

The lights used in film or television production come in a seemingly infinite variety of sizes and shapes. They are categorized by the type of lightbulb they use, by the intensity and quality of light they produce, and by other characteristics such as the way they are mounted or how they control the light they emit.

Types of Lamps

Three main types of lamps are used in lighting instruments for professional moviemaking: tungsten-halogen, high-frequency fluorescent, and HMI. These are the standard lamps whether you are shooting with a film camera or a video camera.

Tungsten-halogen lamps, also called **quartz-halogen** or **tungsten** or **quartz lamps** (see Figure 5.9), have a bulb made of quartz glass (to withstand the heat), are filled with a halogen gas, and contain a tungsten filament. When electric current passes through the filament, it heats up and produces light. The more resistance the filament has, the brighter the light glows, and the more power it consumes. This difference is expressed in **watts,** a measurement of the amount of electric current a particular lamp draws. Thus, a 1,000-watt bulb produces more illumination and requires more power than a 500-watt bulb. The purpose of the halogen gas is to create a sort of restoration cycle. The halogen helps to deposit the evaporating tungsten back on the filament as the lamp burns. The result is a lamp that maintains its

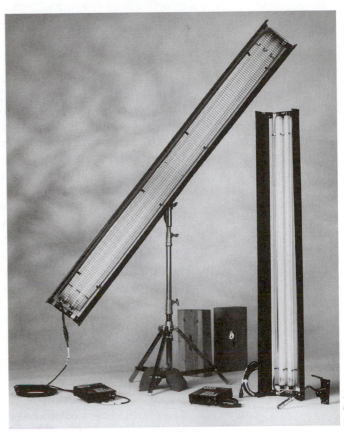

Figure 5.10

An HMI light, shown with its ballast, produces daylight-balanced light with less heat and lower power requirements than incandescent lights. (Photo courtesy of Mole-Richardson Company)

Figure 5.11

Two high-frequency fluorescent (kino) lamps. (Photo courtesy Kino Flo, Inc.)

color temperature (3,200 degrees K) and light output for a long time. Be especially careful to avoid touching the surface of a tungsten-halogen bulb. Oil from the fingers, or any foreign material for that matter, will weaken the quartz envelope and cause it to burn out much more quickly. The bulb might even explode when it gets hot. When changing a quartz bulb, you must use a glove or a piece of cloth or paper to protect it.

Situations that call for daylight-balanced lighting of about 5,500 degrees Kelvin often use special **HMI lights.** (HMI is the abbreviation for *hydrogen medium-arc-length iodide.*) HMI lights (see Figure 5.10) have a restoration cycle similar to that of a quartz light and maintain their color temperature and light output for long periods. They are frequently used as a supplemental light outdoors or to illuminate large areas. They are expensive, however, and require a bulky ballast unit (high-voltage power supply) to produce consistent lighting. In some lighting situations,

HMI lights are impractical or too expensive. In these cases, it may be necessary to convert regular 3,200-degree Kelvin tungsten-balanced lamps to the color temperature of daylight by attaching a blue filter to the front of the light housing. Because these filters reduce the light output of the lamp by 30 to 40 percent, additional lighting instruments may be necessary to obtain the same amount of illumination.

Another type of light is **high-frequency fluorescent,** also called **high-speed fluorescent,** and most often referred to as a **kino** after the main manufacturer, Kino Flo (see Figure 5.11). These are not to be confused with traditional fluorescent lights—the kind commonly used in schools and office buildings. Those are difficult and unpredictable as a light source for shooting film or video, mainly because their color rendering in the reds is usually poor. However, high-frequency fluorescent lighting outputs red, greens, and blues in a manner that guarantees consistent color temperature. In fact, the lamps

can be manufactured to be either 3,200 degrees K or 5,500 degrees K. To switch from one to another, you simply change the lightbulb. Kino lights also eliminate the flicker problem common with regular fluorescent lights; while office lights oscillate at 60 cycles per second, high-frequency lights (as their name implies) average between 25,000 and 40,000 cycles per second. This makes for a constant pattern that is completely acceptable for film and video recording. The lights are very low energy because they operate through a chemical reaction involving stimulated phosphors. As a result, kino lights use 90 percent less energy and generate less heat than tungsten lights, and the bulbs last for 10,000 hours, as compared to about 400 hours for tungsten.[11]

Sometimes ordinary household incandescent lights can be used to augment lighting, especially if they are in a lamp as part of a scene. Most of them have a color temperature of 2,800 degrees K—close enough to 3,200 degrees K that they can blend in with tungsten lamps.

Basic Lighting Instruments

Lighting instruments also are typically classified by the quality of the light they produce and how the light can be shaped and controlled by the lighting instrument itself. *Hard* and *soft* are common terms for describing light quality. A **hard light** has a narrow angle of illumination and produces sharp, clearly defined shadows, whereas a **soft light** scatters the light to create a much wider angle of gentle, diffused illumination. Kinos generally give off soft light whereas HMIs and tungsten can be either, depending primarily on the lamp housing. For example, a tungsten bulb can be placed in a **softlight reflector** that blocks the light directly in front of the lamp and bounces it back into and off the reflector's surface. The result will be a soft, diffused light with the degree of softness determined in part by whether the reflector's surface is highly polished or matted (see Figure 5.12). A tungsten bulb placed in a **parabolic reflector** will produce a more concentrated beam of hard light because all the illumination is directed outward without being bounced off any surfaces.

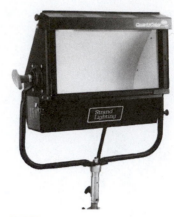

Strand Lighting

Figure 5.12
A softlight reflector with the lamps recessed along the bottom. (Photo courtesy of Strand Lighting)

Lighting equipment manufacturers and rental houses frequently categorize different types of lights according to their primary function. From this perspective lighting instruments are often classified as **key lights, fill lights,** or **scenery** (or **background**) **lights.** Key lights provide the main source of illumination in a typical lighting setup, so they tend to be hard lights with a beam width that can be focused. Key lights come in a variety of closed-face (usually with a lens) and open-face designs.

Fill lights supplement key lights, reducing the shadows and contrast range in relation to the key light. Fill lights usually produce a softer, more diffused light. They are often open faced and are usually more limited in their ability to vary the angle of illumination. Many, in fact, have a fixed focus.

Scenery lights add depth and control contrast between the subject and the background or set. They are often a form of soft light and provide flat, even lighting over a wide area. Describing lights by their function has definite limitations. A lighting instrument can serve many purposes. A light sold as a key light can easily be used as a fill light. The real issue is not what the light is called but whether it does what you want it to do in a particular situation.

Lights are also classified as to whether they are **spotlights** or **floodlights.** The former usually illuminate small, concentrated areas, and the latter cast a diffused and even beam of light over a fairly large area. However, many spotlights are variable and can cover either a small or large area.

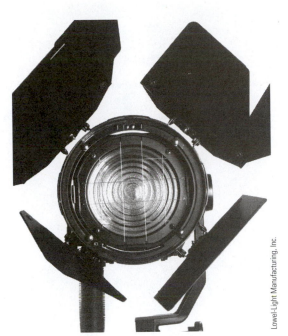

Figure 5.13

A Fresnel spotlight with barndoors attached. (Photo courtesy of Lowel-Light Manufacturing, Inc.)

Lowel-Light Manufacturing, Inc.

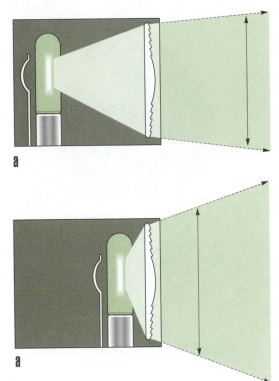

Figure 5.14

(a) A spotlight in the spot position with the bulb moved toward the back of the lamp housing, and (b) a spotlight in the full flood position with the bulb moved toward the front lens.

The **Fresnel spotlight** is one of the most widely used lights in professional film and television production (see Figure 5.13). You can vary its beam width by adjusting a control knob or lever on the back of the light that moves the bulb-reflector unit toward or away from the Fresnel lens. At the **spot** position, the lamp is farthest from the lens. This converges the light rays and produces a narrower, more concentrated beam. At the other end of the adjustment range, the **flood** position, the lamp moves closer to the lens (see Figure 5.14). Flooding creates a wider and somewhat more diffused beam of light that illuminates a broader area. Common uses of Fresnels are as key lights or to light essential areas of the set, but their controllable beam width means they can be adapted for almost any application. They come in many wattages and with various types of lamps.

Some variable beam spotlights do not have lenses. For the lightweight and highly portable tungsten spotlights used for location lighting, an open-face design is commonplace (see Figure 5.15). Although providing less beam control than a Fresnel, this type of instrument does allow the beam width to be varied from spot to flood.

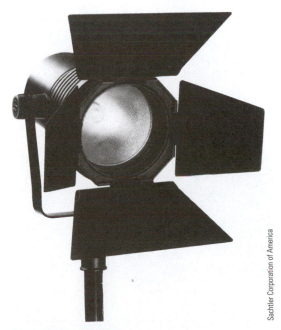

Figure 5.15

An open-face quartz spotlight with barndoors. (Photo courtesy of Sachtler Corporation of America)

Sachtler Corporation of America

Strand Lighting

Figure 5.16

A scoop. (Photo courtesy of Strand Lighting)

Mole-Richardson, Hollywood, U.S.A.

Figure 5.17

A quartz lamp broad on a lightweight stand. (Photo courtesy of Mole-Richardson, Hollywood, U.S.A.)

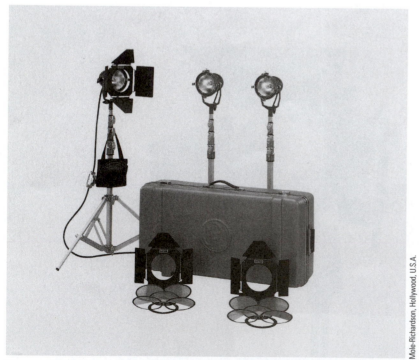

Mole-Richardson, Hollywood, U.S.A.

Figure 5.18

A portable location lighting kit with lights, stands, barndoors, and other accessories. (Photo courtesy of Mole-Richardson, Hollywood, U.S.A.)

Lens-less, open-face lighting instruments come in many other varieties. Most of these lights are some form of floodlight. One of the oldest types, a **scoop,** contains a single bulb in a bowl-shaped metal reflector (see Figure 5.16). Scoops range in diameter from 10 to 18 inches. **Broads** are rectangular floodlights that typically use quartz lamps in an open-face housing (see Figure 5.17). They produce a broad beam of relatively diffused light and are often used for fill lighting.

Many lighting equipment manufacturers sell portable lighting kits for location use. Such kits usually contain three or four small lighting instruments with stands, extension cords, and other accessories in a carrying case (see Figure 5.18). Location kits typically use quartz lamps

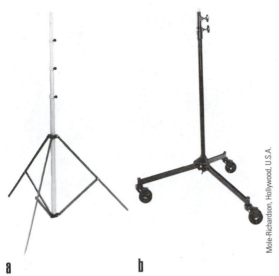

a b

Figure 5.19

(a) A lightweight telescoping light stand, and (b) a somewhat heavier light stand. (Photos courtesy of Mole-Richardson, Hollywood, U.S.A.)

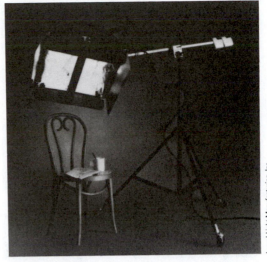

Figure 5.20

A softlight on a boom arm. (Photo courtesy of Lowel-Light Manufacturing, Inc.)

ranging from 500 to 1,000 watts, and most portable instruments are open-faced broads, although small Fresnel spotlights are also available.

Mounting Equipment

In the studio lights usually hang from a **grid** of pipes on the ceiling. Elsewhere, the most common mounting device is a **light stand.** Stands are made of metal, have tripod bases, and vary in size from the light alloy stands found in portable lighting kits to heavy-duty **C-stands** equipped with casters. They can be telescoped to a height of 6 to 8 feet (see Figure 5.19).

Telescoping **boom arms** (see Figure 5.20) and **extendable lighting poles** often hold lighter, more portable instruments. **Space-clamps** (see Figure 5.21) hold lights on shelves and similar structures. **Wall plates** or **base plates** are sometimes used to attach lights to flat surfaces.

Alligator clamps (also called **gaffer grips**) are spring-loaded clamps that can be used to secure a lightweight instrument almost anywhere. One of the most widely used light-securing devices, a **C-clamp,** attaches lighting instruments to a lighting grid or lighting pole. The screw in the C-clamp locks the clamp securely to the support.

Figure 5.21

A high-frequency fluorescent mounted with a space-clamp. (Photo courtesy of Lowel-Light Manufacturing, Inc.)

Controlling the Light

If lighting is going to be used expressively, it must do more than simply provide enough illumination to ensure proper exposure. It must in some way be controlled so that it falls in the

Figure 5.22

A portable light with flags attached to flexible shafts. (Photo courtesy of Lowel-Light Manufacturing, Inc.)

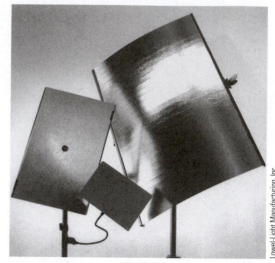

Figure 5.23

Several reflector variations. (Photo courtesy of Lowel-Light Manufacturing, Inc.)

Figure 5.24

A lightweight umbrella reflector. (Photo courtesy of Lowel-Light Manufacturing, Inc.)

proper places and assumes the desired shapes. A number of lighting aids have been developed to control and direct the light.

Barndoors, for example, block off the beam of light, preventing unwanted shadows and keeping direct light out of the camera lens. They are thin metal sheets on a frame that attaches to the front of the lamp housing. They are available for most lighting instruments in either a two-leaf or four-leaf design (see Figures 5.13 and 5.15). **Snoots** serve a similar purpose. They are

metal funnels of different diameters that attach to the front of the light and restrict the beam to a circle pattern. Other light-directing accessories, such as **flags, dots,** and **fingers,** are made with heat-resistant opaque cloth or thin metal sheets. Filmmakers put them on stands and place them between the light and the subject to create shadow areas or to keep light from reaching certain surfaces (see Figure 5.22).

One of the most valuable light-directing accessories is a **reflector** (see Figure 5.23). It bounces light (for fill) back into the scene from a bright light source like the sun or a powerful key light. Reflectors are mounted on stands or held by grips during production. Any movement of a reflector, however, whether caused by a person holding it or the wind, will create a moving light pattern and may make the light unusable.

Some portable lighting kits use an **umbrella reflector** (see Figure 5.24) to create an extremely soft light source. The umbrella attaches to the light stand, and the light is turned into it. The beam bounces off the umbrella's reflective interior surface, producing a highly diffused pool of light. A piece of white cardboard, a sheet of white Styrofoam, a space blanket, or even crumpled aluminum foil taped with **gaffer tape** to a cardboard backing can provide a homemade reflector. Professional reflectors typically have a different surface on each side of a sturdy base: a hard, highly reflective side that redirects the light without scattering it, and a more matted

Figure 5.25
The diffusing material standing behind this fluorescent Kino Flo lamp will scatter the light when it is placed on the lamp. (Photo courtesy of Kino Flo, Inc.)

a

b c

Figure 5.26
A butterfly scrim (a) can diffuse light over a much larger area than a single or a double scrim. Made from stainless steel, a single scrim (b) and a double scrim (c) fit into a variety of accessory holders. (Photo (a) courtesy of Matthews Studio Equipment, Inc.; photos (b) and (c) courtesy of Mole-Richardson, Hollywood, U.S.A.)

side that redirects and softens the light bounced from it.

Placing a light-diffusing material in front of the light source changes the quality of the light a lamp emits. Common light-diffusing materials such as fiberglass, silk, frosted glass, and heat-resistant plastics can alter light quality according to the diffusion characteristics of the material employed. Diffusion materials can be mounted in a filter holder in many lighting instruments (see Figure 5.25). They can also be placed on a stand between the subject and the light source. Because they are used with intensely hot lights, the stronger, more heat-resistant materials are preferred. Large diffusers can be suspended on frames over the entire set for location shooting.

A **scrim** is an accessory for reducing light intensity without changing the color balance of the light transmitted through it. Scrims are made of translucent black fabric or stainless steel mesh similar to a common household window screen. They mount in a holder on the lamp, or they can be placed on a stand between the light and the subject. Outdoors, large scrims such as a **butterfly scrim** (Figure 5.26a) suspended on a large frame reduce the intensity of sunlight in an area as large as 20 square feet. Scrims are available in varying thicknesses. Single scrims (Figure 5.26b) cut the light by one half-stop,

and double scrims (Figure 5.26c) cut the light by a full stop. Half-scrims cover only half of the instrument's opening.

Dimmer boards control the intensity of the light, but they are somewhat bulky and therefore are rarely used for remotes. Dimmers use varying resistance to change the amount of voltage reaching the lamp. However, reducing the voltage changes the color temperature, so dimmers can adversely affect color rendition.

One of the most obvious ways to change light intensity requires no special equipment or supplies. It involves simply moving the light closer to or farther away from the subject being illuminated. As the light is positioned farther away, the intensity of the light decreases. The falloff is not

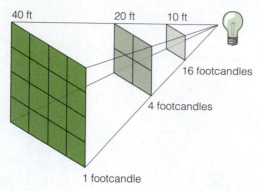

40 ft 20 ft 10 ft

16 footcandles

4 footcandles

1 footcandle

Figure 5.27

The inverse square rule. The intensity of the light varies according to the square of the distance from a simple light source.

proportional to the distance, however. According to the **inverse square rule**, the intensity of the light decreases by the *square* of the distance from the subject. In other words, moving a simple light source (such as a candle) from 10 feet to 20 feet from the subject will reduce light intensity on the subject by roughly *four times* (see Figure 5.27). Most lighting instruments, of course, have some means of directing or focusing the light rays, which alters this formula. In actual practice this axiom simply means that close-ups of actors require less light than medium or long shots, for which the lights must be placed farther away to remain out of the frame.

A number of computer programs can aid in the control of light. They can, for example, undertake the calculations for the inverse square rule or help you determine whether you should use a single or double scrim. You can use them to keep track of where you positioned reflectors or what settings you used for a dimmer board and then refer to that information if you need to re-create the lighting effect. They can show you how the lighting will look if you vary the wattage of the bulb or place a colored filter over a lamp. Most of these computer aids can easily be programmed into a cinematographer's personal digital assistant or laptop computer.

Electric Power Requirements

Artificial lights require electricity to function. The three basic sources used to power lighting equipment in film and television production are batteries, gas-powered generators, and house-

hold current. Battery-powered lights are becoming more and more common as battery technology improves and lights require less power. High-frequency fluorescents are particularly conducive to battery power because of their low energy use. Generators can provide large amounts of electricity for prolonged periods of time. They are used primarily by professional production companies to illuminate large areas (and power many lighting instruments) with a power source that can be transported to virtually any location.

For the majority of productions, the most common power source is the current supplied to a house or building by the utility company. Portable lighting instruments are usually designed to operate with the 120 **volt** current available from wall outlets in almost every building or home. Lamps of different wattages draw greater or lesser amounts of power. Exceeding the power limits that a household electrical system can provide will cause an overload, resulting in tripped breakers and, sometimes, burned connectors or cables.

Power circuits in most buildings or houses have breakers that handle either 15 or 20 **amps** per electrical circuit. If the lights plugged into a circuit exceed that limit, the circuit breaker will cut off the current. To determine the amperage rating for a circuit, you must find the breaker box or boxes and read the breaker limit. All electrical outlets and lighting fixtures at the location are routed through these breakers, and each power circuit has its own breaker switch. If you blow a circuit, the switch will flip to the middle, neither off nor on. Unplug the lights that blew it, and reset the circuit breaker by flipping the switch off, then on. The circuit is working if the breaker stays in the on position.

Obviously, it is vital to know which wall outlets are controlled by each breaker switch so you don't overheat a circuit. If that information is not written in the breaker box, you will need to compile your own map of the circuits. To do this, plug a light into each wall outlet in a particular room and switch the breakers off and on to determine which outlets are on which circuit. An inexpensive night-light is ideal for this purpose. A single circuit may have wall outlets in several rooms, such as a hallway, bedroom, and bathroom.

Once you have mapped a circuit, you will need to do some simple mathematics because circuit breakers (and most generators and batteries) are rated in amps, but appliances and bulbs are labeled in watts. Fortunately, a relatively simple formula converts watts and amps: *amps times volts equals watts.* The power voltage in the United States is about 120 volts. But to make the calculation even easier to do in your head, use 100 volts instead of 120. This provides a margin of safety to keep from blowing circuits and also makes the multiplication simpler because you can multiply the number of amps given on the breaker box by 100. This tells you how many watts you can safely plug into the circuit. For example, if the circuit can carry 20 amps, you can plug in 2,000 watts' worth of lights (2,000 watts = 100 volts x 20 amps).

This would mean you could plug in four 500 watt lamps, two 1,000 watt lamps, or any other combination of lamps adding up to 2,000 watts. Of course, you can use this much only if nothing else is plugged into the circuit. If a refrigerator or other power-consuming equipment is operating, you must deduct the number of watts each uses.

If the circuit in a room you are lighting cannot provide enough power for all your lighting instruments, you will have to route power to your lights from a different circuit. Extension cables used for this purpose should be of a heavy enough gauge to handle the wattage they are expected to carry. Common household extension cords are too lightweight and can be dangerous. Long extension cable runs can also reduce the voltage supplied to the lamps and may affect color rendition. A 1-volt drop in power supplied to an incandescent lamp lowers the color temperature by 10 degrees Kelvin.

As noted earlier, renting a generator is the common solution to limited location power. Generators are not cheap, but some rental houses provide student discounts, and in many cases a rented generator may be the only way to assure reliable power. Another option might be to negotiate with a neighbor to buy power from them. Finally, another option available from most lighting rental houses is a range plug. This plug is different from the standard two- or three-pronged Edison plugs. It plugs into the 240 volt outlet

used for electric stoves and clothes dryers and breaks it down into two 120 volt legs. In a house with limited circuits it can be invaluable.

Professional film and television crews typically hire a licensed electrician to help deal with electrical problems. An electrician can bypass the breaker box and route the power into a separate distribution box that has its own breakers. This enables power cables to be run directly to the distribution box and to be routed where they are needed without the constant risk of tripping circuit breakers. Bypassing the circuit breaker box, however, should be done only by a qualified electrician.

Lighting Safety

Setting up and operating lighting equipment, especially on location, requires planning and care. Lights must be securely mounted, and barndoors or filter holders should be locked in place or taped to any supporting structure for additional stability. Electrical cords and extension cables should be taped down with gaffer tape or paper tape or be covered with rubber matting to keep people from tripping and pulling the lights down (see Figure 5.28). Power cables coming from the light should be secured to one of the legs of the light stand.

A fully extended tripod-base light stand is inherently unstable, and you should secure the legs with sandbags to keep them from tipping over (see Figure 5.29). Some heavy-duty light stands have anti-sway bars to increase their stability or come with rings at the base for securing power cords. Pointing one leg of the light stand in the direction the lighting instrument is facing helps to distribute the weight more evenly and improves the stand's steadiness.

Because lighting instruments get very hot, never place them near flammable materials such as curtains or upholstered furniture. An overloaded circuit or inadequate extension cable can also cause a fire. The placement of gels, filters, or diffusing materials on the lighting instrument also requires careful attention. It is imperative to attach these light-shaping materials in such a way that the heat can escape from the bulb and surrounding area.

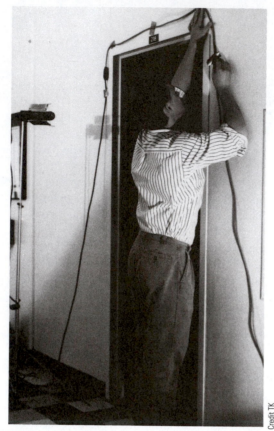

Credit TK

Figure 5.28

Taping down extension cords can prevent injuries and reduce the chances of lights being pulled over.

Matthews Studio Equipment, Inc.

Figure 5.29

A sandbag can be used to secure top-heavy light stands. (Photo courtesy of Matthews Studio Equipment, Inc.)

Even if a light has only been on for a short period, it is usually too hot to touch. If it is not possible to let the light cool down, use insulated electrician's gloves to adjust barndoors or to change scrims or filters. Turn lights off as soon as production is completed so they have time to cool before being packed away. Be careful when removing tape from floors or walls; it is easy to damage wallpaper or painted surfaces as the tape is peeled away.

Most of these safety precautions are just common sense. In the heat of production, however, with time running short and pressure building, cutting corners is a real temptation. That is when accidents occur. To protect the crew and cast from injury, you must always handle electrical power and lighting instruments in a careful, systematic, and professional manner.

In addition to well-maintained lighting instruments and the proper filtration materials and securing devices, a number of items should be part of your location lighting kit. These include a fire extinguisher, insulated gloves for each crew member handling lights, burn ointment, rubber matting, gaffer tape, and spare bulbs. Finally, the quality and safety of location lighting are directly related to the amount of advance planning. Scouting a location for power requirements *before* the shoot tells you what to bring.

Notes

1. Several camera models use the zebra pattern. Its stripes are visible in the viewfinder over the areas of the picture that are near the 100 IRE unit level, the uppermost limit of brightness. It is adjustable in cameras. The zebra stripes could be set to a level, for example, of 65 to 70 IRE, the approximate level for Caucasian skin tone and a level that is not so close to the camera's clip levels.

2. Overexposure in video can be especially troublesome. For an excellent discussion of this issue, see Harry Mathias and Richard Patterson, *Electronic Cinematography: Achieving Photographic Control over the Video Image* (Belmont, CA: Wadsworth, 1985), pp. 99–109, 164–173, 180. They recommend exposing for extreme highlights and then moving down to the required fill levels.

3. Another measurement often used, especially in Europe, is lux. One lux is roughly one tenth of a footcandle.

4. Mathias and Patterson, pp. 171–172. The authors describe a simple procedure for establishing an ASA rating for any video camera. This requires a chip chart and waveform monitor in addition to the light meter and camera you will be using. After lighting the chip chart evenly, open the camera's iris to the point at which the white chip on the chart is at 100 IRE units on the waveform monitor. After checking to see which f-stop that requires on the camera, change the ASA slide or

dial on the light meter until you reach the same f-stop reading as the one on the camera. You then can use that ASA slide or setting as the ASA for your camera.

5. Remember that the range of f-stops is a result not only of the variance of light falling on the scene but also of the varying reflections of different surfaces within the scene. A single light source can result in different ranges, depending on the nature of the subject. For example:

Contrast Ratio	Range in F-Stops
1:1	0
2:1	1
4:1	2
8:1	3
16:1	4

6. "What Is Color?" *TV Technology,* 6 February 2002, p. 22.

7. The actual percentages needed to make white are 59 percent green, 30 percent red, and 11 percent blue.

8. Rosco Laboratories, one of the biggest manufacturers of filters for film and television, has developed complete vectorscope readings for every Roscolux filter, including phase angles, chroma amplitudes, and waveform monitor luminance values. Thus, various colors will plot at different places on the vectorscope according to their phase angle and chroma amplitude.

9. For a good discussion of filters, see Chuck Gloman, "What's So Swell About Gels?" *TV Technology,* 29 June 1998, p. 48; and Stuart Singer, "Polarizing Filters," *International Photographer,* May 1997, pp. 26–27.

10. The filter factor is the inverse of the fraction of the light transmitted (for example, $\frac{1}{4}$ is two f-stops). You can divide filter factors into ASA and make all subsequent exposure calculations based on the new or recalculated ASA. With a filter factor of 4, for example, the ASA might be 320 without the filter but 80 (320/4) with the filter.

11. See "Cameras, Action . . . Lights!" *TV Technology,* 23 March 1998, p. 178; Steve Michelson, "HSF Lighting Takes to the Field," *TV Technology,* 23 March 1998, p. 226; and "Lighting for EFP," *TV Technology,* 23 January 2002, p. 29.

chapter six
Approaches to Lighting

L ighting is more than simply obtaining adequate exposure. It is a way to direct the viewer's eye in the frame, to establish the character, the mood, and the dramatic quality of the image. Lighting can establish the time of day, bring out or mute certain colors, or create a feeling of safety or danger. Light can be used to emphasize or deemphasize depth. Layered in planes from the front to the rear of the frame, light can also help define the space in three dimensions. The lighting styles discussed in this chapter are employed while shooting on a set or location. Virtual lighting is created in computers and is used most often for movies where backgrounds or visual effects dominate.

Lighting Styles

The lighting in most modern dramatic motion pictures tends to be more or less realistic; it looks like the natural light we experience in everyday life (see Figure 6.1a). The key to this style of lighting is that the light must *appear* to be coming from some real light source in the movie, such as a streetlight, a ceiling fixture, a table lamp, or the sun. This kind of lighting is often called **source lighting** because it mimics or augments the direction of the light and the light source in the scene.

The opposite lighting approach, one that could be called *expressionistic* (or *stylized*), is more concerned with creating a particular mood or feeling in the shot than in seeming realistic (see Figure 6.1b). Such distinctions are not always clear-cut. To produce an image requires light, even in places where light is unlikely. It may be totally unrealistic to have a spotlight illuminating the slimy monster in a dark sewer, but realistic lighting is not the primary objective in such movies. Even motion pictures that make every effort to employ realistic lighting can slip into movie lighting conventions that totally defy our experience with light in real life: the pitch-black alley behind the bar that is *always* lit by a convenient full moon or the light streaming from beneath the dashboard in the front seat of the otherwise dark automobile (see Figure 6.2).

There are many different approaches to lighting. Numerous books and magazines discuss the aesthetics of lighting,[1] but ultimately the style of lighting employed tends to defy any simple formula or rule book. A lighting setup must take into account not only the technical limitations of the camera, lens, and recording medium but also the dramatic needs of the story.

Basic Three-Point Lighting

Three-point lighting is perhaps the most traditional approach to lighting. It creates a balanced, sculpted image that emphasizes three-dimensionality in the otherwise flat, two-dimensional film or video frame. In the studio, of course, it is possible to control the light totally, but the same basic principles apply to location lighting.

The primary light source in three-point lighting is called the **key light**. The key light simulates the main source of illumination for a scene—the sun (or streetlight) outdoors, a lamp or lighting fixture indoors. It typically is placed 30 to 45 degrees from the camera-to-subject axis and is elevated at an angle of 30 to 45 degrees above the camera-to-subject axis (see Figure 6.3). The key light is often a focusable lighting instrument like a **Fresnel** that is adjusted somewhere in the middle of the flood-to-spotlight range (see Chapter 5). It creates some shadows, giving shape to the subject. As the dominant lighting source, it is the light most responsible for setting the basic f-stop used to shoot the scene.

The **fill light** is placed on the opposite side of the camera from the key light, from near the camera to as much as 45 degrees away, and usu-

a

b

Columbia Studios

Figure 6.1
In an episode of the TV series Werewolf, *actor Chuck Connors is seen (a) in a lighting setup that is basically realistic and (b) in a lighting setup that is more expressionistic. (Photos courtesy of Columbia Studios)*

ally at camera height. It fills in, at least to some degree, the shadows created by the key light. For that reason it is never more intense than the key light and almost always employs a softer, more diffused light source, such as a **high-frequency fluorescent** or a **tungsten** light in the flood position (see Chapter 5). Too much fill light can create a flat, low-contrast image.

The third basic light in a three-point lighting setup is called the **back light.** It is placed above and behind the subject at enough of an angle to keep the light from coming directly into the camera lens. The back light helps to outline the subject (particularly in the head and shoulder area because the light is coming from above and behind) and separate it from the background.

Additional lights, sometimes referred to as **separation lights,** amplify or enhance the modeling provided by traditional three-point lighting (see Figure 6.4). An **eyelight** is a small, focusable light placed near the camera (at eye level) to add a sparkle to a person's eyes. A **background light** illuminates the background, not the back of the subject like a back light. It helps to separate the performers from the background or set. A **kicker light** is similar to a back light in function. It is usually placed low, behind the subject, often directly opposite the key light. It too helps to separate, or "kick," the subject out

Amazing Movies

Figure 6.2
This scene from Merchants of Venus *is an example of lighting a scene in a way that is believable but not realistic. This is actually only a shell of a car with lights from under a mostly nonexistent dashboard—a place where lights would not be in real life. To enhance the effect of a car being driven down a street at night, director Len Richmond had crew members whiz by with white and red lights to give the effect of passing headlights and taillights. (Photo from Len Richmond's* Merchants of Venus *courtesy of Amazing Movies, Dianna Ippolito, photographer)*

from the background. The intensity needed for a back light or kicker light can vary greatly. A brunette requires more light, a blonde less, and a bald person even less. A properly lit scene may

Figure 6.3

(a) The basic angles for the key and fill lights in relation to the camera subject and (b) the vertical angle above the camera subject for the key and back lights.

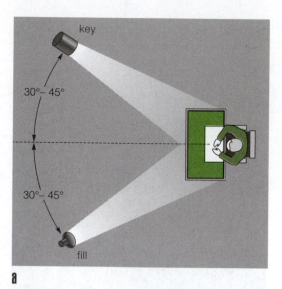

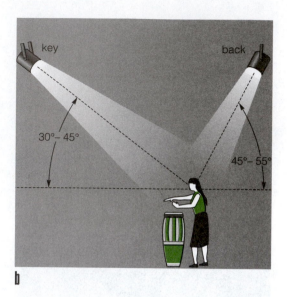

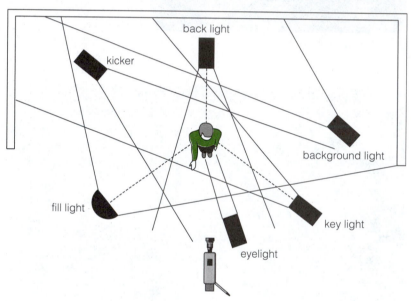

Figure 6.4

A complete lighting setup with key light, fill light, back light, kicker light, background light, and eyelight in their typical positions.

not even require separation lighting, and some lighting directors avoid kickers and back lights to achieve greater realism.

Comparison of Lighting for Film, SDTV, and HDTV

Like many other facets of moviemaking, lighting styles for film and video have merged. This is mainly because the technical characteristics of

television cameras have continually improved. Television cameras of the 1950s required a significant amount of light, called the **baselight level**, just to produce an image. Programs were aired live, usually with three cameras, so lighting had to be designed so it would illuminate the shot regardless of which camera was being used. Generally light was poured over the entire action area, producing relatively flat, even lighting.

In contrast, the much greater sensitivity of film stock made it far easier for filmmakers to shoot on location with lower light levels and more natural (or realistic) lighting techniques. **Film-style lighting** grew out of the single-camera shooting method for film: the lighting setup is changed as the camera position is changed for virtually every new shot. This is a slow and tedious process, of course, but what film-style lighting loses in time it makes up for in control.

As technological improvements in video equipment began to narrow the differences between film and video, applying film-style lighting techniques to **standard definition television (SDTV)** production became increasingly possible. Standard definition is the 525-line **NTSC** system that has been used in the United States since the 1940s. It wasn't called "standard definition" at the time because it was the *only* television system, but now that **high-definition television (HDTV)** has been developed, the older system is referred to as "standard."

With high definition, the differences between what is needed for film and for video lighting are narrowing even further. Film still has greater

latitude, or **contrast range**, in that it can reproduce a greater range of brightness levels (from the darkest to brightest points in the scene) than video. This means there will be more details in dark areas and light areas of a frame on film than on video. But the contrast range gap is narrowing with each new model digital camera.

Shooting movies with video cameras, especially high-definition **24P** cameras (see Chapter 3), is relatively new, so cinematographers are experimenting with how best to light with this medium. Sometimes HDTV is too sharp, and unimportant background items can draw the viewer's attention away from important foreground information. In these cases, the background needs to be more dimly lit than it would if shooting with film.[2]

The film image is less affected by strong highlights than video because each successive film frame presents an entirely new recording area, unaffected by the previous frame. In a video camera, each frame is scanned from the imaging device so elements remain with the pixels. Therefore video may need some type of contrast reduction, such as a **diffusion** or **low-contrast filter** (see Chapter 5). Sometimes large dark areas of a video frame show a great deal of **noise**. The answer to this problem may be to use fill lighting to bring up the light level in those dark areas.

Including both a **black reference** (some black object within the shot) and a **white reference** (such as a white handkerchief) can often improve a video image. Video cameras have difficulty when the lighting for a scene is low contrast—at relatively the same brightness level at either end (dark or bright) of the contrast range. Using a white and a black reference helps to fill in or extend the video signal over the full range the camera is capable of reproducing.

One of the challenges for cinematographers, whether they are working with film, SDTV, or HDTV, is that increasingly directors want to shoot with two cameras at the same time so that they can capture the same emotional level for editing. This means that the lighting must sometimes look right for both long shots and close-ups. As both film stocks and video imaging devices improve, lighting for multiple cameras becomes more doable. Electronic calculators also help cinematographers calculate distances, depth of field, and other measurements that can aid in showing what lighting is needed for two cameras. But nothing beats experience when it comes to the art of lighting scenes effectively.

Preparing to Light

Lighting, like any other element of the production, requires advance planning. The lighting director needs to understand the exact nature of the scene being shot. What kind of mood is the director trying to create? What kind of lighting instruments does that require? Are any special lighting accessories needed? At what time of day is the scene supposed to be taking place (and will the scene actually be shot at that time)?

If you are not going to be shooting in a studio, careful and systematic location scouting is imperative. You will need to survey each location to determine how much light it will require and how lights can be mounted. How many crew members will you need to set up the lights or handle the reflectors? Seeing the site at the time of day you are actually planning to shoot is important. The position of the sun (and the prevailing lighting conditions) changes dramatically from early morning to late afternoon.

Once you have some idea of how many lights you are going to need and how they will be mounted, survey the location for electricity. How much power do you need, and how much is actually available there? This is the time to find the breaker box and map out the power circuits. How many wall outlets do you have, and where are they located? If you need to run power from additional circuits, how long do your extension cables need to be? Do you have a contact person so you can gain access to the breaker box? Do you need to hire a qualified electrician? If the power at the location is inadequate, you will need to rent a generator or perhaps negotiate with people nearby to buy power from them.

You also need to consider how you will transport your lighting equipment. Lights and lighting accessories are large and bulky. They are also fragile. What kind of vehicle do you need to transport the equipment? What kind of access

Figure 6.5

(a) Shooting against (into) the light can create many problems with exposure, flare, and unwanted reflections. Shooting with the light (b) usually eliminates these problems and is almost always easier.

a b

do you have for the vehicle when you reach the location? Ultimately, you will need to develop a checklist so that you don't forget anything. Here are some of the major items:

1. Lighting instruments and spare lamps (number, type, and size)
2. Mounting equipment (number, type, and size)
3. Lighting accessories (barndoors, flags, filters, diffusers, reflectors)
4. Power cables and mats, sandbags, and gaffer tape
5. Generator (if needed)
6. Safety equipment (fire extinguisher, gloves, and such)
7. Transportation
8. A weather report

Outdoor Lighting

Shooting outdoors usually means that you will have enough light to meet the baselight requirements of almost any film stock or electronic imaging system. The sun itself can be a powerful key light, not only defining the time of day (based on the color temperature and angle of the shadows) but also dictating the direction of the light in the scene. Shooting with the light (in the direction the light rays are falling) is the sim-

plest and most common technique for outdoor shooting. Keeping the sun at your back usually eliminates the problems associated with lens flare and backlighting. The photos in Figure 6.5 illustrate shooting with the light and against it.

Light in the early morning or late afternoon casts longer, more clearly defined shadows, creating a greater sense of relief or modeling and a more dramatic image. A shot of a high mountain lake looks quite different in the flat light of midday than early or late in the day. The time of day also affects the color tones in the image. The late afternoon sun casts a particularly warm golden light. Many cinematographers prize the look of this "golden time" and set up their shooting schedule to take full advantage of the atmosphere it establishes for a scene. For similar reasons they have used the dramatic red glow of a sunset as the backdrop for scenes in countless motion pictures.

The quality of the outdoor light we actually experience ranges from very harsh and direct to soft and diffused. In fact, natural light is usually a mixture of different light qualities. The sun can be both a source of hard direct light and a source of fill as the sun's light is reflected from clouds, buildings, and the ground to form a softer, more diffused general skylight. In most cases, however, reflected skylight does not provide enough fill for outdoor shooting. Without adequate fill light, a sunlit image can easily ex-

ceed the contrast range of a camera's imaging system. As a result, outdoor lighting usually involves some kind of contrast reduction, a way to reduce the enormous range between bright sunlight and the dark shadows of the shade.

Contrast Reduction

Throwing additional fill light into the scene, as we have already discussed, is one way to reduce contrast outdoors. This is why professional film and television companies so commonly use artificial lighting outdoors, even on a bright sunny day. This situation necessitates the use of daylight-balanced light sources such as **HMI lights**, **kinos** with 5,500-degree K bulbs, or tungsten-balanced lights converted (with a blue filter) to daylight color temperature.

An even easier and cheaper method of providing daylight-balanced fill light is using **reflectors** (see Figure 6.6). Reflectors can bounce direct sunlight back into the scene for fill lighting. If the sun is the primary light source in a scene, the reflector will have to be placed in the standard fill light position (on the opposite side of the camera from the key light) to reflect the sunlight into the scene. Reflectors are mounted on stands (or sometimes handheld) above eye level to simulate skylight. If they are too low, or if they create a too clearly defined light pattern, the reflected light they cast can look artificial and unnatural.

Another way to reduce contrast is to suspend a large **scrim** or light-diffusing medium over the entire set area. This can virtually eliminate shadows, creating soft, dreamy, highly diffused lighting. The same thing can be accomplished simply by shooting in a shaded area or on an overcast day.

Sometimes you can put a filter on the camera to control outdoor lighting conditions. A **neutral density filter** reduces the overall light level in an excessively bright outdoor scene. This can be helpful when you want to reduce the **depth of field** by forcing the camera to shoot at a wider **f-stop** (see Chapter 3). **Haze filters** and **UV filters** reduce the bluish cast on overcast or hazy days. **Polarizing filters** minimize unwanted reflections from water or glass. Low-contrast or **soft-contrast filters** reduce the contrast range.

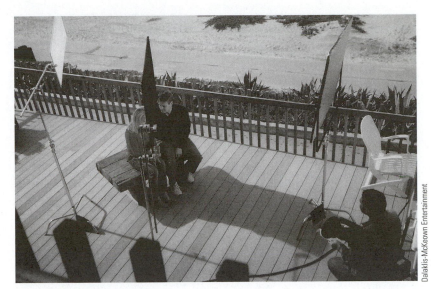

Dalaklis-McKeown Entertainment

Figure 6.6

Reflectors are an excellent way to bounce light back into a scene. (Photo courtesy of Dalaklis-McKeown Entertainment)

Filters generally cause some loss in image quality, but in many situations they may be the only workable way to deal with existing lighting conditions.[3]

Maintaining Continuity in Changing Light

When the sun is the primary light source, there is always the potential for lighting-induced **continuity** errors. Movies are usually shot out of sequence, and long delays between camera setups are commonplace. Shots that supposedly occur sequentially in time may have been shot at different times during production, even days or weeks apart. If those shots are to flow together seamlessly in the final motion picture, the lighting within the scene must be consistent from shot to shot.

This means that the light quality must be the same for each shot in the scene. If the first shot takes place in direct sunlight, it will look strange if the light in the next shot is suddenly the more diffused light caused by a passing cloud. Similarly, the direction of the light must be consistent. A shot taken at noon when the sun is almost directly overhead contains few shadows. If that shot is followed immediately by a shot that clearly displays the long shadows of late afternoon, the continuity violation is obvious.

Even the natural changes in the sun's **color temperature** throughout the day can be the

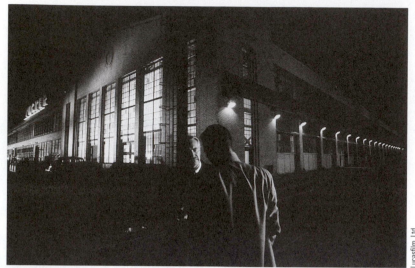

Lucasfilm, ltd.

Figure 6.7

Night-for-night lighting created by cinematographer Vittorio Storaro for Francis Ford Coppola's Tucker. *Turning all the lights on in the Tucker car assembly plant provides backlighting for the actors and motivation for the unseen light source illuminating them from the upper right-hand side of the frame. (TM and © Lucasfilm Ltd. [LFL] 1988. All Rights Reserved. Courtesy of Lucasfilm, Ltd.)*

source of continuity errors. The color temperature of sunlight at 4 p.m. is visibly different from the color temperature at 6 p.m. The automatic **white balancing** circuit in a video camera, or **color compensating filters** on a film camera, can correct for these small shifts in color temperature. However, you cannot eliminate gross changes in the shadows or in the overall quality of the light.

The only way to avoid such lighting-induced continuity problems is to organize your shooting schedule carefully when working in natural light. Trying to shoot a long complicated scene late in the day when the light is changing rapidly will almost certainly lead to problems. Group similarly lit scenes together in your shooting schedule, and avoid shooting different sections of the same scene at different times of day. Shooting part of a scene before lunch and finishing the rest of the scene after a long break can easily create incompatible lighting conditions.

Shooting at Night

Night scenes abound in feature films. Shooting at night, what filmmakers call **night-for-night**, produces the most convincing results (see Figure 6.7). One of the biggest battles in night lighting is finding a convincing, believable (well-motivated) source—a store window, streetlight,

or bright moon—for the illumination of the scene. Artificial lights are then used to simulate the light that would be coming from that source. Night lighting is easier if the actors avoid wearing dark clothing that makes them blend into the background.

Dusk-for-night shooting is just what it sounds like—shooting at dusk. The sky at twilight provides a natural blue fill. Artificial lights provide the key. The biggest problem with dusk-for-night shooting is that twilight is so short. The rapidly changing lighting conditions require constant monitoring and readjustment of lights.

Another method, called **day-for-night**, is a well-known film technique for shooting "supposed" night scenes during the day. This involves increasing the contrast and darkening the sky, usually by using a deep blue filter for color filming. Some cinematographers use film that is balanced for artificial (3,200 degree) light and shoot without an 85 orange filter, thus enabling the film to "see" the daylight as blue. The scene is then underexposed by 1.5 to 2.5 f-stops. The film laboratory can also enhance the day-for-night effect during printing. With the proper tinting and some trial and error, many of these night effects are possible in video as well. A scene can be made to look more like night if a light blue gel is used on the lighting instrument. This is because moonlight is conventionally enhanced by a bluish cast.

Adapting to Weather Conditions

When shooting outdoors, natural weather conditions can change the quality of the light dramatically. A funeral scene shot on a dark overcast day reads differently from the same scene shot in bright cheery sunlight. The highly diffused light of an overcast day often improves a color image. The low-contrast lighting can mute certain colors, making them more subtle and pastel. Shooting just after a rain has stopped can pick up a myriad of reflections and moving water patterns. Snow, fog, and mist each create a distinct mood-provoking atmosphere (see Figure 6.8). Even extremes in temperature can alter the quality of the light. On a cold day the steam curls from virtually every heat source. In the

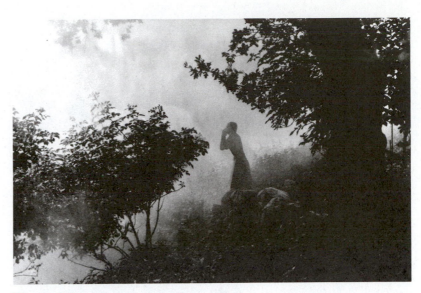

Figure 6.8
Director Carl Dreyer exploits the diffused light of a fog-shrouded forest in Day of Wrath *(1943).*

desert the hot air rising from a highway can imbue a shot with a sense of unbearable heat as the light is distorted through the shimmering haze.

Obviously, you cannot control the weather or the temperature, but you can use naturally occurring conditions when the opportunity arises. Professional filmmakers, of course, can "make" weather to some extent with fog and rain machines. Wetting down the streets to create water reflections and glitzy highlights is a time-honored movie tradition. But even without such resources, the lighting in different weather conditions can provide the perfect atmosphere for a special scene. With a weather report, a little patience, and some luck, there is nothing to stop you from using natural weather conditions to your advantage.

Indoor Lighting

Interior lighting demands a certain amount of flexibility, a willingness to make things work even in difficult conditions, especially on location. In a studio equipped with an overhead grid, a full complement of lighting instruments, and other accessory equipment, lighting is much easier to set up and control. A friend's living room, a neighborhood restaurant, or a lecture hall at school may be the perfect setting for your movie, but it may be a nightmare to light in terms of mounting the lighting instruments or obtaining adequate power. Good location scouting can alleviate some of these problems, but successful indoor lighting still requires an ability to adapt to each new situation.[4]

Shooting in Available Light and Low Light

In some cases it may be possible to shoot indoors relying totally on available light, such as the light provided by an overhead fixture or sunlight coming through a window. In both film and video, shooting in available light is a more viable option than ever before. Each new generation of lenses seems to be faster, and new film stocks and electronic imaging systems require less light to record an image. Still, even with these improvements, shooting in available light may not produce a satisfactory image. It may be difficult, if not impossible, to control adequately the intensity of available light, its color temperature, or its direction. Thus, shooting with available light almost always involves trade-offs and compromises. And available light almost always means low light levels in interior locations.

In general, low-light shooting is somewhat easier in film than in video. If the available light is inadequate for a particular film stock and lens combination, the most common solution is to switch to a faster, more light-sensitive film stock. Professional filmmakers, in fact, often use two types of film when shooting a movie: a slower, more fine-grained stock for outdoor shooting (where light levels are seldom a problem), and a faster tungsten-balanced stock for shooting interiors or low-light situations. Film manufacturers have continued to improve film speed, producing stocks that are not only more light sensitive but finer grained as well.[5]

In a situation in which the light levels are still too low for the film stock, the film can be shot *as if* it actually had a higher EI. This requires a special laboratory procedure called **pushed processing,** or **forced development.** Pushed processing entails increasing the developing time (or temperature of the developing chemicals) as the film is processed. It can raise the effective EI of film stock by as much as one or two f-stops. There is a trade-off, however. Pushed processing

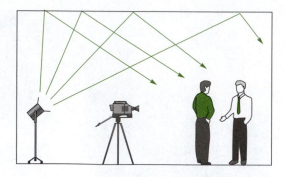

Figure 6.9

As long as the ceiling and walls are light (preferably white), light can be bounced back into the scene to produce relatively soft, even illumination.

Figure 6.10

A tiny Nooklite can be hidden easily behind objects within the set. This kind of instrument is invaluable for lighting hard-to-reach areas. (Photo courtesy of Great American Market)

Great American Market

Figure 6.11

A typical mixed-lighting situation. The sunlight's color temperature (5,500 degrees Kelvin) is different from the tungsten-balanced (3,200 degrees Kelvin) instruments providing the main light for the man's face.

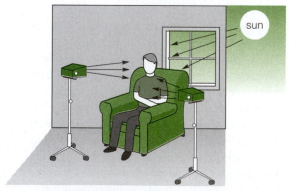

tends to increase grain and contrast in the image. Negative film can be pushed more than reversal film, but pushed processing usually results in reduced image quality. Much the same thing occurs when you boost the **gain** of the video signal electronically.

Bounce Lighting

A common problem in location lighting is hiding lights (particularly the back light) from the camera's view. The low ceilings in most locations make it impossible to suspend the lights above the scene, the usual procedure in a studio with an overhead lighting grid. One way to provide back light or additional fill in a cramped interior location is to bounce light into the scene. **Bounce light** is light reflected into the scene from the ceiling or wall. Aim a lighting instrument at the ceiling and adjust it to the proper angle so that the reflected light falls where you want it (see Figure 6.9). This tends to create a diffused, even kind of lighting and can be a valuable way to establish an overall baselight level for an interior location.

Obviously, bounce lighting will not work if the ceiling is too high or too dark to reflect the light. It works best if the ceiling is white or a light-colored material because bounced light will pick up the color of the surface from which it is reflected. This kind of subtle color shifting is difficult to compensate for in film, but white balancing in that light should adjust the color balance correctly for a video camera.

If bouncing light is not workable in a particular location, one solution might be to amplify the light in the **practical lights** on the set—the table lamps or lighting fixtures that already appear in the scene. This entails replacing the bulbs in those lamps or lighting fixtures with 3,200-degree Kelvin bulbs. You sometimes can achieve a similar effect by placing a very small lighting instrument, such as a Nooklite (see Figure 6.10), in a corner of the set where it can be blocked from view by a piece of furniture.

Mixed Lighting

When the lighting for a scene contains both daylight and artificial light, maintaining the proper color balance is extremely difficult, whether you are shooting with video or film. **Mixed lighting** is common when shooting location interiors. Imagine a scene with a person sitting in an easy chair in a living room (see Figure 6.11). Some light in this scene is streaming through a large window behind the person. The sunlight has a color temperature of 5,500 degrees Kelvin or even higher,[6] but the key and fill lights illuminating the character's face are provided by lights rated at 3,200 degrees

Kelvin. Trying to color balance for such mixed lighting conditions can cause problems for any cinematographer.

If you shoot this scene on daylight-balanced film stock, the person's face will be red. With tungsten-balanced film stock, the face would be correct, but the sunlit background would be very blue. With video there will be the same discrepancies depending on whether you white balance for indoor or outdoor light. There are several ways to solve this problem. One is to place sheets of orange Wratten 85 **color conversion filter** (the same filter used to shoot tungsten-balanced film in daylight) over the window. Another is to match the color temperature of daylight by using daylight-balanced 5,500-degree K lighting instruments, such as HMIs or kinos with 5,500-degree lamps. A third method is to convert 3,200-degree lights to 5,500 degrees by placing blue filters over them. Any of these methods will make all the light roughly the same color temperature (see Figure 6.12).

Another form of mixed lighting involves fluorescent lights commonly found in commercial buildings and schools (as opposed to high-frequency fluorescents). These lights break up the spectrum, usually emitting only a few wavelengths, primarily the greens and blues and very little in the way of reds. Similar problems occur with other "noncontinuous" light sources such as the mercury vapor or sodium lamps commonly used in streetlights or in large commercial applications. If only fluorescent lights are used, white balancing a video camera under them can sometimes produce satisfactory results, especially if the lights are warm-white. Film is more problematic. The broken color spectrum presented by the fluorescent lights will fool some color temperature meters. Most cinematographers use tungsten-balanced film to shoot under fluorescent lights, but depending on the bulb type, daylight film might be more appropriate. If fluorescent light is mixed with daylight, tungsten light, or even high-frequency fluorescents, the result will probably be quite unsatisfactory. The film lab or the nonlinear editing system may be able to correct the color somewhat, and filters over the camera lens may help, but you need to experiment because there are many types of fluorescent bulbs.

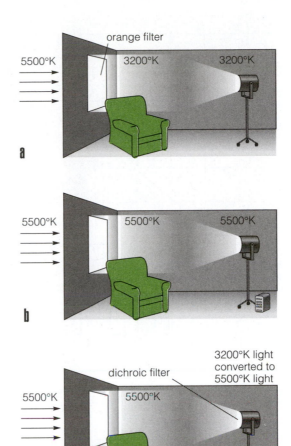

Figure 6.12

Three solutions for a typical mixed-lighting situation. Gel the windows with orange 85 filter gels (a). This will match the more bluish sunlight to the much redder 3,200-degree Kelvin light indoors. By using a daylight-balanced (5,500-degree) HMI light indoors (b), the color temperature will match the sunlight streaming through the window. A 3,200-degree Kelvin light could also be converted to a temperature of 5,500 degrees Kelvin with a blue filter placed on the lamp (c). The disadvantage of this approach is that the filter greatly reduces the amount of light from the 3,200-degree instrument.

The easiest solution is to turn off the office-style fluorescent lights and light the scene entirely with tungsten or kino lighting instruments. In fact, in many mixed lighting situations, the simplest solution may be to block out one of the sources. Closing a heavy curtain over the window might eliminate (or reduce) the sunlight enough to allow the tungsten lights to dominate the lighting of the scene. Conversely, turning off all the lights and working only with light coming in the window might work. Depending on what is being shot, it may be acceptable to let the light coming through a window in the background go blue. Certainly this seems to be more common than it once was in film and video.

Lighting for Movement

Lighting a scene in which a character (or the camera) moves is much more difficult than lighting a single fixed area. Most directors draw up a **blocking** diagram for shots that contain

Figure 6.13

A lighting plot with a key explaining the type, power, and function of each instrument. In this example, the lights are hung from a grid.

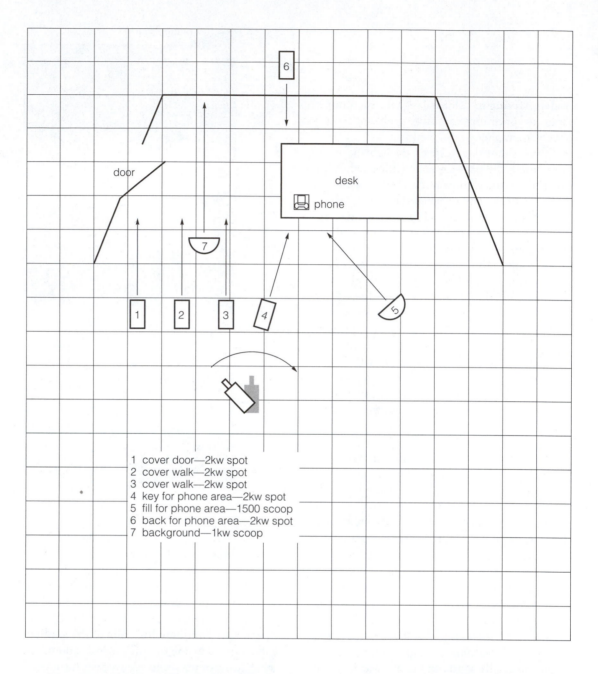

door

desk

phone

7

1 2 3 4

5

6

1 cover door—2kw spot
2 cover walk—2kw spot
3 cover walk—2kw spot
4 key for phone area—2kw spot
5 fill for phone area—1500 scoop
6 back for phone area—2kw spot
7 background—1kw scoop

complicated movement. The cinematographer needs to look at the blocking diagram, or at least consult with the director, to see precisely where the movement occurs and whether any particular areas within that movement require special emphasis. For example, a woman walking from the door to a desk needs to be lit as she walks but may need more balanced, three-point lighting when she picks up a phone from the desk at the end of the movement.

Drawing up a **lighting plot** on graph paper is a good way to begin planning. A lighting plot is a diagram of the set that also shows the camera position, the location of lights, their size and

type, and the direction they will be pointing (see Figure 6.13). Using one means the lights can be set up and placed in position even before the actors arrive on the set. The lights cannot be focused or finely adjusted, however, until the director actually blocks out the scene with the actors. This is one reason **stand-ins** are used in movie production. Lighting a spot where the actor will stand is not the same thing as lighting a 6-foot actor or his stand-in.

Perhaps the easiest method of lighting for movement is simply illuminating the entire area with soft, diffused lighting (see Figure 6.14). This avoids some of the problems associated

with uneven lighting in a large area: actors walking in and out of hot spots or disappearing into darkness between pools of light. For added effectiveness, the soft light can be bounced over the entire shot area, providing an even, overall baselight level.

For a shot in which a character moves toward or away from a light, you can place a half-scrim on the lighting instrument to even out the lighting. The half-scrim should mask the bottom of the light with the open (unscrimmed) half at the top (see Figure 6.15). If the light is angled correctly, the half-scrim will reduce light intensity near the light but allow full illumination farther away, evenly balancing the light intensity between the two positions. This allows the character to walk closer to the light without the illumination becoming excessive.

Another common technique for lighting movement is to use standard three-point lighting for the areas that require it and to add fill lighting in the gaps between those areas. In this situation an **incident light meter** is especially helpful for checking light levels across the entire scene area, particularly in the gaps between lighting triangles. A similar technique involves *overlapping* the areas of key, fill, and back lights. This way, the same light performs different functions in different parts of the set. The key light can be the primary light source when the actors are in an entryway, but when they move over into the living room, that light might provide back light.

In any lighting setup special care must be taken to avoid unwanted shadows. Multiple shadows or the shadow of the sound boom draws the viewer's attention to the lights. These problems intensify if the shot contains movement. The shadow of a moving sound boom (as it follows the actors) is too obvious to ignore.

You can reduce or eliminate such shadows in several ways. Shadows tend to be much more conspicuous against a light-colored background than against a dark background or dark floor. Adjusting the lights to a different angle can eliminate shadows or at least shift them out of frame so they are not visible in the shot. Placing the actors farther from the wall will also make their shadows less visible. Sometimes a **flag** or **barndoor** can block the light that is causing a

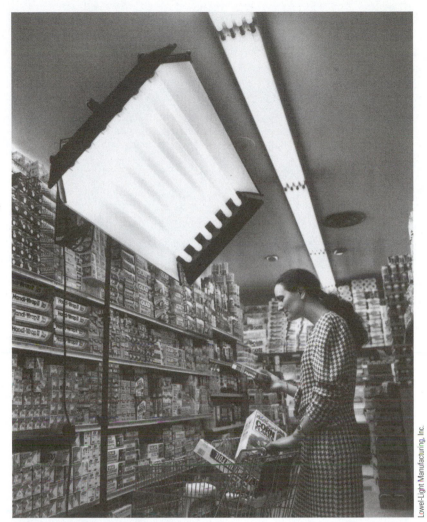

Lowel-Light Manufacturing, Inc.

Figure 6.14

The soft light from these high-frequency fluorescent lamps can be effective for much of the distance that the woman might move with the shopping cart. (Photo courtesy of Lowel-Light Manufacturing, Inc.)

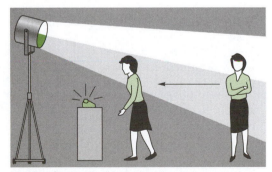

Figure 6.15

A half-scrim is invaluable when the subject must move closer to the lighting instrument (with a subsequent increase in illumination). By reducing the light emitted from the bottom half of the instrument with a half-scrim, the light intensity can be balanced more evenly between the two positions.

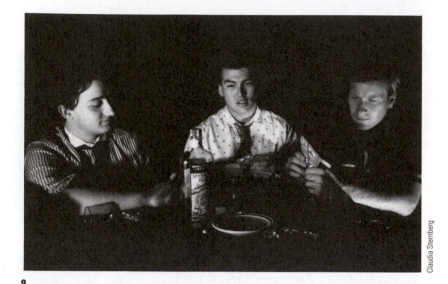

a

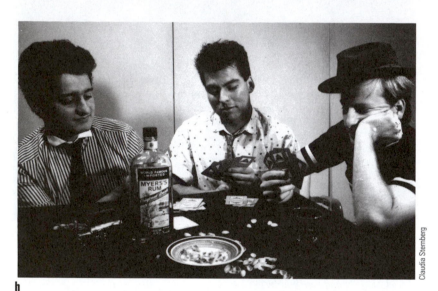

b

Figure 6.16

The same scene with low-key lighting (a) and with much brighter high-key lighting (b). (Photos courtesy of Claudia Sternberg)

boom shadow. If that is not possible, moving the boom to a different position or miking the sound without a boom might work. Finally, altering the quality of the light in the scene may be the easiest way to reduce shadows. If the lighting is hard, the shadows are more intense. Simply diffusing the light to produce a directionless, overall illumination will diminish or eliminate most shadows.

The director's rehearsals with the actors provide a final opportunity to recheck the lighting to see whether movement in the shot introduces shadows that were overlooked as the lighting setup was being completed. The time to catch hot spots, dark areas, or moving shadows is before shooting begins.

Variations in Lighting

The mood created by lighting is established to a great degree by the **lighting ratio**—the ratio of the key light plus the fill light to the fill light alone. If, for example, the key light and the fill light together have an intensity of 300 **footcandles,** and the fill light alone equals 100 footcandles, the lighting ratio is 3:1. You add fill light to the key light because the fill light actually provides some illumination to the key side of the subject. This ratio is often expressed as the f-stop difference between the key and fill. A 2:1 lighting ratio has one f-stop difference between key and fill and the fill alone; a 4:1 ratio has a two f-stop difference; an 8:1 ratio has a three f-stop difference.

A commonly recommended lighting ratio is 3:1, though film will still show some shadow detail with a lighting ratio as high as 8:1 or 10:1, and video is acceptable at 8:1. The lighting ratio between the key light and the other lights on the set, such as the back light, the kicker light, or the background light, is far more subjective. It depends in part on how much light the subject or background will reflect and on the particular mood you are trying to create.

Lighting is often described as *high key* or *low key* (see Figure 6.16). These terms can be extremely confusing. **High-key lighting** is generally bright, even illumination. The key-to-fill ratio is low, resulting in a low-contrast image. It might be easier to understand high-key lighting if we used the term high-fill, because the fill light intensity is actually high in relationship to the key. Conversely, **low-key lighting** uses a low amount of fill light in relationship to the key. That is, the ratio of key to fill is high in low-key lighting, as much as 8:1 or higher. Historically, the tendency has been to use high-key lighting for lighter subjects, such as comedies, musicals, and romances. High-key lighting is bright,

happy, and relatively flat. Low-key lighting is much darker, more brooding, and harsh. Dramas (some might say melodramas), horror films, and thrillers—the kinds of movies in which something, good or evil, is always emerging from the shadows—traditionally use low-key lighting.

Other factors help to determine the emotional impact of the lighting. The direction of the light (front, side, or back), the angle of the light (above, below, or eye level), and the quality of the light (hard or soft) can affect the image as profoundly as the lighting ratio. For example, lighting from the front tends to reduce shadows and flatten the image. If frontal lighting is soft and diffused, it will also smooth out the texture of the surface it illuminates. Lighting from the side creates sharper shadows, particularly with a hard light source. Side lighting throws the subject into relief and can highlight texture with small shadows. Backlighting can be used to emphasize depth.

Shooting directly into the light **silhouettes** the subject, accentuating its outline while minimizing specific details. This can make the image more abstract. Lights angled sharply from above or below create more distinct, dramatic shadows than lights closer to eye level. Light from directly above creates a pool of light on the subject it is aimed at and obscures the background—a type of light often referred to as **cameo**. Selective lighting on one part of a shot (such as a woman's hands) is often called **Rembrandt lighting** because it was a style used by the famous painter (see Color Plate 9). The shape, the color, and the sense of depth can change dramatically, according to whether the illumination is hard and direct or soft and diffused. The number of variables in lighting makes the combinations almost infinite. The photos in Figure 6.17 show various lighting strategies. Also, look at Color Plates 8, 9, and 10, and see if you can figure out how these images might have been lit.

Technological advancements make possible at least one generalization about lighting: The tendency today is to use fewer lights. Faster lenses and more sensitive imaging systems in both film and video make it possible to use less lighting, to place lights farther away, and to have

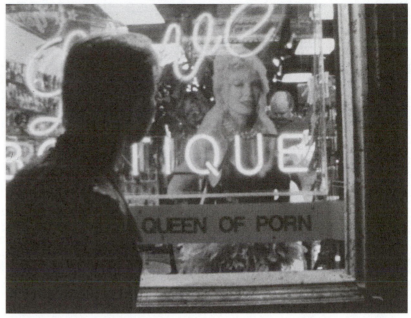

a

b

Figure 6.17

(a) In this scene from Len Richmond's Merchants of Venus, *the bright lights inside the shop turn Michael York into a silhouette. Before he arrived in front of this shop, he was walking down the street in a long tracking shot where his face was lit by light mounted on a camera.*

(b) In Carl Dreyer's Day of Wrath, *the lighting consistently casts shadows across the face of the young woman, Anne, who is accused of witchcraft. The brooding, low-key lighting in this film underscores its deep sense of mystery and ambiguity.*

(continued)

Kino Flo, Inc.

Amazing Movies

c

d

e

Janus Films

Figure 6.17 *(continued)*

(c) The Kino Flo light mounted on the ceiling casts soft light onto the table.
(d) This flattering photo of Beverly D'Angelo was created from natural light and re-
flectors—but no artificial lights. Beverly wore special makeup with little particles in it
that reflect light and give her face a glowing look.
(e) This is a typical low-key shot from Ingmar Bergman's The Seventh Seal. *The ratio*
of key light to fill light is fairly high.
(Photos (a) and (d) from Len Richmond's Merchants of Venus *courtesy of Amazing*
Movies, Dianna Ippolito, photographer of (d). Photos (b) and (e) from Janus Films.
Photo (c) courtesy of Kino Flo, Inc.)

more shadow areas within the shot. This makes
the set or location more comfortable for the ac-
tors, and it also makes changing lighting setups
much faster.

One of the best things about the video revo-
lution is the widespread availability of VCRs,
DVDs, and video rental stores. The opportunity
to rent and watch a wide variety of films means
you can study lighting as never before. Lighting
defines the tone and style as much as any element
in a movie. In the hands of talented directors,
production designers, and cinematographers, the
approaches to lighting are almost infinite.

Notes

1. See, for example, almost any issue of *American Cine-
matographer* or *Lighting Dimensions*. Some books
that deal with lighting include Tom LeTourneau,
Placing Shadows: The Art of Video Lighting (Woburn,
MA: Focal Press, 1998); Brian Fitt and Joe Thorn-
ley, *Lighting Technology* (Woburn, MA: Focal Press,
1997); Blain Brown, *Motion Picture and Video Light-
ing* (Woburn, MA: Focal Press, 1996); and Dave
Viera, *Lighting for Film and Electronic Cinematogra-
phy* (Belmont, CA: Wadsworth, 1993).
2. "Through the Looking Glass," *Emmy,* June 1991,
pp. 34–36.

3. John Premack, "Taking the Sun at Face Value," *TV Technology,* October 1995, pp. 39–45; and "Lighting for EFP," *TV Technology,* 23 January 2002, p. 29.

4. James Caruso and Mavis Arthur, "Interior Lighting Techniques," *Video Pro,* March 1995, pp. 34–37; and Chuck Gloman, "Soften the Lighting Blow," *TV Technology,* 7 September 1998, p. 76.

5. See, for example, Kodak's 35mm tungsten-based color negative film, Kodak Vision 5289. It has an ASA of 800 tungsten and 500 daylight with a No. 85 filter.

6. Depending on atmospheric conditions and the time of day, the color temperature of blue skylight can range from 7,000 to 30,000 degrees on the Kelvin scale.

chapter seven
Microphones and Recorders

Sound is an essential element of movies and should be given much thought and care. If you need proof, watch your TV set with the sound off for a while and see how well you understand what is happening. Then turn the sound up, cover your eyes, and listen without seeing the picture. You probably will be able to understand what is happening much better without the picture than without the sound.

Nevertheless, student (and even some professional) moviemakers often become so absorbed in setting up proper picture composition that they forget to leave time for proper microphone positioning. They hastily place a microphone in front of the talent and then fret over the poor sound quality during postproduction—when it is too late.

Much of what is needed for good sound is the same for film and video. Recording equipment differs, but microphones, cables, and connectors are identical. Most significant, the basic principles of sound are the same for virtually all media.

The Nature of Sound

To select the right audio equipment and to record sound properly, you need to understand a number of characteristics of sound. These include pitch, loudness, timbre, duration, and velocity.[1]

Pitch and Frequency

Sound waves travel in well-defined cycles. The number of times per second that the wave travels from the beginning of one cycle to the beginning of the next is its **frequency,** which is measured in **hertz (Hz).** For example, a sound wave that goes from the beginning of one cycle to the beginning of the next at 200 times per second is said to have a frequency of 200 Hz. The sound made by the differing frequencies is the **pitch.** Bass sounds have lower frequencies and lower pitch than treble sounds (see Figure 7.1). For example, a bass violin has a frequency of about 100 Hz, whereas a triangle has a frequency of about 13,000 Hz. Men's voices generally have a lower frequency (hence lower pitch) than women's voices. People with exceptionally good hearing can hear a range of frequencies from about 20 Hz to 20,000 Hz.

Each microphone and tape recorder has its own **frequency response**—the range of frequencies that it will pick up. The frequency response needed depends on the type of sound being recorded. For example, the range of frequencies used by the human voice is from about 200 Hz for a deep male bass to 3,000 Hz for a high female voice. For recording speech, a mic and recorder with a somewhat limited frequency response will probably be adequate. On the other hand, for recording music, you would want a wider frequency response, perhaps as broad as 20 Hz to 20,000 Hz.

Microphones and recorders may not pick up all frequencies equally well. As a result, equipment manufacturers usually represent the ability to pick up various frequencies with a graph called a **frequency curve** (see Figure 7.2). Some mics and recorders do not pick up the very high and very low frequencies as well as they pick up midrange frequencies; therefore, the frequency curve will be higher in the middle. Sometimes this is because the equipment is inexpensive and not well constructed, but other times this is entirely intentional. For example, some mics have a **speech bump;** they *intentionally* pick up human speech frequencies better than they pick up other frequencies. Other mics have a switch with two positions, one for speech and one for music. When the mic is in the speech position, it records a narrower band of frequencies than when it is in the music position. Microphones and recorders that pick up all frequencies equally well are said to be **flat** because they have a flat curve.

You can manipulate frequency characteristics in other ways. For example, some mics boost the

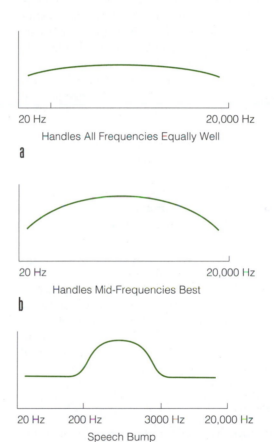

bass frequencies as a person moves closer to the mic. This is called **proximity effect** and is usually undesirable because it gives the voice a fuzzy sound. However, it can make some male voices sound mellower.

There is no universally correct frequency response or frequency curve. The choice depends on the use intended. Sometimes a very limited frequency response, perhaps 1,000 Hz to 2,000 Hz, is desirable to create a tinny sound similar to an answering machine.

Obviously, all the equipment within a complete recording system should have a similar frequency response. A symphony orchestra recorded with high-quality wide-frequency response mics should not be fed into a $50 cassette tape recorder with narrow frequency response.

Loudness and Amplitude

In addition to having a frequency, a sound wave has a height or **amplitude**. Amplitude is related to loudness. As the amplitude increases, the sound will appear to become louder. Loudness is measured in **decibels (dB)**. A whisper is about 20 dB, conversation is about 55 dB, a rock concert can get well above 100 dB, and a gunshot blast is 140 dB. The **threshold of pain** starts at about 120 dB.

The range of quietness to loudness is called **dynamic range.** Different pieces of equipment have different dynamic ranges. If something is recorded louder than the system can handle, the result is **distortion.** For example, if a system has a 60 dB range, and you plan to record at 20 to 100 dBs, some of the sound will not record well. With analog equipment, the loud notes will become a muddy jumble, and the frequencies will not come out of the equipment with the same clarity with which they went in. With digital equipment sometimes the sound will disappear or turn into pops. For recording speech, mics and recorders with a limited dynamic range are quite adequate. But for recording a rock band or symphonic music, every piece of equipment in the system should have a large dynamic range, in the neighborhood of 90 dB.

Another element related to loudness is the **signal-to-noise ratio (S/N).** Most electronic

Figure 7.1

A low-frequency sound has fewer cycles per second than a high-frequency sound.

Figure 7.2

These drawings show three common frequency curves for microphones and other electronic equipment. The curve in drawing (a) is often referred to as a flat curve because the equipment it represents reproduces all frequencies with about the same accuracy. The curve in drawing (b) represents equipment that produces middle frequencies better than it produces high or low frequencies. Drawing (c) represents a mic that best reproduces frequencies in the human speech range.

equipment has inherent **noise** built into it; it comes from the various electronic components, such as those used for amplification. One of the specifications provided for equipment is its signal-to-noise ratio, usually something like 55:1. This means that for every 55 dB of signal recorded 1 dB of noise is present. A ratio of 55:1

is considered good, whereas one as low as 20:1 is considered poor. Generally, more expensive equipment has a higher signal-to-noise ratio. Digital equipment is more sensitive to self-noise because it picks up softer, subtler sounds better than analog equipment.

Timbre

Timbre (sometimes called tonal quality) deals with such characteristics as mellowness, fullness, sharpness, and resonance. It is what distinguishes a violin from a clarinet when both are playing the same pitch at the same loudness. It is also what distinguishes each person's voice.

Harmonics and **overtones** contribute to the production of timbre. A sound has one particular pitch, called a **fundamental,** but it has other pitches that are exact multiples of the fundamental frequency (harmonics) and pitches that may or may not be exact multiples of the frequency (overtones). The way the fundamental combines with its harmonics and overtones is part of what creates timbre.

The room in which something is recorded can also affect timbre. All other things being equal, a voice will sound hollower in a large room than in a small room. Timbre can also vary for different mics. Although two mics may have the same frequency response and dynamic range, one brand may sound mellow while another sounds sharp. Choosing the right mic to enhance a given timbre is mostly a matter of trial and error and experience.

Duration

Another characteristic of sound is **duration,** the length of time that a particular sound lasts. Duration has four parts: attack, decay, sustain, and release. **Attack** is the amount of time it takes a sound to get from silence up to full volume; **decay** is the time it takes sound to go from full volume to a sustained level; **sustain** is the amount of time sound holds its volume; and **release** is the amount of time it takes sound to go from sustained volume to silence. These four together add up to duration.

Clipped speech that occurs in certain dialects is largely the result of duration differences between that dialect and what we consider standard American speech. Much of the difference between the sound of a violin when it is plucked and when it is bowed is due to changes in duration. A note played in staccato on the piano has a shorter duration than one played while pushing the sustain pedal.

Velocity

Velocity refers to the speed of sound. This speed is 750 miles per hour, but it is relatively slow. It is certainly much slower than the speed of light, as anyone who has experienced thunder and lightning can attest.

This relatively slow speed can cause **phase** problems. If two microphones pick up the same sound at slightly different times, they can create a signal that is out of phase; one of the mics is receiving the sound when the wave is going up, and the other is receiving the sound when the wave is going down. The result is that some or all of the sound is canceled, and little or nothing is heard.

One way to avoid the phase problem is to follow the **three-to-one rule.** No two microphones should be closer together than 3 times the distance between them and the subject. In other words, if one mic is 6 inches from a person, the second mic must be at least 18 inches from the first mic. In this way the mics will pick up very little of each other's sound. Another way to avoid phase problems is to place the mics head to head so that they receive the sound at exactly the same time (see Figure 7.3).[2]

Phase problems can also occur when only one mic is used. If that mic is placed in the middle of a room that has perfectly parallel walls, the sound will bounce in such a way that some sound waves cancel each other out. This can be avoided by placing the mic so that it is at an angle to the walls and is not equidistant from the walls. One way to do this is to place the mic on a diagonal of the room, slightly off center (see Figure 7.4).

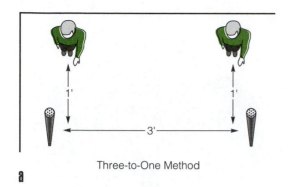

Three-to-One Method

a

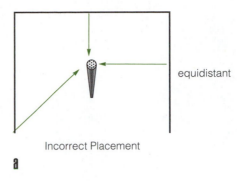

equidistant

Incorrect Placement

a

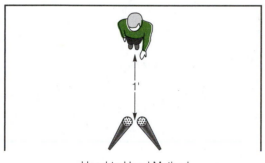

Head-to-Head Method

b

One Example
of Correct Placement

b

Figure 7.3

The two main methods of preventing multiple microphone interference. The three-to-one method (a) shows how to place the mics so that they are at least three times as far apart from each other as they are from the subject. The head-to-head method (b) shows the placement of mics facing each other.

Figure 7.4

This placement of the microphone (a) is likely to cause phase problems because the mic is parallel to the walls and the same distance from all of them. Position (b) would be preferable because the mic is at an angle and slightly closer to one wall than to the other.

Microphones

In addition to differing in frequency response, dynamic range, and timbre-producing qualities, microphones have particular characteristics that relate to their directionality, construction, and positioning.[3]

Directionality

Directionality in a microphone involves its **pickup pattern.** The main pickup patterns likely to be used in moviemaking are **cardioid** (picking up mainly from one side in a heart-shaped pattern) and **omnidirectional** (picking up from all sides).

If only one or two people are speaking and background noise is not desirable, a cardioid mic is appropriate. These mics are the work-horses in film because their pattern picks up sound from the front, where the talent is located, and not from the rear, where the camera and other equipment are operating.

Omnidirectional mics are best for picking up a large number of people and are excellent for gathering background noise. Because of their broad pickup pattern, they do not pick up distant sounds well. Usually, an omnidirectional mic must be closer to talent than a cardioid mic to achieve the same volume as the cardioid.

Sometimes sound for a movie must be picked up from a great distance to keep the mic out of the picture. In these circumstances, more extreme cardioid mics, referred to as **supercardioid, hypercardioid,** and **ultracardioid,** are used. Their patterns are longer and narrower than those of the regular cardioid (see Figure 7.5).

Stereo recording requires at least two microphones or specially designed stereo mics that

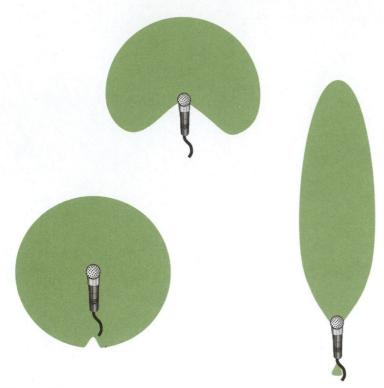

Figure 7.5

The most common pickup patterns are cardioid (top), omnidirectional (bottom left), and supercardioid (bottom right). (Artwork by Michael Swank)

M-S method

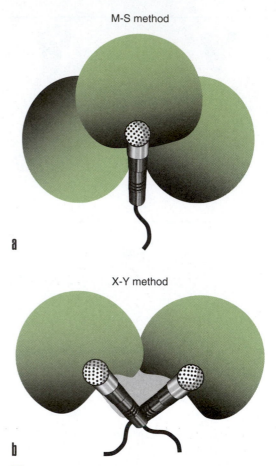

a

X-Y method

b

Figure 7.6

Two methods used for stereo recording. The M-S method (a) uses a bidirectional and a supercardioid mic. The X-Y method (b) uses two cardioid mics. (Artwork by Michael Swank)

have several different pickup elements within them. One approach to stereo recording is called **M-S (midside) miking.** This uses **bidirectional** (picking up from two sides) and supercardioid microphones. The bidirectional mic picks up sound to the left and the right, and the supercardioid mic picks up sound to the front (see Figure 7.6a). The output of both mics is fed through a complicated circuit that makes use of their phase differences to produce left and right channels. This setup gives a strong center sound, which is compatible with monaural. In fact, sometimes a switch on an M-S stereo mic will disengage the bidirectional element so that the mic can be used to record monaural sound.

Another method of stereo recording is called **X-Y miking.** Two cardioid (or omni) mics are placed next to each other. One angles to the left at a 45 degree angle, and the other angles to the right at 45 degrees (see Figure 7.6b). This way, both mics pick up sound from the center, and sounds for each side are picked up primarily by one mic or the other. When the recording is played back through stereo speakers, it yields definite left and right channels, but the center

sound is not as strong as with the M-S method. With both the M-S and X-Y methods, you can use two mics (which come packaged in kits), or you can use one mic with stereo elements (see Figure 7.7).[4]

Surround sound, which can encompass up to 360 degrees, is usually recorded with a number of cardioid and/or supercardioid mics, each pointed at a different spot around the circumference of the circle. However, there also are single unit surround sound mics (see Figure 7.8).[5]

Most microphones have a set pickup pattern, often written on the mic or the box it comes in; it is not easy to discern the mic's pickup pattern simply by looking at it. Some microphones have interchangeable elements so that the mic can be changed from one form to another: for example, from cardioid to omnidirectional. In other instances, mics have a switch to change direc-

Shure Brothers, Inc.

AKG Acoustics, U.S.

a

b

Figure 7.7

Microphones for stereo recording. Photo (a) shows how two cardioid mics might be set up on one stand to record both left and right channels. Photo (b) is an AKG C522 stereo microphone that contains the elements necessary for X-Y miking. (Photo (a) courtesy of Shure Brothers, Inc.; photo (b) courtesy of AKG Acoustics, U.S.)

tionality, perhaps from cardioid to supercardioid. A more complicated variation is the **zoom mic.** It can be changed gradually from cardioid to ultracardioid so that sounds at different distances can be heard clearly.

Construction

The two main types of microphones used for electronic moviemaking, based on their construction, are dynamic and condenser.

A **dynamic mic** uses a **diaphragm**, magnet, and coils of wire wrapped around a magnet (see Figure 7.9a) to generate sound signals. The diaphragm moves in response to the pressure of sound and creates a disturbance in the magnetic field that induces a small electrical current in the coils of wire.

A **condenser mic** (Figure 7.9b) has a diaphragm plus an electronic component called a **capacitor** that responds to sound. A diaphragm moving in response to sound waves changes the capacitance in a backplate, which then creates a small electrical charge. Because charging the backplate requires a power supply, many condenser mics have batteries or some other external power source. Other mics, called **electret condenser mics,** have permanently charged backplates.

Dynamic mics and condenser mics are fairly rugged and have wide frequency responses. However, the dynamic mic is slightly more rugged because its sound element is sturdier than that in a condenser mic. The condenser mic, on the other hand, has slightly better high-frequency response. Dynamic microphones do

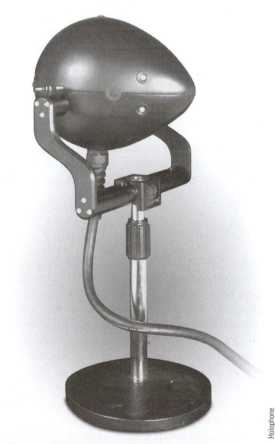

Holophone

Figure 7.8

A surround sound microphone system called the Holophone. (Photo courtesy of Holophone)

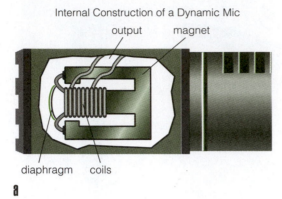

Internal Construction of a Dynamic Mic

output　　magnet

diaphragm　coils

a

Internal Construction of a Condenser Mic

output　　backplate

diaphragm

b

Figure 7.9

The construction of the two most common types of microphones, the dynamic mic (a) and the condenser mic (b).

Figure 7.10

A fishpole in its collapsed (unextended) position. (Photo courtesy of Beyer Dynamics)

not work well with some individuals because the mics have a tendency to exaggerate plosives and sibilance. In other words, *p*'s will pop and *s*'s will **hiss.**[6]

Positioning

You can use many devices to position mics. The most common in moviemaking is the **boom**, a long pole with the mic on the end of it. The boom operator positions the mic above the actors and moves it as each person speaks. Sometimes these booms are elaborate devices with wheels, gears, and hydraulic lifts. Sometimes they consist of a pole (called a **fishpole**) held by the boom operator (see Figure 7.10). Often they have a **shock mount** on the end to isolate the mic from vibrations.

Stands can also hold mics, but because these stands will show in the picture, they are appropriate only when a mic would naturally be present—a singer in front of a **floor stand** or a

radio commentator sitting by a **table stand.** Sometimes people simply hold microphones. This is common for news and documentaries, but for dramas such an obvious show of the mic must be motivated.

You can also hide microphones on the set in or behind props such as flower vases and figurines. You must plant mics carefully, in part so they won't show and in part so their pickup is adequate. **Hidden mics** (also called plant mics) are not desirable if people in the scene move a great deal because their voices will fade in and out as they move close to and away from the mics. But they are useful if you need several areas miked and you only have one boom operator.

Mics can also be built into cameras or tape recorders, but **camera mics** are not advisable for moviemaking because they are usually too far from the actors to pick up their sound well.

Figure 7.11

A lavaliere microphone is often attached to a tie, and its power supply is worn on a belt. (Photo courtesy of Audio-Technica)

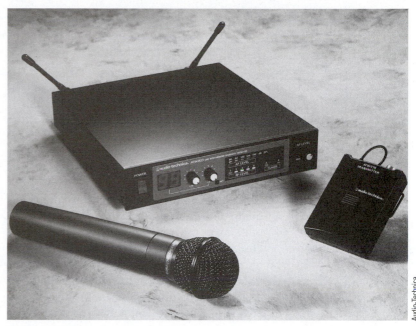

Figure 7.12

This photo shows a wireless microphone with its transmitter pack (right) and receiver. (Photo courtesy of Audio-Technica)

What they do pick up well is the noise of the equipment, which is definitely undesirable in a narrative movie. Mics mounted on cameras can prove satisfactory for news and documentary work, however. For example, a mic mounted on a camera is often best for an uncontrolled situation in which people are not willing or able to take the time to talk into a properly setup microphone.

Very small microphones called **lavalieres** (see Figure 7.11) attach to clothing or hide in small areas such as car visors. Although lavs show in the picture, they usually will not be noticed because they are so small. If they are attached to a cable, they may limit the actor's movement. Although you can hide the cable under clothes, it is likely to show in a long shot that includes the set. The sound from a lav may be inadequate when clothes rustle and when people turn their heads to one side or the other.

Some microphones—be they lavaliere or stand mics—do not have long cables. They are called **wireless mics,** and they operate on FM frequencies. The mic has a small antenna attached to it or to a transmitter pack that can be hidden in a pocket or clipped on a belt (see Figure 7.12). This pack sends the audio signal to a receiver that can be located a considerable distance from the mic and attached to recording equipment such as a DAT. Because the mics do

Figure 7.13

A microphone case, a windscreen, a shotgun mic, and a shock mount. (Photo courtesy of Shure Brothers, Inc.)

not have cables, the actors can move about freely and quickly (often with a miniature lav totally out of sight under a costume), and cables do not need to be hidden on the set.

Another way to pick up distant sound for a movie is to use a **shotgun mic** (see Figure 7.13). This mic has a very long but narrow pickup

pattern, usually super-, hyper-, or ultracardioid. It can pick up from a distance, but it must be pointed carefully and repointed if the sound source moves because of its narrow pickup. Unfortunately, this narrow area can include sounds reflected from an object, such as a building. Shotgun mics have been known to pick up the noise of a trash truck not in the immediate area; the sound had bounced off a building in the background that was in the microphone's path. A shotgun mic also tends to pick up some sounds to its rear, so its rear portion should be pointed toward something that is silent. Shotgun mics are almost always covered with a **windscreen,** a metal or foam cover that cuts down on small noises such as wind. Other mics often have built-in or added on windscreens, especially if the recording is being made outdoors.[7]

Cables and Connectors

Most microphones (wireless excluded) use cables and connectors to carry the electrical impulses from the mic to other equipment. These are actually the elements most likely to prove troublesome during recording sessions. Connectors that are not soldered properly and cables that contain broken wires are common causes of audio failure.

Balanced and Unbalanced Cables

Cables consist of wires protected by a shielding, usually made of plastic. These cables are referred to as **balanced** or **unbalanced.** A balanced cable has three wires—one for the positive, one for the negative, and one for ground. Unbalanced cable has two wires, one for the positive and one that acts as both the negative and the ground.

Balanced cables are better because a separate ground wire means they are less susceptible to extraneous interference. Unbalanced lines are usually used for consumer-grade equipment because they are cheaper, but professional equipment uses balanced lines. Always take care to avoid placing audio cables (balanced or unbalanced) parallel to power cables because this can induce hum.

Both analog and digital can use the same cables, but digital signals are less likely to travel well in low-quality, inexpensive wires, such as ones that mix aluminum and copper rather than being comprised primarily of copper. Because digital mics pick up subtle sounds, digital technology needs high-quality cables to carry the sounds.[8]

Connector Types

A variety of connectors attach mics to mixers and recorders, and recorders to headphones. A **phone plug** is a long, slender connector with a sleeve and tip, and the **miniphone plug** is a smaller version of the phone plug. The **RCA connector** (also called the **phono plug**) has a short prong and outer covering. The **XLR connector** has three prongs and an outer covering. It also has a guide pin and lock so that it remains firmly in place. For many years it has been the professional standard because its three prongs accommodate the three wires of a balanced line. The **BNC connector** is a twist lock that has been used for video and is now starting to be used for audio. All of these connectors have male plugs and female jacks (see Figure 7.14). Usually, the male connector is at the end of the mic cable and plugs into the female connector built into the recorder.

Phone and miniphone connectors can be either **monaural (mono)** or **stereo** (see Figure 7.15). Monaural versions have one ring, and stereo versions have two. RCA, XLR, and BNC connectors are always monaural. If you want stereo, you need two connectors, one to the left channel and one to the right channel. The BNC connector is used for digital signals but not for analog. XLR and RCA have also been adopted by the digital world, but phone and miniphone remain analog.

Other connectors are available, but they are not common. Sometimes manufacturers make unusual connectors, hoping people will buy only their brand of equipment. This policy usu-

Phone Plug sleeve tip

Microphone Plug sleeve tip

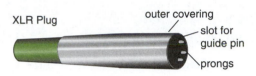

XLR Plug

outer covering
slot for
guide pin
prongs

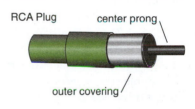

RCA Plug center prong

outer covering

BNC Plug

twist lock

Figure 7.14
Commonly used audio connectors.

ally backfires, especially in the professional world where different situations call for different mics. A variety of digital connectors have been developed, but this technology is still evolving and no definite standards have arisen.

Adapters are available to convert the more common connectors from one form to another. For example, an adapter fitted on the end of an RCA plug can change it to a miniphone. This adapter consists of a female RCA jack and a male miniphone plug. Most production facilities have a variety of these adapters on hand because the connectors needed usually change as microphones and recorders are changed.

In general, professional high-quality equipment uses balanced lines and XLR connectors. When cost is a factor, the combination is likely to be unbalanced lines and miniphone connectors.

Recorders

Sound travels electronically from a microphone through cable and connectors to recording equipment. In recent years many new types of recording equipment have become available, mainly because of the advent of digital recording.

Sound for movies used to be recorded only in analog fashion, either on the same videotape used for recording the picture or on a separate reel-to-reel audiotape. Analog audio, like its video counterpart (see Chapter 3), produces a continuously variable electrical signal with a shape defined by the sound wave it represents. Each time the analog signal is rerecorded or processed, it is subject to degradation because the signal changes shape slightly. Digital recording converts the audio information into an electrical signal composed of a series of on and off pulses. These do not degrade when they are rerecorded, so sound kept in digital form can be dubbed numerous times without losing quality. Digital audio also has a clearer, sharper quality than analog sound. Some sound technicians feel that digital sound is overly sharp and prefer to continue to work in analog because of its slightly more mellow quality.

Figure 7.15
The connector at the bottom is stereo, as distinguished by its two rings. The connector at the top is mono.

When planning sound recording, the director and sound mixer must take into account the concept of single system versus double system. Then they can select the exact equipment they want to use for the recording. The sound recordist must have a thorough understanding

of how the equipment actually records the sound to ensure that the type of recording will be compatible with the equipment used for editing. The person recording the audio should also be very familiar with the features of the particular piece of sound recording equipment to maximize the sound quality and to operate the equipment efficiently during the production process.

Double System and Single System Sound Recording

Double system sound records the picture on one piece of equipment and the sound on another. **Single system** sound records both within the same piece of equipment.

Double system sound recording has its roots in film production, which has traditionally recorded sound on an **audiotape recorder,** totally separate from the film. One reason film has traditionally used double system recording has to do with editing—film was physically cut when edited. This meant the sound for each frame had to be adjacent to it if the cut were to be made properly. But placing the sound at the same point as its accompanying picture was impossible because taking a picture is an intermittent process. The film stops in the camera momentarily to be exposed. If sound were recorded intermittently, it would be unacceptable. As a result, if sound was recorded in a film camera (and sometimes it was back when news was recorded using film), the sound recording equipment was usually placed ahead of the picture by about one second. In this way the film was running at a more uniform pace by the time the sound was recorded. However, this made for difficult physical editing. If the editor made the edit at the appropriate point for the picture, some of the sound needed was lost. If the editor made the edit to accommodate the sound, too much picture showed. The solution was to record sound and picture separately and then match them at a later time.

Single system sound became the norm in early video production because from the very

beginning videotape recorders were made to capture both sound and image. The audio and video **heads** of a VCR cannot be at the same place either, but because video editing involves electronic manipulation rather than physical cutting, the sound and picture can be kept together. Most material shot on film today is not physically cut. It is transferred to video and edited electronically. However, the trend in recording sound, whether with a film camera or a video camera, is to record double system. This seeming contradiction comes because double system recording allows for greater control than single system recording. A person operating a camcorder is preoccupied with framing a proper picture and usually cannot, or does not, pay proper attention to what is being recorded aurally. If the sound is recorded on a separate piece of equipment, one crew member can give the sound full attention—even to the extent of closing his or her eyes while the recording is taking place to concentrate totally on listening for sound problems or imperfections. In addition, separate audio recorders often yield higher-quality sound than the sound track on a video recorder.

Of course, when the dialogue and picture are recorded separately, they will need to be put in **sync** at some time in the future. With single system film or video this is no problem because the two ride together. When double system was first used in film, a cable connected the film camera to the audiotape recorder and sent a pulse to the tape recorder as each frame passed through the film camera. In effect, this created electronic **sprocket holes** on the audiotape. Another method of maintaining film–sound sync was to equip both the camera and tape recorder with a special **crystal** sync control unit that governed the speed of both units so accurately that sync problems did not occur. Both these methods required the use of a **slate** with a clapper on the top (see Figure 3.14 in the camera chapter). The closing of the clapper was filmed, and the sound of the clapper closing was recorded on tape. In editing, the two were matched and from there on the sound would be in sync with the picture for that particular shot.

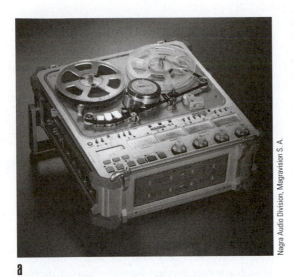
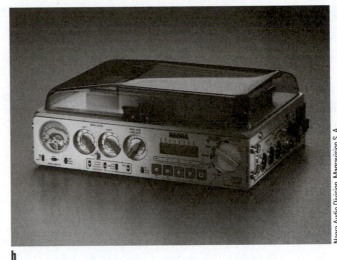

Figure 7.16

A four-channel Nagra-D digital audio recorder (a) and a Nagra recorder that records onto a hard drive (b). (Screen shots courtesy of Nagra Audio Division, Magravision S.A.)

Video equipment did not incorporate these cable or crystal methods and at first used only single system recording. When **time code** was made available, it became possible to record the time code frame numbers on the videotape, the slate, and the audiotape simultaneously. A little later, magnetic stripes were added to film stocks, and time code numbers could also be recorded next to the frames of film. In other words, a signal that will translate to 2 minutes, 5 seconds, and 15 frames (00:02:05:15) can be recorded on the audiotape at exactly the same time it is recorded on the videotape or film. During editing, the time code numbers are lined up, and the material is kept in sync. Time code is the primary method used today for keeping double system material in sync whether the picture is recorded on film or on video.[9]

Types of Recorders

For many years sound for film was recorded on a separate reel-to-reel analog tape recorder. The brand name that became synonymous with film audio recording was Nagra. This company's recorder was sturdy and contained the features most needed for recording good film dialogue. Nagra now manufactures digital recorders that use reel-to-reel tape and operate very much like the analog Nagra. Nagra and other companies

also make machines that record on a hard drive (see Figure 7.16). These recorders have many of the features of older recorders, but they do not use tape. Sometimes the hard drive can be removed from the recorder and placed in a nonlinear editing system so that the sound can be transferred directly.

Another recorder that is now often used to record film sound is the **digital audiotape (DAT)** recorder. This is much smaller than the Nagra and uses cassette tape. It is not as rugged as a Nagra, but it is more portable and less expensive. Some of the least expensive DAT machines are not capable of recording time code, but they hold sync fairly well without time code. Professionals do not use the DATs without time code, but students may use these less expensive DAT recorders and a clapper and slate, in the same way it has been used traditionally in film production, to establish the beginning of picture and sound recording. If the shot is not too long, the sync will usually hold through the editing process.

Any time you are using a tape recorder (whether reel-to-reel or cassette), buy high-quality tape. Tapes are plastic bases coated with metal oxide, and some of the oxide may fall off on cheaper tapes, creating **dropouts,** a loss of signal because there is no oxide to record it or because the oxide dropped off after the recording was made.

Figure 7.17

The needle on the left VU meter is riding in the mud. The needle on the right VU meter is peaking in the red.

Anyone recording audio should know how the particular machine is recording and should make a careful list of what methods (sampling rate, bit depth, mono or stereo) were used so that the production sound can be matched within an editing system.[10]

Recording Methods

Camcorder formats and audio recorders have different ways of placing sound on the recording medium (videotape, audiotape, hard drive). Some editing systems do not recognize all the recording methods in existence and may not be able to play back the sound properly. You may record beautiful sound but later find it difficult to edit.

Two things to note in digital recording are **sampling rate** and **bit depth.** Sampling rate is how many times per second the information is converted into the 0s and 1s of digital technology. The two most common sampling rates are 44.1 kHz (44,100 times per second) and 48 kHz (48,000 times per second), although some recordings are now made at 96 kHz. 48 kHz is the standard for DVD and HDTV, and 44.1 is the standard for CDs. Bit depth is a quality of sound that is related to signal-to-noise ratio. The higher the number of bits, the higher the signal-to-noise ratio and the better the quality of the sound. Each bit yields approximately 6 decibels of signal; so in 12 bit audio, the signal is 72 dB louder than the noise. The bit depths used most often are 12 bit, 16 bit, and 24 bit. Sometimes a recording system will use 12 bit for stereo and 16 bit for monaural.

On many recorders, sound can be recorded on different channels, which are different places on the tape or disk. This capability can give you additional control when you are recording. For example, you can record two people at opposite ends of a room by recording one person's mic on one channel and the other person's mic on another channel. This method permits you to adjust each person's volume separately, or the two channels can be used for the left and right channels of stereo.

Features of Sound Recorders

The video recorders and the audio recorders used for moviemaking have the same function controls as most recorders—play, record, stop, pause, fast forward, rewind. Some tape recorders allow you to hear the sound as it is rewinding or fast forwarding so that you can cue it easily.

Audio and video recorders usually have two types of inputs—mic and line. **Mic inputs** are for microphones, and **line inputs** are for other equipment, such as tape recorders and CD players. The difference between mic and line inputs is the amount of **amplification** that the signal is given. Tape recorders and similar equipment usually have some means of amplifying the audio signal. Microphones do not, so they need the extra amplification provided by the tape recorder. Therefore, you should always make sure the mic is plugged into a mic input, not into a line input. If you make a mistake, the sound will not record at a level high enough to be useful.

High-quality tape recorders have a **VU (volume unit) meter,** a device that shows how loudly the sound is being recorded. Sometimes this is an actual scale that has a red area at one end where the needle indicating the volume level should not linger. In other cases, the VU meter is a bar of flashing diodes that change color from green to red when the signal is too high. In either case, **peaking in the red** (also called **overmodulation**) is undesirable. As already mentioned, for analog the signal will be distorted and for digital it may pop. On the other hand, sound that regularly rides at the low end of the meter (**riding in the mud**) will not be loud enough. See Figure 7.17 for examples. Ideally, audio should ride between 20 and 100 percent on the VU meter.

Another feature often found on higher-end recorders is **equalization.** This function enables you to cut out or emphasize certain frequencies, such as treble or bass. Sometimes unwanted noises in the high frequencies, such as whining from equipment, can be filtered out through equalization so that they are not recorded. Of course, anything else at that frequency range will be filtered out too. You definitely should not use equalization to get rid of frequencies in the voice area when you are recording dialogue.

Some recorders have **automatic gain controls (AGCs).** When this control is on, the gain is automatically adjusted so that the recording is neither too soft nor too loud. If the control is not on, an operator must adjust the volume control manually to change the degree of loudness.

The counter on a tape recorder can be valuable for finding your place. Most counters display the minutes and seconds into the recording and can be reset to zero so that new counting can begin whenever you want. Some have an option that allows you to see the time remaining on a tape or disk. Digital recorders often allow you to give different recordings names (for example, fire take 1, motorcycle take 4). These names are visible in a little window on the recorder and can be cycled so that it is easy to access the one you want.

A connection for earphones, a headset, or a speaker is also necessary. The only way you can really tell whether you are recording the sound properly is by listening to it as it is being recorded or afterward.

Some recorders, especially camcorders, have very little in the way of audio recording features. Not only do they not have features such as equalization, but they don't even have a meter, making it difficult to know if sound levels are set properly. Before using (or preferably before purchasing) a video system for moviemaking, consider carefully the audio features available. Many users (and salespeople) become so enamored with the video features of a recording system that they forget about audio and end up with something that is unacceptable and difficult to edit.[11]

Figure 7.18
A portable audio mixer. (Photo courtesy of Soundcraft USA)

Audio Mixers

Audio **mixers** are not absolutely essential in a production shoot. When they are used, they are between the microphones and the recorders. Sound from microphones is routed into a mixer where the volume can be adjusted and sound can be altered in other ways (for example, it can be equalized) before it is sent on to the recorder. If there is only one microphone being directed into a high-quality sound recorder, there is no overriding need for the sound to go through a mixer. In fact, the mixer can get in the way of other production equipment. But if there are several microphones, or if the sound is only being recorded on videotape that is in the camera, or if the audio is complicated and the person recording it wants optimum control, then a mixer can be valuable. Many companies make portable mixers (see Figure 7.18), and most of them contain the same features discussed for sound recorders.

a a c d

Figure 7.19

To coil cable using the over-under method, make a natural loop for the first coil (a). Then twist the cable for the second loop (b) and place it next to the first loop (c). The third coil is a natural loop (d), the fourth is a twisted loop, and so on until the cable is neatly coiled.

Care of Audio Equipment

Although most audio equipment is manufactured to hold up under fairly rugged recording conditions, it should be treated as gently as possible. Microphones should always be carried in their cases, most of which are foam lined. Carrying mics in their cases also helps prevent the loss of accessories such as clips and batteries. You should never blow into a microphone to test it; such puffs of air can damage the sound element. Always telescope mic stands, such as a fishpole, down to their smallest size for carrying. If they have cases, use them for carrying and storing.

Never pull cables out of their sockets by tugging on the wire; remove the connector gently with your hand. Some connectors require that you push a lever to release them. Always do so; don't just yank. Be sure to coil the cable properly. One way, called the **over-under method,** involves making repeated circles with the cable (see Figure 7.19). Another way is to lay the cable on the floor in a figure 8 and then double the top half of the 8 over the bottom half. Then put tape or specially made cable holders over the wire so that it stays in place. Treat cable gently because the small wires inside the cable break easily. The breaks are difficult to find and difficult to repair. Also, cable that is not coiled becomes snarled, and the next time you try to use it you will find yourself spending precious time untangling it.

Handle recorders carefully so that their internal electronics do not become damaged. Clean video heads and audio heads frequently with special head cleaners. It doesn't take much time to treat audio equipment properly, but malfunctioning audio equipment can waste enormous amounts of time during the production process.

Notes

1. For several other approaches to the nature of sound, see Stanley R. Alten, *Audio in Media* (Belmont, CA: Wadsworth, 2001); Michael Talbot-Smith, *The Audio Engineer's Reference Book* (Woburn, MA: Focal Press, 1998); "The Difference Between What You Hear and What You 'Hear,'" *TV Technology,* 9 February 2000, p. 30; and "The World Above 20k," *Mix,* May 2002, pp. 26–28.

2. Another method for minimizing phase problems is referred to as the 8 and 8 method. The mics should be placed either closer together than 8 inches or farther apart than 8 feet.

3. A good way to study microphone characteristics is to look over the specifications provided by manufacturers. These are readily available on the Web sites of four major microphone manufacturers: www.sennheiser.com; www.electrovoice.com; www.shure.com; and www.audiotechnica.com. See also "You Can Never Have Enough Mics," *Mix,* August 2002, pp. 38–40.

4. There actually are several types of X-Y miking, all using two microphones. Sometimes the mic heads are overlapped, with the one on the left pointing right and the one of the right pointing left. In this way the sound hits each mic at the same time. Sometimes the mics both point forward, but they are spaced apart. See "Two Ears, Two Mics: Stereo Micing for TV," *TV Technology,* 24 March 1999, p. 58.

5. "A Look at Surround Microphone Techniques," *TV Technology,* 27 June 2001, p. 36.

6. "Microphone Basics," *TV Technology,* 12 July 2000, p. 44.

7. "From Mini to Shotgun, Mics Take Many Forms," *TV Technology,* 26 March 2001, p. 90; and "Tricks of the Trade," *Mix,* April 2000, p. 170.

8. "The Right Connection," *Mix,* October 2000, p. 92.

9. Timothy Liebe, "Double-System Sound, A Shooting Secret You Can Share," *Video,* February 1995, p. 24.

10. You should always read the manual for any recording system thoroughly. Not only will it instruct you in the basic operation of the equipment, but it will provide recording methods and give technical information you may need to pass on to others.

11. For more about the recording process, see Francis Rumsey and Tim McCormick, *Sound the Recording* (Woburn, MA: Focal Press, 1997); Bruce Mamer, *Film Production Technique* (Belmont, CA: Wadsworth, 1996); "Crime Scene Audio," *Mix,* September 2002, pp. 74–78; and John Watkinson, *The Art of Sound Reproduction* (Woburn, MA: Focal Press, 1998).

chapter eight
Approaches to Sound Recording

Sound in a finished movie is extremely important for conveying information and establishing mood. Therefore, anyone recording sound should keep in mind how it will be used in the service of the story during the editing process. It is the sound designer's job to determine the nuances of sound (see Chapter 1), but everyone involved with the recording process should keep the overall purpose of the sound uppermost in their minds.

Today's movie fans go to theaters with surround sound and expect dramatic, high-quality sound. In addition, more and more people are including high-quality audio systems as part of their home television-viewing environment. Moviemakers must take great care when recording sound, because movie theater and home speakers pick up even minor sound discrepancies. In previous eras, when speakers were smaller and less sensitive, listeners could barely perceive such problems as a change in background noise, but now they can hear just about any audio aberration.

Elements of Microphone Pickup

Central to all sound recording is the microphone. How it picks up the sound determines the quality and utility of the sound. Some elements of microphone placement are common to all recording, be it dialogue, narration, music, sound effects, or background noises. These elements include the need for presence, perspective, balance, and continuity.

Presence

Sound **presence** refers to the reality of the sound. It must appear to be coming from the picture. This means that it must have the quality people expect when they are in a location similar to that shown on the screen. For example, sound in a gymnasium will be very different from sound in a living room with thick carpets and heavy drapes; sound recorded to accompany a gymnasium scene should have the echo characteristics people expect of that environment.

One of the main elements of sound presence is how *live* or *dead* the room sounds. A gymnasium is quite live (bouncy), and a living room with carpets and drapes is dead (absorbing). One reason is the size; all else being equal, large rooms are more live than small rooms. But an even more important difference involves the surfaces in the room. Hard surfaces such as wood and concrete create live sound, and soft surfaces such as carpets and drapes deaden sound. Hard surfaces tend to bounce the sound from side to side, whereas soft surfaces absorb it. In other words, live sound has a great deal of **echo** and **reverberation,** and dead sound does not.

Echo and reverberation have slightly different technical definitions, but they create the same kind of effect. With echo the sound bounces once, and with reverberation it bounces a number of times. Sound that does not bounce is usually referred to as **direct sound,** which is generally dead. (Figure 8.1 depicts echo, reverberation, and direct sound.) Neither live locations nor dead locations are wrong. The amount of deadness or liveness required depends on the type of presence you are trying to create. But sound with a high degree of echo or reverberation often sounds muddled. In particular, the high frequencies tend to blend into each other and become indistinguishable.

For that reason sound technicians often try to deaden a room so that the sound can be understood. Dead sound can be enlivened with echo and reverb during the editing process, but it is very difficult to remove echo and reverb during postproduction. The easiest ways to deaden sound are to hang blankets slightly in front of the walls, place carpet on the floor, put drapes over windows, and place cloths over hard tables. Moving the mic closer to the subject also makes for deader sound, whereas moving the mic farther away has the opposite effect. Removing carpets, drapes, and other cloth can enliven the sound.[1]

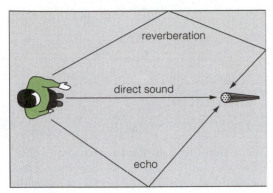

Figure 8.1

Direct sound goes to the source without bouncing off any surfaces, echo bounces off one surface, and reverberation bounces off two or more surfaces.

Of course, most of this must be done in relation to the picture. Closed drapes that show in the picture probably are not a problem because the drapes will also make the presence of the sound match that of the picture. But blankets hung in front of walls would look strange. Sometimes sound technicians need to make compromises in the perception of the deadness or liveness of the scene so that the sound can be adequately understood. In general, though, the audience will perceive a setting with many hard surfaces as producing live presence and a setting with soft surfaces as dead.

Perspective

Sound **perspective** is related to distance. Generally, the voice of a person in the distance should sound different from the voice of that person when shown in a close-up. In this way the viewers will feel closer to or farther from the person, reinforcing what they see on the screen. Similarly, the sound of a bell ringing in the distance should be different from the sound of a bell ringing in the foreground.

The easiest way to achieve proper perspective is to move a boom mic farther from the person or object for a long shot than for a tight shot. This usually needs to be done anyway to produce a proper picture because a mic close to the talent will show up in a long shot. Achieving proper perspective is more difficult, if not impossible, with a lavaliere (lav) or table mic. The lav mic is attached to the person and moves as he or she does. A person wearing a wireless lav mic is never going to sound farther away. A table mic must look like it is in front of the person, so it too is essentially unmovable.

Mics hidden in the scenery can provide perspective if the picture relates to where the mic is placed. In these cases, the person moves away from the mic rather than the mic moving away from the person. However, if the camera follows a person with a close-up as that person is moving away from the hidden mic, the perspective will be wrong. The camera should show a medium or long shot as the person is walking away from the mic.

Sometimes, because of the needs of the picture, it is impossible to record the sound in proper perspective. In these instances, the sound is recorded as best it can be so it can serve as a **scratch track** when it is rerecorded in a studio environment (see ADR section later in the chapter).

Balance

Balance refers to the relative volume of sounds. Important sounds should be louder than unimportant sounds. The human ear can listen to sounds selectively, but the microphone cannot. You can be talking to a friend in a noisy area, yet you hear your friend over the other noises because you concentrate on doing so. If you record your friend with a microphone, you will not be able to pick out his or her voice nearly as well as you can in person. Try placing a microphone in the middle of a table when several people are having several conversations. When you play back the tape, it will be a garble. Yet, if you are at the table, you can hear one particular conversation.

The need for balance is one reason microphones have been designed with directionality. A cardioid mic can act a little more like the selective ear than can an omnidirectional mic. The best way to achieve proper balance is to record every important element **flat**; that is, try to make the volume of every scene, every person, and every sound effect more or less the same. Then adjust relative volumes in postproduction.

This assumes, however, that you have access to sound postproduction facilities that can mix various sounds and alter them in a variety of ways. If this is not the case, you must take sound balance into account during the recording process. You may, for example, want to have one person appear to have a booming voice, or you

may want the sound of a waterfall to partially drown out a conversation. In those cases, you would record sound that is not totally flat.

Continuity

Continuity of sound refers to sameness from shot to shot. Sound continuity is as necessary as visual continuity. The **script supervisor** (see Chapter 1), who keeps track of continuity of visual elements, should also keep track of continuity of aural elements. If a water spigot is dripping during the man's close-ups, it should also be dripping during the woman's close-ups if you are going to intercut the two shots.

Elements that affect presence and perspective should also maintain continuity. If drapes were hanging over windows for long shots, they should also be there for close-ups, even though they won't be seen in the picture. Removing them will make the room sound more live and create a discrepancy in tone between the long shots and the close-ups.

The script supervisor also should note how far a mic was from a person if shooting is going to stop for the day and the same scene is going to be continued the next day. Knowing this distance is also advantageous when different angles of the same scene are being shot. If the mic is 3 feet from the man during his close-ups and 5 feet from the woman during her close-ups, the shots may not intercut well. To the extent possible, each actor's dialogue should be recorded on a separate track so that, if something needs to be changed, it can be treated separately during postproduction.

Using the same microphone for the same person throughout a production also helps to maintain continuity because the sound will be similar. But sometimes you have to use different mics. For example, you might need a wireless lav for a long shot of a person standing on an overpass and then a boom mic for a close-up of that person. If you are using different mics, the sound person should listen to recordings of the various mics available and select ones that sound fairly similar in terms of frequency response, dynamic range, and timbre characteristics. Keeping track of sound continuity can distinguish a professional production from an amateur one. It is fairly easy to do but is often neglected.

Eliminating Unwanted Noises

When shooting a movie, the recording equipment often will pick up noises that have no relation to the scene being recorded. One is the sound of the equipment itself. Film cameras have motors that can create noise. Placing various devices, such as soft foamy cases called **barneys** and hard cases called **blimps,** over film cameras muffles motor noise. Most of the noise created by video shoots comes from the electronics of such equipment as monitors, cameras, hard drives, and video testing gear. For this reason microphones should be positioned as close to talent and as far away from equipment as possible. This is easy when equipment and talent are naturally far apart, but when they are close, you will have to compromise. One possibility is to move the camera farther from the talent and use a longer lens.

Another disturbing noise is wind. You may not hear the wind with your ears, but it often blows against the microphone sound element, making a low-frequency huffing sound. Placing a **windscreen** on the mic will help to eliminate wind noise (see Figure 8.2). The recording system may also pick up the hum of fluorescent lights. The best solution for this may be to turn off all fluorescent lights.

Recording equipment with mechanisms for **equalization** (see Chapter 7) can sometimes be used to eliminate unwanted sounds at certain frequencies. This is often better done in postproduction when you have more time and control. Most equalizers have one position that cuts out high frequencies and another that eliminates low frequencies. If you are trying to tape birds chirping and the low hum of a motor clutters the audio, you can use the equalizer to cut out the low frequencies. Conversely, the bird chirpings can be cut out when recording the rumble of a train. The problem arises when the sounds you want to record are at about the same frequencies as the sounds you do not want to record. In these cases, and in many others, equalization is not the answer.

A better solution may be to increase the directionality of the mics so that only the desired

sounds are picked up. However, highly directional mics, such as the **ultracardioid,** can pose problems because they lose the signal if the subject moves slightly. In general, the more directional the mic is, the harder it is to control the small area it picks up.

The best time to solve sound problems caused by the surroundings is during the early planning stage (see Chapter 2). If someone checks out the area before recording begins, plans can be made to remove the offending sounds or to choose a different location. During production you can assign someone to keep pedestrians and, if possible, automobiles away from the production area. This minimizes the likelihood of unwanted sounds on the set.

Both the sound engineer and the continuity person should listen carefully for distracting sounds during shooting. If the unwanted sound will hurt the overall effect of the movie, fix the audio problem, and reshoot the shot that had the distracting sound.[2]

The principles of presence, perspective, balance, continuity, and unwanted noise apply to almost all recording. Certain specific approaches apply to particular types of recording such as dialogue, ADR, voice-overs, sound effects, Foley, ambient sounds, and music.

Miking Dialogue

Dialogue is the most important sound element to record properly during production. You can create most other sounds during postproduction if necessary, but rerecording synchronous dialogue after the fact is a difficult, time-consuming task.

Selecting the Mic

The first step in miking is to select the proper microphone according to the directionality, construction, and positioning characteristics (see Chapter 7). The **cardioid** mic is the most commonly used for moviemaking, but an **omnidirectional** mic will pick up broader sound such as that of a crowd scene, and a **supercardioid** mic will pick up narrow sound. Using a supercardioid mic is tricky because it picks up sounds close to the rear of the mic as well as sounds dis-

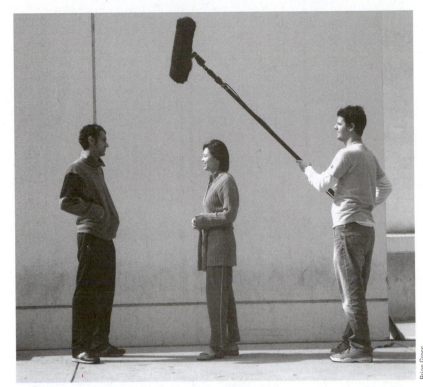

Brian Gross

Figure 8.2

The windscreen on this boom mic will help lessen any rustling noises from this outdoor location. (Photo courtesy of Brian Gross)

tant from the front of the mic. It should not be positioned where loud noises, such as honking horns, are right behind it. Also this type of mic telescopes the sound to the front in much the same way a telephoto lens compresses distance (see Chapter 3). As a result, background noises may rise to an undesirable level.

You can use either a **condenser mic** or a **dynamic mic.** The condenser gives slightly better fidelity, and the dynamic mic scores slightly higher on ruggedness. But the type of mic you use may depend on the individual person's voice (or "sweet spot"). The **fishpole** is the device most used for mic positioning, mainly because it can handle changes in perspective well. However, stand mics might fit naturally into the scene, and **hidden** or **lavaliere** mics solve the problem of the boom showing. **Wireless mics** are appropriate if a person is going to move a great deal, and **shotgun mics** are useful when sound must be picked up from afar. On-camera mics usually do not pick up dialogue very well, but sometimes they are all that is available.

For optimum pickup of voice frequencies, select a mic with a **speech bump.** To emphasize a particular male voice, choose a mic that creates

Figure 8.3

Proper placement of a mic on a fishpole.

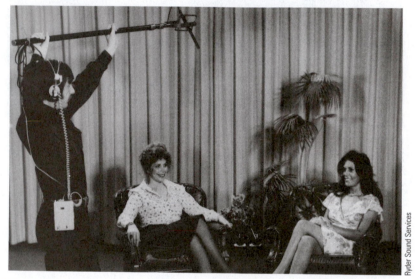

Figure 8.4

If a long shot and close-up are being recorded at the same time, keeping the boom out of the long shot may require holding it farther away. (Photo courtesy of Ryder Sound Services)

a **proximity effect.** Check out the difference in timbre created by various brands of mics.

Sometimes you may want to use two different microphones to record the same sound. For example, using a boom and a lav, record the boom on channel 1 and the lav on channel 2. Then decide later which sound you want to use. Although miking this way allows for postproduction flexibility, it usually slows production because of the extra time required to set and operate the two mics.

Setting Up the Mics

Ideally, a mic on a fishpole should be positioned above a person's head, pointed toward the mouth (see Figure 8.3). It should be rotated as the person moves so that it always points at the mouth. The best distance for a cardioid is 1 to 4 feet in front of the mouth and 1 to 3 feet above it; an omni should be slightly closer. However, the boom or fishpole should not show in the picture nor should its shadow.

Accomplishing all this often requires compromises. Some directors like to use two cameras at once, shooting both long shots and close-ups at the same time. This can make for a difficult situation. The camera operator may have to cheat a little on the height of the long shot, or the cinematographer may have to change the lighting slightly to get rid of the boom shadow, or the audio person may have to move the mic slightly away from its optimal position (see Figure 8.4).[3] If the mic position must be changed, the sound crew should experiment by placing the mic in various sites and then selecting the one that sounds best. Sometimes this position may be rather unorthodox, such as close to the floor pointing up. Some boom operators place a strip of white tape on the tip of the mic windscreen so the camera operator can readily see the mic if it dips into the shot.

Position hidden mics with care. They should not be in, on, or near something that will be moved during shooting. A lav should be attached 8 to 10 inches from the mouth but not where it is likely to pick up the sound of rustling clothes. You also need to be careful in positioning shotgun mics, and monitor them constantly so that they pick up the dialogue. If the talent moves, the mics also must move. If using two mics at once, be careful not to place them close together in such a way that they will cause a phase problem.

Special Dialogue Situations

Miking two or more people requires adherence to many of the principles already discussed and a few others. When using only one microphone, you'll have to move it often so that it picks up the person talking (see Figure 8.5). The boom is a favorite of moviemakers because it is easy to move. Difficulties arise with one mic, however, if the various people speak at different volumes. If one person has a booming voice and another

is soft-spoken, an equitable balance is hard to achieve. You could ask the two people to try to speak at more similar levels, or move the person with the stronger voice farther from the mic than the person with the weaker voice. Another solution might be to record two takes of the scene, one recording the first person and the other recording the second person. With two takes, you'll need to pay attention to continuity so that the shots will edit together well.

Another approach is using a different mic for each person so that each person's level can be set separately. This works best if the mics are attached to a portable mixer that can be used to set the separate volumes. Recording one voice at a higher level than the other will compensate for any differences in volume, but if the differences are great, one mic will pick up more background noises than the other, creating some unwanted differences when the sounds are edited together. Also, the mics need careful placement so that they do not cause a phase problem and cancel each other out. Some types of miking depend more on multiple mics than other types. When using wireless lav mics, there must be one for each person. One lav cannot pick up several people equally unless they are very close together.

Miking for **stereo** or **surround sound** requires special care. Often dialogue is recorded mono and then edited in such a way that is becomes stereo or surround. But if it is recorded as stereo, it is best to use **M-S miking** (see Chapter 7) because it picks up the center sound, which is likely to be people talking, better than **X-Y miking**. For surround sound, it is best to have each mic recorded on a separate track so that there are plenty of options during the editing process.[4]

Miking Automatic Dialogue Replacement

Under some circumstances, proper dialogue pickup is impossible. If a scene must be shot in a noisy factory or on a busy airstrip, the sound will not be intelligible to the audience. In these cases the actors record their dialogue in a soundproof studio, usually after the movie has been shot. What is recorded during production is a

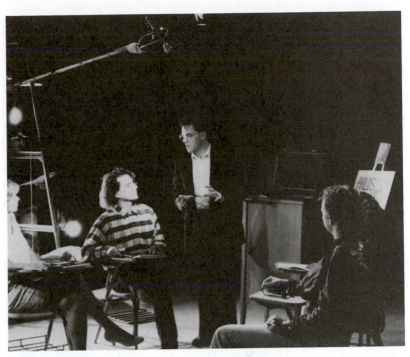

Figure 8.5

In this shot five people are talking, so the movement of the boom becomes important.

scratch track—dialogue that you know you are not going to use but that serves as a guide to the actors when they record the actual sound later. The selecting and positioning of mics does not require a great deal of care. The sound must simply be clear enough to be used as a reference during rerecording.

This rerecording process is called **automatic dialogue replacement (ADR)**, sometimes referred to as **looping**. The actors are brought back to a soundproof room where they watch short segments of themselves on a screen and listen through earphones to the audio that needs to be replaced (see Figure 8.6). They rehearse the lines until they feel they can deliver them in sync with their lips as seen on the screen. When they are ready, they record the lines into a microphone—usually a cardioid mic on a boom or a floor or table stand. Then they go on to the next few lines and rehearse and record. Computer programs can create the short segments (loops), and the audio can be recorded and deleted as often as needed. Some actors are better at ADR than others, but, in general, it is best to bring the actors back as soon as possible so that they still have the feel of the scenes in their minds. For this reason, sometimes an ADR space is set up on location so that actors can record the ADR shortly after they have acted out the scene.

Figure 8.6

An ADR session. The woman at the podium on the right is rerecording dialogue for the scene being projected on the screen. (Photo courtesy of Ryder Sound Services)

A related type of recording is that which is done to dub a movie into a foreign language or to provide the voice for animated characters. Although dialogue is not being replaced because of a production problem, the recording does need a facility where short loops of the picture can be shown to actors who mouth the appropriate words.

ADR is expensive, so the more dialogue that can be recorded correctly during production the better. Dialogue recorded on a sound stage should rarely need ADR because it is possible to control the elements. Occasionally actors have to move so fast that they sound unnecessarily out of breath; then the sound needs to be rerecorded. Sound recorded outside is more problematic because of extraneous noises, and it should be carefully monitored. If an airplane is heard in a Civil War movie, the dialogue will need to be rerecorded, but it is easier and cheaper to do this on the set than to bring actors back for ADR. Most of *Titanic* was looped because of construction noises. While cast and crew were shooting on one side of the ship, construction crews were building the other side. The buzz saws and beeps of trucks backing up made recording clean production audio difficult at best.[5]

The sound created during ADR sounds different from the other dialogue because it is recorded in a soundproof studio. Before it can actually be used in the final movie, it is mixed with ambient sounds (such as that of the factory or the airport) at a low level.

Miking Voice-Overs

Voice-overs (VO) are recorded in a fashion similar to ADR, but they are easier to record because they do not involve synched sound. For this reason they are usually recorded in totality rather than in small loops, but they are best completed in a soundproof room—sometimes the same room used for ADR. They serve such purposes as explaining complicated processes, indicating what a person is thinking, representing someone's conscience, or commenting on what is occurring in the picture (often called **narration**).

The performer watches the picture and reads the narration or other form of VO at a pace that matches what is on the screen. When what is being conveyed through words is the dominant element, the voice-over can be recorded before editing, and the picture is then edited to the narration. In this case, the recording can be done just about anywhere because there is no need to play back a picture.[6]

As with ADR, a cardioid mic on a table stand, floor stand, or boom serves best. If you are using an ordinary table, you might want to put a cloth over the table so the mic and stand will not vibrate. People can also hold mics to record voice-overs, provided they do not need their hands for holding a script. In fact, the positioning of the script is one of the primary concerns in regard to voice-overs.

Actors must handle the script carefully so that it does not interfere with sound pickup. For example, they must never hold a script in such a way that it covers all or part of the microphone. Pages should not be stapled together because they may make a shuffling noise when they are turned, which is picked up by the mic. Rather, the actors should have loose script pages that they can carefully lift off and place to the side. The person reading should not have to turn his or her head away from the mic to see the script.

The distance between the mic and the person's mouth should be constant unless, of course, the voice-over is to sound as though it is fading off into the distance. Each page of the script should end with a complete sentence so that the actors do not have to turn pages in mid thought. Also, putting the script pages in plastic sheaths cuts down on rustle.

Miking Sound Effects

Moviemakers add many **sound effects** during postproduction, but they record some during production, especially the **hard effects**—those that need to be in sync with the picture. The sound of a cowbell needs to coincide with the shaking of the bell; a door slam needs to sound as the door actually slams. These are noises best recorded during production; in fact, it is almost impossible not to record them while the dialogue is being recorded.

Hard effects that are an integral part of the dialogue should be recorded as realistically as possible because they cannot easily be removed from the track. In other words, if the cowbell is shown in close-up at the front of the scene, it should sound close. If the mic is far from the cowbell, taping talent at the rear of the scene, the bell's perspective will be incorrect. Sometimes this means recording the effect with a separate mic.

In other instances, sound effects are not actually recorded—someone verbally indicates that the effect is needed. For example, if a phone is to ring, one of the crew members might say "ring, ring" at the point in the script where the phone rings. This tells the people who add sound effects during editing that they need a ringing phone at that point.

Sound effects that need not be synchronous can be recorded separately from the picture. Several crew members might go to a waterfall to record its sound, which will be mixed with the dialogue or narration during postproduction. Some surrealistic sound effects are created through experimentation. For one of the effects in Episode I of *Star Wars,* the sound person recorded an electric razor in a bowl. The sound for the snitch used in the Quidditch match in *Harry Potter and the Sorcerer's Stone* was made

from wind chimes, a handkerchief speeded up, and a few other noises.[7]

Either omnidirectional or cardioid mics are good for recording sound effects because they pick up in a broad pattern. If the sound effect is being recorded in stereo, X-Y miking is best because it picks up distinct rights and lefts, which is where sound effects tend to be most predominant. Just about any positioning device will do for asynchronous sounds because there's no problem with the mic appearing in the picture.

Many of the sound effects used with a movie are not recorded for that particular movie. They come from CDs or other sound effects libraries and are gathered by sound effects editors while other sounds are being created during shooting.

Miking Foley

Foley work involves a special type of sound effects recording. An unusual sound effect, such as a hyena laughing, that cannot be found on a CD can be created in a Foley room, but Foley is more often thought of in terms of background sounds such as footsteps, clothes rustling, and branches waving in the wind.

The Foley process is named after Jack Foley, the man who designed the room in which Foley activities take place. This room contains a large screen, several cardioid and omnidirectional mics, a number of sound effects devices, and many walking surfaces—gravel, sand, dirt, cement, carpet, hardwood floor (see Figure 8.7). There may be a wide variety of shoes—high heels, tennis shoes, sandals, or even specially made shoes for the robots and druids of *The Phantom Menace.* A Foley room often contains a variety of cloth that can be rustled to simulate people walking past furniture, water to be poured from one container to another, twigs and branches to be snapped, dishes and utensils to be jiggled, and a variety of other articles.

People called **Foley walkers** watch the movie being projected on a large movie screen or TV monitor (a 16:9 TV monitor if the movie is widescreen or HDTV) and perform the acts needed to provide synchronous sound for the actors' movements, recording them all through properly positioned microphones. For example,

Figure 8.7

A Foley room setup. The two Foley walkers are using the various pits and equipment to perform, in sync, the sounds that should emanate from the picture on the screen. (Photo courtesy of Ryder Sound Services)

if the movie shows an overweight man walking on dirt in tennis shoes, the Foley walker will put on tennis shoes, place the mic by his feet, and walk heavily in the dirt pit in step with the man on the screen. In addition, Foley walkers clap their hands, scream in terror, slap faces, or fall for fight scenes. Most Foley walkers are very graceful; in fact, many of them are dancers or ex-dancers. Foley walkers sometimes work in pairs—a man imitating men's movements and a woman imitating women's movements—but sometimes they work alone and do the actions for each character in the scene in turn. A technician usually sits in an adjoining room and records all the sounds on an audio recorder that is synced with the picture.

Occasionally Foley is recorded at a location rather than on a Foley stage. For example, *K19: The Widowmaker,* starring Harrison Ford and Liam Neeson, took place on a submarine. To increase authenticity, the Foley was recorded on a World War II submarine at San Francisco's Fisherman's Wharf.[8]

Because all the sound needs to be synchronous, it cannot be recorded until the final version of the picture has been prepared. For this reason, Foley recording usually occurs part way through the editing process, and the material is then edited into the final movie.

Traditionally, student productions have incorporated very little Foley work because of the complexity of the setup, but the little touches provided by Foley are often what differentiate, at a subconscious level, a professional motion picture from a nonprofessional one.

Miking Ambient Sounds

Ambient sounds are asynchronous noises mixed in during postproduction to give a scene authenticity. Sometimes they are called **wild sounds** because they can be recorded separately from the picture. One type of ambient sound is **room tone.** This is simply a recording of the general ambiance of the place where the dialogue is being recorded. When taping room tone, everyone should be quiet, but all the overall sounds of the room should be just as they have been during the production. In other words, if an air conditioner was running when the dialogue was taped, it should be running when the room tone is taped. All the equipment and set pieces used during production should be in place so that reverberation does not change. During postproduction, room tone smooths cuts from one shot to another. In the hectic pace of production, people often forget to record room tone. However, it is a very simple

process that should be done for all productions, professional or student. A sudden absence of room tone on the audio track calls attention to itself.

Another type of ambient sound is **atmosphere sound.** This adds a certain feeling to a scene. For example, the sound of a bubbling brook enhances the bucolic feeling of a serene country scene. The hustling, bustling mood of a street scene, which is actually shot in a studio, needs traffic noises. Factory sounds might be taped during a busy time because the factory was not operating when the scene was shot. As with room tone, these atmosphere sounds are mixed into the sound track during postproduction.

A third type of ambient sound is **walla walla.** This is the recording of people's voices so that the actual words they are saying cannot be understood. In fact, the term gets its name because sometimes the people talking say "walla walla" over and over at different speeds and with different emphasis. Walla walla might be needed if only a few characters are in a bar scene shot in the studio but the illusion is that the bar is filled with people. Or many people appear in the bar scene, but they only pretend to talk while the principals are saying their lines. A crew would go to an actual bar and tape the general noises, which would then be mixed into the sound track, or actors could be hired to "walla walla." All kinds of scenes—people walking through a museum, people at a party—need walla walla.

The distinctions among these various types of ambient sound are often muddy. Factory noise could be room tone, atmosphere sound, or even walla walla if factory workers are talking to each other. Sometimes ambient sounds and sound effects are one and the same. A dog barking could be considered a sound effect or an atmosphere sound. The definition is not important; what is important is recording the sounds so that they are available for later use.

Mic placement is not overly crucial for ambient sounds because you are trying to pick up general noises. This is one situation in which an on-camera mic may suffice. The most convenient way to record ambient sounds, however, is with whichever mic you use for dialogue. Usually only a few minutes of ambient sound are needed, so it can be recorded at any time, as long as cast and crew are quiet.

Miking Music

Postproduction is the usual time for composing mood music for a movie. However, music inherent to the plot, such as a rock group's performance, needs to be recorded during production. And occasionally the music composed during postproduction needs to be recorded in a studio. When this is the case, musicians gather in a recording studio that has a large screen onto which the movie can be projected. A conductor (often the composer) leads the orchestra while watching the movie on the screen. This ensures that all the passages will be the right length. Technicians in a control room record all the music.

If the music needed during production (such as that of a rock group) can be taken from a prerecorded CD, it must at least be lip-synced. This requires some sort of playback setup so that the group or individual can hear the music. Playback can be something simple, such as a portable CD player on the set, or it can be something more elaborate, such as a public address system. Somehow, picture and sound must be in sync. For this reason moviemakers usually rerecord the CD on the audio track of the videotape or on a separate audio recorder (reel-to-reel, DAT, computer) while the actors are lip-syncing. Time code can aid in making sure sync will be maintained throughout the entire process.

There are several methods for recording music during either production or postproduction. You can record the whole musical group on one track or tape individual instruments and mix them later. When recording the whole musical sound at once, you must take great care in placing the mics so that the recorded sound achieves the best balance possible. A mic placed above the string section of the orchestra, for example, will produce a recording in which the strings dominate the brass and percussion.

Individually miking a large group such as an orchestra is usually not practical. This technique is used more for small groups or individuals. You can mix the recordings from various mics as the recording session is taking place, or you can record each mic on a separate track and mix them later. If sounds are mixed live, each mic feeds into a different input of an **audio mixer.** Technicians raise and lower the volume of each

mic so the instruments are recorded at an appropriate level. Then they feed the mixed music to a single track (or two tracks if the sound is to be stereo) of an audio recorder. The disadvantage of this method is that the mixing must be done in real time. If one of the technicians makes a mistake, it cannot be corrected. However, for something simple, such as a singer accompanied by a guitar, this type of recording works quite well. The singer could be recorded with a mic placed about 6 inches from his or her mouth, and the guitar could be recorded with a mic placed by its sound hole (see Figure 8.8). You can decide on the appropriate mix of guitar to voice, and then record the whole song at those volume levels through a mixer and into an audiotape recorder.

If the music is going to be mixed later, each mic must feed to a different track on a recorder. The sounds may go through an audio mixer to be recorded, but there is no need to adjust their levels because each sound is going on a separate track and can be isolated later. The sound technicians can send each track back through the mixer, adjust the volume of each track, and send it to one track of another audio recorder. This can be done in a fairly leisurely manner. The technicians can listen to the music, practice different levels, and add reverberation or in other ways improve the sound. They can correct mistakes because the original recording can be played over as many times as needed.

Another method of recording music is to record different instruments at different times, each on a separate track of the tape or computer program. This is the usual method when one musician wants to play several instruments. He or she might first play the guitar melody of the song. Then, while listening to what has just been recorded, the musician could sing the words to the accompaniment of the guitar. The guitar would be *playing back* from one track, and the singing would be *recording* on another track. After that, the musician might listen to guitar and singing and add drums on another track. All three tracks are played back through an audio mixer and recorded on a single track of another recorder. In the process, the sound operator can change the volumes of the guitar, voice, and drums so that they blend with each

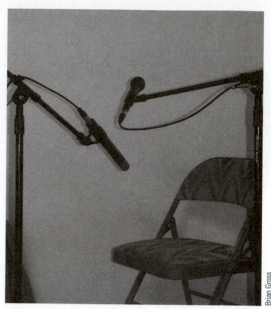

Brian Gross

Figure 8.8
This is the setup that could be used for a singer/guitar player. One mic is by the mouth, and one is by the guitar sounding board. (Photo courtesy of Brian Gross)

other properly. The method of recording used usually depends on the complexity of the music and the size of the budget.[9]

Recording Techniques

You should always carefully monitor the sound you are recording to ensure the best quality possible. If at all possible, monitoring should involve looking at a meter and listening through headphones. Headphones are not always reliable because they often have volume controls. With the headset volume cranked up all the way, you may think you are recording properly when in fact you are **riding in the mud**. Conversely, if the headphone volume is low, the recording may actually be **overmodulated**. The meter often shows what is going into the recorder but not what is coming out. The headset gives you the result and assures that you have, indeed, recorded.

Most recorders have an **automatic gain control (AGC)**. This circuitry prevents the signal from being recorded at too low or too high a level. If the sound is low, the AGC automatically boosts it; if it is high, it lowers it. However, AGC is not always appropriate. For one thing, most AGCs do not handle silence well. If there is a pause between lines of dialogue, the AGC will boost the gain, increasing the ambient noise. This

Figure 8.9
This mixing cart is used for a variety of film and TV work and includes a DAT (on the upper left shelf), a Nagra (upper right), and a portable mixing board (center). Sound can also be sent from this cart to a camcorder.

Figure 8.10
In this situation, the sound of three microphones is being sent through the portable mixer.

can be quite disturbing if silence was really what was wanted. AGCs also try to compensate for changes in perspective. A distant sound should sound lower than a close sound, but AGC will try to boost the distant sound. You may want to put the sound gain on manual rather than automatic so you are the one making the decisions about the relative volume levels. This approach is similar to that of overriding automatic focus and automatic iris on the camera (see Chapter 3).

Sometimes you'll be recording sound directly into the recorder on one or more tracks of the audiotape, videotape, or hard drive. Other times you will send it through a portable mixer where various sounds are mixed and sent on to the recorder (see Figure 8.9). Neither method is right or wrong; the determining factor is the production situation. A mixer is not essential when recording one person's voice with one mic. However, to record a musical group or to record several people who have different microphones, you will probably need more inputs than the recorder can handle, so you will need a portable mixer (see Figure 8.10). Taking along a mixer adds to the bulk of what you carry to the field and usually adds to the setup time.

If you are recording double system by using a DAT or Nagra but are shooting the picture on videotape, there is certainly no harm in recording audio on the camcorder as well as on the separate recording equipment. You will be increasing your flexibility and covering your bases

in case something goes wrong with one of the recordings.

Whenever you are recording sound of any sort, listen to at least part of it in the field to make sure it is acceptable. Recording it again is fairly easy during production. Fixing it later ranges from difficult to impossible.

Notes

1. David R. Schwind, "Room Acoustics," *Mix,* August 1997, pp. 58–70.
2. Doug Schwartz, "Audio Mechanics Use Sonic Solutions to Solve the Mystery of the Misdirected Mike," *Computer Video,* January/February 1995, p. 32.
3. "Episode II, Attack of the Clones," *Mix,* June 2002, pp. 85–102.
4. "Experimenting with Mic Techniques," *TV Technology,* 24 April 1997, p. 39; "Two Ears, Two Mics: Stereo Micing for TV," *TV Technology,* 24 March 1999, p. 58; "Location Recording," *Mix,* September 2002, pp. 28–30; and "A Look at Surround Microphone Techniques," *TV Technology,* 27 June 2001, p. 36.
5. "Finding Your Voice," *Mix,* April 2000, p. 23.
6. "Recording the Voice-Over," *Mix,* April 2000, p. 16.
7. "Sound Effects Recording," *Mix,* April 1997, pp. 22–24; "Harry Potter and the Sorcerer's Stone," *Mix,* December 2001, p. 86; and "Finishing the Phantom Menace," *Mix,* May 1999, p. 44.
8. "Foley Goes to Sea," *Mix,* August 2002, p. 74.
9. Rick Clark, "Acoustic Ensemble Recording," *Mix,* July 1998, pp. 30–39.

Directing

There is no one right way to direct.[1] Directing is not a science. It is an art and a craft. No two directors and no two directorial situations are the same. Some directors are bombastic, and others are quiet. Some give actors a great deal of freedom, and others give precise instructions. Directors have a great deal of say over who is hired for cast and crew for a feature, whereas production companies are more involved with hiring for commercials. Those directing dramas can engage in exhaustive preparation, whereas documentary directors do more thinking on their feet.

Much of what has been discussed in previous chapters deals with directing. Directors oversee all the planning detailed in Chapter 2, and they make many of the aesthetic decisions discussed in Chapters 4, 6, and 8. They work closely with the cinematographer and sound designer on equipment principles covered in Chapters 3, 5, and 7. And, as we shall see in the next few chapters, directors are also very involved in the editing process. Throughout all of this, directors assume a number of different roles—creative visionary, supervising technician, CEO, and psychologist.

The Roles of the Director

As creative visionaries, directors intensify the emotional impact of a film. For example, a director makes the ultimate decision regarding when to cut from a medium shot of a couple in the park to an impelling close-up of a knife hidden in the bushes. Likewise, the director decides when to retake a shot because the actor's performance did not convey enough sadness, and he or she bears ultimate responsibility for making sure the various elements of a movie are consistent and correct. The clothing worn by the 19th century shoemaker must be historically accurate; the roses a women picks in her garden must not change to tulips when she places them in a vase inside her front door; the overall look of a horror movie should be in line with its purpose of instilling mystery and suspense.

Directors must be able to handle the technical as well as the artistic aspects of a movie. They must understand cameras, lenses, lights, microphones, and all the other equipment used in the process of moviemaking. They must know how to shoot a live action scene so that it will meld with the visual effects being created in a production house miles away from the film location. They cannot leave to chance the possibility that they will not have the right microphone connector when shooting at a desert location.

Of course, directors do not actually undertake each activity needed to make a movie all by themselves. They delegate to many others. A costume designer researches 19th century clothing; a script supervisor makes notes about the type of flowers used in a scene; the production designer plans a consistent look for a film; camera operators, cinematographers, and sound engineers have specific responsibilities related to equipment. But the director has the overall "buck stops here" responsibility and must select cast and crew carefully and oversee their actions. In this way, directors are much like company chief executive officers (CEOs). They set direction and lead people through a process to an intended end. However, most CEOs oversee ongoing companies with a fairly stable group of employees whose jobs may remain relatively constant for years. In modern moviemaking, a new "company" is formed for each movie, and that company is dissolved when the movie is completed. Directors are involved in many more rapid hiring decisions than the average CEO, and they move through all phases of their CEO tenure in a matter of months.

On top of the artistic, technical, and administrative responsibilities heaped on directors, they must also be psychologists. The movie business is filled with artistic temperaments, egos, and creative talent. Although directors are in charge, they cannot force their vision down the throats of all those working for them. Most cast and crew want to contribute to the movie in a meaningful way—and often they have good

ideas. An actor may use a gesture that adds humor to the scene; the editor may try a rearrangement of shots that winds up intensifying suspense; a production designer may uncover a fabric that adds authenticity to a period piece. The director must be able to accept workable suggestions appreciatively and still reject well-intentioned ideas that are not workable or not in line with the director's vision.

The cast and crew of a movie are usually thrown together without benefit of much knowledge of each other's personal and professional habits. Conflicts invariably arise—the boom operator insists on standing where the cinematographer absolutely needs to place a light; the lead actors stop speaking to each other because they have different interpretations of a scene. During production, cast and crew are often far from home for long periods of time. They cannot escape from each other, and they tend to get on each other's nerves or build bonds that are far too cozy. Some people become homesick or must leave to handle family emergencies. Personal and interpersonal problems can greatly inhibit (or even stop) the production process. It is the director who must, for the sake of the movie, resolve disputes and handle temperaments.

Despite the artistic, technical, managerial, and psychological burdens placed on a director, many, many people "want to direct." And rightly so. Directing is a prestigious, powerful profession, and those who rise to the top are paid well. Directing challenges creativity and places the director in contact with some of the world's most fascinating people. The work a director completes influences and entertains millions of people, not only those alive when the movie is made but those in generations to come. That work includes dealing with the script and the writer, supervising the crew, and serving as the main interface with and guidance to the actors. Directors conduct the rehearsals, call the shots during production, and tell the story through editing decisions.

Working with the Script

The first thing most directors do is read the script. Of course, if the director is the writer or has been involved in selling the script idea, this step may already be completed. Some directors like to make notes on the script the first time they read it; others like to just let the script wash over them. Others like to stop reading occasionally and write down impressions, and still others like to keep elaborate diaries where they note not only their feelings about the script but their perceptions of all aspects of directing the movie. There is no "right" way to handle most of the directing functions. Whatever works is best, but most directors find certain conventions to be helpful.

Many directors follow the reading of the script with a formulation of the vision for the movie—something concise but definitive that can be passed on to others who work on the film. For example, "This is a dark story that shows how what a father considers to be love can actually damage the children he is trying to encourage. Although it takes place in modern times, many elements of the Victorian era come into play in the lifestyle and actions of the family." Such a statement can give the production designer concepts for designing the look of the movie, the actors perceptions on how to play their roles, the cinematographer thoughts for lighting, and the composer ideas for the music.

Directors need to become intimately involved with the script and its characters. Naturally, this involves many readings, but it may encompass other activities. You can outline the script in the traditional I, A, 1, form, make a list of ways the characters reveal themselves to the audience, or jot down the elements of the set that are particularly important to the story. You can write up elaborate character descriptions that include physical characteristics, personality traits, goals, obstacles, shortcomings, values, and perhaps even backstory of what you think each character did before the time frame of the movie. Like many directors, you can **storyboard** the entire movie (see Figure 9.1), drawing pictures of how you visualize each shot. You can also make **blocking** diagrams (see Figure 9.2) that show how actors and cameras move in each scene. The more you visualize, the better. Think about colors, ambient sounds, and music. You can even use computer programs that help visualization by simulating lenses and camera angles.

Figure 9.1

Computer programs can speed up the storyboard process, especially for people who are not natural artists. This program from StoryBoard Quick™ allows a director (or anyone else) to select predrawn characters, props, and locations. Clicking the mouse on the appropriate tool (a) can change perspective, size, screen direction, or other features. The frames created (b) can include dialogue and stage directions as well as pictures. (Graphics courtesy of Power-Production Software)

a

Conery's car screeches to a stop in front of the warehouse...

He runs up the dark staircase.

Conery kicks the door open and it's Eva...She's been found!

Eva: "I can't believe you, what are you doing--" Conery slams his hand over her mouth.

The evil Vance's footsteps echo through the building as he advances on our hero.

Conery turns to listen as we move in closer on his face...

b

As the director, you can do your own break-down—not the type the UPM (or AD or line producer) does to make a schedule and budget (see Chapter 2), but one that breaks the script down into larger or smaller elements than scenes. One form of larger elements is **sequences**. These are several scenes that form a unified idea. For example, a chase sequence may have a number of scenes—the bus station, the city street, the abandoned warehouse. When you look at sequences, you may find individual scenes that are not necessary or realize an additional scene may be needed. One element smaller than a scene is a **beat**. This is a change of direction or emotion within a scene. Character A may be showing resentment toward Character B, but when Character B starts to cry, Character A's resentment may change to pity. Analyzing beats can help you find places where actors should move or change expression. Tell the story to a friend. Note where your friend seems to become bored; maybe that part of the script can be eliminated. Likewise, note what parts of the story you leave out, what parts you struggle to tell, what parts seem redundant. All of these activities increase your familiarity with the script and also help you ferret out its problems.

At some point most directors create a **shooting script** (see Figure 9.3), breaking the screenplay into individual shots that contain the dialogue and other information from the script the writer has prepared. But directors add camera angles, movements, positions, and other information related to shooting. All this is considered to be the province of the director rather than the writer.

Working with the Writer

If there are problems with the script (and there are bound to be), the director must work with the writer on rewrites. Unlike a novel where one person authors a book that is published and goes thump on the table, a movie script is a blueprint that serves as a suggestion for the movie and is a constant work in progress until the movie is released. Sometimes as soon as a script idea is bought, the original writer is dropped from the

Figure 9.2
This blocking diagram involves four people sitting at a restaurant table, one of whom gets up and leaves. The angles with numbers by them are camera setups. For example, camera setup 2 is a pan shot of the girl as she gets up from the table and goes to the door. To make the blocking diagrams more comprehensible, directors sometimes use a different color for each character.

project and other writers are brought in to handle rewrites (see Chapter 1). This decision is often made by the producer who has found the writer uncooperative in making the changes needed to sell the script. Some writers don't want to do their own rewrites. They have been through the process and found it distasteful so would rather just take the money they have made to date and run. Some production companies have barred writers from the set, an act the Writers Guild found so demeaning that it supported clauses in writers' contract allowing them on the set.

If a director and the original writer have a collaborative rather than adversarial relationship, they can benefit each other. They are the only two people who have an overall view of the story to be told. While others are involved in putting together pieces of the movie, they reflect on what the whole jigsaw puzzle looks like. Directors need to realize that the script represents the writer's passion, and the more they understand the passions, the better they will understand the script. Even when there are problems with the script, the director should be appreciative of the labor the writer has put into it and enthusiastic about undertaking the project. If

Figure 9.3

A script in shooting script format.

```
                    SHOOTING SCRIPT

     SCENE 5

     INT. BIOLOGY LAB - DAY

          11.    M.S. of Marilyn peering through a microscope. PULL
                 BACK to reveal John coming into the room and sneaking
                 up behind Marilyn.

          12.    M.S. of John.

                              JOHN
                 Caught you.  You just can't give up
                 figuring this out, can you?

          13.    M.S. of Marilyn.

                              MARILYN
                 I guess not. There is just something
                 here that is so bizarre.

          14.    TWO SHOT of John and Marilyn.

                              JOHN
                 Have you thought of going to the office
                 and looking at some of the other research?

                              MARILYN
                 Do you think that would help?

                              JOHN
                 It couldn't hurt.

                                               DISSOLVE TO:
     SCENE 6

     INT. LIBRARY - DAY

          15.    L. S. HIGH ANGLE of library stacks ZOOMING IN to show
                 Marilyn riffling through a thick book.  PAN to show
                 John clicking through computer screens.

                              JOHN
                 Nothing here so far.
```

this can't be genuine on the part of the director, then the director isn't the right person for the movie.

Disagreements between a writer and a director who respect each other can be beneficial to the movie. They can help the director visualize more fully, and they can help the writer give the characters more depth. It can be particularly healthy for the writer and director to discuss how events in their lives relate to the movie, but sometimes one or both of them won't want to go there, so it shouldn't be forced. The director and writer should come to a common agree-

ment about the premise of the film; otherwise the rewrite process will be a tug-of-war.

When approaching a writer about rewrites, the director can start with small things that the writer will probably agree with—inconsistencies, parts of the script that need to be amplified rather than parts that need to be cut. From there the two can tackle more complex issues. Often the relationship works best if the director and writer have separate but supportive roles. For example, the writer can emphasize the character's words while the director concentrates on the character's actions. When the writer and direc-

tor disagree, they can go back to some point of agreement and try again.

Rewrites, at their best, are a tricky proposition. A rewrite of one scene usually necessitates rewriting other scenes to eliminate inconsistencies. Writers are under pressure from the producer and director to deliver the pages, and they often feel they are not given enough time to do their work justice. Directors can make allies of writers if they don't insist on a "perfect" script as they go into rehearsal. This will give the writer a little breathing room. And besides, the actors will want to further change the script no matter how "perfect" it is.

Working with a Crew

Ideally, directors should wait until they have a clear vision of the movie before hiring a crew. This is so they can make sure they hire crew members who share their vision. But the reality is that directors usually have to start hiring at least some crew members quickly. One solution to this problem is for directors to hire people they have worked with previously whom they feel certain will share their vision—whatever it turns out to be. They also want people who will get along well with each other, and the surest way to accomplish that is to hire people who have exhibited compatibility on other movies. But hiring the same people over and over can lead to staleness, and some movies have special needs that a director might not have encountered before.

Hiring Crew

When directors are hiring new people (or even sometimes when they are hiring people they know), they should check out references carefully. Asking other directors and producers is probably the best way to get credible references. Be sure the people giving references understand what you are looking for. Even though the people you are considering hiring are good workers, they might not be what you need for this particular movie. A cinematographer who has lit award-winning romantic scenes may not share your vision regarding lighting for a gritty cop movie.

The director should interview all main craftspeople such as the director of photography, assistant director, production designer, editor, and composer. If these people share the director's vision, they, in turn, can hire others who do. Some directors like to watch work people have done in the past and discuss it with them. They are interested not so much in the final product as in the underlying philosophy the potential hire had toward the work and how the person dealt with the problems and challenges. Sometimes directors and applicants will watch someone else's work and discuss it. The idea is to see if the director and potential hire share similar aesthetic sensibilities. If a director is thinking of the movie in terms of strong primary colors and the production designer being interview expresses a predilection for always working with pastels, then the director had best not hire that production designer. On a more straightforward level, some directors simply share their vision of the movie with the applicants and listen to their reactions. They should not look for brown-nosers who agree with everything but rather for people who listen carefully and give supportive ideas. Directors want to hire people who will enhance their own thinking and who will be fun to have around.

Student directors rarely hire crew; rather, they use members of the class. However, it is often within a class setting that students make judgments about each other and then hire each other later in their professional life. Occasionally professional directors don't have the opportunity to make hiring decisions either. The producer may exert primary influence in this area, and directors then have to work with the people the producer selects. Regardless of the situation, directors, including student directors, should make it clear to the crew early on that they are supportive of everyone and want a healthy relationship with all.

Handling Crew

Once crew members are in place, the director has to walk the delicate line of allowing them to give input but not allowing them to take over. Directors handle this in different ways. Some lean more toward the authoritarian model, and

Brian Gross

Figure 9.4
This student director is meeting with some of his staff/classmates. (Photo courtesy of Brian Gross)

others are more democratic. You, as the director, must pick the style that works for you. You are the main storyteller, but remember that the craftspeople are all creative and want the freedom to make their mark on the movie too. Don't give in to an idea because someone throws a temper tantrum, or you will have a lot more temper tantrums on your hands. Keep control. If you feel like your assistant director is trying to take over your job, don't blame the AD. Look to yourself. The AD probably felt consciously or subconsciously that you had created a power vacuum and, for the good of the movie, was trying to fill it. Sit down with the AD and discuss the situation openly. You will both grow and profit from such a discussion.

In fact, when there are any problems, face them head on. Try to make the person (or people) that you think is causing the problem part of solution. Don't just fire them or shun them—unless you are really a believer in strong authoritarianism. Preferably, have them participate in meetings to come up with ideas on what to do about the problem. Although these meetings can be difficult, they clear the air and keep up morale. One way to keep problems from getting overly personal is to talk about the needs of the story. Everyone on a movie shoot should be able to relate to that, and telling the boom operator he needs to alter his behavior because of the needs of the story is softer than telling him he's driving you and the sound recorder nuts. Of course, sometimes you may need to tell him he's driving you nuts.

Hold regular production meetings (see Figure 9.4) with all the main people so that people don't get lost in their own little areas and lose sight of the overall movie. Take notes (or have your AD take notes) on what is decided at the meeting, and send email summaries to all outlining what was decided regarding their sphere of influence. This will give crew the opportunity to reply if they disagree, and you can nip potential problems in the bud. The email also serves as a record of what individuals were supposed to do—in case they don't follow through.

Keep in mind that some people are listeners/talkers and others are readers/writers.[2] In other words, some people understand instructions better if you talk them through it. Others are more likely to comprehend and prefer written communication. Try to determine each crew member's preference and, within reason, communicate accordingly. Perhaps more important, decide if you are a listener or a reader, and let your crew members know. If you tend to pay attention to things primarily when you see them in writing, ask your underlings to email you reports on a regular basis. Let them know how you use these reports, otherwise the talkers/listeners among them may think you are simply creating busywork. If you prefer the give and take of conversation, schedule one-on-one meetings or phone calls.

Be sure to give people credit for their good ideas, both privately and publicly. In fact, it doesn't hurt to give someone credit for an idea that you may actually think was yours. The best way to get people to buy into something is to make them think it was their idea. If you are intent on a particular camera angle that you know is going to create a great deal of work for your DP, be somewhat subtle about the idea, and see if the DP will have an inspiration that is close to what you have in mind. Then you can slightly modify the "DP's idea."

Don't be aloof with any members of the crew, but, on the other hand, don't go around department heads and talk to people who work for them unless you are asked to or unless the situation gets really bad. If the production designer is having a problem with a particular set designer and asks you to intervene, try to have a meeting with both of them. If you notice bad vibes between the two people, bring this to the attention

of the production designer first and then have whatever type of meeting you feel is best.

It is sometimes necessary to fire someone, and this should be handled as delicately as possible. Try to explain the reasons to the person, or he or she is very likely to repeat the behavior in some other situation. Sometimes getting fired is the best thing that can happen because it makes an individual realize and correct shortcomings.

One of the trickiest problems a director has is integrating people into the crew who are hired late, either because they are replacing people who were fired or because they weren't needed for the beginning work on the movie. If the crew has jelled, a newcomer may not be welcome. The director must show support for bringing this person on and communicate that to everyone.

The bottom line of what directors should aim for with the crew is that all the artists working together make the sum more than its parts. The director, through both compassion and discipline, creates an atmosphere for cooperation and collaboration. Moviemaking should be an experience where one plus one equals three.

Auditioning Actors

A director needs a definite sensibility and respect for actors. They are the ones who put their image on the line, and they are the ones called upon to make a story worth recording. Although some actors receive high pay and fame, they are still likely to have insecurities because it can all disappear so quickly. During the moviemaking process, the director should protect the actors so that they are not distracted from performing at their best and should discuss problems with them confidentially—and definitely not in front of the crew.

Preliminaries

The director's work with actors begins with casting (see Chapter 2). This is a crucial period not only for selecting actors but also for building relationships with them. As with everything else, directors have different styles. Some interview actors extensively and place more emphasis on the interview than on the actual acting audition.

Some trust their gut instincts, and others research actor backgrounds extensively. Some make quick decisions after an initial audition, and some prefer numerous **call-backs** so that they can evaluate the actors a number of times.

Ideally, actors auditioning for parts should receive the entire script several days before the audition. Some directors send not only a script but also their vision statement about the movie and maybe even a description of the actor's character, as they perceive it. In that way actors will have time to understand the context of their character in the overall movie. Handing an actor a script several minutes before the audition will reveal how well someone reads, but it won't show much about how well that person *acts*. But the ideal is not always achieved. Sometimes lead actors are sent the entire script, and it is also made available at the production company so those auditioning for lesser parts can read it in the office. Sometimes the whole process of contacting agents, lining up actors, supplying the script, and auditioning takes place in one afternoon. Some big name actors refuse to audition, feeling, correctly, that their reputation and body of work will get them parts.

For movies, the director is the lead person at an audition. The producer, casting director, and writer may be in attendance, but the director should be positioned in the room so that he or she can have the main interaction with and best view of the actor. When it comes time to select who will get the part, the director tries for consensus among the group but, in most instances, will be the one making the final decision. Auditions are often videotaped so performances can be reviewed. In addition, the director and others usually make notes about each potential actor.

Almost all auditioning processes consist of some interviewing, even if it is only small talk when the actor comes into the room. The actor needs to become acclimated to the room and learn who all the people sitting there are. Actors brought into a room full of strangers and asked immediately to read lines will show how well they handle pressure but not how well they act.

Directors who use extensive interviewing have many different techniques. They often begin by asking the actors to give their vision of the movie in general and their character in particular. They

do this to see if the actor's vision is closely enough related to their own. Other directors tell the actors their own vision, or discuss the vision that was previously sent, and have the actors react. Usually directors are not looking for actors who slavishly agree with them but rather people who bring their own creativity to the part. Some directors ask potential actors to tell the story presented in the script from their character's point of view, or they ask the actors to tell them about another character they have played and how they feel that character would interact with the character in the script. In leisurely audition situations, directors may actually project a movie the actor performed in and discuss how the actor approached the part. Prior to the interview, the director may have thought about the type of actor who would be best for the part. Perhaps the director feels someone raised in a poor background or someone who played sports would be most likely to convey the character effectively. The interview can include questions that obtain that background information.

The Process

For the actual audition, it is best to select a scene where the character reaches some turning point. This allows those watching the audition the opportunity to see how the actor handles struggle. When the auditioning actor's character interacts with another character, it is best to have a professional actor play the other part. This gives the auditioning actor more confidence and a better feeling about the process. To make the audition fair, the same person should read with all potential candidates. Compliment everyone, even the people you know you won't pick, but don't lead them on. Consider their feelings.

After the actors have auditioned, the people who have watched the auditions review their notes and, if necessary, review the videotape. Then the director leads a discussion and attempts to reach a decision regarding whom to hire. Several actors may be called back for another look. If a call-back is needed, the director should have a firm idea of what the purpose is. Do you want to see how the actors handle different material? Do you want to see how they react to your directing? Do you want to see several actors together to see

how they act with each other? When actors get call-backs, they get their hopes up. Deal with them in a civilized, organized manner. If you want them to read different material, try to pick something that is very different from what they read before. If you want to see how they react to directing, give specific instructions of how you want them to play the character differently. Tell them you are just experimenting so they don't think they have made a mistake. It is a very good idea to bring actors together not only to see how they act together but also to see how they treat each other as people. Compatibility and good chemistry among actors throughout the production process is a definite plus. Also, when you bring actors together, sometimes their performance improves, so try to bring as many as possible together before hiring them.

Auditions for student movies can be every bit as complex as auditions for professional productions. But usually they are not, mainly because students do not have money to pay actors. Directors can select actors from classmates, community theater participants, or the public at large. An auditioning process is worthwhile, but if your pool of actors is not professionally experienced, look for people who are similar to the characters they will be portraying.

Rehearsing

As with everything else, directors' styles related to rehearsals vary. Some give actors very specific instructions, and others let the actors play the role and intervene only when they think something is wrong. Some bully actors into doing their best, others try to inspire, and some do both. Some vary their style from actor to actor, giving bully-style specific instructions to actors who like that and saying little to actors who resent it. Some spend the early rehearsal time dealing with character analysis; others jump right into rehearsing the dialogue. Again, you need to find your own comfort zone.

Early Rehearsing

For directors who feel actors will perform best if they have psychological preparation for portray-

ing their character, there are a number of exercises you and the actors can engage in. You can bring in the writer(s) and have them tell the actors how they perceive the characters. You can have the actors talk about experiences in their own lives that are similar to the character's. You can improvise scenes that aren't in the movie but are alluded to—perhaps scenes from the character's childhood. You can have the actors do research on something that might have been an important influence on their character. For example, for a Civil War movie where the character's lover dies at the Battle of Gettysburg, the actor could research details of that particular battle.[3]

But sooner or later all directors start rehearsing the movie at hand. The first rehearsals, be they professional or student, usually start during the planning stage. There is never time for sufficient rehearsing. You, the director, will need to be attending to other problems presented to you on a regular basis by the production designer, sound designer, and others. So you need to prioritize what you do during rehearsals. You may want to concentrate on complicated scenes that you think will create problems during production. You may want the actors to read without any directing on your part to see what their natural inclinations are and then select for rehearsal the scenes for which you need to assert your directorial ideas. You might want to rehearse several scenes that you think will set the pacing for the entire movie.

Another approach is to concentrate on rehearsing **business**—actions that actors undertake to augment or counter the emotion of what they are saying or to add reality (see Figure 9.5). For example, an actor might touch a photo lovingly to enhance the emotion of loneliness. Or an actor might profess to be feeling perfectly calm while twisting a scarf uncontrollably. Having characters do ordinary things such as folding clothes or fixing a lamp will add reality and interest to what could otherwise be an overly talky scene. Some stage business (such as touching the photo) can express inner thoughts. Inner thoughts are difficult to get across in a movie, because movies are dialogue and action oriented. So it may very well be worth rehearsing the elements that convey this information.[4]

Figure 9.5

Actors rehearsing business. This waiting room scene calls for one actor to be napping, another to be reading a magazine in a relaxed manner, and the third to be showing signs of anguish.

You might want to work on blocking (also called **staging**), trying variations on your previously drawn blocking diagrams or storyboards until you find what is most comfortable for the actors and what you think will work best from the camera's point of view. You may find that what looked good on your blocking diagram is very uncomfortable for one of the actors, who must crane his neck to see another actor, or that the wastebasket needs to be moved because actors keep tripping over it. You may find that some arrangements create more tension than others. Assume, for example, that you have five people in a car—a father, a mother, a teenage son, a preschooler, and a baby. Play the scene with the preschooler in the front between the parents. Put the mother in the back with the baby. Have the teenage son drive with the father sitting next to him. Each arrangement will give a different dynamic to the scene.

Ways to Improve Rehearsals

If rehearsals get bogged down and nothing seems to be working right, there are a number of things you can do. You can have everyone sit around a table and read without any action. This will bring the actors back to elements of the essence of the movie and hopefully relax them enough that they can move forward in a more fruitful direction. You can temporarily

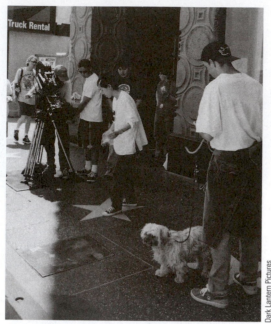

Dark Lantern Pictures

Figure 9.6

Director Ann Lu (center) directing a rehearsal of cast and crew as they work on a scene for Dreamers. *(Photo courtesy of Dark Lantern Pictures, www.dreamersthemovie.com)*

throw out the script and improvise. The actors may come up with new words that are more comfortable for them and that reinvigorate them. Have the actor think of something the character might be thinking but wouldn't say because it is too abrasive or intimate. That can get the actor more involved with the character.

The problem may be that you are rehearsing scenes out of sequence, and the actors cannot fully appreciate their characters' mood because they haven't dealt with what came earlier. Talk about the difficulties or performing out of sequence, and go over some of the scenes and emotions that have preceded the scene you are working on. If a particular actor is "temperamental," this may be because of insecurities about something else such as the size of his or her dressing room or the fear of not doing well. Talk to the actor about this. You may not be able to solve the problem, but the fact that you are willing to listen may help.

In all your dealings with actors, you have to know when to rein them in, when to let them go, and when to help them. You need to keep them focused on the story and the emotional state of their character (see Figure 9.6).

Shooting

Rehearsals are still a big part of actual shooting. How much, once again, depends on the style of the director. Some directors like to start the production by inviting everyone involved with the movie—cast, crew, producer, writer—to a rehearsal, which is really just a **read through** of the entire script. If most of the people are strangers to each other, this is also a good opportunity to start building rapport. Some "get-acquainted game" may be called for. For example, pair people off in twos and, after about 15 minutes of talking to each other, have each person introduce his or her partner to the rest of the group.

Or you can just start with a read through where the actors are intermingled with the crew or where the actors are around a table at the front of the room and crew members are in audience-type chairs—whatever suits your style. During the read through, have someone read the stage directions so everyone understands what will be happening. This is particularly valuable to crew members who will be setting the stage or following the action with cameras and microphones.

Try to watch everyone as best you can. See where they get restless, where they laugh, where they become totally engaged. It is good for the writer to see all this too as a basis for the inevitable rewrites. Be sure to tell the actors not to "act" but simply to read the script. This will put them at ease because they won't need to feel they are being judged, and it will make for a more relaxed reading. After the reading, you can simply dismiss everyone, or you can have all or some of the people stay and talk about how they feel about the story and the various characters.

The director sets the tone for everyone on the set. If you are secure and confident, you will get more respect than if you are nervous and tense. You may be wise to mimic the tone of the scenes being shot for the day. If they are somber, be low-keyed. If they are lighthearted, be mischievous.

A Typical Pattern

There are, of course, many ways to direct a movie, but let's look at a typical professional pattern. The night before (or earlier) the director will decide

on the staging for the scene(s) to be shot the next day. This involves not only thinking about how to block the actors but also deciding how many different shots to take of a scene to have enough **coverage** for the options needed in editing. Early in the morning, the cast reports to makeup. While the actors are sitting in makeup chairs, they may practice their lines by looking at each other in the mirror. The crew (especially those involved with putting up the set and configuring the lights) starts setting up the stage. The director has a meeting with department heads to discuss the plans for the day. When the cast is ready and the stage is roughly set, the director conducts a **technical rehearsal** (see Figure 9.7). With the crew watching, the actors go through the motions but do not give their all. This rehearsal is primarily for the benefit of the crew.

Then the director and the actors leave the set and go somewhere else to rehearse. Sometimes this is a full-blown rehearsal; sometimes the director tells the actors to go off by themselves to practice lines or to build up the emotion they need for the scene; sometimes the director works with one actor who has a particularly emotional part in the next scene.

Meanwhile the crew prepares for the shoot, often under the direction of an assistant director. The **gaffers** finish lighting the set, taking into account any particular needs they saw during the technical rehearsal. A painter may touch up the set where nails were hammered. The camera and sound crews set up their gear. When the stage is set, the director brings the cast back for a final rehearsal. Usually the director watches on **video assist** but from a point of view where it is also easy to see the actors on the set. If there are many actors, especially extras, in the scene, an assistant director may give directions to them. Some crew members may watch video assist, but most watch the stage. After the rehearsal, the crew make necessary minor changes—move a barn door so it doesn't cast a shadow, place a microphone a little lower, powder the actors' foreheads. When the director decides everyone is close to optimum form, shooting the master scene commences.

The assistant director is usually the one who says "stand-by" and then "roll sound" and "roll camera." At these commands the production

Dark Lantern Pictures

Figure 9.7

A complicated shot of this nature requires a technical rehearsal. (Photo courtesy of Dark Lantern Pictures, www.dreamersthemovie.com)

sound mixer starts the Nagra or DAT (see Chapter 7) and the camera operator starts the camera. Obviously, if the movie is shot single system, both start at the same time. The AD says "marker," and a camera assistant or someone else holds the **slate** in front of the camera and reads what is on it.

After the shot is slated, the director says "action" and the actors begin. Camera and sound record until the director says "cut." If the director is totally pleased with the shot, he or she may move on to the next shot of the same scene. Usually directors do more than one take, however. They want options in editing, so they **bracket**. They may want to bracket technically by having the camera take the shot slightly overexposed or slightly underexposed. They may also have the actors bracket—play the scene with a little more or a little less intensity.[5] After the master shot, the director usually sets up for close-ups. The same procedure follows—roll sound, roll camera, slate, action, cut. After close-ups, the director may shoot **reaction shots, cutaways, cut-ins,** and other shots that may be needed during editing. Always shoot enough to show the audience what it needs to see. If, for example, an integral scene of the movie shows an actor feeding a cat, definitely get a shot of the cat.

Throughout rehearsal and shooting, the **script supervisor** stays close to the director making notes and making sure the director

Phoenix Films

Figure 9.8

The script supervisor will need to keep careful track of continuity for this scene. How much of the pumpkin is cut in each shot? How are items arranged on the table? Where are each person's hands during each shot? (Photo courtesy of Phoenix Films, Mark Chodzko, and Carol Carrick)

actually shoots all the lines of script dialogue at least once. Script supervisors are the keepers of continuity. They makes notes on such things as where props were located, whether doors were ajar, unusual filters used on the camera, where actors' hands were when they were saying certain words, the direction people walked, the amount of food on a plate, and the color of someone's tie (see Figure 9.8). They also prepare an **editor's script**. On this script they note any changes, such as dialogue rewording, that were made during production. They also mark all takes on the script so the editor will know how much of the scene each take covers. On the page opposite each page of script, they list all the shots and give pertinent information about each (see Figure 9.9).

Another bit of paperwork that needs to be completed during production is the **camera report** (see Figure 9.10). This includes a list of the scenes shot on a particular roll of film (or tape) along with the number of takes and pertinent information about each. If the camera report is for film, it will include information about the film and instructions for processing it. A camera report for videotape will include time code numbers to help the editor find each shot at a later time. The report also includes the number of the film roll or videotape. This is particularly important for theatrical length movies that require many rolls of film or tape but is less im-

portant for student productions shot on only one tape. The "remarks" column helps both the editor and the director as they prepare for editing. An assistant director, camera assistant, or production assistant fills out the camera report, and copies of it go to those who need it—the director, the lab, the editor, the producer.

When one scene is finished, another is started. If it is in the same location with similar lighting and props, the setup time can be minimal, but any scene change takes some time. If the location changes, the crew will **strike** (tear down and clean up) the old location and start setting up at the new location. Even if the shoot takes place in a natural location, such as a park, minor changes will need to be made in the service of the script.

Dailies

At some point during the day, the director and others may watch the **dailies**[6] from the day before or the day's shots recorded through video assist. Directors differ on how and when past footage is viewed. Most agree that watching every shot right after it is recorded is a waste of time mainly in that it really slows down production. On the other hand, if people look at a shot that is not going well, they can often see the problem and fix it quickly—in that way decreasing production time.

One of the crucial decisions is whether or not to let the actors watch dailies. Many actors are self-conscious about seeing themselves on tape and tend to downgrade their performance. Watching dailies can lead to a lack of self-confidence. Other actors demand reshoots if they don't like what they see. However, showing the actors specific mannerisms or using the dailies to talk about how the character might change can be very beneficial.

Others who may or may not watch the footage with directors include the editor, the cinematographer, the sound operator, the assistant director, and the script supervisor. Some directors like to watch dailies during lunchtime, whereas others think it is better to mix with the cast and crew at that time and to view material at the end of the day. Some directors like to have editors on the set to edit shots together shortly

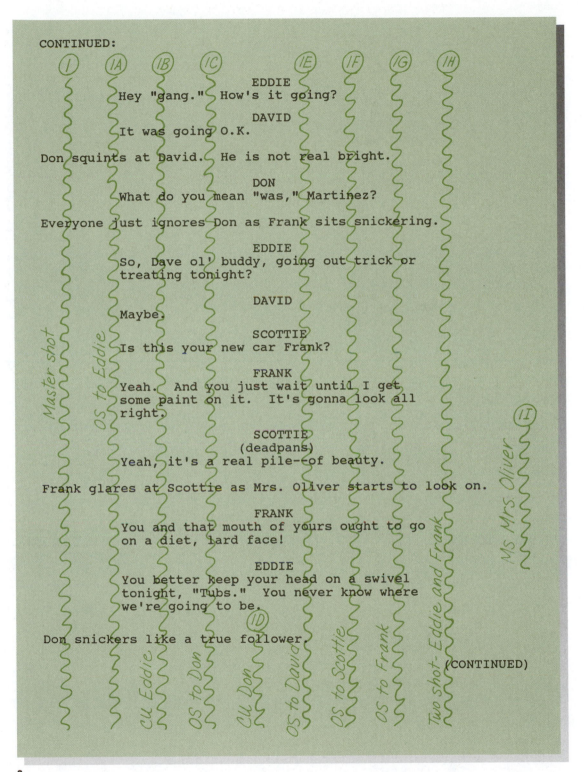

CONTINUED:

① ①A ①B ①C ①E ①F ①G ①H

EDDIE
Hey "gang." How's it going?

DAVID
It was going O.K.

Don squints at David. He is not real bright.

DON
What do you mean "was," Martinez?

Everyone just ignores Don as Frank sits snickering.

EDDIE
So, Dave ol' buddy, going out trick or
treating tonight?

DAVID
Maybe.

SCOTTIE
Is this your new car Frank?

FRANK
Yeah. And you just wait until I get
some paint on it. It's gonna look all
right.

SCOTTIE
(deadpans)
Yeah, it's a real pile-of beauty.

Frank glares at Scottie as Mrs. Oliver starts to look on.

FRANK
You and that mouth of yours ought to go
on a diet, lard face!

EDDIE
You better keep your head on a swivel
tonight, "Tubs." You never know where
we're going to be.

①D

Don snickers like a true follower.

①I

(CONTINUED)

Master shot *OS to Eddie* *CU Eddie* *OS to Don* *CU Don* *OS to David* *OS to Scottie* *OS to Frank* *Two shot- Eddie and Frank* *MS Mrs. Oliver*

a

Figure 9.9

(a) A page of script and (b) the corresponding notes made by the script supervisor. Note that the script supervisor has listed a few minor dialogue changes and has drawn lines that show how much of the script each shot covered. The sheet of notes lists each shot and all its takes, how long the shot was, whether the shot was completed in its entirely (C for complete) or stopped midway (I for incomplete). It also uses NG for takes that are definitely no good and includes other pertinent comments.

after they have been shot; they prefer this instead of or in addition to viewing dailies. Increasingly directors who shoot with digital video do not look at dailies at all. They trust what they have seen on the monitor.

Other Considerations

At the end of the day everything needs to be struck unless the shoot is in a studio and everyone is coming back there the next day. The director delegates overseeing striking the set to an

Figure 9.9
(Continued)

1	Master shot	10/11
1	:44 C NG Hair blend with sky	
2	:33 C NG camera jerked	
3	:35 C good	
1A	OS to Eddie	10/11
1	:20 I NG Don moves in front of lens	
2	:36 C good	
1B	CU Eddie	10/11
1	:33 C looks too close to camera	
2	:35 C OK	
3	:34 C best	
1C	OS to Don	10/11
1	:37 C sun in and out of clouds	
2	:10 I Don said "Marcus"	
3	:34 C OK	

1D	CU Don	10/11
1	:15 C good	
1E	OS to David	10/11
1	:10 I NG boom shadow	
2	:33 C	
1F	OS to Scottie	10/11
1	:33 C good	
1G	OS to Frank	10/11
1	:10 I NG car noise	
2	:35 C	
1H	2-shot Eddie + Frank	10/11
1	:26 I NG Frank laughed	
2	:27 I NG Frank laughed again	
3	:33 C good	
1I	MS Mrs. Oliver	10/11
1	:15 C	

b

AD or someone else. The **line producer** writes up the **daily production report** (see Figure 9.11) to send to the producer who will want to know if everything is on schedule and on budget. Sometimes the director has a meeting with the cast and the primary crew members to talk about the next day. Often everyone is too tired to do this so even trying is counterproductive. Some directors go home and edit the day's scenes on their home editing equipment. Most plan the next day's shoot and perhaps even email the various department heads to let them know what will be happening. And then they get up and do it all over again the next day.

Student shoots are usually not a day-in and day-out proposition, so they don't follow this pattern precisely. Sometimes the shooting can only occur during class time, which makes the director's planning all the more important. In other instances, it takes place on the weekend. Again, planning and execution are every bit as important as for a professional production because time is limited and cast and crew are depending on the director's leadership.

When there are problems on the set and things are not going right, the director needs to stop and solve them. Pretending problems are not there will not make them go away. If a particular person seems to be causing a problem, talk with that person privately. Actors, particularly, will lose trust if you share their troubles. The problem may be that everyone has gotten too boisterous on the set. Actors often need quiet to get into their parts, and crew members who are standing around gabbing don't do their work properly. Call everyone together, and assert your authority. Ask for professional behavior, and you will probably get it. Make sure none of the crew members are giving instructions to the cast. Actors become quite confused if someone other than you tells them what to do. If the mood on the set doesn't seem right, try playing some music that is the proper mood. You could even have some music for the movie composed ahead of time and play that.

Editing

After the last scene has been shot, most of the cast and crew pack their bags and head home or go on to other projects. Some of the actors may need to come back for ADR, and people involved with sound may work on for a while. But the director's work is far from finished. Now he or she works primarily with the editorial staff.

Editing is a lonely job. The editor and the director better be particularly compatible because they will share a tiny room for hours on end (see Figure 9.12). Editing is rewarding because it is the point at which you really make the story. You see all your hard work come to fruition as you decide on pacing, intensity, and the like.

Figure 9.10

An example of a camera report. (Courtesy of Crest National)

Some directors allow their editors to make the first cut while they tie up loose ends from production and perhaps even take a well-deserved vacation. Taking a break after shooting can be good for the movie. When you come back, you will be able to see the movie more clearly and be less reluctant to leave material that you slaved over but that doesn't work on the "cutting room floor." With computers there is, of course, no cutting room floor, but the concept remains the same.

The **editor's cut** is based on the script, the script supervisor's notes, things the editor observed if he or she was on the set or watched dailies, and, of course, instructions you have given. When you see the editor's cut, you will probably be disappointed. Some parts may be bad because the editor cut to the script and the script was flawed. The editor may have selected shots from bracketed material that you think are the wrong ones. That is why there is a **director's cut.** The Directors Guild of America contract says that directors have 10 weeks to deliver the director's cut, and they can make it free of interference from writers, producers, or studios.

Make an editing plan that works for you. You may want to start with easy changes you want to make to the editor's cut and then proceed to

Figure 9.11

An example of how a daily production report might be filled out.

DAILY PRODUCTION REPORT

Title __Old Mother Witch__ Date __October 16__

Director __Mark Chodzko__ Production No. __1__

Script Supervisor __Susan Stribling__ Day __18 of 25__

First Call __1:30 p.m.__ First Shot __3:07 p.m.__ Meal __5:15 p.m. for__ some of
cast. 6:00 for crew

First Shot __7:30__ Meal __----__ First Shot __----__

Wrap __11:38 p.m.__ Finish __12:42 a.m.__

	Scenes	Pages	Minutes	Setups
Total in Script	24	28	20	138
Taken Previously	16	20-5/8	13	92
Taken Today	4	3-1/8	3	24
Total to Date	20	23-6/8	16	116
To Be Taken	4	4-2/8	4	22

Cast Member	Makeup	Report on Set	Dismiss on Set	Meals Out	In
Grace Ridgley	2:00	3:00	5:45	5:45	6:45
Tommy Mays	6:00	7:00	11:38	5:15	6:00
Cynthia Thomas	6:00	7:00	8:37	5:15	6:00
Loreen Washington	7:00	8:30	11:38	----	----
Steve McLean	7:30	8:30	11:38	----	----

Scenes Shot Today __7, 5, 21, 12__

Scheduled Finish Date __10/24__ Estimated Finish Date __10/23__

COMMENTS (Explanation of Delays, Cast and Crew Absences, Etc.)

30-minute delay on Scene 21 because of need to get extra
extension cords.
Grip (Tom Coates) had to leave at 10:30 because of a family
emergency. This made wrap time extra long.

more difficult changes. If you didn't allow for an editor's cut (and most student productions don't), you and the editor may want to plow in and edit from the beginning of the movie to the end. But with nonlinear editing that's not necessary. You can edit all the scenes shot in one lo-

cation or all the scenes involving one actor. It's up to you.

You may even want to start with scenes you know will need intense music. That way you can get the composer going even though the movie isn't finished. Your relationship with the com-

poser becomes important at this stage. Although you may have conveyed ideas to the composer as early as the planning stage, this work now becomes more intense. You may want to build a temporary track from library music to give the composer a rough idea of what you want or to see for yourself what impact that music will make on the scene. You and the composer, who may be in another city, will be communicating back and forth as you request music that is more intense, less intruding, or whatever.

As you and the editor work on cutting each scene of the film, look at everything that was shot for that scene except material that you know is technically flawed. With nonlinear editing, it is easy to build two or more cuts of the same scene and watch them side by side to see which you prefer. Try to follow the script, but you may find some scenes aren't needed. Do your best to make actors look good even though they probably won't be totally satisfied with your choices regardless of what you do.

If you really need to reshoot something, try to do so, but expect objections from your producer because of the cost. Before deciding you need to reshoot, see if your editor has ideas on how to salvage the scene without reshooting. In fact, ask your editor for opinions frequently. Editors have seen many scenes rescued in post, and they usually have a bag of tricks. Most editors also have an innate sense of rhythm that you should use and respect.

If it is necessary to undertake ADR, have the actors bracket as they did during production. Get several performances at different intensities, but also ask the actors how they think they should read the lines because, by now, they really know their characters. Make sure the final sound mix serves the needs of the story.

When you think your movie is just about finished, test it on an audience, even if that audience is your classmates. This can be a devastating experience because your ego is so involved. Set your audience up for the movie by telling them what to expect, and be willing to make changes based on their input. If you don't initiate testing, your producer probably will, so it's advisable to seek the input while the movie is under your control.

When the movie is finished, you will probably experience a psychological letdown. It's hard

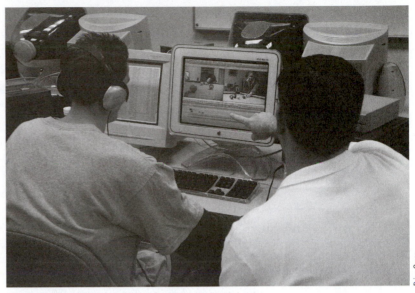

Brian Gross

Figure 9.12

The director and editor at work. (Photo courtesy of Brian Gross)

to let go of something you have been so intensely involved with. But, hey, there's always the next movie.

Notes

1. Some excellent books on directing are Mark Travis, *Directing Feature Films* (Studio City, CA: Michael Wiese Productions, 2002); Alan A. Armer, *Directing Television and Film* (Belmont, CA: Wadsworth, 1990); Steven D. Katz, *Shot by Shot* (Studio City, CA: Michael Wiese Production, 1991); Sidney Lumet, *Making Movies* (New York: Knopf, 1995); and Kevin J. Lindenmuth, *Making Movies on Your Own: Practical Talk from Independent Filmmakers* (Jefferson, NC: McFarland, 1998).

2. The reader/listener concept is well delineated in Chapter 6 of Peter F. Drucker, *Management Challenges for the 21st Century* (New York: Harper Business, 1999).

3. Mark Travis's book has several excellent chapters that deal in more detail with psychological ways directors can prepare actors for their character representations.

4. Chapter 6 of Alan Armer's book is particularly effective on this subject.

5. This is confusing because the word *bracketing* has two meanings. Both are appropriate, so the confusion will probably not be resolved.

6. *Dailies* is a term left over from early film production. The film shot each day was processed overnight so it could be viewed the next day. The concept still exists for movies shot totally on film, but video assist and shooting on digital tape are rendering the concept obsolete.

chapter ten
Editing

Commenting on the impact of digital technologies in 1992, director James Cameron said: "From the standpoint of the filmmaker, we're going to reach a point in a few years where we're going to think of postproduction in a different way. We're going to think in terms of image capture, which is the photography, and we're going to think in terms of the manipulation of the image—not just editing, but changing the components of what we've shot and recombining them in different ways, almost like an image mix in the same way that we mix sound."[1] Cameron's way of thinking has become commonplace as the years have passed and the areas of **preproduction, production,** and **postproduction** have merged.

As discussed in Chapters 1 and 9, **editors** are often on the set with laptops so they can edit scenes together shortly after they are shot. This enables the director to make sure he or she has shot the right material to put the scene together in a meaningful way. Showing investors part of a "finished" movie can keep those investors happy and perhaps help raise additional funds. Edited scenes can be sent electronically to others who need to deal with them, such as the composer or a visual effects house. Editing parts of a movie while other parts are still being shot can speed up the whole moviemaking process. For all these reasons, editing of many movies (*Star Wars: Attack of the Clones, Forrest Gump, The Flintstones*) starts before the shooting phase has ended[2] (see Color Plate 8).

Still, however, most editing is undertaken after all the footage has been shot. Almost all movies are edited on **nonlinear** editing systems. These are glorified computers with editing software (such as Adobe Premiere, Avid, Final Cut Pro, Media 100, Pinnacle Edition DV, and i-Movie) that takes advantage of the major characteristics of computers. The **random access** fea-

ture allows you to pull up any footage quickly, as opposed to waiting for tape to rewind. Material can be moved about, copied, deleted, and in other ways manipulated with the click of a mouse; multiple versions of the same scene are easy to create, store, and access. A wide variety of editing software is available, ranging from simple systems that can be loaded on a personal computer to edit "home movies" to complex systems that handle an entire theatrical movie. Regardless of the system, the footage must be prepared so it can be input and organized, edited and manipulated into the form its originator wants, and output to some form that can lead to its being viewed by others.

Making Material Computer Ready

Most nonlinear editing systems require that you place your footage into a computer. The steps needed to prepare the footage for such placement differ depending on how you shot the movie. As more and more movies are recorded using multiple formats (for example, some footage on 35mm, some on digital video, some HDTV, some VHS, and some Super 16), a variety of methods are employed so that everything winds up in one form that can be combined.

Film

The procedure is most complex if material is shot on film. First the exposed film must be taken to the laboratory to be developed and processed (see Figure 10.1). Usually this means you get back a negative, although reversal film can be processed too (see Chapter 3). Professional films are shot on negative, and a negative is usually what the **telecine** stage requires. In this stage, the film is cleaned and transferred to videotape. The telecine equipment (see Figure 10.2) reverses the polarity of each negative frame so that the image recorded on the tape is a positive. The equipment is also very gentle on the film. It does not pull it as a film projector does; rather, a **flying spot scanner** or a **linear CCD**

Figure 10.1

Film being processed. The exposed film is taken off its reels in a dark room (far right) put through several chemical baths, and then hung to dry. (Photo courtesy of Crest National)

Figure 10.2

This Cineglyph high-definition telecine can be used to transfer film to either standard definition or high-definition digital video. (Photo courtesy of Digital Audio and Video)

array electronically views each frame as it flows from a source reel to a take-up reel and translates the **luminance** and **chrominance** values into digital 0s and 1s.

This gentleness is essential because there is only one negative of the filmed material. If it is ruined, it cannot be restored. If the movie is going to be distributed on film, at some point the negative must be cut so that copies of the edited film can be made for theaters. For that reason, once the negative is through the telecine stage, it is stored in a cool, safe place until all the editing decisions have been made in the nonlinear editing system. If the negative is cut, there must be some way for the decisions made in electronic-based editing to be understood by the person cutting the film negative. The method involves **time code** (see Chapter 3), a special bar code numbering system called **Keykode** (Kodak's system) or **Mr. Code** (Fuji's system), and latent **edge numbers** that print out on the edge of the negative when it is developed (see Figure 10.3). As the film is transferred, any time code that it has with it is transferred also. If there is no time code, it is added so that it can be used for electronic editing. The bar code system is similar to that used at grocery store checkout stands. When the film is transferred to tape, special equipment tied to the telecine reads the bar codes and, through a computer program, relates them to the time code and the edge numbers. After electronic editing decisions are made, the time code numbers can be translated to the edge numbers so that the original negative film can be conformed properly.[3]

One of the problems inherent in transferring film to video involves the speed of each. American TV operates at 30 frames per second, and most film is shot at 24 frames per second. To compensate for this, a **three-two pulldown** method has been devised for the transfer of film to video. Generally the odd-numbered frames of the film are placed on two **fields** (a field is half a frame; see Figure 3.7) of the video signal, and the even-numbered film frames occupy three video fields (see Figure 10.4). Over the course of 24 frames, 6 extra film frames are added to equal the 30-frames-per-second rate of video. Of course, if the film is being transferred to the 24P video format, this three-two pulldown is not needed, but that assumes that the video will be placed in an editing system that operates at 24 frames per second.

During the transfer process, the telecine operator can alter the film image to some degree,

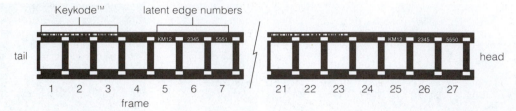

Figure 10.3

A diagram of 16mm film with edge numbers and Kodak's machine-readable Keykode numbers. The edge numbers cannot be seen on the raw stock but are visible once the film is processed. On 16mm film the edge numbers come every 20 frames, and on 35mm they come every 16 frames. The first edge numbers (KM12 in this example) refer to the date and emulsion batch. The other two sets of edge numbers are part of a sequence of numbers that go from the beginning to the end of the reel of film.

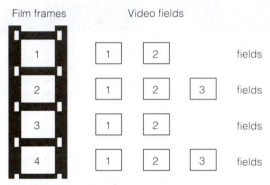

Figure 10.4

The three-two pulldown method, which compensates for the speed difference between film (24 frames per second) and video (30 frames per second). Film frames are alternately scanned with two fields (one video frame) and then three fields (in effect, 1-1/2 frames) so that 24 film frames equal 30 frames (60 fields) of video.

depending on the characteristics of the equipment. Some telecine scanners are capable of limited visual effects, such as rotating the frame or cutting off part of the image. **Colorization** (also called **timing**) often occurs at this stage. If the film is too red or too bright, its characteristics can be changed during the transfer process. Also, if shots for one scene do not match each other in terms of color, one or the other of them can be tweaked so they do look alike. In these cases, the director might sit with the **colorist** (or **timer**) as the film is being transferred to make sure the changes are to his or her liking. Of course, not everything needs to be transferred. If the director is not planning to use a particular group of shots in the editing process, there is no need to transfer those shots to tape.

Sound is not part of the telecine process. It is transferred separately, usually to **DAT** so that it, too, is digital and can be placed in the nonlinear editing system. It is important that time code attached to sound is transferred so it can be matched with the appropriate time code of the picture. Sometimes sound is transferred for shots even though the video is not transferred. If the picture was out of focus but the sound was particularly good, the sound may be used with a different picture.

Analog Video

If material was shot with an analog video format, such as **VHS** or **Hi-8** (see Chapter 3), it must undergo an analog to digital conversion to be accessible in a nonlinear editing system. This is done with a digital capture card or cards[4] (and accompanying software) and is sometimes transparent. When the cards are built into the computer, it is merely a matter of connecting the output of the analog VCR to the proper connector on the computer; the software **digitizes** the tape material (video and audio) as it plays into the computer. Another way is to dub the analog tape to a digital format such as **Mini-DV** or **DVCAM**. The digital recorder must have the necessary electronics built into it so it can convert the analog signal to digital.

Usually, it is necessary to employ **compression** when going from analog to digital. Compression conserves space on the hard drive and is also an important variable in overall image quality. Many different **codecs** (codec is an abbreviation for *co*mpression/*dec*ompression) are available for the compression process. The one

most often used with video editing is M-JPEG, but other codecs such as MPEG 2 and MPEG 4 are common.[5] Many factors go into compression, but one way to look at it is that some of the frame information is left out. For example, one form of compression, called **spatial compression,** looks for repetition among pixels.[6] It says, "All pixels in this sky area are light blue." And then it does not record information about each pixel. To some degree, the picture loses sharpness and definition because, in reality, some of the pixels are slightly different shades of light blue than others. With some compression systems, called **lossless,** all information from the original clip is preserved, and when the material is decompressed, it is back to its original quality. This limits the degree of compression that can take place, however. With **lossy** compression, some of the quality does not come back. For example, if the sky actually contained 80 shades of light blue, the lossy system might restore only 65 of those shades. You can usually choose the amount of compression you want. A high compression ratio such as 50:1 provides a lower quality picture than a low ratio such as 2:1 and generally means that you have to work with an image of poor resolution. The advantage of a high compression ratio is that you can get more footage on your hard drive because it uses less room.[7]

Not much is shot with analog video anymore, so the need for hardware and software to accommodate its entry into nonlinear editing systems is diminishing.

Digital Video

Digital video is the simplest of all to prepare for nonlinear editing. Basically it is a straight transfer from the digital videotape into the computer with no degradation. Digitization, compression, and audio sync are all handled in the camcorder during shooting. The computer does need an interface (codec) card, but the transfer is seamless. The 0s and 1s that have been recorded on the tape come into the computer though a **FireWire** cable and connector[8] (see Figure 3.26).

If video and audio are recorded on a removable hard drive, that drive can be inserted into a nonlinear editing system with provision for removable hard drives, and the material does not even need to be played from a recorder into the computer. At present if a movie is recorded using the 24P format, it may need to be transferred using the three-two pulldown technique so it can be edited in a system set for 30 frames per second. There are also nonlinear editing systems designed to work with 24P (and there probably will be more in the future).

With today's editors, regardless what format you start with, it is a good idea to get your footage onto digital videotape that will play on your camcorder and transfer into your nonlinear system. That is the most common method for making material computer ready.

Setting Up the Computer

Before you can start putting footage into the computer or editing it, you will need to install the nonlinear editing program you plan to use. You will also need to create a folder where you will save your project. Whether you are doing this at home with inexpensive software or using a more elaborate system at work or school, the process is similar and often does not even involve activating the nonlinear editing software.

If you are working with a nonlinear system that is being used by other people, you may be required to set up a **scratch disk** so that everything you create goes into one place and does not become mixed up with other projects. You may need to fill in some screens in your software program so your computer knows what you are using for an input and output (for example, FireWire), and you will probably need to select whether you want to transfer in video only, audio only, or both. You may also need to indicate how you captured the audio while you were shooting (for example, 48 kHz or 96 kHz) so that the editing program works to the same parameters (see Chapter 7). All editing programs have many screens with choices. Generally you use the defaults or the settings chosen by your engineer, but it is a good idea to read the instruction manual so you know what the various choices control.

Scene	Take	Time Code Min:Sec:Frames	Description	Comments
2	1	05:10:00 – 06:12:07	L S Street	Search for best sound
2A	1	11:15:03 – 11:17:04	C U Tom	Use as reaction
2	3	10:12:07 – 11:07:20	L S Street	
2C	1	15:16:04 – 15:18:19	C U Maria	Use doorbell sound
3	1	20:34:12 – 21:15:12	L S Livingroom	
3F	2	29:17:02 – 30:17:07	M S Bill + Teresa	See if works
3D	1	26:12:12 – 27:13:02	M S Bill + Teresa	Use this if 3F doesn't work

Figure 10.5

A type of pre-edit list you might make prior to working on the computer. (Artwork by Donny Sianturi)

Logging

Logging is important in the process of deciding which footage will be placed in the computer so that it can be used as part of the final movie. It is possible to place every frame recorded into the computer, but this is generally a bad idea. Computers have limited hard drive space, so you can easily run out of room.[9] And, in all likelihood, the computer is being used for projects other than yours (especially in classroom situations). Even if the computer can hold everything, you are much better off limiting your input so you can work more efficiently and with less confusion. It is best to make some editing decisions before you sit down at an expensive setup that you can only access for a limited amount of time.

Several bits of paperwork produced during shooting can help you narrow down what you put in the computer. The **script supervisor** keeps an **editor's script** (see Figure 9.9) that gives a guideline of what to use where. The assistant director or a production assistant usually fills out a **camera report** of what is shot (see Figure 9.10). The comments on this report about the quality of what was shot can certainly help you decide what to eliminate. As discussed previously, you can weed out some filmed material prior to its going to telecine. The editor's script and camera report come in very handy at this stage. You can also connect a camcorder to your home TV set and make notes about what takes to include. This works particularly well if you can arrange to get a **window dub**—a copy of all your material with time code numbers inserted over it. You can use it to indicate the time code numbers of film you want to use (see Figure 10.5). On a more formal level, **off-line** facilities (ones not used to produce the final product) have software that captures time code numbers as you view the tape and make decisions. These time code numbers can later be transferred to an **on-line** editing system where the final product is produced.

Once you have made some initial decisions (or even if you haven't), you use the nonlinear editing software to decide what to put into the computer—a process called logging on most computer systems. Place your footage into a tape deck connected to the computer.[10] If you haven't viewed it previously, you can view it and (using the mouse and icons on the screen) mark where you want to start a shot that will go into the computer and where you want to end it.[11] Or, if you know the footage well, you can fast forward (again with software controls) and mark your in- and outpoints. Or you can type in time code numbers for each entry. You give every clip a name and type in other information about it as you are logging it.

You should always log your clips so that there are at least 5 seconds in front of what you are

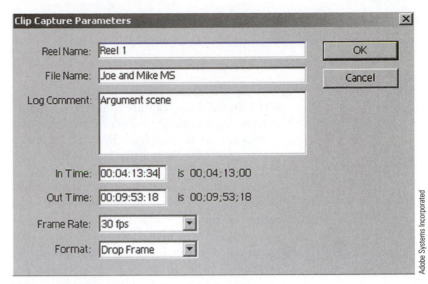

Figure 10.7

Some of the parameters that relate to capturing. (Adobe product screen shot reprinted with permission from Adobe Systems Incorporated)

Figure 10.6

A bin from Adobe® Premiere®. (Adobe product screen shot reprinted with permission from Adobe Systems Incorporated)

planning to use (**head**) and 5 seconds after what you are planning to use (**tail**). These heads and tails give you flexibility when you are editing and are also needed for a number of transitions and visual effects. If you have several short clips, combine them to keep down the clutter.

As you log your clips, their names or little pictures of their first frames (called **thumbnails**) will appear somewhere within the computer program—in bins, a library, a browser (see Figure 10.6). However, logging clips does not actually get them into the computer. It only indicates what clips you plan to put in. **Capturing** is what actually places them in the computer.

Capturing

Before you capture, you often need to enter (or check) parameters to make sure you are capturing the material correctly (see Figure 10.7) Most nonlinear editing programs allow you to capture in a number of different ways. One of the most common methods is **batch capturing**. After you have logged everything you want to put in the

computer, you give the computer a command to capture it all at once. The computer automatically rewinds the tape and records each clip you indicated onto the hard drive. It does not capture any of the material you did not log. You can also **direct capture**. Without marking anything first, you tell the computer to start capturing, and it will record from the tape deck onto the hard drive until you give it a command to stop capturing. This is a good type of capture to use if you know you want to put everything you shot on the hard drive, but it has the inherent problems of possibly overloading the hard drive and supplying too much disorganized material. A third method is **clip capture**, which enables you to capture clips one at a time right after you have logged them. This is an effective method for just a few clips scattered on several tapes, but it is a much slower method than batch capturing if you are working with many clips.

Most nonlinear editing software has some way of indicating which clips have merely been logged and which have been captured. They also allow you to save the time code numbers for what you logged and captured to a floppy or zip disk. Then, if for some reason, your footage disappears from the computer, you do not need to make all the logging decisions over again. You simply import what you saved on your disk, put your tape in the tape deck, and give the computer the command to capture all the material again.

You can usually specify the quality you want the material you capture to be. Draft quality gives you a rather fuzzy, grainy picture, but it does not use as much hard drive space as higher quality. What editors often do is use draft quality for a rough edit so they can work with a great deal of material. Then they use the time code numbers to recapture only the material they used for the rough edit in a higher quality mode. With less material in the machine, they can edit a better-looking version to show to others.

You can capture material other than your taped footage. For example, you can bring in music from a CD, sound effects from DAT, a still photo from some other computer program such as Photoshop, or elaborate effects prepared at a visual effects house. Usually you have to capture these materials in a slightly different manner so that they are compatible with the nonlinear editing software you are using. For example, a CD is recorded at 44.1 kHz, but most digital systems use audio that is 48 kHz, so that CD audio has to be converted before it can be used with the editing equipment.

After you have captured your footage, be sure to save your project. Save frequently while you are editing. Computers are susceptible to crashes, and it is discouraging and, in the professional world, expensive to have to redo work you have already done. If you want to take a break after you have captured all your material and you are working on a computer that has other projects on it, be sure to close your project so the next person does not accidentally have access to it. If your system has provisions for a removable hard drive, take all your footage with you and insert the hard drive when you return.[12]

Cutting Clips Together

Once the footage is logged and captured into the computer, the creative act of building the movie can begin. Because of the flexibility of nonlinear editing, there are many ways to work on a movie. If you are a student, you might want to work on all the easy scenes first, leaving the more complicated scenes until you feel totally comfortable with your editing software. Professional editors often work with scenes for which they have all the footage while leaving other scenes that are still being shot for later. Sometimes a scene is only partially edited, awaiting elements from a visual effects house or audio workstation that will be incorporated later. Some editors (or directors) like to perfect one scene or sequence of a movie before moving to another; others like to get all the shots for an entire movie arranged in a general order and then go back and fine tune.

It is sometimes advantageous to have several people editing one movie. This is certainly possible with nonlinear editing because footage for three scenes can be captured into one computer while footage for two other scenes is captured into a different computer. In the professional world, when editing time is short, an editor may give general direction to several **assistant editors** who edit portions on their own computers. Then the edited scenes can be captured into one computer to compile the entire edited movie. At the student level, it is often advantageous to divide the footage so that everyone has a chance to do some editing. For student-produced group projects, it is easy to find plenty for 10 people to do during the planning and shooting stages of moviemaking, but it is more difficult to engage everyone during editing. Ten people in an editing suite, all expressing their opinions, can lead to bedlam. If the footage is divided (or if smaller groups capture all the footage into as many computers as are available), then everyone can have an editing experience.

Nonlinear editing software is so flexible that it is easy to edit in a variety of ways. To explain the basic process, we will assume that you alone are editing a short, rather simple movie and are putting the shots together in the general order that you want for the finished product.

Windows

Nonlinear editing gives you access to various **windows** of material. These windows can all fit on your computer screen, but they can be confusing and difficult to see if there are too many on one screen. For this reason, many software

Figure 10.8
In this Avid setup, the first frame of each clip that has been captured is shown on the right-hand monitor. The left-hand monitor shows the clips to be edited, the material that has already been edited, and (below that) the time-line. The computer and VCR are further to the left, and the keyboard and mouse reside in front of the monitors. (Photo courtesy of Avid Technology, Inc.)

programs recommend that you spread the material over two computer monitors. Most also recommend a TV monitor where you can see how your movie will look on someone's home TV (see Figure 10.8).

Although systems differ, one window (called bin, project, library, browser, or explorer, depending on the program you are using) contains a list of all the clips you logged and captured into the computer. Another window (source, viewer) shows you the clip you are planning to edit, and a third window (program, target, canvas, record, edit) shows you what you have already edited. The workhorse window is the **timeline,** a screen that shows how you have assembled the material you are using for your movie. Other windows show tools you can use as you edit or special functions you may use often. Most programs give you the option to organize the windows on your desktop in a variety of ways, so choose the one that feels most comfortable to you (see Figure 10.9).

The Assembly Process

To start putting your movie together, select the first clip you want (probably something with picture and dialogue) from the window that lists the clips, and bring it into a window where you can view it. There are many ways to do this (and everything else related to nonlinear editing)—you can drag the clip, click on appropriate icons, use menus, or type keyboard commands—the choice is up to you. Once you have the clip where you can see it (such as in the source window), play it using the transport controls on the window. Other controls allow you to mark precise **inpoints** and **outpoints** that designate exactly how much of this clip you want to use (see Figure 10.10). Of course, you can always go back and change your mind. That is a beauty of nonlinear editing. Because the clip is stored in the computer, it is easy to add or subtract frames at any time.

Once the in- and outpoints are marked, drag that portion of the clip to the timeline. (Or you can do it the other way around. Drag the clip from where it is stored to the timeline, then double click on it in the timeline, and it will appear in the window where you can view it.) On the timeline place the picture on the first video track and the sound on the first audio track, or two tracks if it is stereo. The video part of the timeline shows the first frame of your clip, and the audio portion shows a waveform of the sound. This is one example, but you have many

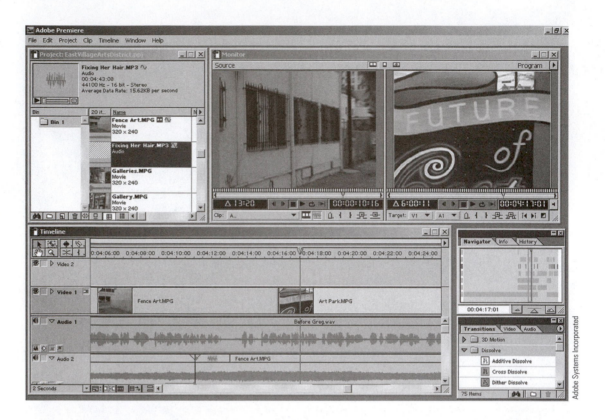

Figure 10.9

This overall view contains the bin where the clips are stored, the source window where you can view and edit material, the program window where you can view your edited material, the timeline where you manipulate material, a window to help you get around the system, and a window for adding transitions. (Adobe product screen shot reprinted with permission from Adobe Systems Incorporated)

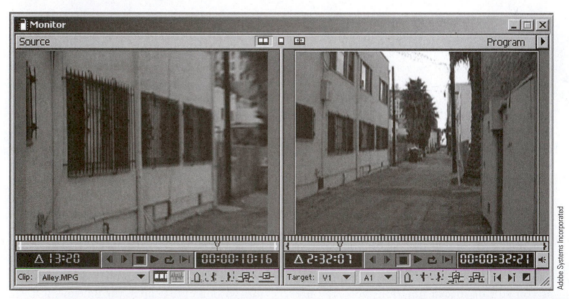

Figure 10.10

This shows both the source and program windows. The controls at the bottom move the image forward and backward. The icons at the very bottom can be used to mark in- and outpoints. If you know time code numbers, you can type them in and the footage at that number will appear. (Adobe product screen shot reprinted with permission from Adobe Systems Incorporated)

options to choose from as you build your timeline (see Figure 10.11).

Then bring in the next clip you want to use, mark its in- and outpoints, and position it on the timeline right next to your first clip. If you wish to at this point, you can view the first two clips as they have been edited together. There are many ways to view, but one is to use the transport controls on the window that shows

you what you have edited (refer to Figure 10.10). You can see the results of your editing on the computer screen or on the TV monitor.

Continue to bring in more clips, mark their in- and outpoints, and place them where you want them to be on the timeline. Remember to save frequently. If you are planning to have music or sound effects or still photos, bring those clips in just as you have done for picture

Figure 10.11
A timeline with one track of video and three tracks of audio. (Adobe product screen shot reprinted with permission from Adobe Systems Incorporated)

Adobe Systems Incorporated

and dialogue clips. Audio clips usually show a waveform that indicates the volume of the sound, and still photos usually have a frame of the picture. You can bring these elements in as you are editing each scene, or you can wait until the end and add them all at once. When you have all the clips you intend to use for your movie on your timeline, you have created a **rough cut.** When you view your rough cut, you will probably see ways to improve your movie.

Fine Tuning

As you watch your movie, you may feel that some shots last too long and lose their impact and that others are too short for the audience to grasp what is happening. Shortening or lengthening shots is very easy with nonlinear editing. Because all the footage is stored on the computer, you can seamlessly pick up a few frames from the original captured footage, or you can "remove" frames, in which case they simply stay where they are but no longer show up on the timeline. Nonlinear editing is **nondestructive** in that even though something is eliminated it is still there and can be retrieved at any time. Shortening and lengthening shots is called **trimming,** and, as should come as no surprise, there are many ways to trim.[13] One way uses an icon that looks like a razor blade, which can "shave off" a few frames or cut a shot into several pieces. Usually you will want the shot following the one you trim to move backward or forward

(**ripple**) so you do not have a hole in your movie where you took out frames or overlapping frames where you added something. Different commands or menus will allow you to indicate that all the gaps should be filled, overlapped, or deleted.

You may also decide that you want to move the audio in relation to the video. This, too, is easy. First, unlock the two so that they do not ride together. Menus, keystrokes, or a mouse click on a chain icon usually accomplishes this. Then drag the audio or video backward or forward until it is positioned correctly.

If you want to exchange two scenes, you can cut and paste (or click and drag). If you decide to show a picture at several different places, you simply select what you want and copy it to its new locations. By the same token, you can select a bit of audio (perhaps the sound effect of a ringing bell) and **loop** it to play over and over throughout a particular sequence. While you are making changes in one scene, you might want to lock the other parts of your timeline so they cannot be altered accidentally.

If you feel you need to add some **voice-over,** most systems allow you to record directly onto the hard drive by attaching a microphone to the computer. Of course, you should be in a quiet location for the voice-over to be recorded properly. If you placed the sound on your timeline in mono but feel it would be more useful in stereo, you can change that, too, with a few mouse clicks. In short, there are many things

Adobe Systems Incorporated

Figure 10.12

A graphic being created using the character generator function. (Adobe product screen shot reprinted with permission from Adobe Systems Incorporated)

you can do to improve your movie. One of the inherent problems with nonlinear editing is that it is so easy to make changes that people are tempted to fine tune forever, but eventually you must get to the **final cut.**

Adding Graphics

You will probably want some graphics in your movie—opening and closing credits at least. Fancy, stylized credits are often created in a visual effects house (see Chapter 12) and are then incorporated into the movie, but nonlinear editing programs have provisions for creating attractive, eye-catching credits. A built-in **character generator** can be accessed through a pulldown menu and used to type in words and numbers.

You can choose to place the credits over video or over one of many possible background colors. You can also choose the **font** you want for the letters, as well as the size and color of the letters. In fact, you can shade either background colors or letters, perhaps having a light blue top change gradually into a dark blue bottom. You can add black or colored shadows around the letters so they are easy to read regardless of the background. You can underline, boldface, italicize, and change the spacing between lines and between letters. What's more, once you have done all these things, you can change them easily—in much the same way you change ital-

ics to underlining in a word processing program. You can position the letters in the middle of the screen, at the bottom, or wherever you want them (see Figure 10.12).

Once you have built the graphics using the character generator, drag them (or in some other way place them) into the timeline. Here you can make them last for as long as you want by indicating the length of time they should be on in terms of frames or seconds. If you don't like the amount of time you chose, you can trim the credits with or without trimming any accompanying video. If you don't like the look of the overall graphic, you can always go back to the character generator and modify it. Somewhere along the way you can select how the titles and graphics will appear in the finished product. You can select to have them roll up the screen, crawl across the bottom of the screen, zoom in, blink, and so on.

Often graphics need to be **rendered**—built so they can be played back in real time. Before they are rendered, you can display a frame on a video monitor to see how the credits will look, but if you try to play back the entire movie, the credits will not show because the information cannot be processed quickly enough. Rendering (which on some programs can be done in the background while you are working on other things) builds the graphics so they can play back at 30 frames per second.

Aside from opening and closing credits, graphics are usually not abundant in dramatic movies, but they can play a large role in documentaries and other projects of an informational nature.[14]

Adding Transitions and Other Effects

You may also want your movie to have some **transitions**—methods of getting from one shot to another. If you just place your shots on the timeline one after another, the shots will **cut** from one to another. However, you may prefer to have one shot fade in slowly while the other fades out (a **dissolve**), one shot push the other off the screen (a **wipe**), or one shot **fade-in** from black at the beginning of the movie or **fade-out** to black at the end. (The aesthetic reasons for using various transitions are discussed in Chap-

ter 11.) In a similar fashion, you may want to have transitions with your audio such as having one sound fade in while another fades out or fading out sound at the end of the movie.

Somewhere within your nonlinear editing software is a menu for transitions (see Figure 10.13). It will list the transitions you can choose and probably show you an example of each. Select the transition, and drag it to your timeline. On some timelines, you simply place the transition on top of the two shots that are side by side and, instead of having a cut, you will have the selected transition. On other systems, you place the two shots involved on two different video tracks and place the transition between them (see Figure 10.14). The latter is often referred to as an **A-B roll** after a film cutting process of the same name (see Chapter 14). The A-roll is one track of video, and the B-roll is the other. By manipulating these two tracks, you can do effects between them.

Some systems handle fades in a different manner than other transitions, and some handle them in the same manner, inserting black as one of the shots. For the transition to look correct, you may need to add some frames to one or the other of the shots. This is when you will be glad you captured a little more of the shot than you thought you might use. Usually there is a way for you to set the length of the transition—a 3-second dissolve, a 5-second page turn.

Figure 10.13

A list of transitions that might be available on a nonlinear system. (Adobe product screen shot reprinted with permission from Adobe Systems Incorporated)

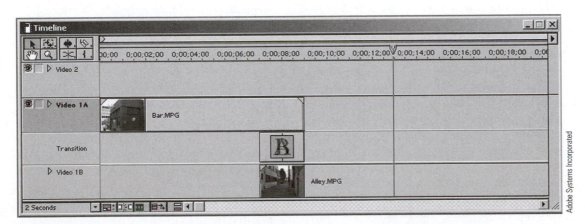

Figure 10.14

This timeline shows a dissolve between two shots. (Adobe product screen shot reprinted with permission from Adobe Systems Incorporated)

Figure 10.15

In this situation, the music fades to a low level and stays there for a while and then fades back up to a high level again. This would be appropriate if there were dialogue in the middle section that you wanted to make sure was audible over the volume of the music. (Adobe product screen shot reprinted with permission from Adobe Systems Incorporated)

Audio transitions are similar in that a fade-in goes from silence to sound, a fade-out goes from sound to silence, and a **crossfade** goes from one sound to another. (Another audio transition is a **segue,** which is an abrupt change from one audio source—usually music—to another. It is somewhat analogous to a cut in video.) Sometimes audio transitions are created in a manner similar to video transitions—by placing the transition name between or on top of the waveforms. However, often they are produced using points (sometimes called **handles**) and lines (often referred to as **rubber bands**). For example, you might want to bring down the volume of the audio because it is under dialogue. You could create a point (by using a tool that looks like a pen or pencil) where you want the lower volume to start, then draw a line (stretch the rubber band) down to a handle where the volume is to ride. After the dialogue is over, raise the volume with more handles and rubber bands (see Figure 10.15).

Most nonlinear editing systems can create effects other than transitions. For example, you can manipulate filters to change the look of graphics and video footage or the sound of audio. One type of filter blurs the image, and another distorts it in a variety of ways. If the camera operator forgot to place an orange filter on the camera when shooting outdoors, you can use the nonlinear software to add that filter effect. An editor can use filters to do the job that can also be undertaken by the film timer—that of correcting color within various shots or scenes of a movie. However, a timer working in a film lab must apply the timing setting to an entire frame; with nonlinear software an editor can color correct a small portion of a frame because the information is in digital form and each pixel can be manipulated separately. It is possible to use several filters at the same time and to spread a filter effect over one clip, multiple clips, or a portion of a clip. Audio filters can get rid of a high-pitched noise, add **reverberation** to sound, make

one person's voice sound like many people, and the like. Both video and audio filters are applied from menus in manners similar to transitions.

Nonlinear software can change the speed of either picture or sound. At a simple level, you can individually delete frames to create fast motion or duplicate frames for slow motion. Likewise, you can remove or stretch portions of sound. Some programs are designed so that the software itself creates the change of speed according to the parameters you give it.

Some systems have capability for **matting,** in which two shots are combined in such a way that they form a whole. This is often referred to as **blue-screening.** Some action (such as a man running) is photographed in front of a blue screen; when the matting is undertaken, the blue drops out and a different background (such as a swimming pool) is inserted. It then looks like the man is running on the swimming pool. What nonlinear editing systems can do in relation to blue-screening is rather limited.[15] Complicated visual effects are usually completed on computers specially equipped for them and are then imported into the movie. The same is true for complicated audio effects. If there are many tracks of ADR, sound effects, and music, they are usually mixed separately (see Chapter 12).

Transitions and other effects that need rendering use the same process as graphics rendering. The entire movie can be rendered at one time after you have finished editing, but this takes a long time, and you will not be able to see how elements look as you are building them. It is better to render things after you create them. However, you can do the initial rendering at a lesser resolution so that it goes quickly; then render the whole movie at a higher resolution when you have finished.

Useful Tools

Nonlinear editing programs have many features that aid the editor. **Undo** is probably one of the

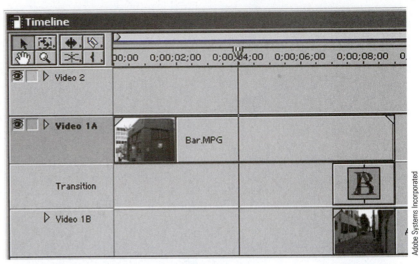

Figure 10.16

The playhead on the timeline allows you to move through what you have edited at varying speeds depending on how quickly you drag the playhead with the mouse. (Adobe product screen shot reprinted with permission from Adobe Systems Incorporated)

most valuable. If you make a mistake or don't like an edit you made, simply click on the undo icon to eliminate your last action. Some programs show you a list of the actions you have taken the whole time you have been editing, and you can choose which you want to undo.

There are many ways to move around your movie. A **playhead** symbol that moves through a **scrubber** strip allows you to scrub through the strip at the rate you drag the playhead. You can watch and listen to one frame at a time, or skip through the movie quickly (see Figure 10.16). A **jog** control takes you through the movie one frame at a time, and a **shuttle** control goes through the tape with varying speed depending on how far the control tab is to the left (reverse) or right (forward). With some programs the arrow keys allow you to move one frame at a time or one second at a time or to the beginning or end of the movie. You can also place markers on your timeline, and set the program so that you can be transported to those markers quickly.

You can zoom in or out of specific parts of the screen or magnify frames of the entire timeline. Often this is accomplished by working with a magnifying glass icon. In some programs this glass is included on a tool palette along with other useful items such as the razor blade for trimming, a tool for pulling frames on the timeline next to each other, and a tool for marking in- and outpoints (see Figure 10.17).

Many tabs have pulldown menus. For example, a tab may allow you to edit shots together in a variety of ways—you can insert a shot between two shots, overwrite a shot already on your timeline with another shot, superimpose one shot on top of another, or select a shot and have it "fit to fill" (use as much of it as needed to fill a particular hole in the timeline).

There may be a "Find" command to help you locate clips, and a menu that allows you to access the clips you have worked on recently. Rollover labels tell you what the different tools and transport controls are for, and there are often several varieties of audio meters and audio mixers. And then there is the ever-handy "Help" menu to aid you when you are confused.

Don't expect to find all these functions on your editing system, but if you look hard enough, you will probably find something simi-

Figure 10.17

This tool palette shows (from left to right, top row then bottom row) a tool to select items, one to draw a block around sections, one to make sure edits ripple, a razor tool for cutting parts of clips, a hand tool to move elements, a tool to zoom in or out on a particular part of the screen, a crossfade transition tool, and a tool to mark in- and outpoints. (Adobe product screen shot reprinted with permission from Adobe Systems Incorporated)

lar. Also, this does not begin to cover all the possibilities inherent in nonlinear editing. You will find many more options when you read the instruction manual for your particular system.

Outputting the Project

When you work in a nonlinear editing system, your movie is not actually there. The timeline is merely a list of editing decisions that you can keep changing until you are satisfied with your work (or run out of time). Although you can watch the whole movie on a monitor attached to the computer, you cannot show it other

Adobe Systems Incorporated

Figure 10.18

A screen for setting up a countdown. (Adobe product screen shot reprinted with permission from Adobe Systems Incorporated)

places until you **print to tape** (or CD-ROM or the Internet). The various options related to how you intend to show your project will be discussed in Chapter 14. Here we will assume you are going to output the movie to digital tape.

You must make sure your computer is properly connected to the videotape recorder and that you have all the settings correct so that the signal actually records on the tape. Don't forget to put a tape in the machine and, if there is other material already on the tape, make sure you are not going to record over something you want to keep. You can often choose the quality you want for your tape—VHS, Betacam, DVCAM (low, medium, high). Do you want stereo or mono sound? Do you want interlace scanning or progressive scanning for HDTV? Do you want to export just one project or several projects all at once? Do you want to make several copies of the movie? Do you, perchance, want to export only part of the movie—maybe just the last 3 minutes or just the sound?

Before you actually export your movie, build a **leader** to go at the beginning of it. A leader provides technical and identifying information and also prevents placing program material at the head of the tape where it is most likely to be subject to damage. Most systems present you with a menu of items you can choose for the leader and build it for you. The standard leader for the beginning of a program consists of **color bars** and **tone**, a **slate**, and a **countdown**.

Color bars and a 1 kHz tone are important when someone is playing the tape back on some other system. An engineer can use the **vectorscope** and bars to make appropriate adjustments in color so that the colors recorded are the colors played back. He or she can also make sure the tone registers on a **VU meter** at 100 percent so the audio will play back as it was recorded.

The slate identifies the program and contains such information as the program title, the director's name, the date the program was edited, and the program's length. If the system you are using does not have provision for filling in information for a slate, you can easily create one with the graphics provided with the software. Someone playing back the tape uses the slate information to make sure the right program is being shown.

The countdown (see Figure 10.18) gives the number of seconds before the program material will appear. Countdown numbers usually go from 10 to a single frame of 2, followed by black. Countdowns stop at the number 2 so that 2 seconds of black can play before the program's image appears. If the tape is being broadcast, the countdown is used to make sure it comes on at the right time.

Once you have everything ready, give your system the command to print. If you haven't rendered everything that needs rendered, the system will do the rendering at this point. Make sure the VCR is set to record, and play the leader and the movie through the FireWire into the tape recorder. Check the tape after you have recorded it to make sure your recording is acceptable. Computers are notorious for hiccupping or in other ways causing glitches, so examine the copy before you leave the computer station. In addition to outputting your project, save your capturing and timeline information to a floppy or zip disk. If you are going to be undertaking further editing on another system, this information can serve as your **edit decision list** (**EDL**) so that the editing can progress rapidly (see Chapter 12). However, it is handy to have regardless, just in case you want to redo something at some future time.

Once your project is finished, remove it from the computer so other people have sufficient hard disk space for their projects. Usually this is a matter of hitting the delete key or dragging the

project to the trash bin and emptying the trash. Close down the nonlinear editing program so that the next person using the computer can start fresh.

Linear Editing

Before there was nonlinear editing, there was **linear** editing.[16] It wasn't called that—it was simply referred to as video editing. As mentioned in Chapter 1, film used to be edited by cutting the actual film and splicing it together so the shots were in the proper order. Long after film editing was developed, video editing appeared. The very earliest video editing was of a cut and splice nature too, but this was abandoned because it was impractical. The human eye cannot see individual frames of video on tape, and the equipment designed to enable the human to see the end of one frame and the beginning of another was tedious and unreliable. What developed instead was an electronic process dependent on recording desired material from one tape to another. The shots were recorded from the beginning of the program to the end in a linear fashion. This form of editing was not used often for editing theatrical movies, but it was used (and still is to some degree) for television programs and student movies.

Linear editing involves at least two tape recorders—one containing the source material from which the final program material will be selected, and the other containing the tape onto which the selected material will be recorded. After editing an entire production, if you decide that the second edit should be 2 seconds shorter, there is no easy way to fix the problem. You can either edit everything over again from the second edit on, or you can rerecord the first two edits to another tape, shortening the second edit, and then dub (edit) the rest of the material onto that same tape. Although it is possible to have linear editing for digital material, linear editing had its heyday when material was recorded in an analog fashion. A problem with rerecording analog material is that it experiences **generation loss** because signal information is lost or contaminated when the material is dubbed from one analog tape to another. Digi-

Winsted Corporation

Figure 10.19
This linear editing system has two VCRs, two monitors, and a controller. (Photo courtesy of Winsted Corporation)

tal nonlinear editing does not suffer from generation loss, and material can be moved around easily.

Cuts-Only Editing

Some linear editing that is still used involves a **cuts-only** process. This process can butt one video image and its dialogue against another; it cannot be used to show two pictures at a time. In other words, a cuts-only system cannot execute a dissolve or wipe because doing so would involve overlapping two shots for a brief period of time.

These systems involve two videotape recorders, one or two monitors, and an edit controller (see Figure 10.19). One videotape recorder, called the **source deck,** contains the original camera footage. The other recorder, called the **edit deck** (or the **record deck**), is the machine onto which selected materials from the source deck are edited. One monitor shows the output of the source deck; the other shows the output of the edit deck. (With some editing systems, both the source and edit outputs appear on the same TV monitor.) The edit controller is used to mark the editing points and to cue the decks to execute the editing decision.

Figure 10.20

An edit controller. The round knobs are the search dials—one for each deck. (Photo courtesy of Panasonic Broadcast and Television Systems Company)

Controllers can usually undertake all the regular videotape recorder functions—play, fast forward, rewind, pause, stop—for both machines through remote control buttons. They also have a **search dial** that allows the operator to move the tape of either machine at varying speeds to find exact locations (see Figure 10.20). The edit controller is used to set the inpoint on the source machine where you want the shot to begin and on the edit deck at the point where you want to start recording the edit. You can also use the controller to set the outpoint on the source machine, or you can end the edit manually.

Once you have set the inpoints on both machines with the controller, you can preview the edit; that is, you can see exactly what it will look like without transferring any signal. If you don't like how the edit looks, you can use trim controls on the controller to change the edit points. When you are satisfied that the edit will work properly, press the edit button on the controller to execute the edit. Both the source deck and the edit deck **preroll** (back up)[17] to get up to speed. When they reach the inpoints, the controller will place the edit deck in record so that the edit begins. You can review the edit by rewinding the tape or by pushing the review button on the edit controller.

More Advanced Linear Editing

As already mentioned, a simple cuts-only system can do no more than butt two images together. It cannot fade, dissolve, or wipe, and it cannot add graphics or lettering to the image.

Because of these limitations, people often use expanded editing systems that include equipment for transitions and graphics.

For example, to dissolve, you must have two source machines so that the two images can be recorded on the edit tape at the same time. The most common way to achieve this is to run the images of both source machines through a **switcher**—a piece of equipment that mixes video signals together. Manipulating a lever or knob on the switcher makes one picture gradually replace the other. Wipes can be undertaken in a similar manner, and fades can mix black that is generated by the switcher with a source machine image.

To add graphics, the output of a stand-alone **graphics generator** (sometimes called a character generator) can be routed through the switcher and onto the source tape. For example, if you are building an opening sequence that includes a video image of a cityscape and the opening credits, the switcher can be used to place the credits on top of the cityscape. The features of the graphics generator are very similar to those on a nonlinear editing system—you can select font, size, color, and so forth.

Using this equipment adds to the cost of the linear editing process and is not as versatile as nonlinear editing. For that reason, very few organizations are buying new linear editing systems. Nonlinear systems are rapidly replacing this older form of editing, but it served many useful purposes for several decades.

Notes

1. Quoted in *Cineon: The Sea of Truth* (Rochester, NY: Eastman Kodak Company, 1992), videotape.
2. "Editing on the Fly," *TV Technology,* 22 September 1999, p. 12; and "Episode II: Attack of the Clones," *Mix,* June 2002, p. 92.
3. The main software that relates to the bar code is Slingshot from Trakker Tech. See also "Keykode Number Emmy Earned Through a Collaborative Effect," *Eastman Images,* Fall 1994, p. 7. In addition, Aaton cameras have a special coding system called Aaton dots. It does not come into play unless an Aaton camera has been used.
4. Daniel Greenberg, "PC Video Capture Cards," *Digital Video Magazine,* September 1995, pp. 71–82.
5. In M-JPEG the "M" stands for "Motion" and the "JPEG" stands for "Joint Photographic Experts

Group," the organization that developed the codec. The original JPEG codec was used for still pictures, and M-JPEG treats each frame as an individual picture. "MPEG" stands for "Motion Picture Experts Group," the organization that developed that codec. It considers the frames as a group and is more often used with transmission than with editing. MPEG has been through many transformation and improvements—MPEG 1, 2, 3, and 4. The latest version, MPEG 4, is being touted for its scalability—its ability to compress video into a single stream that can be used for many applications including cell phones, HDTV, digital movie theaters, and the Internet. See "All Right Mr. DeMille, I'm Ready for My Close-Up," *Mix,* September 2002, pp. 97–98.

6. Another type of compression is temporal compression. It looks for things that don't change from frame to frame, such as the building behind a person who is talking. This uses keyframes—the ones for which all the data is recorded. The fewer keyframes, the smaller the data rate, but the picture quality suffers.

7. There are many variables involved with compression. One is bit depth—the number of colors that are used. Another is frame size—the smaller the frame you are willing to work with, the more you can compress. One rough calculation of approximate video quality and the number of minutes of video that can be stored per gigabyte is as follows: at a 2:1 compression ratio (roughly Digital Betacam quality), 1 minute 37 seconds of video could be stored per GB; at 10:1 (S-VHS), 8 minutes of video per GB; at 30:1 (VHS), 24 minutes per GB; at 60:1 (low quality), 48 minutes per GB. See "Dressed to Compress," *AV Video Multimedia Producer,* January 1999, p. 33.

8. "Setting the World on Fire(Wire)," *Mix,* October 2000, pp. 129–130.

9. In general you can figure that digital video requires 3.6 megabytes of storage for each second of program material, and one gigabyte of storage holds 5 minutes of digital video. To consider how much you need overall, a good rule of thumb is to multiply your program length by 4 because you will be putting in more material than you will actually use, and you will need to manipulate what you put in. If you are making a 15-minute movie, you would need 3 GB times 4 or 12 GB. Fortunately, computer storage is constantly getting larger and cheaper. In 1989 600 MB of storage cost $9,000; 10 years later 18 GB cost $1,000.

10. You must, of course, have the material on a tape that can play in the VCR you are using; a DVCPRO tape will not play in a DVCAM recorder. If material has been recorded on a hard drive, the drive can slip into a computer with provisions for removable hard drives. This will probably be done more in the future.

11. With nonlinear editing programs, as with all computer programs, there are many different ways to accomplish a particular task. For example, with Final Cut Pro you can use the mouse to mark in- and outpoints, or you can hit the "I" key on the keyboard for inpoint and the "O" key for outpoint.

12. "Logging and Capturing Strategies," *DV,* March 2002, pp. 36–41.

13. You can take the shot back into the source window and reset its in- and outpoints by using the icons provided. Or you can set new points with keyboard strokes, such as "I" and "O." Sometimes you can shorten or lengthen shots by dragging the ends or by clicking on a key that adds or subtracts one frame with each click. On some programs, you can go to an edit menu and type in the number of frames you want to remove or add. If removing frames creates a hole, you can select the hole and use "Delete" to get rid of it, or you can use the cursor to drag the next part of the movie so it fills the hole. You can use a "Snap" feature to make sure all clips are positioned right next to each other on the timeline. Some systems have a special trim window where you can place two shots and manipulate their beginnings and ends until they work well with each other.

14. For more on graphics, see Lynda Weinman, "2-D Animation's Not Just for Mickey Mouse," *New-Media,* July 1995, pp. 41–46; and "Graphics Get High-Tech Look," *Broadcasting and Cable,* 1 February 1999, p. 46.

15. Some systems use Alpha Matte. It is a special white or black that disappears when placed over other video. It works because the function finds the pixels in the image that match the Alpha Matte and makes them transparent.

16. Several good books on linear editing are Arthur Schneider, *Electronic Post-Production and Videotape Editing* (Boston: Focal Press, 1989); Steven E. Browne, *Videotape Editing* (Boston: Focal Press, 1989); and Gary Anderson, *Video Editing and Post-Production: A Professional Guide* (White Plains, NY: Knowledge Industry, 1986).

17. Most linear editing systems need a preroll of between 3 and 5 seconds. For this reason, material should always be shot with at least 10 seconds of uninterrupted video before what is going to be used and 10 seconds extra at the end. If a linear system tries to back up 5 seconds and finds there is a break in control track, it will abort the edit.

chapter eleven
Approaches to Editing

Some stories about editing have been told so often that they have become clichés: the actor whose great performance was left out of the movie, the editor who "saved" a film during the editing, the psychologist who blames the fast cuts of music videos for the 3-second attention span of the American teenager. These are all exaggerations, of course, but they contain just enough insight into the power and purpose of editing to have a semblance of credibility.

Editing can intensify the mood and place the audience within the action. Effective editing can create something that is greater than the sum of its parts; it can take two disparate concepts and create a third that is more powerful than the individual shots. Examples of powerful and effective editing abound: the shift of rhythm in *Psycho* in the scene in which Norman cleans up after "Mother" has made a mess in Cabin 1; the scene in *The Wild Bunch* in which 98 different shots are held together by the drumbeat of the steam engine as Angel separates the train cars to steal the weapons; the Omaha Beach battle scene in *Saving Private Ryan* where slow motion, silence, and sound effects add to the feeling of the horror of war (see Figure 11.1).

In one way editing is relatively simple. The act of joining one shot to another is not difficult to accomplish. On the other hand, choosing which shot to use, where it goes, and how to cut it can be far more complicated. Fortunately, editing decisions are not irrevocable. With nonlinear editing, shots can easily be lengthened or shortened. The editor can try an entire group of shots in one position, move it to another, and then return it to its original position. Several versions of the same scene can be created, compared, and selected. The editing process is one of trial and error, of testing and retesting. Cuts are made, reviewed, then made again. Ulti-

mately, someone—the director or the producer—must decide that a particular cut is the final cut. Otherwise, given the almost limitless number of editing patterns possible, the process might never end.

The editor is responsible for selecting and arranging shots according to the director's overall plan for the movie. Some directors give editors more freedom than others (see Chapter 9). In theatrical filmmaking the script is the guide to the movie's basic structure, but the editor can play a major role in determining its rhythm, mood, point of view, and pace. Individual shots are selected or rejected for a variety of reasons: the quality of the acting performance, the technical quality of the picture or sound, the effectiveness of a particular camera angle or movement, the emphasis a shot gives to a scene, or the narrative usefulness of the shot in conveying specific meaning at that point in the story. Once these decisions have been made, the real job of editing can begin—establishing relationships between the individual shots in both time and space.

Conventional Hollywood Patterns

The classic style of Hollywood editing has changed over the years and continues to be a work in progress, but it is the dominant standard for theatrical moviemaking worldwide. Editing is now more fast-paced with more cuts per minute than in decades past,[1] in part due to the influence of music videos and the fact that the young movie going audience wants a faster feel. In addition, it is easier to make fast cuts with nonlinear equipment than with older forms of editing. But the purpose of Hollywood editing involves narrative clarity and dramatic pacing—the editor and director want to cut the movie in such a way that the audience understands the story, and they want to hold and engage the viewer to create what they feel is the appropriate emotional response to the story. There are other forms of editing (discussed later in this chapter), but the Hollywood pattern is the norm and is far too pervasive to ignore.

Figure 11.1

This shot from the Omaha Beach scene of Saving Private Ryan *helps to convey the horrors of war. (Photo from Photofest)*

Editing in the Service of the Story

In the hands of the early film pioneers, particularly D. W. Griffith in the United States, editing quickly became one of the most important tools for motion picture storytelling. This kind of narrative editing was perfected in the Hollywood studios of the 1920s and 1930s. In this classic Hollywood system, the editing is almost totally subservient to the dramatic needs of the story. A key element in this approach is that it attempts to make the cut from one shot to the next flow as smoothly and unobtrusively as possible. This is most apparent within the **scene**, the basic building block in conventional motion pictures. The scene consists of a unified action, usually occurring in a single time and place. It may be composed of a single shot, but in most cases a scene is made up of a number of shots.

In the typical Hollywood film, the story unfolds scene by scene. In most cases the scenes are organized in chronological order, showing only those events that advance the story or provide some piece of information significant to the plot. The story may move from one time period to another or from location to location, but within each individual scene the editing creates the illusion of continuous time and place. This can be seen in a group of scenes from Steven Spielberg's *Saving Private Ryan:*

Scene 2　The June 1944 D-Day World War II battle on Omaha Beach in France is re-enacted, establishing Tom Hanks as a Captain for a group of men.

Scene 3　A group of secretaries type letters to relatives who lost men in the war. A supervising secretary gathers several letters.

Scene 4　The secretary takes the letters to a nearby office where several military men discuss the fact that three Ryan brothers have been killed in the war and that the other is behind enemy lines in Normandy, France.

Scene 5　A car drives up a country road toward a farmhouse. A woman in a farmhouse (the Ryan mother) looks out the window as the car approaches and then goes to the door. Two men get out of the car and approach the woman as she falls to the ground.

Scene 6　General George Marshall talks to several other military men about the need to find the one Ryan son who is still alive and bring him home.

Scene 7　Back in France 3 days after D-Day, a superior gives Tom Hanks the assignment of leading a group of men to find Private Ryan.

These six scenes illustrate some basic patterns of conventional Hollywood storytelling. The

story moves forward in time, skipping extraneous events. We do not see the men who go to the Ryan house get in the car to start the drive, and we do not see the sequence of events to get the orders from Marshall's office to France. Those details are insignificant. In fact, it is impossible to determine exactly how much time passes from the end of the battle scene to the secretarial typing to the visit to the farmhouse. It may have been hours or days or months. A caption on Scene 7 tells us it is "D-Day plus 3" so at that point we surmise that only a short period of time has passed. Locations vary according to the needs of the plot. Within these six scenes are five locations and fragments from several days. There are also omissions and editing ploys to affect the emotions. We do not see the men actually talk to the mother; each audience member is left to experience that impact in her or his own way. Editing techniques are used in the battle scene to horrify and make the audience uncomfortable. Obviously, the editing can organize the story footage freely in time and space, but this pattern allows the audience to follow the story line and experience the emotion of the events.

The Hollywood system of editing in the service of the story also attempts to mask the cuts, to make them less apparent, an approach that is sometimes referred to as **hidden editing** or **invisible editing**. One element that makes this approach effective is that each successive shot is psychologically correct from the audience's point of view. Film theorist André Bazin has compared this to a stage play, where the viewer's attention shifts naturally from one character to another according to the logic of the drama, the dialogue, and the movements or gestures in the scene.[2] For example, a shot of a character who suddenly turns and looks off screen is naturally followed by a shot of what the character is looking at. When two people are carrying on a conversation and one stops talking, we expect a cut to the other as that person replies. This does not mean that the editor must always cut to the shot the viewer expects. In fact, cutting against the natural flow of the action and against the audience's expectations often heightens the drama. Nevertheless, in traditional filmmaking cutting to a shot that is totally unrelated to the basic action in the scene would be inappropriate.

Editors are also charged with showing the actors at their best because poor acting definitely does a disservice to the story. If an actor looks inappropriate at the beginning of a shot, the editor can **overlap cut** by using the actor's voice but continuing to show the picture for the last shot for a second or two. If there are problems in the middle of a shot, the editor can cut away to another shot temporarily and strengthen the actor's performance. By eliminating bad takes and by taking parts of lines from other takes, the editor can sometimes create a better reading.

At its core Hollywood-style continuity editing is self-effacing: it does not call attention to itself. It avoids disconcerting shifts in time or space and encourages anything that makes the shots in the scene flow together smoothly and unobtrusively. The editing is supposed to serve the story, organizing scenes and the different shots within individual scenes in a clear, logical, and convincing manner. From the point of view of the Hollywood editor, if the audience is unaware of the editing, its attention is focused where it should be—on the actors and the story.

Maintaining Continuity

The Hollywood system is sometimes referred to as **continuity editing** because it attempts to make the cut from one shot to the next flow as smoothly and unobtrusively as possible. The continuity system creates the illusion of continuous action by carefully coordinating every element of the **mise-en-scène,** the cinematography, the sound, and the editing. The editor and the director must consider various types of continuity (see Figure 11.2):

Technical pictorial continuity. The picture should look the same from shot to shot if the assumption is that the shots are in the same time and space. A shift in color, brightness, or light direction will ruin the perception of reality for the audience.

Technical sound continuity. Similarly a change in volume or tone between two conjoined shots will call attention to itself and ruin the continuity.

Performance continuity. An actor's performance should be consistent from shot to shot. An

a b

Figure 11.2
How many types of continuity errors can you find between the first shot (a) and the second (b)?

actor who appears angry in one shot of a scene should not be smiling in the next shot. A continuity error in this area will be very obvious to the audience.

Physical continuity. This also applies to actors. They should look the same from one shot to another. In mid-scene a man should not change from a red tie to a yellow tie. Similarly, an umbrella that is a prop in one shot should still be there in following shots.

Temporal continuity. There should be time for actions to take place. For example, if a burning candle on a dinner table is at full height as an actress says her line and then becomes very short as an actor answers her, there would not have been enough time for the candle to burn that much. Worse yet is the almost-burned out candle during the actress's line and a tall just-lit candle during the actor's response.

Atmospheric continuity. If there is background noise in one shot, there should be the same background noise in the next if, indeed, they are in the same time and place. Similarly, if it is cloudy in one shot, it should be cloudy in the next.

Activity continuity. Something that has already happened in one shot should not happen again in the next. For example, if a woman folds a red shirt in one shot, she should not fold that same red shirt in the next shot. On the other side, an action that is crucial (such as a slam dunk in a basketball game) should be shown in its entirety without the middle part of the action being cut out.

Spatial continuity. This involves keeping the audience from getting lost. If you cut from a wide shot of a building to a medium shot, the medium shot should be of something that is recognizable in the wide shot. In addition, if a person is traveling one direction in the first shot, he or she should not appear to change direction in the second shot, unless, of course, that is part of the plot.

Logical continuity. Sometimes other aspects of continuity can be violated if what is happening is obvious and logical to the audience. For example, cutting from a shot of the outside of the White House to an office setting suggests that the office is inside the White House, even though the office was not in sight in the exterior shot.

The **script supervisor** helps to guard against continuity violations during production, and the editor tries to hide them in the editing. But how the scene was staged for the camera is also very important. Technically, a single shot, no matter how complex, will always maintain continuity. Problems arise when someone tries to edit a group of shots together seamlessly, with no sense of break, jump, or discontinuity in the action.

To make it easier for the editor to hold continuity among these different shots, directors frequently use a technique called **overlapping action.** During production, the director makes sure that action in one shot is repeated, at least in part, in the shot that may follow it. In other words, a character opening a door in one shot

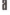
a

b

Figure 11.3

Cutting from shot (a) to (b) might maintain perfect continuity in terms of time and space, but the cut will appear to "jump" because the shots are so similar in size and angle.

repeats that movement exactly when shot from a different angle. This provides the editor with a number of possible places at which to make a **match cut,** a cut in which the character's movement and position are perfectly aligned in time and space from one shot to the next. Failure to do this results in what is commonly called a **jump cut,** an obvious and jarring break in continuity from one shot to the next. A similarly abrupt jump occurs if part of the action is repeated in successive shots. This is sometimes called **double action.**

Hollywood filmmakers also recognize a related problem. Even when two shots match perfectly in time and space, a jump can appear to occur if the camera angles or the size of objects in the shots are *too similar*. Correcting for this requires emphasis of the difference between two shots by changing their angle and size. Judging how much the shots should vary is not always

easy. If the change between the shots is too great, the edited footage can be disconcerting; if the change is too small, their similarity will make the cut seem to jump (see Figure 11.3).[3]

Using the Master Shot Method

In the film-style shooting method, a scene is shot from a variety of angles and perspectives. To ensure a continuous and clear flow between these different shots, Hollywood filmmakers developed an elaborate system that encompassed a number of editing techniques and procedures for shooting the scene (see Chapter 4). It involves analyzing and breaking the action in the scene down into its logical components. The first step in this method is to shoot a **master shot.** This is usually a wide shot or long shot that covers all the action and dialogue in the scene or portion of the scene. The master shot has the effect of locking continuity for all other shots. It establishes the lighting, the costumes, the props, the setting, and the spatial relationships of the actors. Once set, shooting additional shots from different angles and perspectives breaks the scene down further.

A typical editing pattern is to start with a **long shot** (probably part of the master shot) that orients the audience, then move to a **medium shot** that involves the main action, and then to a **close-up** that isolates a particular character or action. Sometimes an **establishing shot** is added to this pattern. It is a shot before the long shot that establishes where the action is taking place. For example, in the movie *Flight 90* an establishing shot of the exterior of an airport lets the audience know that what they are about to see is happening in an airport. In reality, the outside of the airport may be in Cincinnati and the inside may be on a sound stage in Burbank, but because the shots are next to each other, the audience believes the action that they see is inside the airport. After the establishing shot comes a long shot of the interior of the airport, followed by a medium shot that shows the people in the ticket line and the ticket agent, and then a close-up focusing on the ticket agent (see Figure 11.4).

Reversing this pattern—starting with a close-up of some detail within the scene—can build anticipation, making viewers wonder where they

Figure 11.4

The traditional exposition pattern—moving closer and closer within the scene. This part of the made-for-television movie Flight 90 *begins with (a) an establishing shot to set up the airport location, followed by (b) a long shot inside the terminal, cutting to (c) a medium shot in the ticket line, and to (d) a close-up of the ticket agent. (Photos courtesy of Finnegan-Pinchuk)*

are (see Figure 11.5). These questions are answered as subsequent shots reveal and establish the space in which the scene is taking place. Withholding some information is a good way to build suspense. Showing a close-up of a dagger and a medium shot of the back of a man holding the dagger and then cutting to an entirely different scene is more likely to increase the audience's fear and curiosity about the dagger than if a long shot and establishing shot were also part of the sequence.

There are many ways to break down a scene into increasingly greater detail. **Point-of-view** shots can add a subjective feeling that a scene

needs, and a well-placed **freeze-frame** can lend emphasis to a particular person or event. One common pattern is the **shot/reverse shot** (see Figure 11.6) where two people are seen delivering lines. In framing, these shots usually mirror each other. The shot/reverse shot pattern often uses **over-the-shoulder shots**.

The scene breakdown might include **reaction shots**, such as a son's reaction to what his mother is saying on the telephone (see Figure 11.7). The **shot/reaction shot** pattern gives the editor the option of focusing the audience's attention on the character responding to the dialogue or action rather than on the person speaking or the

Figure 11.5
*Reversing the traditional pattern. Isolated close-ups of (a) the man, (b) the dog, and
(c) the woman in a scene from* Flight 90 *create questions in the audience's mind about
what the action is and where it is taking place. These questions are answered by the
last shot in sequence (d), which brings the three together in the same shot. (Photos
courtesy of Finnegan-Pinchuk)*

Figure 11.6
A shot and a reverse shot in Flight 90 *mirror each other in composition and subject size.
(Photos courtesy of Finnegan-Pinchuk)*

action itself. Alfred Hitchcock, a director who felt that the event was usually less interesting than a character's reaction to it, frequently exploited the power of the reaction shot.[4]

For shot/reverse shots and shot/reaction shots, the editor needs to be highly conscious of **eyeline match** (see Figure 11.8). Because these shots may isolate people in the frame, the directions in which they are looking off-screen (toward each other) and their angles of view must match precisely. If one person is standing and another is kneeling, the eyes of the one standing must angle down to where the other person is kneeling. In effect, the direction established by the eyes creates a target area that the editor must match in the shot that follows.

Another way to complete a breakdown of a scene is to use close-ups of significant details within the scene. The editor will use some of these close-ups for **cut-ins** and some for **cut-aways.** A cut-in focuses on some element that appeared in the previous shot. For example, in Figure 11.9 the shot of the baby is a cut-in because it is seen in the shots before and after it. A cutaway is a shot of something that did not appear in the previous shot. In Figure 11.10, the instrument panel is a cutaway because it is not seen in the shots before and after it. Cut-ins must maintain continuity, but continuity is not crucial for cutaways.

Of course, for the editor to use these various shots, the material needed must have been shot. If the director didn't shoot a close-up of the baby, it can't be used as a cut-in. If the director didn't feel it was necessary to record a reaction shot of the boy, there will be no shot/reaction shot in that scene. This is why the director needs a clear vision of the movie early on so that planning and shooting can be undertaken with editing in mind.

Ensuring Consistent Screen Direction

Obviously, it is not easy for the editor to maintain continuity when the scene is broken down into many different shots. It was for precisely this reason that the so-called **180-degree rule** evolved. This system of shooting, as you will recall from Chapter 4, is used to ensure a continuous and

a

b

c

Figure 11.7

The young boy's reaction shot (b) is cut between shots of his mother talking on the telephone (a and c) in a scene from Flight 90. *(Photos courtesy of Finnegan-Pinchuk)*

a

a

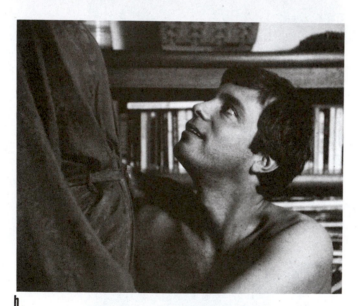

b

b

Figure 11.8

The eyeline established by the woman in shot (a) must be matched by the man's eyes in shot (b). (Photos courtesy of Finnegan-Pinchuk)

c

unconfusing space from one shot to the next. The placement of characters in the shot establishes an **axis of action,** or *line*. As long as all shots are taken on one side of that line (within the 180 degrees), the space presented in those shots will be consistent when they are edited together.

 This principle is also helpful in preserving a constant screen direction when the shot contains movement. Once a character begins moving in one direction, the next shot should

Figure 11.9

In this series of pictures, the close-up of the baby (b) is used as a cut-in between shots (a) and (c). If you look closely, you can see a continuity problem with the baby's arm and the man's hand. (Photos courtesy of Finnegan-Pinchuk)

Figure 11.10

In this sequence from Flight 90, *shot (b) functions as a cutaway between shots (a) and (c). Because neither pilot appears in the cutaway, continuity can be dropped momentarily and picked up again when we return to the pilots in shot (c). (Photos courtesy of Finnegan-Pinchuk)*

maintain that direction. Again, crossing the imaginary 180-degree line can cause confusion, making the character appear to reverse direction abruptly on the cut. When a character enters or leaves the frame, that too sets up anticipation of direction for the next shot. If an actor walks out of the frame by moving from left to right, we expect him to enter the next shot from the left side. A shot directly down the axis of an actor coming toward or away from the camera is neutral, allowing the editor to establish a new screen direction in subsequent shots.

For most conventional Hollywood editing, the director should select shots that ensure consistent screen direction. This practice usually allows the editor to build the scene according to the logic of the drama, the dialogue, and the actor's movements or gestures. With such coverage the editor can also develop a sense of off-screen space, building expectations that can be used to motivate and drive the film forward.

Finding the Cutting Point

By looking carefully at two shots in succession, the editor can select the appropriate cutting point at the end of the first shot and the beginning of the next. This can be difficult for an editor trying to accommodate both rectangular and widescreen formats. For example, it is customary to let an actor exit a frame before cutting. If the editor waits for the actor to exit the widescreen, there may be several seconds of no action in the rectangular version. Conversely, cutting for the rectangular format cuts the actor off on the widescreen. Another difficulty with finding the cutting point involves looking for continuity details. Hands, arms, feet, and other elements must be in similar positions from shot to shot. This is much easier if the director has provided many cutting places by overlapping action during shooting.

One technique for making two shots flow together more smoothly is **cutting-on-action**. Rather than letting the actor complete an action in one shot and cutting to the next, the action *begins* in the first shot and ends in the second. Continuing the same movement across two shots draws the viewer's eye naturally to the next shot, helping to mask the cut and make it less obvious.

a

b

Figure 11.11

Compressing time by eliminating unimportant material is a common editing practice. Here a shot of an airplane that has just landed on the runway (a) is followed by a shot of the airplane as it docks at the terminal (b). Eliminating a portion of time in this manner is seldom confusing to the viewer. (Photos courtesy of Finnegan-Pinchuk)

Often the editor will find it necessary to drop continuity and then pick it up again. This is where cutaways and reaction shots are especially handy because they do not include elements present in the previous shot. They allow the editor to momentarily drop continuity, either for aesthetic reasons or to hide continuity problems that occurred during shooting.

Controlling Rhythm

The editor also is responsible for controlling the rhythm or tempo for each scene and for the movie as a whole. Each shot has its own pace or rhythm, determined by the speed of the dialogue or the movement of the camera or actor in the shot. But the editor can control or alter that pace by varying the length and number of shots in the scene. The shorter each shot is, the faster the tempo becomes. Long, uninterrupted shots slow the tempo. Similarly, an editor can expand the time it takes for a scene to unfold by inserting in the main action a series of extra shots, such as cutaways, reactions, and different angles.

The editor can compress time by cutting shots shorter and by using cutaways or reverse shots that eliminate some part of the action while maintaining a semblance of continuity (see Figure 11.11). For example, the first shot of a person going to bed might be of the person

starting up the stairs. The next shot is that person opening the door, taken from an angle within the bedroom. Time compression is commonplace in theatrical films. It enables the editor to control the tempo and eliminate extraneous material while moving the story forward.

Manipulating Time and Space

A completely different kind of time-space manipulation occurs in **parallel editing** or **cross-cutting.** By alternating shots from one line of action to another, the editor can imply that the two actions are occurring simultaneously (see Figure 11.12). This would seem to be a complete violation of continuity, but in conventional filmmaking what holds the different actions together is their relationship in the story and the implication that they are occurring at the same time. You have probably seen an old melodrama in which the black-caped villain is tying the heroine to the railroad tracks. This traditionally is cross-cut with scenes of a steam engine roaring down the track and the hero riding furiously to the rescue on his white horse. When these scenes are intercut, usually at a faster and faster pace to build suspense, we understand their conventional meaning—the hero is trying to reach the heroine before the train does.

a

b

c

d

Figure 11.12
Parallel editing. The film Flight 90 *relies heavily on parallel editing to develop the narrative. The preparation of the airplane (b, d) is intercut with scenes of many characters (a, c, e) as they prepare to board the ill-fated flight. (Photos courtesy of Finnegan-Pinchuk)*

e

Although the individual scenes are unrelated in space and time, the cross-cutting unifies them in the context of the story. Cross-cutting need not be so melodramatic, however. It can be used to comment on, or compare, different lines of action or to expand time in the scene.

An editor might also choose to **flash back** or **flash forward** to a scene or sequence that portrays events in the past or future. In traditional moviemaking a line of dialogue or some other device (pages flipping on the calendar or a dissolve from an old woman in a rocking chair to a young woman in the same chair) cues the viewer to a jump to the past or future. The first scene of *Saving Private Ryan* shows an old man in a cemetery. A close-up of a far-off look in his eyes cues a flashback to the Omaha Beach battle scene. Judicious use of shots coming into or out of focus can also cue a flashback.

A **flash cut,** a shot just a few frames long, can present a brief image from the past or future that is almost subliminal—Magnum, P.I. flashing back to some moment in Vietnam or forward in anticipation of some event. A less traditional filmmaker, such as Alain Resnais in *Last Year in Marienbad,* uses this kind of time shifting to disorient the viewer.

Creating Transitions

Thus far we have been concerned only with **cuts,** a transition in which one shot instantaneously replaces the next. This is not the only kind of transition that the editor has at his or her disposal. **Fades,** dissolves, wipes, and a whole arsenal of digital effects provide other ways to join shots together.

A **fade-in** is a gradual transition from black to a full view of the image. A **fade-out** is the reverse, a transition from the image to black. The editor can also choose how quickly or slowly these transitions occur. Most movies and television shows begin with a fade-in and end with a fade-out. Using a fade-out to end a scene or sequence *within* the movie usually implies a stronger degree of closure, a more final conclusion to the scene than a straight cut. To use a punctuation analogy, a straight cut between two scenes is like a comma, whereas a fade-out is like a period. Furthermore, because a scene ending with a fade-out is usually followed by a fade-in to the next scene, the fades suggest a greater passage of time between the two scenes than does a regular cut. This sensation is heightened if the fades are executed more slowly. Most fades go to or from black, but some movies have made successful use of fades to white, which can give an eerie feeling.

A **dissolve** is a much softer transition than a fade or a cut. It entails the gentle fading of one shot *into* the next. Actually, as the first shot fades out, it overlaps with the second shot as it fades in. For a brief time in the middle of the dissolve, the two shots are superimposed. This is much more visible in a long, slow dissolve than in a short, quick one. Like a fade, a dissolve suggests the passage of time, although possibly with less emphasis. Editors often use dissolves to hide problems (such as a reversal in screen direction) or as a transitional device when some part of an action is omitted. Because dissolves visibly (albeit briefly) combine shots, they suggest a relationship between them that can be exploited effectively. For example, the editor might select a dissolve to amplify the link between a shot from the present and a shot from the past.

Whereas a dissolve is a soft, unifying transition, a **wipe** is generally a hard, abrupt, and obvious one. In a wipe the second image pushes across or into the first image, replacing it on the screen. The two images are not superimposed as in a dissolve; rather, the cutting edge of the second image has a visible pattern or shape (vertical, diamond shaped, circular, rectangular) as it gradually replaces the first image. A wipe suggests the passage of time or a change of location in the same time. Sometimes wipes are used to add a touch of humor to the transition between two scenes. This was often the case during the era when serials and melodramas were popular. A wipe can be stopped in the middle to allow two shots to play at once. Such a **split screen** is often used for telephone conversations with one person on the left-hand side of the screen and another person on the right.

Digital video effects provide another type of transition. Once an electronic signal is converted into digital form, an editor can manipulate its shape, size, and movement to create almost any transition imaginable. Such effects (spins, twirls, flips, page turns) are obvious, of course, and not particularly useful in conventional Hollywood-style storytelling where the objective is usually to make transitions as invisible as possible. Digital effects are very common in music videos and other artistic pieces where their presence adds to the overall effect.

These various transitions—fades, dissolves, wipes, and digital effects—imply the passage of time. In the appropriate place they can be just the transition the editor needs to punctuate a scene, to shift tempo, or to link a series of shots. Student moviemakers often overuse these transitions, however. Unless there is a good reason in the context of the story for using a fade, dissolve, wipe, or digital effect, the cleanest and most efficient transition is still a straight cut. Using transitional effects too often lessens their impact when you really need them.

Alternatives to Conventional Editing

Many films do not follow the editing patterns of conventional Hollywood movies. Music videos, independent films, commercials, documentaries, and movies made outside the United States are most likely to employ other editing methods, but many "Hollywood movies" use alternative editing techniques as well. Any number of "traditional" films purposely lose continuity, shift color, contain jump cuts, or in other ways violate the principles just discussed. As with filming (see Chapter 4), once you know the "rules," you can certainly break them. Before trying something unconventional, it is best to have a reason, but that reason can be simply the desire to experiment. Nonlinear editing makes experimentation so easy that there is really nothing to lose except a little time. Editing works best if you have a plan, but allow yourself the freedom to take advantage of the spontaneous ideas that come from "what if."

Montage Editing

Perhaps the best-known alternative editing system is **montage editing.** This term has been applied to so many different types of editing that it can be confusing. Montage is simply the French word for editing, but it implies a more comprehensive building up or assembly of the total film.

Several Russian filmmakers and theorists expounded upon this concept in the 1920s.[5] V. I. Pudovkin, for example, developed a theory of montage based on what he called relational editing—a process that emphasized the different relationships that could be established among a series of shots by using contrast, similarity, symbolism, or repetition. Pudovkin felt that a scene could be constructed simply by adding significant detail to significant detail and that this kind of "linkage" could be done unobtrusively, masked by the logic of the editing and the power of the drama. Film director Sergei Eisenstein, Pudovkin's contemporary and the author of numerous essays on editing, developed an opposing theory based on the violent "collision" of images.[6] Eisenstein believed that an entirely new meaning could be created by blatantly and obviously cutting from one shot to another; the meaning was not contained in either shot alone but was produced exclusively by their juxtaposition.

Today, one place where such concepts are consistently applied is television commercials. Think about the typical soft drink or beer commercial. The sequence of shots might go something like this:

1. Shot of beautiful suntanned teenagers playing volleyball on the beach.
2. Close-up of a beautiful smiling blonde in a tiny bikini.
3. Medium shot of a grinning lifeguard with sunglasses. Drops of sweat are rolling down his handsome bronzed face.

4. Extreme slow-motion close-up of a hand reaching into an ice-filled container. The hand slowly pulls out a can of Brand X soft drink or beer—icy water runs down the side of the can in tiny rivulets.
5. Shot of a dog catching a Frisbee in the surf.
6. Shots of happy beautiful teenagers on beach blankets. The boys and girls are just beginning to talk in the hot sand.
7. Another dreamy close-up of a bottle of Brand X being extracted from the ice chest. (And so on…)

You have seen this pattern enough times to finish it in your own mind. Juxtaposing the shots of the happy beachgoers with the sweating bottle of Brand X creates a meaning that is not contained in the shots of the beachgoers or the soft drink bottle alone. Of course, to make sure you don't miss the connection between Brand X and the active beautiful people (who are obviously successful with the opposite sex), most advertisers would probably insert shots of the teenagers and Brand X together as the commercial progresses.

It was precisely the power of editing to suggest new relationships that most interested Pudovkin and Eisenstein. From their perspective, editing need not always be focused on maintaining continuity. An editor might make a cut for metaphoric purposes: a shot of a Cossack swinging his sword at a peasant cut against a shot of helpless animals being butchered in a slaughterhouse.

Hollywood filmmakers have incorporated montage editing in numerous films. Many films in the 1930s and 1940s contained a montage sequence, often credited to special montage editors such as Slavko Vorkapich and Jack Killifer. Hollywood montage, however, tended to adopt the Russian methods in a unique way—it created a discrete sequence designed either to establish a particular mood or to condense a long and complicated action in a brief on-screen time period.

The bicycle ride (cut to the tune of "Raindrops Keep Falling on My Head") in *Butch Cassidy and the Sundance Kid,* the basketball shots at the opening of *Like Mike,* and the tribute to Beethoven cut to his Ninth Symphony in *Immortal Beloved* (see Color Plate 9) are typical of Hollywood mood montages. So are many of the montages of music videos—shots that loosely relate to the music but intensify its emotion. Just as common are the time-compression montages. We have all seen the montage shorthand for "the election campaign": shots of speech making, baby kissing, spinning newspaper headlines, more speech making, pages of the calendar turning, more speech making. Together this series of shots equals The Long Election Campaign. Many series TV shows open with a montage that condenses the backstory so that people tuning in for the first time will understand what is happening.

Although this technique clearly uses many of the Russian montage principles, it is basically a special device Hollywood editors use to abridge time without confusing the audience. In effect, conventional Hollywood filmmaking uses montage in the same way that it uses other editing technique—in the service of the story.

Time and Space Alterations

Although there are many time-space relationships, conventional Hollywood editing tends to limit itself to a handful of possibilities.[7] In a traditional Hollywood motion picture, the editing typically organizes events in chronological order. The story moves forward, omitting unimportant segments of time. Time reversals are not the usual way of advancing the story, although flashbacks are used occasionally to explain the past. Cuts forward in time are very rare, and editing that creates a jump in time or space is usually avoided.

But that is not the only way to present time or space. Imagine, for example, a music video that shows a dancer repeatedly performing the same dance step. Each shot, in effect, repeats the action of the previous shot. Yet the space (or background) in each shot might be totally different (at the seashore, in the snow, in a forest). This kind of editing would generally be unacceptable in conventional Hollywood filmmak-

ing but is rather commonplace in music videos. Freed of the constraints of narrative editing, the editor can explore many more time-space relationships, cutting to the beat of a very different drummer.

But even narrative editing can effectively alter time and space. Christopher Nolan's 2000 Academy Award nominated movie *Memento* had three story lines going at once. One was going backward, one was going forward, and the third was in real time. To someone used to watching only movies edited in a conventional manner, alterations of time and space can be very confusing. But they can also be very effective because they obscure elements and cause audience members to think and undergo cinematic experiences other than those related to narrative stories.

Less Is More

Understandably, some filmmakers rebel against effects and the fantasy, sex, violence emphasis of Hollywood. One such group of directors founded DOGMA in Copenhagen in 1995. They drew up a "Vow of Chastity" that includes 10 points related to shooting and editing. Among them were these:

Optical work and filters are forbidden.
The sound must never be produced apart from the images or vice versa. (Music must not be used unless it occurs where the scene is being shot.)
Temporal and geographical alienation are forbidden. (That is, the film takes place here and now.)
The film must not contain superficial action. (Murders, weapons, and so on must not occur.)
The director must not be credited.[8]

A number of DOGMA films have been produced, not only in Denmark but also in France, Korea, Argentina, and the United States. To date they have a limited following. Employing all the elements listed by the DOGMA followers creates a different kind of movie from what is currently produced in Hollywood. Various alternative filmmakers (and perhaps some Hollywood directors) may employ some of the DOGMA principles—those that suit their particular movie—and the craft of moviemaking will grow because of this infusion of new ideas.

Dominant Elements

The story is dominant in Hollywood movies, but certainly films can be made with other dominant elements. In fact, the editing itself can be the dominant element with wipes, digital effects, and abrupt obvious cuts making an aesthetic statement. The editor may select cutting points to create a particular rhythm or beat. The tempo of the music, not the natural rhythm of the shot, might govern those decisions, which is often the case with music videos. An editor may match shots according to some shape, form, movement, or color in successive shots, a rationale that has nothing to do with consistent screen direction or smooth, continuous action. For example, a shot of a spinning tire might be cut to a spinning roulette wheel because of the similar shape and movement in the two shots.

Even if the story is preeminent, its various elements can receive different amounts of emphasis. For example, in Steven Soderbergh's *Traffic* (see Figure 11.13), you would be hard pressed to understand all the connections in the plot—the variances in the drug deals, how many cartels there were, how they each operated, and so forth. But that would not affect your ability to feel the futility of drugs and their effect on the characters of the movie. In this film, editing in such a manner that the story was understandable was subservient to editing to create emotion.

Shot Ordering

The master shot plan with its establishing shot, long shot, medium shot, close-up pattern is also far from the only way to edit shots. Some films (for example, Jim Jarmusch's 1984 *Stranger Than Paradise*) have been composed almost totally of long shots. Many sequences in Ron

Figure 11.13

Steven Soderbergh's Traffic, *which came out in 2000 and starred Michael Douglas as a drug fighter and Erika Christensen as his hooked-on-drugs daughter, had scenes that did not explain all the details of the drug transactions but gave a feeling of the hopelessness of the drug world. (Photo from Photofest)*

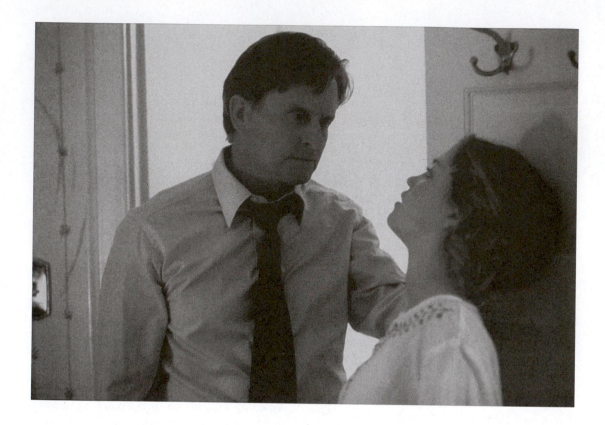

Howard's 2001 film *A Beautiful Mind* were shot and edited from the point of view of the main character, John Nash, the award-winning mathematician who suffered from schizophrenia. This enabled the schizophrenic scenes to appear to be real.

British filmmaker Nilesh Patel made a documentary about his mother making samosas, a native Indian fried turnover dish. But he did not use the traditional "cooking show" documentary shot order. In fact, he didn't even show his mother's face. He decided instead to shoot and edit in the style of the fight sequences in *Raging Bull.* "I wanted to make a film of a woman creating something using the same techniques that we often see in violent sequences," he said. "People often describe those sequences as being very beautiful or choreographed. I thought that this subject matter had the potential to be cinematic in the same way that a car chase could be."[9]

The beauty of editing is that there are almost infinite possibilities. When audiences (or directors) tire of a particular style, creative minds and hands come up with something new to add va-

riety and interest to the moviemaking and movie-watching experience.

Notes

1. "Cutting to the Chase," *Hollywood Reporter,* 23–25 February 2001, p. A1.
2. André Bazin, *What Is Cinema?* trans. by Hugh Gray (Berkeley: University of California Press, 1972), pp. 31–32.
3. The so-called 30-degree rule (discussed in Chapter 4) evolved to respond to this problem.
4. See, for example, François Truffaut, *Hitchcock* (New York: Simon & Schuster, 1967); David Sterritt, *The Films of Alfred Hitchcock* (Cambridge: Cambridge University Press, 1992); and Alfred Hitchcock and Sidney Gottlieb, *Hitchcock on Hitchcock: Selected Writings and Interviews* (Berkeley, CA: University of California Press, 1997).
5. See, for example, V. I. Pudovkin, *Film Technique and Film Acting* (New York: Grove, 1970), and *Kuleshov on Film: Writings of Leo Kuleshov,* trans. and ed. by Ronald Levaco (Berkeley: University of California Press, 1974). For a general discussion of the Russian montage experiments, see David Bordwell and Kristin Thompson, *Film Art: An Introduc-*

tion (New York: McGraw-Hill, 1993), Chapter 7, and Gerald Mast, *A Short History of the Movies* (New York: Macmillan, 1986), Chapter 8.

6. Eisenstein's combined essays are contained in two volumes: Sergei Eisenstein, *Film Sense* (New York: Harcourt, Brace & World, 1947), and *Film Form* (New York: Harcourt, Brace & World, 1949).

7. For a systematic classification of time-space relationships and an excellent discussion of traditional nar-

rative editing and alternative approaches, see Noel Burch, *Theory of Film Practice,* trans. by Helen R. Lane (New York: Praeger, 1973), pp. 3–15.

8. Shari Roman, *Digital Babylon* (Hollywood: Lone Eagle, 2001), p. 41.

9. "A Loving Tribute to a Mother's Cooking," *American Cinematographer,* October 2002, p. 93.

chapter twelve
Enhanced Audio, Graphics, and Visual Effects

Nonlinear editing (NLE) software contains provision for editing at least some audio, graphics, and visual effects (see Chapter 10). But in moviemaking these elements are often treated separately and then combined with the picture and dialogue edited on the nonlinear editing system. The reasons for this vary. Sometimes the NLE software is not running on a computer powerful enough to handle specific effects, such as complicated animation. Sometimes the software does not include provisions for undertaking specific tasks, such as construction of three-dimensional moving titles. Sometimes several tasks must be done at the same time, such as picture editing and sound effects mixing, so the movie can be released on time. And sometimes it is simply a matter of people preferring certain software or certain methods of operation.

Audio

When film was actually cut and edited (see Chapter 1), sound was completed separate from picture because most film editing equipment was concerned only with picture and dialogue. Automatic dialogue replacement, voice-over, sound effects, Foley, ambient sounds, and music (see Chapter 8) were gathered, mixed, and placed on material that was separate from the picture until the final stages of printing at the lab. Now the trend is to amalgamate picture and sound. In fact, there is even a trend to credit the same person for film editing and sound editing, something that was totally unheard of in past Hollywood productions. However, for most complicated Hollywood films, there is still a separation of sound and picture at some point so that the sound can be enhanced to meet the capabilities of modern motion picture theaters and the expectations of sound-savvy movie buffs.

Computer audio programs that work with personal computers, specialized computers called **digital audio workstations (DAWs)**, and **multitrack audiotape recorders** can all be used to enhance the audio.[1]

A number of traditional tasks must be undertaken with sound. They are more crucial when the sound is complicated, but they are steps to be considered even for relatively simple student productions. These tasks include spotting, gathering and recording, sweetening, positioning, and mixing.

Spotting

Spotting involves looking through a movie and deciding what the sound needs are. This is best accomplished after picture and dialogue have been edited because the needs will be more obvious. But some sounds can be planned long before editing begins. A movie with a large number of car chase scenes will need car crash sounds, and those can be gathered long before the movie is finished. The sounds for Fluffy, the three-headed dog monster in *Harry Potter and the Sorcerer's Stone* (see Color Plate 10), were created while the movie was in production.[2]

But once picture and dialogue are edited, someone must go through the movie and indicate all the places where additional sound is needed. Sometimes the same person spots for all sound, and sometimes one person spots for **sound effects**, another for **Foley**, and another for **automatic dialogue replacement (ADR)**. The composer is involved with music spotting because of his or her expertise in this area. For the *Star Wars* movies, music spotting was a joint project between director George Lucas and composer John Williams.[3]

Most spotting is undertaken by a sound editor. If the different sounds are being spotted separately, a **sound effects editor** will look at the entire movie to find places where sound effects are needed. This editor makes up a **spotting sheet** indicating at what point in the movie each effect should be placed (see Figure 12.1). Often the person will make a note as to whether or not the sound needs to be synchronous. The sound effect of a dog barking off-screen is much easier to execute than a dog barking on-screen because

SPOTTING SHEET

Project Title The Event Page Number 4

Spotter Al Marcino Date Prepared 10/21

Item	Sync/Nonsync	In Time	Out Time	Description
1	NS	01:42:15:10	01:43:12:09	Airplanes taking off
2	NS	01:45:26:29	01:46:15:12	Muddled voices
3	S	01:49:52:12		Door slam
4	NS	01:49:52:12	01:53:05:05	Traffic noises
5	NS	01:54:03:27	01:56:22:17	Restaurant noises
6	S	01:56:13:25		Gunshot
7	NS	02:03:14:23	02:04:03:10	Phone ringing
8	NS	02:10:52:12	02:11:01:24	Glass breaking
9	NS	02:11:27:03	02:12:04:19	Dog barking
10	S	02:12:46:18		Glass breaking
11	NS	02:15:33:16		Thunder
12	NS	02:16:12:15	02:19:22:04	Rain, wind, and thunder
13	S	02:21:45:23		Car backfire
14	NS	02:21:50:20	02:23:47:04	Children playing
15	NS	02:23:47:04	02:26:33:12	Ocean waves
16	NS	02:24:55:23		Thunder
17	NS	02:26:10:10		Thunder
18	S	02:30:12:14		Hit glass
19	NS	02:33:05:06	02:34:55:07	Dogs barking
20	NS	02:35:12:14		Door slam
21	S	02:36:36:11		Door slam

Figure 12.1
A spotting sheet lists various sound effects that will be needed for a movie sound track.

the off-screen barks do not need to be in sync with the dog's mouth. The person spotting sound effects will also verify the usability of the sound effects recorded on location. Does the car's backfire actually sound like a backfire, or does it sound more like a cannon? The sound effects editor makes decisions about which production sound effects to use, which to improve, and which to replace.

The person who spots for Foley makes up a **Foley setup sheet** for the Foley walkers. This lists all the actions they need to perform (walking up

Figure 12.2

A Foley setup sheet indicates what sounds should be made at which points in the movie and lists the materials needed to make those sounds.

FOLEY SET UP AND LOG

Program _The Top_ Date _11/4_

Foley Walkers _Susan O'Donnel Jack Washington_

Time Code	Track 1	Track 2	Track 3
00:20:03:40	Maribel walking (red shoes, concrete)	Jim walking (tennis shoes concrete)	
00:25:00:00	Maribel's dress rustles (silk)	glasses clink (white plastic glasses)	candle is lit (match)
		dishes move (fork and plate)	
00:30:00:00	waitress walks (brown shoes, carpet)		customer knocks on door (screen door)
00:35:00:00		coffee is poured (water, pitcher, cup)	

stairs, clinking glasses, rustling clothes) to give aural realism to the movie scenes (see Figure 12.2). Foley walkers use the setup sheet to determine whether they have all the supplies they need. For example, if the setup sheet calls for wind chimes, they might need to purchase or request some.

The ADR spotter makes note of all the places where the dialogue is unacceptable. This person should be sure to listen to the production dia-

```
                          TIMING SHEET

TITLE: Up in Arms

DATE: November 4                        START: 00:50:03:21

CODE                    TIME              DESCRIPTION

                                    Max and Oliver enter the room and
                                    glare at Maggie.

00:50:03:21          :00:00:00      Music starts as Maggie moves
                                    toward the sofa.  The camera
                                    follows her as she sits and stares
                                    at the two men.

00:50:10:23          00:07:02       CUT to MS of Oliver.

00:50:12:21          00:09:00       Oliver: You don't seem to be
                                    showing no respect.

00:50:13:24          00:10:03       Cut to CU of Maggie.  Maggie: Why
                                    should I?

00:50:14:25          00:11:04       Cut to CU of Max glowering.

00:50:15:22          00:12:01       Max: That really ain't a smart way
                                    to talk to two nice gents like us.

00:50:17:02          00:13:40       Music swells as a LS reveals
                                    Oliver and Max moving in closer to
                                    Maggie, who is still sitting on
                                    the sofa.

00:50:27:00          00:23:38       CU of Maggie looking frightened.

00:50:29:04          00:25:42       MS of Max and Oliver.  Music stops
                                    abruptly.  Max and Oliver laugh an
                                    evil laugh.  Max: That's all for
                                    this time, babe, but next time you
                                    don't get off so easy.
```

Figure 12.3

An example of a timing sheet, which goes to a composer as an aid for writing the music. The actions taking place and their durations are specified so the composer can work (at least some of the time) without actually watching the movie.

logue on a high-quality speaker. Sometimes ADR spotting is completed right after the footage is shot and before it is edited so that the actors can be brought in as soon as possible to redo their lines. With today's computer technologies, an actor's lip movement can be changed so a spotter can even indicate places where the actor needs to say different words. If a movie needs **voice-over** (**VO**), the ADR spotter indicates that also.

The end result of music spotting is a **timing sheet** to aid in the composition process (see Figure 12.3). This sheet gives **time code** numbers for the places where music is to be heard, tells the length the music is to run, and gives a description of what is happening in the scene. Along with this timing sheet, the composer is given a VHS, DVD, or computerized copy of the movie (or just the part of the movie that needs music) with time code on it. Sometimes this video copy has special marks on it that indicate where music is to start and where it is to end.

Gathering and Recording

Methods for miking dialogue, ADR, VO, sound effects, Foley, ambient sounds, and music are discussed in Chapter 8. When a microphone is

used, the sounds are recorded onto a tape recorder or computer hard drive, and these sounds are recorded from real people, objects, or musical instruments. They may be recorded before, during, or after production, but they are sounds recorded for that particular movie.

Many of the sounds in a movie are not recorded specifically for that movie. Rather, they come from extensive sound libraries that can be found on editing software, CDs, DVDs, and the Internet.[4] Some of these are free, and others are relatively inexpensive. Many production companies also keep their own well-documented libraries of sounds they create for each movie in case those sounds can be used again for another movie.

Dialogue and ADR are always recorded for a specific movie, but the sound editor may find that the best dialogue for a particular scene is on a shot for which the picture is not being used. So that dialogue will be gathered even though it is not part of the picture/dialogue edit. **Ambient sounds,** such as **room tone, atmosphere sound,** and **walla walla,** are also often recorded for a particular movie. However, there are sources for all sorts of room tone sounds (large auditorium, jail cell, high-ceiling living room, and so forth), and they can be mixed in to give a consistent sound to all the scenes in a particular location. Likewise plenty of recordings of bubbling brooks, factory noises, and the like can be purchased as atmosphere sound, and background conversation in various places (a bar, the street, a museum) can be used for walla walla.

Foley is also likely to be recorded for a particular movie because the walking and rustling and such must be in sync with the movements seen on the screen. But sometimes Foley noises can come from some sound on an Internet file or CD and, through computer technology, be made to fit with particular actions in the movie. For example, the sound of one footstep can be placed in a computer, and the audio characteristics of that footstep can be manipulated so that it can take on just about any sound—an overweight man walking on dirt in tennis shoes, a woman in high heels on a pavement, a horse galloping through a field. What's more, the step can always be placed in perfect sync. This computerized Foley can be created by someone hit-

ting a key on a piano keyboard that is attached to the computer. The sound (for example, the click of a woman's high heel) is created and programmed to occur whenever someone pushes middle C on the keyboard. A person watches the movie and plays middle C each time the woman's shoe hits the pavement. The harder the key is hit, the heavier the sound will be. If the person misses and gets one or two of the steps out of sync, this mistake can be corrected later by looking at the computer screen **waveform** and moving the step to the right position. A number of Foley effects can be created at once. A man's footstep on dirt could be programmed into A above middle C; the clink of a glass could be accessed from G-sharp. Someone "playing a keyboard" can create as many effects as hand-eye coordination will allow. In fact, sometimes creating effects is like playing the piano. Glass clinks that are low-pitched could be programmed into the bottom of the keyboard and could become progressively higher pitched with each note that progresses toward the top end of the keyboard. The person creating effects plays the various keys depending on the size and shape of the glasses being clinked.

Sound effects are very likely to come from an outside source. It is these sounds that are most numerous on CDs and other sound libraries. Most of these sources are very well indexed, so the job of the sound effects editor is to winnow the sounds down by selecting the ones whose names sound most usable, and then listen to all of those to select what will work best with the movie. For example, a sound effects CD may contain 50 sounds of automobiles. If a sound effects editor is looking for something to accompany the picture of a car careening around a corner, he or she wouldn't bother listening to sounds labeled "car starting up" or "car stalling" or "car stopping" but would listen to sounds labeled "car on highway," "car on bend," and "car speeding." Like Foley, sound effects can be created digitally by changing pitch, volume, and timbre characteristics of a sound. A door slam can become an explosion, or raindrops can be changed to machine-gun fire. The sound effects, because they are likely to come from a variety of sources, are usually recorded on a tape recorder or computer hard drive (see Figure 12.4).

Sound Effects Sheet

Title: **The Movie**
Director: **Brown**
Scene: **3**
Page: **2**

FX1	FX2	FX3	FX4	FX5	FX6
00:50:01 CHIMES → 00:54:17	00:56:10 FOOD SIZZLING	00:51:22 TOASTER POP 00:59:33 GLASS BREAK → 01:02:14	00:57:12 MATCH STRIKE	00:59:03 FIRE WHOOSH → 01:03:12	00:59:03 PAPER FIRE
	→ 00:10:12				→ 00:10:12

Figure 12.4

This type of sheet would be used by the person recording sound effects if enough picture has been edited that the sound effects can be placed in their proper positions. If not, the sound effects can be laid down and moved at a later time.

Music is another movie element that, more and more, is not recorded using microphones and people. In the past composers have written notes on music sheets by hearing them in their head or by plunking them out on a piano. Then musicians in a large recording studio would play the notes, and the music would be recorded (see Chapter 8). This method still exists, but it is rapidly being replaced by music composed and performed by one person using a computer setup (see Figure 12.5).[5] The composer/performer may have a synthesizer, a drum machine, and other electronic equipment. The equipment is tied together through musical instrument digital interface (MIDI), a technical standard that allows electronic instruments to interact with each other. For example, a musician playing a melody on an electronic keyboard can use MIDI to coordinate, select, start, and stop the rhythm coming from a drum machine. MIDI also interacts with SMPTE time code, making it easy for MIDI to "shake hands" (in computer terminology) with computer audio systems.[6]

Figure 12.5

This composer works out of his home where he has a synthesizer, a drum machine, an audio mixer, and a computer with Cakewalk software on it. (Photo courtesy of Brian Gross)

Figure 12.6

A screen from the computer program Cakewalk, which can be used to assist people who are composing music. (Screen shot courtesy of Cakewalk)

Figure 12.7

A screen from SonicFire Pro, a program that composes music according to specifications needed for a particular movie. (Photo courtesy of Sonic Desktop)

A fair number of computer programs exist to help composers create music (see Figure 12.6).[7] For some of these, the music is stored on the computer hard drive. For others, only the commands that activate the electronic instruments are stored within the computer; these **triggers** store and convey information such as pitch, volume, and timbre. The main difference is the amount of storage needed. For example, storing the triggers for a snare drum for a 3-minute piece of music might take about 15 kilobytes, whereas putting the snare drum sound itself on the hard drive would use up about 15 megabytes—a thousand times more space. In either case, once the music is composed, it can be output to a DAT or other storage device in the same way that the edited picture can be recorded on a Mini-DV tape (see Chapter 10).

The MIDI-SMPTE-computer alliance has simplified much of the movie music composition process. For some TV shows and movies, the music is spotted in Hollywood by a person with musical training, and the timing sheet and a copy of the movie are sent to a composer in another state. The composer writes and performs the music and sends it back to Hollywood over high-quality phone lines or on a tape, a zip disk, or a CD. This music is then organized with all the other movie sounds.[8]

You can obtain music for a movie without using a composer. The music may not sound as applicable, but for low-budget movies it is often adequate. For example, some software programs compose music for you (see Figure 12.7).[9] You import your video into the program and answer a series of questions about what kind of feel you want (mystic, sports, drama) and how long you want it. The program then "composes" music for you from royalty-free sounds available in the software.

Previously composed music can also be used for a movie, including popular songs of the day (or yesteryear). However, most previously composed music requires copyright clearance, an often time-consuming and expensive process (see Figure 12.8). Music that is old enough to be in the **public domain** does not require copyright clearance, but special arrangements of it

```
                    MUSIC SHEET

Title: Us and Him
Director: Sharon Gomez
Date: February 17
_____
CI=Credits instrumental; CV=Credits vocal; VI=Visual
instrumental; VV=Visual vocal; VPA=Visual performance (dancer,
mime, etc.) accompaniment; BI=Background instrumental;
BV=Background vocal
_____

Time Code      Title, Composer(s), Publishers    Society   Use   Time

00:10:15:14    Happily Engaged                             BI    2:08
               Joey C. Newman (50%)               BMI
               W.G. Snuffy Walden (25%)           BMI
               Bennett Salvay (25%)               BMI
               Exhibition Music, Inc.             BMI

00:36:11:02    Here Comes the Bride                        BV    :49
               Richard Wagner
               Arrangers:
               Joey C. Newman (50%)               BMI
               W.G. Snuffy Walden (25%)           BMI
               Bennett Salvay (25%)               BMI
               Exhibition Music, Inc.             BMI

00:57:25:24    The Wedding March                           BI    3:06
               Felix Mendelsohn
               Arrangers:
               Joey C. Newman (50%)               BMI
               W.G. Snuffy Walden (25%)           BMI
               Bennett Salvay (25%)               BMI
               Exhibition Music, Inc.             BMI

01:12:05:16    In My Life                                  BV    :56
               John Winston Lennon (50%)          BMI
               Paul James McCartney (50%)         BMI
               Sony/ATV Songs LLC                 BMI
```

Figure 12.8

Precomposed music must be copyright cleared. The research that goes into making a sheet such as this can be used for clearance. Note that the arrangements must be cleared, even though some of the music is old enough to be in the public domain.

may not be in the public domain. In these cases, the arrangements need copyright clearance.

In addition, a number of libraries offer copyright-cleared music for a nominal fee.[10] Many of these deliver the music over the Internet. Anyone choosing to use this music can be assured that it does not need copyright clearance; either it has been specially written and recorded for the library, or it is in the public domain. These libraries often also categorize the music: chase music, romance music, or dinner music. The problem with many of these music libraries is that much of their music sounds more or less the same. Another difficulty with using prerecorded music is fitting it into the allotted time. Because it was not specially composed to fit a certain set of actions, it will not necessarily end when the action ends. Sometimes it is more difficult to try to find music that fits a scene, both in terms of time and mood, than it would be to have it composed.

Students who do not have elaborate recording facilities at their disposal often find it easier to use prerecorded music. However, with MIDI-based electronic equipment readily available and with music departments on most campuses, specially composed music is becoming more prevalent.

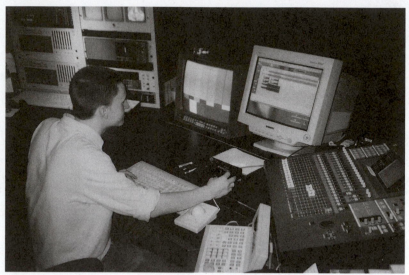

Figure 12.9

ProTools in operation. (Photo courtesy of Crest National)

All the sounds that are going to be used for a movie (dialogue, Foley, effects, and music) must be gathered and indexed, usually with the aid of a computer. It helps if all the audio has been transferred to one place (such as a digital audio workstation) before anything more is done with the movie sound track, but it is not necessary. While the sound effects editor is trying to locate some hard-to-find effect and the composer is recording the music, other sounds can be undergoing sweetening and positioning.

Sweetening

Sweetening is a term that refers to making the audio sound better. Usually sweetening is accomplished using a computer software program such as ProTools,[11] which is designated for audio (see Figure 12.9). But some of it can also be accomplished by sending the sound through various "black boxes" that alter the sound. Sweetening can be undertaken at any point along the way—right after audio is recorded, after a number of sounds have been gathered together, when sounds are being edited to fit a certain space, or even as sounds are being mixed together.

During sweetening you might fix the sound of some dialogue by bringing in dialogue from a shot that wasn't used for the picture or by replacing one word with a word recorded in ADR and then making the ADR blend in with the production dialogue. You might use a filter (either a stand-alone piece of equipment or a filter function in an audio software program) to get rid of a high-frequency hashing sound from a lav microphone. You may be able to enhance a sound effect recorded on stage so it sounds more realistic (for example, change the reverb on that backfire so it sounds more like a backfire and less like a cannon). If an actor made a mistake and said "walks" instead of "walk," the *ess* sound can be eliminated.

When you listen to the sound in relation to the picture, you are likely to decide it needs some changes. Maybe the voice-over goes a second too long in relation to the picture. With computer technologies, it is fairly easy to imperceptibly eliminate a little of the silence in the voice-over so that it becomes the proper length. In the same vein, prerecorded music can be stretched or shortened a small amount to fit action without distorting the music. A dog's bark can be speeded up or slowed down to fit with the action of the scene. When a visual effects house finished one of the flying scenes in *Harry Potter,* it had more twigs falling off the broomsticks than the audio people had envisioned, so the audio had to be sweetened to include more twig breaking noise.[12]

Positioning

If sound is handled separate from picture, somewhere along the way it must be positioned so that it is where it should be in relation to the picture. This is done in one of two ways, depending on how the sound is to be mixed. One is computerized. The picture can be imported into a sound program on a PC or DAW, and all the sound elements can be placed on a timeline where they are needed—a gun shot to accompany the pulling of a trigger, a bubbling brook behind a country scene. The sounds can be manipulated very easily. Because the computer screen displays waveforms (see Figure 12.10), it shows exactly when each portion of sound occurs. If a sound effect comes in a little too soon, it can be moved slightly with a few clicks of the mouse. When placing sounds on a timeline, it is best not to have two of them right next to each other on the same track. If they are next to each other and you need to trim or extend one, this may interfere with the other. Computer audio

Figure 12.10

With a waveform showing characteristics of the sound, it is easy to move the sound slightly to line it up with the picture or with other sounds. (Screen shot courtesy of Cakewalk)

programs have an almost infinite number of tracks, so for most productions each sound can have its own track if necessary. If you are using many tracks, someone must generate a list of what is on each one.[13]

The other way to position sounds is on a multitrack tape recorder. As its name implies, this recorder uses audiotape that has a multitude of tracks (8, 16, 24, or more) on which sound can be recorded. Before computer programs became available, these machines were the workhorses of movie sound. The original multitrack recorders were analog, and many of them used 2-inch tape (see Figure 12.11). Now there are multitrack digital recorders, but the analog ones are still used, especially by audio people who like the "analog sound." Audio is recorded to the multitrack recorder from a variety of sources such as a Nagra for dialogue, DAT for music, CD for sound effects, and DAW for Foley. The multitrack is also tied to a VCR so that the sounds can be positioned properly in relation to the picture. Each type of sound goes on a different track. Some of the tracks are left empty for the output of the mix. There are not as many tracks as available with computer editing, but again it is best not to have two sounds next to each other. For example, if a thunder sound effect is immediately followed by a car skidding effect, it is best to put the thunder on sound effects 1 (track 11 in Figure 12.12) and the car on sound effects 2 (track 12 in Figure 12.12).[14]

Hard effects (whether recorded in a computer or on a tape) that need to be in sync with a particular action (such as Foley footsteps) must be positioned very carefully. That is one of the reasons time code is crucial when hard effects are recorded; the time code on the sound can be used to match the time code on the picture. Some sounds can be positioned more loosely. For example, atmosphere sounds are often placed continuously on a track so that they can be brought into the movie at any point during the mix.

If all the sounds won't be ready at the same time, sound editors sometimes build **temp tracks** to get a general idea of what the audio will sound like. For example, if the music for a series TV drama isn't ready yet, the sound editor may put in some music from a previous episode,

Figure 12.11

A 24-track multitrack recorder that uses 2-inch tape. (Photo courtesy of Tascam, TEAC Professional Division)

just to get a feel for where the music will go and how it will sound. For *Phantom Menace*, they made a temp track of the aliens' voices to see how they would fit in.[15] Sometimes all the picture and sound for a movie is placed on a server, and everyone who needs to position something

Track	Sounds
1	Original production dialogue
2	Foley 1
3	Foley 2
4	Edited dialogue 1
5	Edited dialogue 2
6	ADR 1
7	ADR 2
8	Ambient sounds 1
9	Ambient sounds 2
10	Walla walla
11	Sound effects 1
12	Sound effects 2
13	Sound effects 3
14	Music 1
15	Music 2
16	Music 3
17	Dialogue mix—right channel
18	Dialogue mix—left channel
19	Music mix—right channel
20	Music mix—left channel
21	Effects mix—right channel
22	Effects mix—left channel
23	Blank
24	Time code

Figure 12.12

Sounds and how they might be positioned on a 24-track tape.

can access the server to do their particular job—add room tone, compose music, sweeten some dialogue.

Different directors and sound editors have varying views on how to position the sound. Some like to have several dialogue tracks—perhaps one for master shots and another for close-ups, or one for the male lead and another for the female lead. They do this if they feel the sounds will need different treatment in terms of volume or reverb. Others keep all dialogue on one track. Some like to have all the original dialogue available, not just the dialogue in the edited version in case they need to change some of the edited dialogue. Some like to have all the sound effects tracks grouped together; others prefer to interweave effects and Foley.

Once the audio is positioned, the various parts of it will not sound right in relation to each other. The music may drown out the dia-

logue. The gunshot may be too loud. Getting the sound relationships correct is the function of the mix.

Mixing

The main purpose of the **sound mix** is to combine sounds so that they layer in an appropriate manner for the movie. This may involve some last minute sweetening or repositioning of tracks, but the main function is relative volume control.

If the sound is being mixed with multitrack tape, the output of each recorded track (for example, tracks 1 to 16 on Figure 12.12) is sent to an input on a large audio mixer. Several people sit at this mixer, each in charge of a different type of sound. Before mixing occurs someone prepares a **cue sheet**. This lists all the different sources of sound and indicates when each should be brought in and taken out of the sound mix (see Figure 12.13). During the mixing process, all the material is rerecorded onto another track (or tracks) of the multitrack tape (or a different multitrack tape) at the right relative volume. Time code is also laid down on the multitrack tape for synchronizing the various elements. Time code is placed on the bottom track, and the track above it is usually left blank because time code has a tendency to bleed over into the tracks near it.

The technicians sit at the audio console, working with the various sounds as indicated on the cue sheet (see Figure 12.14). They work cooperatively so that the overall sound is balanced properly. If the music is overpowering the dialogue, they may lower the music, raise the dialogue, or do a little of each. Modern boards have memory so that the levels of the different inputs can be stored and called up again. In this way the people mixing sound can try one combination, store it, try another combination, store it, and then compare the two and select the best one. Memory also means that fewer people are needed to mix sound. There always used to be at least three people mixing (one for dialogue, one for effects, and one for music), but two can now do the job because it is so easy to bring something up from memory. Also, if there are

CUE SHEET

Production: *Away with Time* Date: *9/17* Editor: *Peterson*

Track No. 1 Dialogue	Track No. 3 Music A	Track No. 4 Music B	Track No. 6 Effects A	Track No. 7 Effects B
	2:15 <		2:15 fire crackles in fireplace	
2:31 Peter: Try				
				2:41 glass breaks in fireplace
2:47 (last word) think.				
2:49 Susan: No				
3:15 (last word) today				
	3:21 —→	3:21	3:21 wind	3:21 rain
	4:45 ←—	4:45	4:45	4:45
4:47 Peter: Someday				
5:06 (last word) gun	5:06		5:06 gun shot	

< = fade in > = fade out ⇄ = segue (dissolve)

many effects, someone may have done a **premix** to combine some of them so they can be brought up as a unit during the final mix. For *Phantom Menace* 128 premixed tracks were brought to the console for the final mix: 56 sound effects, 16 Foley, 16 dialogue and ADR, 8 creatures, and 32 music.[16]

During the mixing session short segments of the movie are rehearsed over and over until all the sound mixers agree that they have the proper levels. Then that section is recorded and another section is rehearsed. Eventually, all the sound is transferred from the various audio inputs to outputs.

Multitrack mixes for movies are done in stereo or surround sound, and various tracks can be assigned different sounds that will eventually be heard on different speakers. Effects are re-corded so they will appear to come from the left or right, and dialogue is made to sound as though it is coming from the center because people who are talking are generally center screen. Music can be right and left, according to how the music was recorded. Surround sound ambient sounds are recorded on tracks that will play back through the speakers positioned around the back of the room. If there is any chance the movie is going to be dubbed into a foreign language, the final mixed dialogue should be kept separate from everything else. That way the dialogue can be dubbed without remixing all the sound effects, Foley, ambient sound, and music.

When mixing is undertaken on a computer, the line between recording, sweetening, positioning, and mixing blurs. Because all sounds are on different tracks of the timeline, they can

Figure 12.13

A cue sheet used during the mixing session. It indicates when each sound should be taken in and out.

Figure 12.14
A sound mixing session. Note the cue sheet propped up on the console. (Photo courtesy of Ryder Sound Services)

be mixed while they are being positioned.[17] If music is to **crossfade,** one piece of music can be placed on audio track 3 and another can be overlapped on track 4. By using **rubber bands** and **handles** (see Chapter 10), the person operating the computer can bring in one sound and fade out the other.

To be user friendly, some computer programs employ a graphic of an audio board. The person doing the mixing can use a mouse to raise and lower fader bars for the various sounds coming into this "mixer." Other programs look more like a visualization of a multitrack tape with the waveform of each track being predominant. As with all computer applications, it is easy to make changes during the mix. Because the digital

sound does not degrade, and because the system is nonlinear, sound for the end of the movie can be mixed before sound for the beginning. Like multitrack mixing, computer mixing is usually stereo or surround. Audio programs have plug-ins that move sounds so they will play on different speakers. Sometimes these plug-ins are accompanied by a joystick panner, which enables you to be very selective about where you place each particular sound.

After the audio is mixed, either by multitrack or computer methods, the final result is often incorporated in the nonlinear editing program. If the movie is going to be distributed on film, then the mix will go to the film lab to be printed with the negative (see Chapter 14.)

Graphics

In moviemaking, the main use of graphics is for opening and closing titles and credits. Simple credits that merely roll up the screen can be created in nonlinear editing systems. But more complex ones that need a specific background or that must be positioned in a particular manner to fit with footage playing in conjunction with them are often created with special titling software.[18]

Software Programs

Graphics software includes all the applications regularly found in titling functions of nonlinear editing systems, such as varying fonts, sizing, and changing color (see Chapter 10). In addition they include ways to make the graphics look three-dimensional, a wider variation of movements for the credits themselves, and visual elements that can be used to create interesting backgrounds (see Figure 12.15). Also, some of the programs are specifically made for high definition. They take into account the increased resolution and the wider aspect ratio.[19]

Advanced programs (and some NLE programs) have the capability of setting a motion path for graphics using **keyframes.** For example, you might want the title to start low in the middle of the frame and then move to the middle by way of the right-hand side. You would set

Figure 12.15
An example of what can be done using graphics software. (Photo courtesy of Chyron)

keyframes at the bottom, right-hand side, and middle, and the computer would fill in the rest, giving the title a swirling pattern as it moved into place.

Generally, you can save the parameters from one title and use them for other credits. For example, you could design a background that includes a rainbow of colors that gradually merge into each other and specify that the lettering be white Arial font outlined with black. Each subsequent title you make will then automatically employ that background and that particular style of lettering.

Some programs also have provisions for using moving video or one frame of video to form a graphic. For example, you could take a frame from some footage that has a red car in the middle, isolate the car and make it smaller, and then place the small image at the corner of each closing credit. Or you could sample the color of red and match that color for the lettering on each credit. In a similar manner, you can scan in photographs or printed pictures to use as part of the credit. These programs include a large number of backgrounds that you can choose from if you wish.

Titling programs often have provisions for creating graphics beyond words and numbers, such as triangles, squares, or diagonal lines that you can use to create logos, charts, and similar artwork.[20] With 3-D software you can build a wide variety of graphics. For example, you could build a frame the size and shape of the graphic you want—perhaps a box wrapped as a present. You select the color and texture you want for the paper, add some decoration, and then turn the box around so that the viewer can see all six sides (see Figure 12.16). Many programs also allow you to draw things freehand using a pencil-like device connected to the computer.

Once created, enhanced graphics need to be transferred to the nonlinear editing system to be combined with the rest of the movie. Not all programs work with all nonlinear editing, so the editor needs to be sure to check for compatibility.

Optical Titles

Another way to do titles is through **optical printing** (see Figure 12.17). Movies of the past

Figure 12.16
The first picture shows the basic frame for a box, and the second picture shows how this can be developed into a three-dimensional graphic. (Artwork from Michael Swank)

used optical printing regularly, and although it has largely been superseded by computer techniques, it is still used to some degree. First an artist designs and draws the titles. Then these titles are filmed with a regular film camera, and the negative is developed. This negative is taken to a film laboratory and placed on an optical printer that projects the picture onto print stock (either negative or positive, depending on the needs). With the optical printer, the negative with the titles does not touch the film stock

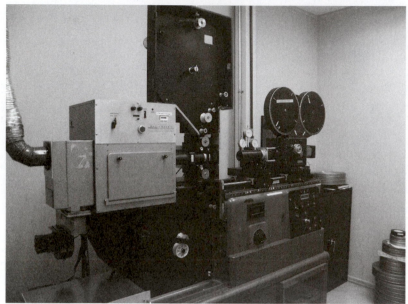

Figure 12.17

An optical printer configured to hold 35mm film on the left and 16mm film on the right so that film can be transferred from one format to another. (Photo courtesy of Crest National)

onto which it is projected. The process is more akin to using a camera to take a picture of the image that a projector is showing.

The film stock can be run back and forth any number of times in the camera so that multiple layers of pictures can be put on it. For example, a shot of several tall buildings might first be transferred from the projector to the camera part of the optical printer. Then the film in the camera would be rewound and a different negative—one containing the title of the movie—would be put on the projector and sent to the camera. The result would be tall buildings in the background with the title of the movie over them. To make the title look like it was laid on top of the buildings, as opposed to merged with them in a superimposure, the lab would use a **matte** process. When it transferred the film of the tall buildings, it would block out the area where the title was to be positioned to keep that part of the reproduced image from being exposed. Then when the negative with the credits was transferred, the letters would be recorded on the unexposed part of the reproduction.

Visual Effects

In recent years, digital **visual effects** have become an important part of Hollywood movie-

making. In *Phantom Menace,* for example, only 200 of more than 2,200 shots did not have some sort of digital enhancement.[21] The number and authenticity of monsters, explosions, flying objects, reconstructed people, and the like has increased greatly since the advent of computers that have enough speed and capacity to create these effects.

Optical Visual Effects

Visual effects also used to be accomplished through optical printing, and occasionally still are. The process was similar to that for graphics. Actors (or objects) were filmed against a **blue screen**,[22] and the real background was filmed separately. The two negatives were taken to the lab and merged onto print stock, often one frame at a time. The background was transferred with mattes that kept the area where the actors would be from being exposed. When the negative with the actors was transferred, the blue dropped out and only the images of the actors were transferred. For example, imagine a scene where a man falls off a cliff. A stunt man could be filmed on a movie stage falling from the ceiling to near the floor (with a rope attached to him for safety). This would be filmed against a blue-screen background. Another crew would film a cliff from somewhere outdoors. Both negatives would be taken to the lab's optical printer, and each frame of the cliff would be transferred with a matted "black hole" that moved slightly down in each frame to where the falling actor would be in that frame. Then the negative of the falling actor would be projected, the blue would disappear, and the actor would be transferred to each frame on the print stock that already had the cliff.

Many other effects were possible with optical printing. A **freeze-frame** involved projecting the same frame from the original negative over and over onto the print stock. For slow motion, some of the frames on the original negative would be projected several times, and for speeded up motion, frames would be left out. Part of the frame from one negative could be projected on the right-hand side of the print stock, and part of a frame from another negative could occupy the left-hand side to create a

a

b

split screen. Or a 16mm frame could be blown up to a 35mm frame. Visual effects were created this way for decades. It was a tedious process, but audience members liked the results.

Computerized Visual Effects

Sophisticated computers, often called **digital film workstations (DFWs),** can be used to create all the visual effects possible through optical printing, plus many more. For example, in *Cast Away,* Tom Hanks is seen standing on a little hill of the island where he is marooned looking out over the ocean. In reality, Hanks was standing on a mound of dirt in a parking lot in Los Angeles and was matted digitally over the ocean scene.[23] In general, computers are faster than optical printing because they can be programmed to move through frames more quickly, and it is easier to change things, such as color and positioning, with a computer.

Computers are excellent for creating monsters, aliens, and other nonexistent characters. The artists start with a basic frame and use a process similar to that described for the Christmas present (see Graphics section). In fact, many visual effects programs contain provisions for titles and graphics. The dinosaurs in *Jurassic Park,* the aliens in *Attack of the Clones,* the newest Godzilla—these and many other movie "stars" have been computer generated.[24] Computers can also be used to change and create human beings. With them, you can put the head of a real person on a computer-generated body (or vise versa). You can scan in the movements of a real person and use those basic movements for a computerized "person" (a process known as **matchmove**). Of course, computers are also effective for creating backgrounds, or using ones from stock footage and altering them slightly from frame to frame (see Figure 12.18). *Attack of the Clones* is filled with computer-generated backgrounds, and *Bill Bailey Won't You Come Home* uses many digital backgrounds from stock footage.

Another technique that is possible because of computer technology is **morphing** (see Figure 12.19). One of the early uses of this technology, which gradually changes one object into another, was for the 1991 film *Terminator 2: Judg-*

c

Figure 12.18

These shots are from video footage of (a) a vintage airplane in motion, (b) moving clouds, and (c) a cityscape. They are part of the royalty-free stock footage provided by Artbeats. (Photos courtesy of Artbeats)

ment Day where the terminator morphed from a patch of linoleum flooring into a prison guard and from a policeman into a housewife.[25] Morphing takes advantage of the computer's ability to make subtle changes from frame to frame. For example, a computer can be programmed to

Figure 12.19
Three frames from a gasoline commercial that used computer-morphing technology. (Photos of car transformation to tiger compliments of Exxon Company, U.S.A. © Exxon Corporation 1991)

change a square into a circle over a period of 2 seconds. The first frame would be a perfect square, and succeeding frames would have progressively rounder corners until a perfect circle was formed 2 seconds later.

Wire removal is also an excellent job for computers.[26] Various people were dangling from wires in the movie *Cliffhanger,* and wires enabled the fancy martial arts of *Crouching Tiger, Hidden Dragon* (see Figure 12.20), but the wires were removed from the scenes with computer software. Adobe Photoshop (a program many students have access to) can be used to remove wires, albeit a little more tediously than other programs. Make each frame a Photoshop file, and then replace pixels that show the wires with pixels from background that is near the wire. Wire removal techniques can also be used to remove a microphone that accidentally dipped into a shot, a lens flare, an unwanted billboard in a driving shot, and so forth. In a similar manner a young girl's skimpy thong-bikini in *My Father, the Hero* was digitally enlarged to provide more coverage and help the producers avoid an R rating.

Color correction (or **timing**) can be undertaken more easily in a DFW than in most non-linear editing systems. Color can be changed one frame at a time, or the color in just a tiny portion of a frame can be changed, or certain parameters can be programmed into the computer so that it changes color in a whole scene of frames in the same manner. Subtle color elements, such as black level or a particular secondary color, can be manipulated easily.[27] Similarly, a wide variety of filters exist in visual effects programs—enough to give images just about any look you want. In the movie *Coneheads* the prosthetic heads worn by the actors were color-corrected to match the ac-

tors' skin tones. A digitally created snowstorm was added to a scene in *Cobb* when the lack of a heavy snowfall could have caused a delay in shooting. In *Wrestling Ernest Hemingway* a sequence where Shirley MacLaine and Richard Harris are looking at each other out of windows was salvaged by digitally matching the natural lighting conditions that had changed over several days of shooting.

Computer systems are often used for major restoration of old films such as *Snow White, East of Eden,* and *Rebel Without a Cause.* Once the image is in the computer, a technician can remove scratches, dust, and glare and can correct color and duplicate material that was damaged by frame deterioration.[28]

More and more artists are using computers to create animated films, replacing earlier methods of drawing each cell of the movie separately. Films such as *Toy Story, Monsters Inc.,* and *Shrek* rely on digital technology to create backgrounds that can be repeated throughout the frames for an entire scene and characters that move in a lifelike manner.[29]

Once individual elements of a movie are created, they have to be joined together, a function that is known as **compositing.** Characters are placed in the frame in relation to each other and the background. If a movie has fairly simple visual effects, they may be composited as they are composed. But with a visual effects intensive movie, compositing takes place after the effects have all been created. Some of the Quidditch match scenes in *Harry Potter and the Sorcerer's Stone* (see Color Plate 10) had at least 20 items composited—14 players, 3 balls, background items, and members of the crowd.[30] Compositing can involve joining elements from various aspects of moviemaking. For example, an explo-

Figure 12.20
Crouching Tiger, Hidden Dragon *made abundant use of wire removal. (Photo from Photofest)*

sion scene might include material shot on a set where explosives were part of special effects, a model that was made of a building and then burned, and added flames and smoke created in a computer. In *The Green Mile* compositing was used to get the best from two shots. In a scene where prisoner Coffey expels insecticide toxins over the heads of guards, one shot had Coffey out of focus and another had the guards looking the wrong way. The two shots were composited to make one good one.

Visual effects is a constantly evolving field. Directors come up with new ideas, and visual effects artists come up with new techniques. For example, in a scene in *Matrix* a camera moves around the action in slow motion—a new technique that hadn't been tried before.[31]

The Process for Creating Computerized Visual Effects

Most visual effects for Hollywood movies are created at small companies that specialize in computerized effects.[32] Some of them are very specialized in that they have become known for creating monsters, or skies, or buildings. Most,

however, are more broadly based in the type of work they do.

A visual effects person is often brought in during the planning stage of a movie to survey the location where the live action will be recorded and make suggestions as to how best to use it to work seamlessly with the effects. Often this same effects person is on the set to make sure the shooting is also undertaken with the role of the computer in mind.

When the material from the production shoot comes to the effects house (be it film, Digital Betacam, Mini-DV, or some other format), it is scanned into a large computer **server.** At this point it is very important to start a system of data management. Each file must be named and assigned to a particular folder. Often a number of people work on the same project, so they each need a printout telling them where all elements are located. If the material is on film, the **Keykode** numbers (see Chapter 10) are noted. Keykode is not actually used during the visual effects creation process, but if the original negative film will be used at some point, the **negative cutter** needs to be able to relate Keykode numbers to effects.

Figure 12.21
Adobe® Photoshop® is software that both professionals and students can use to create and enhance visual effects. (Adobe product screen shot reprinted from Adobe Systems Incorporated)

The **visual effects supervisor** estimates how much computer storage space a project will take from start to finish. The supervisor also identifies all the tasks that need to be done for a particular project. Maybe wires need to be removed from one sequence, color should be changed on something else, backgrounds must be created for several scenes, and several sections need to be built from scratch. Then the supervisor assigns the tasks. If several people are working on the same project, they need to see each other's work. If they are all tied to the same server, if all work is stored on this server, and if there is good data management, sharing information is quite easy. Complicated projects usually involve occasional face-to-face meetings of all concerned.

Generally, the computer artists use off-the-shelf software (see Figure 12.21),[33] but occasionally someone at the effects house will write special software to accomplish a particular chore. If the artist is building a background, he or she may take a digital photograph of something similar, input that into the computer, and then alter it for the needs of the movie. Other times artists build a model of some object or character and photograph it to use as a basis for design. They also shine light on the model to get ideas for how to develop the computerized lighting. Frequently they work from the **edit deci-**sion list made by the nonlinear editing system so that their work coordinates with what has been edited.

Because visual effects involve quite a bit of **rendering,** computer time and portions of the computer are set aside (usually at night) to undertake this task. After each person has created his or her portion of the project, all the pieces are composited, usually in a separate room by different people. Then the effects are put in whatever format the client requires. They can be played within the computer and at the same time be output to tape (Mini-DV, DVCAM, VHS, etc.) If the client prefers a DVD, the effects house can make one with the aid of DVD creation software. The effects can be transferred to film with a **digital film printer,** which is basically a film camera mounted above a computer screen. The effects play back on the computer screen, and the camera records this picture on film. Commonly the effects are sent back to the facility that is editing the movie so that they can be incorporated within the movie. In these cases, it is important that the effects software be compatible with the editing software. The files can be sent on portable hard drives or DVDs. Sometimes an Intranet is set up so that various files, including those of visual effects, can be transferred and viewed in various places. For example, for *Flubber,* an Intranet was set up for an effects house in Simi Valley in California, director John Hughes's production office in Chicago, the postproduction office in Santa Monica, and Disney Studios in Burbank.

The visual effects process is changing the way movies are made. It opens up new artistic avenues for storytelling and challenges those in the industry to keep up to date.

Notes

1. "Digital Audio Workstations," *Mix,* November 1999, pp. 88–104.
2. "Harry Potter and the Sorcerer's Stone," *Mix,* December 2001, p. 85.
3. "Music for the Menace," *Mix,* May 1999, p. 66.
4. Some of the sound effects libraries are Discovery Firm, Gefen, Hollywood Edge, Killer Tracks, PowerFX, Rarefaction, SmartSound, Sonic Foundry, Sonic Science, Sonomic, and Sound Dogs. All of these have Web sites that use their

name and .com. For a list of more libraries, see "Sound Effects Libraries," *Mix,* April 2001, pp. 81–82.

5. "Paramount Scoring Stage M," *Mix,* October 2002, p. 106.

6. "Into the New Millennium With…MIDI?" *Mix,* January 2001, p. 18.

7. One of the most popular is Cakewalk from Twelve Tone Systems, 51 Melcher Street, Boston, MA 02210 (www.cakewalk.com).

8. "Music for the Menace," *Mix,* May 1999, p. 68.

9. One is SonicFire Pro from SmartSound (800-454-1900), www.smartsound.com.

10. Some of the music libraries are Association Production Music (800-543-4729), De Wolfe Music Library (800-221-6713), FirstCom/Music House/Chappell (800-858-8880), Metro Music (800-697-7392), The Music Bakery (800-229-0318), and Sound Ideas (800-387-3030). For further detail, see "Whistling Down the Wire," *AV Multimedia Producer,* November 1998, pp. 111–116. A major TV production that uses only licensed music is *The Sopranos.* The series does not employ a music composer. See "Guns n' Neuroses," *Mix,* April 2001, p. 73.

11. ProTools comes from DigiDesign, which has been purchased by Avid. DigiDesign is headquartered in Daly City, California. The Web address is www.digidesign.com.

12. "Harry Potter and the Sorcerer's Stone," *Mix,* December 2001, p. 88.

13. "A Workstation User Goes Native," *Mix,* July 2000, pp. 108–114.

14. "Multitrack's Mighty Role," *TV Technology,* January 1992, p. 13.

15. "Star Wars Episode I: The Phantom Menace," *Mix,* May 1999, p. 44.

16. *Ibid.,* p. 54; and "The Basics of Mixing," *Mix,* August 1998, pp. 190–199.

17. "Blurring the Lines Between the Edit and the Mix," *Mix,* March 1997, pp. 84–90.

18. Examples are Titledeko from Pinnacle and Lyric from Chyron.

19. "NAB2002 Hosts Wide World of Graphics," *TV Technology,* 20 March 2002, p. 60; and "Graphics Get High-Tech Look," *Broadcasting and Cable,* 1 February 1999, p. 46.

20. "It's Not Your Father's CG Anymore," *ITV Technology,* 2 May 2001, p. 14.

21. "The Link Between Picture and Sound," *Mix,* May 1999, p. 58.

22. Other colors in the spectrum, green in particular, can also be used to create a blue-screen effect.

23. "Harnessing the Elements on *Cast Away,*" *Mix,* January 2001, p. 152.

24. "Bit Factory," *Hollywood Reporter,* 1 March 1999, p. C3; and "Episode II: Attack of the Clones," *Mix,* June 2002, pp. 85–101.

25. "Morph Mania," *Videography,* December 1991, pp. 103–106.

26. "Wire Removal Usage Grows," *On Production and Post-Production,* November 1994, pp. 50–55.

27. "The Link Between Picture and Sound," *Mix,* May 1999, p. 58.

28. "Bit Factory," *Hollywood Reporter,* 1 March 1999, p. C3.

29. "The Artist's Touch," *Newsweek,* 27 May 2002, p. 68.

30. "Harry Potter and the Sorcerer's Stone," *Mix,* December 2001, pp. 85–95.

31. "Cutting Edges," *Hollywood Reporter,* 25 February 1999, p. S4.

32. Kevin O'Neill, Visual Effects Supervisor, Flat Earth Productions, provided much of the information for this section.

33. Some of the main software used is 3-D-Maya, Soft Damaage, Lightwave, Adobe After Effects, Adobe Photoshop, Combustion, Commotion, Shake, Rayes, and Cincon Composite.

Approaches to Enhanced Audio, Graphics, and Visual Effects

Directors should always pay attention to audio, graphics, and visual effects and make sure that they are integrated into the movie effectively. But when these elements are an elaborate part of a movie, they need to be given special care and consideration. The principles that apply to material edited in a **nonlinear** editing system (see Chapter 11) apply to these enhanced elements, but audio, graphics, and visual effects each have their own peculiar needs as well.

Audio

The French theoretician Christian Metz described five channels of information in motion pictures: the image, written language and other graphics on the screen, speech (dialogue and narration), music, and noise (sound effects and ambient sounds).[1] In this analysis there are more possibilities for communicating information through sound than through picture. Metz makes an even stronger point when he discusses how we look at an image versus how we hear sound. We must redirect our attention to read words on the screen or to look at the picture, whereas sound washes over us. Many writers stress the image when discussing film and television. They consider these to be visual media. But as Metz's analysis (and common observation) demonstrates, film and TV are really audiovisual media. The sound we hear influences the way we look at the picture. The same series of pictures projected with different sound tracks can have radically different meanings.

The people who spot for music and sound effects and who edit dialogue must be aware of the various purposes that sound can fulfill. They do not wantonly place cricket chirps, tire squeals, factory noises, soft romantic music, and lines of dialogue in the sound track. They go through a definite thought process, either consciously or subconsciously, to determine which sounds are needed and where they should go.

There is no set list of purposes for sound, but most sound can be thought of in terms of supplying information; enhancing reality or fantasy; establishing time, place, and character; creating mood and emotion; giving a sense of rhythm; directing attention; and relating to the image.

Supplying Information

In many instances sound, primarily the **dialogue,** conveys most of the information in a movie. Talking heads do not give much visual information beyond the emotion that actors can convey through their expressions. The essence of the information is in the words that they speak. For this reason, great care should be taken to ensure that the dialogue is understandable.

If you are spotting for **automatic dialogue replacement (ADR),** the need to supply information must be uppermost in your mind. Any dialogue that is so muddled that it cannot be understood should be rerecorded. If you are editing, consider the clarity of the dialogue in selecting the takes to include in the movie.

Voice-over narration can also convey a great deal of information, but it must be planned and recorded properly so that its message is understood. In productions designed primarily to inform, voice-over is often the main source of information. In these cases, you must decide whether the picture should be edited to the voice-over or the voice-over recorded to suit the needs of the image. Also, the picture and voice-over must be coordinated so that there are no duplications. If the words simply describe what is happening in the picture, they are superfluous and give the impression that the narrator is talking down to the viewer. Another problem arises when a narrator reads words that appear on the screen. Most members of the audience will be able to read the words faster than the narrator can speak them, so the visual and aural information will interfere with each other. The best way to convey information through narration is to

```
      ANNIE SAVOY'S SOLILOQUY FROM BULL DURHAM
                   by Ron Shelton

I believe in the Church of Baseball.

I've tried all the major religions and most of the
minor ones--I've worshipped Buddha, Allah, Brahma,
Vishnu, Siva, trees, mushrooms, and Isadora Duncan.

I know things.  For instance--

There are 108 beads in a Catholic rosary. And--

There are 108 stitches in a baseball.

When I learned that, I gave Jesus a chance.

But it just didn't work out between us...The Lord laid
too much guilt on me.  I prefer metaphysics to
theology.

You see, there's no guilt in baseball...and it's never
boring.

Which makes it like sex.

There's never been a ballplayer slept with me who
didn't have the best year of his career.

Making love is like hitting a baseball--you just got to
relax and concentrate.

Besides, I'd never sleep with a player hitting under
.250 unless he had a lot of R.B.I.'s or was a great
glove man up the middle.

A woman's got to have standards.

The young players start off full of enthusiasm and
energy, but they don't realize that come July and
August when the weather is hot it's hard to perform at
your peak level.
```

Figure 13.1

This opening soliloquy sets the stage for Bull Durham. *(© 1988 Orion Pictures Corporation. All rights reserved.)*

(Continued)

have the voice-over convey facts that relate to but also add to the picture.

When voice-overs are used in movies, they often appear at the beginning of a film to give information about what has preceded the action or to provide information about what is going to happen. An excellent example of this is the opening narration from *Bull Durham* by writer-director Ron Shelton (see Figure 13.1).[2] This voice-over, delivered by Annie Savoy (played by Susan Sarandon), succinctly covers much of the backstory. It also prepares the viewer for the story

The veterans pace themselves better. They finish
stronger. They're great in September.

While I don't belive a woman needs a man to be
fulfilled, I do confess an interest in finding the
ultimate guy--he'd have that youthful exuberance but
the veteran's sense of timing...

Y'see there's a certain amount of "life-wisdom" I give
these boys.

I can expand their minds. Sometimes when I've got a
ballplayer alone I'll just read Emily Dickenson or Walt
Whitman to him. The guys are sweet--they always stay
and listen.

Of course a guy will listen to anything if he thinks
it's foreplay.

I make them feel confident. They make me feel safe.
And pretty.

'Course what I give them lasts a lifetime. What they
give me lasts 142 games. Sometimes it seems like a bad
trade--

--but bad trades are part of baseball--who can forget
Frank Robinson for Milt Pappas, for Godsakes!

It's a long season and you got to trust it.

I've tried 'em all...I really have...

...and the only church that truly feeds the soul--day
in, day out--is the Church of Baseball.

line of the movie. Someone had to select the pictures to use with the voice-over. The picture could have shown Sarandon delivering the lines to the camera, but then the image would not have given much more information than the audio. The pictures could have illustrated the various "religions," but that would have repeated what the words were saying. What was selected—a few baseball photos and shots of Sarandon primping before the mirror and walking to the baseball stadium—conveyed additional information and moved the story toward the next scene.

Occasionally, voice-overs state what people are thinking or reiterate dialogue from earlier in

the movie. For example, in *My Big Fat Greek Wedding*, Nia Vardalos makes witty voice-over comments about her family and her plight as an over-30 unmarried Greek woman, all of which increases the impact and humor of the information contained in the dialogue and actions.

Sound effects and **ambient sounds** can also convey information, albeit in a less straightforward manner than dialogue or narration. Dogs barking can mean someone is coming; the volume of an ambulance's siren is an indication of how soon help will arrive. Off-screen sound effects can tell us that the teenage son has crashed the car into the garage even though we never see the crash and no one in the cast refers directly to it.

Supplying facts is not the primary power of music, but on occasion music can be informative. When lyrics comment on what is being presented, they add another layer of meaning. In fact, in musicals the lyrics often drive the story forward. For example, in *Singin' in the Rain,* the song "You Were Meant for Me" establishes the love interest between Gene Kelly and Debbie Reynolds that Kelly is supposedly unable to articulate (see Figure 13.2). Music can also foreshadow, giving information before the picture or dialogue do. For example, the music can become ominous before tragedy occurs. Music can also heighten the impact of information given by dialogue or narration. It can punctuate the words to give them added importance. In a few films music has been a source of information. The spaceship's musical refrain in *Close Encounters of the Third Kind* was part of a language that the people on Earth had to decode.

Sound can also *withhold* information. In *North by Northwest* Alfred Hitchcock uses the noise of an airplane to drown out part of a conversation between Cary Grant and a CIA agent. Sometimes sound conveys information that is totally *opposite* to the picture. This can be used for comic effect. In *Singin' in the Rain* Gene Kelly's voice tells of his glorious rise in show business while the pictures are showing that he was really a flop. Serious overblown music accompanying the antics of Jim Carrey has a similar effect.

Supplying information is a primary power of sound. Unless the movie is intended to be ab-

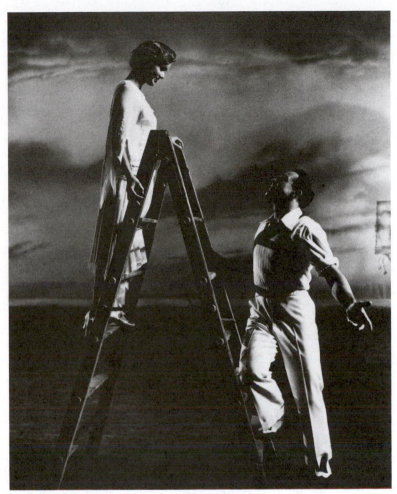

Figure 13.2

In this scene from Singin' in the Rain, *the lyrics advance the story. (© 1952 Loew's Inc. Ren. 1979 Metro-Goldwyn-Mayer, Inc.)*

stract or ethereal, the audience should understand what is happening. If you are spotting a movie, make sure that some sound source gives the audience information you want them to have that is not conveyed in the picture.

Enhancing Reality and Fantasy

Adding reality cues is a major function of **Foley,** ambient sounds, and sound effects. These are the elements that make the viewer believe the **mise-en-scène.** An airport without airplane noises, a crowded waiting room without coughs and muffled voices, or silent footsteps on gravel would not be believable. For dialogue the main reality cue is **perspective;** a distant voice coming from someone who looms large in the center of the screen does not sound real. Sound effects can employ perspective too. In *Jurassic Park* the

sound of the dinosaurs approaching from the rear of the theater gives an exceptionally realistic scariness to the movie. The asteroids in *Armageddon* have a whiz-by sound.[3]

In general, dialogue and voice-overs can set up reality, but the little noises always present in life are what give that reality substance. The sound people on the TV series *Ally McBeal* were so intent on reality sound that they didn't use a Foley studio to record the sound of people wiggling around in courtroom chairs. Rather, they recorded these noises on the courtroom set itself. Director Robert Zemeckis did not want any sounds in *Cast Away* that would make Tom Hanks seem less alone. So the sound track had no crickets or frogs and certainly no music. The track was built primarily with variations of wind, wave, and creaking palm noises.[4]

John Edwards-Younger, in charge of effects for *NYPD Blue,* goes through a definite thought process to make the series realistic. He places **walla walla** in each scene of each episode because there is always noise in bustling New York. The show has a group of actors that have been named the SuperLoopers, who do all the different types of walla walla from very general cafe noises to cops in the background yelling out codes. Edwards-Younger also includes traffic noises in all scenes, be they indoor or outdoor, again because one can always hear traffic in New York, even in a quiet apartment.

He then considers general off-screen elements—perhaps jackhammers or fire sirens if the scene is a busy street. Often these noises are used to fill holes where there is no dialogue, so Edwards-Younger will go through a scene and "paint" in sounds to enhance the aural canvas. He also considers off-screen needs of the story; if a helicopter is coming, it must be heard well before it is seen. Finally, he looks for on-screen needs. Often this requires knowledge of the story line. For example, if a woman officer answers the phone, he must know if she is waiting for the call and answers it quickly or if she is engaged in something more important and lets the phone ring several times before answering. Easier are on-screen **hard effects** such as door slams that give a very concrete sense of reality.[5]

Creating fantasy is another matter. Music is excellent for creating fantasy because most of us do not hear violins as we walk down the street. Sound effects are also excellent for creating fantasy. The sound that is made when one of the Three Stooges "gouges" someone's eyes does not approximate the actual sound that act would make. The sound lets you know that this action is not real. In fact, if the sound were authentic, Three Stooges movies might be truly offensive. In *Harry Potter and the Sorcerer's Stone* (see Color Plate 10), the sounds the owls make are louder than those made by real owls because "it's a movie." If owls were really that loud, they would never catch mice. Sounds that do not exist on Earth give such films as *Star Wars* (see Color Plate 8) a futuristic effect. Dialogue and voice-overs can also add to fantasy. Donald Duck's voice would never be mistaken for real.[6]

Spotting for reality and fantasy is not easy. You must look at the entire scene carefully and determine what sounds would be appropriate. Would there be traffic noises coming in the open window? Will the clinging evening gown rustle as the woman moves? To what extent should the clinking glasses in the long shot of the bar carry over to the close-up of the two gangsters talking? Is the guitar playing in the background acoustic or electronic? What kind of noise might a laser gun make? Is the sound of an extra snapping his fingers in the back of the scene worth including? These are the types of details spotters must consider.

Acquiring and recording the sounds can be difficult too. Sound effects from CD libraries are often not quite right. Going to the actual source sometimes does not work. A real crackling fire doesn't sound very much like one when it is recorded. Wrinkling paper might create a more "realistic" crackle. Creating sounds in computers may not be effective as the sound editors for *The Lord of the Rings* found out. They tried to layer various animal sounds to create something new but found that using the sounds one at a time worked better.[7]

Establishing Time, Place, and Character

Theoretically, the dialogue could establish everything the audience needs to know about when and where the scene is taking place and the type

of people involved. However, using only dialogue to do so can become tedious and stilted. ("I'm glad we're coming to visit Uncle Herman this bright May morning even though I know he is your father's grouchy bachelor uncle who lives on a rundown farm with his cows and pigs and never answers his telephone.") For this reason, sound editors often use other elements to help identify time, place, and character. Voice-overs can do this even more blatantly than dialogue without seeming forced. For example, the narrator in Orson Welles's *The Magnificent Ambersons* opens the film by describing all the characters. People accept narration as expository and so do not find being bombarded with facts unnatural.

Music is excellent for establishing time, place, and character. A Gregorian chant bespeaks medieval times; oriental music sets a movie in China; jazz puts the audience in New Orleans; and "Here Comes the Bride" establishes a wedding. In *Forrest Gump* music from the various decades accompanies Forrest's life story. Character is a little more difficult to establish with music, but some films contain a **motif**, a specific group of notes that is played to herald the arrival of a particular character. For instance, in *Jaws* the same music always signals the appearance of the hungry shark. Music can also indicate character qualities. In old melodramas cellos playing in a minor key often denoted a villain, a sturdy brass march accompanied the hero, and soft violin passages signified the heroine.

Sound editors also use sound effects and other noises to indicate time, place, and character. The cock crowing, the alarm ringing, and the clock striking midnight all indicate time. Putting traffic noises in the background during a close-up of a woman tells us that she is in the city and can eliminate the need for an establishing shot. Similarly, cannon noise can save the cost of a mammoth battle scene and allow you to concentrate on several actors involved in battle. Sound effects can also signal a character's arrival. A particular snort or the sound of creaky shoes can announce that some well-established character is near. Surround sound can provide an unusual type of location cue. An editor can convey sense of space in a particular scene by delaying sound between the speakers in the back and those in the front.

One of the main considerations when spotting, positioning, and mixing sounds that establish time, place, and character is not overdoing them. If the time is evident from the picture or the dialogue, there may be no need to add the crowing cock, which has become a cliché. Like sounds that supply information, sounds that establish time, place, and character should clarify what is happening.

Creating Mood and Emotion

Music is important for creating mood and emotion. Music can express just about any emotion—love, hate, fear, tension, serenity, anger, friendship. Music has its own cultural language in this regard. Soft, slow music is considered romantic, and music in the minor key denotes sadness. However, music is highly subjective. For this reason the director and the composer should be of the same mind about what the music is conveying or the postproduction process will grind to a halt as they argue over the appropriateness of a particular score.[8]

Theme music can provide a comfortable familiar mood, especially if it is associated with a popular production. Series TV makes great use of theme music over opening and closing credits, and John Williams's music for *Star Wars* (see Figure 13.3) is known throughout the world. Movies with sequels, such as the James Bond series, also use music to capitalize on past successes and familiarity. Theme music can be reassuring even within a movie. For example, the theme for *Dr. Zhivago* repeats often throughout the film to reemphasize emotion.

A movie's opening music can set the mood for the entire motion picture. Specifically, it clues the audience to whether the movie is for laughing or for crying. Music within a movie can also create humor by punctuating a humorous event with an unusual musical sound. Or the music itself can be funny, as in the toy store piano-playing scene in *Big*. Tom Hanks using his feet to play "Chopsticks," a ditty just about everyone has heard or played, added to the humor of the scene.

Most film music is composed after the movie is completed so that it can fit the emotion and timing of the scene. Sometimes, however, the

Figure 13.3

The theme music for
Star Wars *is known
everywhere, giving it a
comfort factor. (Photo
from Photofest)*

music comes first. *While You Were Sleeping* used familiar popular music from the past to heighten its emotion. Documentarian Ken Burns (*The Civil War, Baseball*) usually starts with music. As he puts it, "We do not 'score' a picture, which is the mathematical application of timed music once a film is done. When music is added to a film in this way, it can only be 'canned.' What we do instead is record the music of the period before we begin editing, giving ourselves a wide variety of music, which, more often than not, dictates the rhythm and the emotion of every scene before we begin to edit it. So in the case of the Civil War, we will hear the sounds of the music that the soldiers sang and played among themselves, and we will hear it on the authentic instruments that they themselves played. In addition, we isolate certain theme music which we feel can become a bridge to our twentieth century audience, reminding them of music's incredible power to convey the most complicated emotional information."[9]

Although music is written or selected to enhance the script and visual aspects of the movie, it often takes on a life of its own. Many movie scores have become popular in their own right and have hit the top of the record charts, as did the scores from *Saturday Night Fever, Titanic, Against All Odds,* and *8 Mile* (see Figure 13.4).

Sound effects can also create mood and emotion. Waves lapping against the shore or birds chirping connote serenity. Squealing tires create tension. An ominous off-screen thud can raise anticipation. A siren signals danger. A coyote call denotes isolation.

Sound effects are also excellent for creating humor. Many of Jim Carrey's antics in *The Mask* are made funnier by the sound effects that accompany them. You have to be somewhat careful with humorous sound effects, however, so they aren't overblown. In one episode of *Ally McBeal* one of the visual effects showed a character's tongue rolling to the floor. The sound effects people tried the sound of an anvil as the tongue landed but decided that was too much and instead used the sound of a mop on wet cement.

Don't succumb to the temptation to use new ideas for sound effects just for the sake of newness. Some of the classics, such as a squeaky door, work quite well to scare an audience. In some instances, you need to be careful not to make the sound effects too dramatic, especially in movies designed for children. The sound people backed off on their sound effects for *Scooby-*

Figure 13.4
After Eminem starred in the 2002 movie 8 Mile, *the sound track of his music was at the top of the record charts. (Photo from Photofest)*

Doo because the ones they first created were too intense.[10]

Voice elements in dialogue and voice-overs can also create emotion. The muffled voices of an argument add to tension. The tone and content of the voice-over at the beginning of *Bull Durham* say that this movie is not going to take itself too seriously.

One of the best devices for creating emotion is the absence of sound—silence. Because sound permeates most movies, a period of silence creates great tension. The first sound that follows silence greatly intensifies its impact. For example, in *Platoon* there is a long period of silence while the soldiers are watching for the enemy. Suddenly a twig snaps. The audience does not see danger but certainly feels it because of the sound.

Spotting for mood and emotion is probably the most difficult of all spotting because context clues are not obvious in the picture. There is no dress that needs to rustle or lightning that needs thunder. The person doing the spotting must feel the emotional needs and think of ways to fill them.

Giving a Sense of Rhythm

As much as picture editing, music can establish pace—long phrases and a limited number of notes per measure (perhaps a minuet) for slow-paced material and short phrases and a multitude of notes (perhaps heavy metal) for fast-paced material. The music's level of rhythmic energy greatly affects the energy level of a movie scene. Music can also magnify the movie's climaxes—cymbals clashing just as the prizefighter floors his opponent.

It is easier to fit the rhythm of music to the rhythm of the picture if the music is composed for the movie. It is harder if the music is prerecorded. For example, Martin Scorsese's *Casino*

used only existing 1970s and 1980s music. Before editing the picture, Scorsese laid most of the music tracks. He gave the editors directions about actions he wanted to occur at particular lyrics within the songs or at particular musical points. The editors then tried to cut the picture so that it matched the music and still made sense from a visual point of view. Sometimes this did not work out perfectly, and the picture could not be made to hit the music cues exactly. However, because the music was on a digital audio workstation, the editors were able to expand or contract segments slightly so that it fit with the picture.[11]

For some types of editing, music dictates the pace and the picture supplements it. This is almost always true for music videos because the music exists before the pictures. The picture editing decisions are based on the content, the rhythm, and the feel of the music. With this type of editing, the video cuts are generally made on the music beat, although doing so throughout an entire selection can become boring. Music sets the rhythmic agenda for many commercials. Within narrative motion pictures, music can be the driving force of montages. For example, at the beginning of *Wayne's World* a montage sequence is cut to the beat of Queen's "Bohemian Rhapsody."

Sound effects too can add to the rhythmic effect of the movie. Cartoons often use a barrage of effects, mixed with music, to punctuate chases, tumbles, and other antics that make up most of these high-energy minimovies. Dialogue and voice-overs can set pace. Clipped speech delivered in a sarcastic tone is usually fast paced, and raised voices of an argument often build to a climax.

The rhythmic function of sound is subtle. Sound editors and composers must be in accord with the director on the pace, energy, and climaxes of the movie and individual scenes. A high-energy picture with slow sound will lose energy.

Directing Attention

Sound also has the ability to direct the audience's attention. Ordinarily, the audience focuses its attention on the person talking, and that person is usually in the center of the screen. But if a door opens to the right, the audience will expect someone to enter from the right and will probably look in that direction. In this way sound expands the frame, defining off-screen space in such a way that it becomes almost as much a part of the story as the on-screen space. Directing attention with sound can also frighten the audience (à la Hitchcock). If the audience is looking to the right side of the frame because the main sound and action are occurring there, the director can bring in something unexpected from the left. The audience members may be caught unaware, and their fear will be heightened.

Sound can direct attention to particular elements of the frame that might not be noticed otherwise. A car that is backfiring often is just part of a traffic scene, in which case the backfire might not even be heard on the sound track. But if that car's presence in the scene in which the hero gives secret documents to a spy is important to the story, the editor can accentuate the backfiring noise in such a way that the audience becomes aware of it. Then when they again hear the car at the scene of the murder, the audience members who were aware of the backfire become privy to a special clue.

Even more extreme would be including the sound of a bomb ticking, which might not actually be audible in a particular circumstance, to focus the audience's attention on the possibility of an explosion. Sometimes the sound track even includes something totally inaudible, such as a beating heart.

Sound at the end of one scene can foreshadow the next to intensify the audience's reaction to the second scene. A siren wailing at the end of a bucolic scene can draw the audience into the next scene, where a frantic rescue attempt is under way. When the fireplace shoots flames into the living room in *On Golden Pond,* we hear Katharine Hepburn's screams about the fire for several seconds (over a shot of Henry Fonda and the boy) before the cut shows Hepburn and the fire.

Using sound to direct the viewer's attention where the director wants it focused is a rather

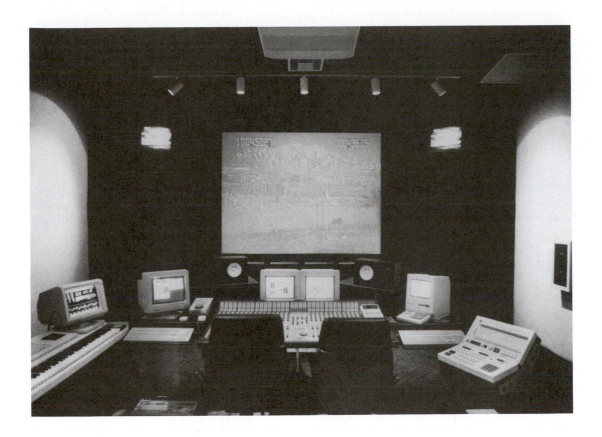

Figure 13.5
Sound and picture are integrated in facilities like this one. The picture is projected onto the large screen, and several people operate the audio controls to mix the various sources properly. (Photo courtesy of Digital Sound and Picture)

subtle art. Sound is not often used for this purpose and probably should not be. Using sound to direct attention should be reserved for especially appropriate circumstances. People who spot for music, sound effects, ambient sounds, Foley, and ADR usually do not consciously consider the various purposes of sound; indeed, these purposes could be identified in many different ways.[12] What is important is that sound is used to enhance the movie.

Relating to the Image

Despite its importance, the sound in motion pictures does not stand alone as does the music on compact discs. Movies by definition involve the juxtaposition of sound and image. In fact, one of the director's primary concerns is establishing or creating effective relationships between the picture and the various elements of the sound track (see Figure 13.5).

The spoken words and ambient sounds recorded with the image during production are referred to as **synchronous sound.** In **double system** film production (see Chapter 7), the editor must actually sync up the picture and sound, but regardless of how this relationship is

created, it is essentially a relationship in time. In other words, we consider the sound and picture to jibe in sync if the sound we hear is perfectly matched in time to the person or object creating that sound on the screen. Conversely, sound is out of sync if a person talking or a hand knocking on a door is not timed precisely with the sound of the words or door knock.

In the first stages of editing the picture and synchronous dialogue track are placed together. But as the editing proceeds, the editor can begin to establish entirely different relationships between the picture and its matching sound. By using **cutaways, reaction shots,** or **close-ups** of isolated details within the scene, the editor may juxtapose the synchronous sound from one shot with images that are entirely different. Furthermore, the editor can make the sound from one scene overlap the following or preceding scene, foreshadowing the scene we are about to see or recalling the scene that has just ended.

Because the editor can position the sound track at any point, it is possible to establish a variety of relationships with the image. The editor can use sound to create a **sound flashback** or **sound flashforward.** We might, for example, hear dialogue, sound effects, or music from a

character's past while seeing an image of the character in the present.

Another area of control concerns when and how to bring in sound in relation to the image. Music, for example, often fades in slowly and unobtrusively at some point in the scene, pushes to a higher level as the intensity of the drama increases, and gently fades out after the climax. In contrast, an explosion or door slam should be abrupt. Such sounds must begin immediately at full volume. A gentle fade-in would destroy the effect.

In their book *Film Art: An Introduction*, David Bordwell and Kristin Thompson examine a variety of sound–image relationships.[13] They differentiate between sound that is **diegetic** (from within the story space) and sound that is **nondiegetic** (outside the story space). When we see the image of characters talking and also hear their words, the sound is diegetic. The same would be true of sound effects or music that emanate from sources on the screen, such as a door slam or jukebox. All these sounds might occur on-screen, but they would still be diegetic sounds if they took place off-screen—provided that they came from the story space.

Nondiegetic sound comes from outside the story space. The most common kind of nondiegetic sound is the musical score that typically accompanies a motion picture. Unless the director is making some kind of joke, we do not expect to see a shot of John Williams and the British Philharmonic Orchestra as the film reaches a dramatic climax; the musical score by convention is not part of the story space. Sometimes sounds seem to be nondiegetic but then become diegetic. For example, in *K-19: The Widowmaker,* classical music (which sounds like a musical score) starts under a scene in the submarine working area but is then revealed to be coming from a tape recorder in the captain's quarters. An omniscient narrator might provide a voice-over introduction to a motion picture, setting the stage for the action to follow. This kind of narration is nondiegetic, but if it is provided by a character in the story, it would be considered diegetic sound.

Whether it is diegetic or nondiegetic, narration can provide information about the past, present, or future that may not be contained in the image. Many directors have made extensive use of interior monologues in which we hear what characters are thinking but do not see them moving their lips in the image on-screen. This kind of subjective narration is diegetic. A narrator who comments on the action from outside the story space would convey a completely different kind of information and set a different tone.

Such distinctions are helpful in demonstrating at least a few of the complex relationships the editor can develop while constructing the sound tracks. No sound is irreversibly locked to its matching image. The director and editor are free to build any number of sound–image relationships in space or time. Sounds may originate from within the story space or from outside it. Sounds may be on-screen or off-screen. They may present information about the past, present, or future. In the hands of a skillful and creative editor, sound–image relationships can make a significant contribution to the completed motion picture.

Graphics

In the same way that sound must be understandable, a major requirement for most graphics is that they be readable. It is a good idea to look at the finished graphics on a rather poor TV set so you know how they will look to people who rent the video. Most of the time you don't want the graphics to call attention to themselves. A graphic on the screen that says "London, 1944" is there to convey information and move the story along, not to show off the artistic skills of its creator. The KISS (Keep It Simple, Stupid) rule is a good one to obey. Fancy opening credits may grab the attention of viewers and hold that attention at least part way into the movie; however, they should still be readable.

Graphic Characteristics

Various characteristics can make graphics readable and also enhance emotional aspects of the movie. Contrast is particularly important as a

HARRINGTON

Arial

Figure 13.6

The top font, which is Harrington, has serifs and is more emotionally oriented than the bottom font, Arial.

readability factor. Titles should not blend into the background. Blue letters will get lost over a scene that is mostly sky. One way to make the letters stand out is to put a border or shadow around them. White letters with a black border can be seen whether the background is dark or light. In addition to aiding contrast, the shading adds fullness and a 3-D effect.

The font of a title should match the style of the movie. Fonts with **serifs** (tops and tails that lead the eye to connect the letters) tend to be emotional or informal whereas fonts without serifs are more factual and formal (see Figure 13.6). Boldfacing gives the visual power, and all capital letters give a solid impression although they are more difficult to read.

Color, whether it be for letters or other graphics, can affect perception. Generally bright colors convey more energy than do pastels. We perceive blues as cold and rather distant and reds as warm and friendly. Some colors, particularly green, are considered calming.[14] Colors on opposite sides of the color circle (see Color Plate 3) have the most contrast.

Shape is another factor to consider when constructing graphics. The triangle is generally considered the most stable shape because it has a large base. Circles indicate closure or a sense of completion. Horizontal lines are restful and stable, vertical lines suggest power and dignity, and curved lines are generally considered relaxed, graceful, and beautiful. Broken lines indicate tension, thick lines show power, and diagonal lines imply action or lack of permanence (see Figure 13.7).

Not all of these characteristics affect all people the same way, so they should be used only as guidelines, not gospel truth. But they are helpful when you want the graphics to fit the

Figure 13.7

Different shapes give different impressions: (a) stability, (b) closure, (c) restfulness, (d) dignity, (e) gracefulness, (f) tension, (g) power, (h) action. (Artwork by Brian Gross)

mood of the movie. For example, if the movie is a light comedy, you might want to consider reddish titles with serifs and other curved lines. This will help the audience know what they are in for and will get them in the mood for the movie.

Structuring Graphics

Generally credits have a sense of oneness and harmony, which is achieved by using the same color base, font, and background. Job titles in the closing credits should have a similar look, and the names should have a similar feel. There can be differences, especially between the size of the credits for high-profile jobs (such as actors, director, and writers) and the low-profile jobs of

a

spect Rati

b

Figure 13.8

If graphics designed to take advantage of widescreen are viewed on a monitor with a 4:3 aspect ratio, there can be problems. Illustration (a) shows a graphic structured for 16:9, and illustration (b) shows the graphic on a 4:3 screen (with only the "spect rat" text visible). (Artwork by Brian Gross)

Figure 13.9

The inner line indicates the safe area for graphics if they are going to be shown on standard definition television. The outer line shows what will probably still be seen on a home TV set. (Artwork by Brian Gross)

crew members, but changes in style should not be jarring.

It is important that the graphics be suitable for the movie. Some of the suitability may relate to balance. As with framing (see Chapter 4), **balanced** graphics have equal apparent weight on each side and at the top and bottom and tend to look stable and solid. **Unbalanced** graphics are dynamic and active. Generally, unbalanced graphics are more desirable because they have more interest, but it depends on what you want to convey about your production. When graphics move on the screen, the movement should be timed to be in rhythm with the rest of what is happening in the movie.[15]

Another consideration, especially with titles and credits, is **aspect ratio** (see Chapter 3). Graphics that look fine with a widescreen or **HDTV** aspect ratio may have major problems when shown on a 4:3 aspect ratio **standard definition TV**. Some of the letters will disappear (see Figure 13.8). Until HDTV becomes entrenched, it is better to keep the credits in the center of the screen. Most software programs show a **safe area** in the middle of the screen where you can place graphics so they will be seen in their entirety on a standard definition TV set (see Figure 13.9).

Visual Effects

Filmmakers have always been fascinated by visual effects, in part because most movies are fantasy, and in the fantasy world anything can happen (even though it is not possible in real life). Way back in 1902, Frenchman George Méliès shot *A Trip to the Moon* that included planets circling above the heads of scientists, a ship landing on the moon, telescopes turning into stools, and many other effects.[16] Obviously Méliès did not create these effects in a computer; rather, he used wires and various camera techniques.

The use of computerized effects has grown as computers have improved to the extent that movies are often criticized for having effects for the sake of effects. They do not add to the

Figure 13.10

In Spider-Man *visual effects and live material had to be carefully coordinated. In this shot the street traffic was shot on film, but the buildings and Spider Man were created in a computer.*

story—in fact, some movies laden with effects don't have much of a story. As visual effects become less of a "gee whiz" phenomenon, Hollywood-style moviemakers will undoubtedly use them more and more in the service of the story.

One of the difficult aspects of effects is creating them in such a way that they meld seamlessly with what is shot on a set or on location. This involves great attention to detail. Clothing, arm positions, walking mannerisms, depth of field, and many other factors must be examined carefully. In some scenes where Spider Man flies around Gotham, the traffic on the street was filmed from a high building, but the buildings and Spider Man himself are computer generated (see Figure 13.10). The computer work and the live traffic shots had to match. Often visual effects artists view the material recorded on-set on a nonlinear editing system so they can carefully compare it to what they are creating.

Lighting can be of particular importance. In *Small Soldiers,* the effects house ILM had to mimic the on-set lighting for Archer walking down a darkened hallway where the Commandos had set a trap for him. This included keeping half of Archer's face in shadow. Little nuances, such as light that comes through the ear lobes has to be matched. Sometimes actors will undergo a body scan, wherein they are recorded as a light encircles them from head to toe. That way the people creating the visual effects know how much shadow to cast from the nose or where there will be lit bulges in the body suit.

If material has been created partly with film and partly with video, the visual effects people can incorporate software that makes video look like film. In fact, this software is often used with material shot totally on video to give it a "film look" (see Figure 13.11).[17]

When effects are used to create a particular emotional impact, they can be very powerful. The scene in *Requiem* where Ellen Burstyn's character goes to the doctor because she is having trouble with her pills was made more gripping by having one part of the frame contain slowed down action and the other part speeded up action to match the feelings of the two characters. Filters, in particular, can make a movie more spooky or a woman more glamorous.

Methods for using visual effects are still in transition because many techniques are fairly new. This leaves plenty of room for experimentation and development—and jobs for people who can think creatively.

Figure 13.11

A screen from CineLook software that is used to make video footage look like film footage. (Photo courtesy of DigiEffects)

Notes

1. Christian Metz, *Film Language: A Semiotics of the Cinema,* trans. by Michael Taylor (New York: Oxford University Press, 1974), pp. 39–91.
2. *Bull Durham* (1988) was an Orion Pictures Release from a Mount Company Production. It starred Kevin Costner, Susan Sarandon, and Tim Robbins. The executive producer was David V. Lester, the producers were Thom Mount and Mark Burg, and the writer and director was Ron Shelton.
3. Tom Kenny, "Sound Design for Steven Spielberg's Dinosaur Epic," *Mix,* July 1993, pp. 128–134; and "Armageddon's Asteroids," *Mix,* July 1998, pp. 58–64.
4. "The Wacky World of 'Ally McBeal,'" *Mix,* April 1999, pp. 8–14; and "The Music of Sound," *Hollywood Reporter,* 26 February 2001, pp. S8–S9.
5. "A Sonic Week in the Life of *NYPD Blue,*" *Mix,* May 1995, pp. 148–155.
6. "Harry Potter and the Sorcerer's Stone," *Mix,* December 2001, p. 92; and "Episode II: Attack of the Clones," *Mix,* June 2002, pp. 85–102.
7. "Audio Au Natural," *Hollywood Reporter,* 26 February 2002, p. S16.
8. "Secrets to Successful Collaboration with a Composer," *AV Video,* July 1992, pp. 52–57.
9. Ken Burns, *Making Film History* (Detroit: General Motors, n.d.), p. 5.
10. "'Scooby Doo' Be Afraid, Be Kind of Afraid," *Mix,* July 2002, p. 90.
11. "Assembling the Soundtrack for Martin Scorsese's *Casino,*" *Mix,* January 1996, pp. 82–91.
12. For other approaches to this subject, see Lee R. Bobker, *Elements of Film* (New York: Harcourt Brace Jovanovich, 1974), pp. 82–107; Herbert Zettl, *Sight-Sound-Motion: Applied Media Aesthetic* (Belmont, CA: Wadsworth, 1999), pp. 306–325; and "Sound With the Stroke of a Brush," *TV Technology,* 24 February 1999, p. 52.

13. David Bordwell and Kristin Thompson, *Film Art: An Introduction* (New York: McGraw-Hill, 1993), pp. 244–273.

14. That is the derivation of the "green room," a room for people who are about to go on TV. The walls are often painted green with the idea that the people who sit in them will be less nervous.

15. For more detailed information on graphic design, see Steve R. Cartwright, *Pre-Production Planning for Video, Film, and Multimedia* (Boston: Focal Press, 1996), pp. 186–191; and Zettl, pp. 47–87.

16. Gerald Mast, *A Short History of the Movies* (New York: Macmillan, 1986), pp. 32–33.

17. CineLook is a product of DigiEffects, 1806 Congressional Circle, Austin, Texas 78742, (888-344-4339), www.Digieffects.com.

The Final Stages of Moviemaking

Y ou have finished your movie and played it from the computer. Now what? If you are a student, you may be happy just to receive your grade. But there are many distribution and exhibition possibilities that both professionals and students can take advantage of once the completed project is assembled in the nonlinear editing system. The most complicated, but most prestigious, is to transfer the movie to film so that it can be shown in theaters.

Transferring Back to Film

If a movie is edited electronically but is going to be shown on film, it must be transferred to film. This process involves negative cutting for the picture, transfer for the sound, and laboratory work for the whole film. Some aspects of the movie, such as visual effects, require special treatment. Then, of course, the film can be projected in a theater.

Negative Cutting

If the movie was shot on film, the **negative** can be cut to match the decisions made during non-linear editing. This is referred to as **conforming**. A **negative cutter** removes the original negative from its cool storage space and uses the special bar code numbering system (**Keykode** or **Mr. Code**) to determine the **edge numbers** that relate to edit points (see Chapter 10). Once the negative cutter has used a computer program to translate the **time code** editing numbers back to edge numbers, she or he can cut the negative film where the corresponding edge numbers appear. These edge numbers are printed when the original film is processed and appear a uniform number of frames apart (every 20 frames for 16mm and 16 for 35mm). As long as negative cutters know the edge number and how many frames past that edge number the edit is to occur, they can duplicate the editing decision made during nonlinear editing. Most negative cutters also like to have a video copy of the movie to check if they have any doubts about the numbers.

Because the negative is so easily damaged (any mark on the original negative will show forever in the prints made from it), it is conformed in a **clean room,** a spotlessly clean editing room with air filtered to remove the dust. Negative cutters wear gloves to keep the oil from their fingers from leaving marks on the film. The negative cutter uses a special splicer that includes a sharp razor blade to cut the film and provision for a special cement to connect the edited frames together securely.

Sometimes a negative cutter prepares two rolls for the film, referred to as **A-B rolls.** These can be needed if dissolves and other uncomplicated effects are going to be printed at the film lab (discussed later in the chapter). The A roll contains the first shot of the movie, and the B roll contains the second. This pattern of alternating shots continues throughout. When the A roll is completed, it contains half the shots in the film, with each shot separated by a length of black leader exactly the length of each shot on the B roll.

Preparing the Sound

The negative cutter does not deal with the sound, only the picture. In past decades, sound was placed on **magnetic film** and taken to the lab to be married with the picture (see Chapter 1). Sound and picture still meet at the lab, but the sound is most likely to be in a digital form, either tape or hard drive, depending on what the lab can handle. Sound that goes with film does not need much special treatment beyond what is accomplished in the final computer-based or multitrack final mix (see Chapter 12). The same sound that is used for the nonlinear editing video material can be used for film transfer.

However, film sound is sometimes more elaborate than video sound because of the audio systems in theaters. Theaters generally provide **5.1 sound** (see Figure 14.1), which means the sound

can come from six different places in the theater. There are speakers to the left, center, and right in the front, and there are speakers to the left and right in the back to give the surround sound feeling. The sixth speaker is a subwoofer located in the front; that is the .1 of the 5.1 system. It is called .1 because it only carries the very low frequencies up to 120 Hz. That is one tenth (.1) of the bandwidth of the other five channels. To take advantage of the sound systems in theaters, movies need to have separate sound tracks that can be sent to each speaker location. Theoretically, movie sound could be **mono** with all six locations playing the same sound, but that is rarely the case. Historically, television broadcasts have been more likely than movies to be **stereo** rather than surround, but many people are now incorporating 5.1 audio systems in their homes, and surround sound is the standard for **HDTV**, so 5.1 (or even 7.1) mixes are becoming the norm for TV and film.[1]

Another matter that is more likely to be an issue with film sound than with video is the need to take into account foreign language dubbing. Film is the international standard because it has been around for so long and because the world has never established a worldwide television standard. If a movie (or a television show) is going to be distributed internationally, it is most likely going to be put on film at some point. This means that the dialogue for the film mix should be kept separate from the effects and music. If new dialogue in a foreign language is a possibility, dialogue should have its own track so that recording the foreign dialogue does not erase the effects and music. Dialogue is put on the channel going to the center front speaker of the movie theater, because actors who are talking are generally in the center of the screen.[2]

Incorporating Visual Effects

Effects that are created in a computer have never been on film, so before a movie can go to a laboratory for final printing, the effects must be transferred to film. This is done through one of a number of high-quality digital film systems. A film scanner digitizes the images of each frame at full resolution and then sends those images to a computer with special software to manipulate

Figure 14.1

A theater set up with 5.1 sound. The front left and right speakers give a stereo effect, and the back lefts and rights give the surround sound feel. The .1 subwoofer handles only low frequencies.

the images, correcting and improving them as need be. Then a film recorder copies these images onto film at full film quality (see Figure 14.2). In essence, the film camera records a high-quality image from a computer screen, although the process is actually more complex than that.[3] One of the complexities is that the effects may have been created in a system operating at 30 frames per second whereas film runs at 24 frames per second. Just as **three-two pulldown** is needed when film is transferred to video (see Chapter 10), so is **three-two pullup** needed when video is transferred to film. After the effects are placed on film, they can be given to the

Figure 14.2

This Cineon Digital Film System developed by Kodak includes a scanner that uses CCDs to digitize each film frame, a high-resolution video workstation in which digital effects can be manipulated, and a film recorder that uses red, blue, and green laser beams to place images back onto film. (Photo courtesy of Eastman Kodak Company)

Figure 14.3

Film is timed on this Hazeltine equipment. The equipment to the right prints out the tape with the timing numbers for the various shots. (Photo courtesy of Crest National)

negative cutter to incorporate with the original cut negative.

Digital film systems can be used for less complicated **visual effects** such as **dissolves** and **wipes.** When this is done, the short sections of the film that are to dissolve are manipulated in

a computer and printed to film that the negative cutter can use. If this is undertaken, there is no need for the negative cutter to prepare an A-B roll. The entire film can be glued together in one strip that includes the dissolves (and other effects).

Sometimes the video or film transfer process is used for an entire movie, especially if the movie is effects laden. The negative is not cut. The entire movie (whether it was shot on film or video) is transferred from its computerized video form onto negative film that can be taken to the laboratory where copies are made. The main drawback with this process at present is cost. It costs somewhere between $250 and $1,000 per minute to transfer from video to film, but as more and more movies adopt this pattern, the costs will no doubt decrease.[4]

Laboratory Work

Once all the material needed for the movie is prepared, it is sent to a laboratory. One of the first things the laboratory does involves **timing**. A **timer** at the film lab evaluates the negative for correct exposure and color balance (see Figure 14.3). For example, if a scene in the original footage was underexposed, the timer could indicate that. When the negative is used to make copies of the movie, the computer that controls the printer should open up the printing light to a higher intensity at that point. Similarly the timer helps control color shift by indicating the amount of red, blue, or green light to be used in the printing process. All the timer's decisions are printed on a tape that is then run through the computer controlling the printing. Computerized scenes should not need much timing because they would have been timed at various points along the way (during telecine transfer, nonlinear editing, or effects creation). But the original negative, which was stored away, will not have had this treatment.[5]

Next the negative is run through an ultrasonic process to remove any dirt or dust that it may have picked up. Then the negative is placed on a **contact printer** (see Figure 14.4) along with new, unexposed print stock. Both pieces of film pass (in "contact") past a light source. The light passes through the negative (according to

the instructions that have been placed on the timing tape) and exposes the **emulsion** on the print stock.

If the negative has been prepared as an A-B roll, the A roll is run through the printer first, and each of its shots is printed on the print stock (see Figure 14.5). When the printer light hits the black leader (which is so opaque that the printer light cannot pass through it), it leaves a section of the print stock unexposed. After the A roll is printed, the partially exposed print stock is wound back to the beginning, and the B roll is printed into the unexposed spaces left when the A roll passed through the printer. If a dissolve is to occur, the negative cutter will have placed shots on the A and B rolls so that they overlap slightly. Then, as the A roll is being transferred, the printer light can be faded out slowly on the shot that is to dissolve out. When the B roll is transferred, the printer light can fade up as the shot that is to be dissolved with the A roll shot is transferred.

The sound is also put on the print stock. This is not as standardized as the picture. A number of different sound systems have been developed for the enhanced sound in theaters, and different theaters have adopted different ones. The first one to be developed, back in the early days of film, was **optical sound**. This type of sound actually prints out on the film next to the picture frames (see Figure 14.6). Optical sound is usually stereo and analog, and just about all theaters have the capability for playing it. The other forms of sound are digital. One is Sony's SDDS system, for which digital data is placed on the outer edge of the film. Another system, Dolby Digital, places the information between sprocket holes. A third system, DTS, uses an external CD-ROM, but the time code to feed the CD-ROM drive is placed between the film frame and the optical track. Sometimes producers cover their bets and have the film lab incorporate all four types of sound on the film print, and sometimes they choose whichever ones they want.[6]

After the negative and unexposed print stock run through the contact printer with the sound being added, the print stock is developed and processed. The positive is called an **answer print**, but it is not necessarily the final version

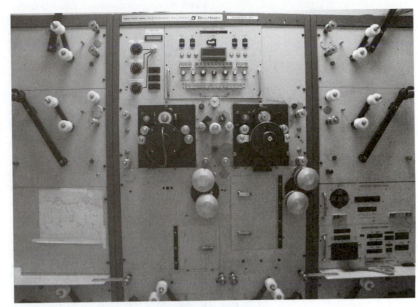

Figure 14.4

This contact printer is capable of making multiple prints of a film. (Photo courtesy of Crest National)

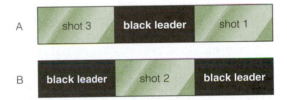

Figure 14.5

A-B rolls alternate successive shots in a checkerboard pattern from one roll to the next, filling the space between the shots with opaque black leader.

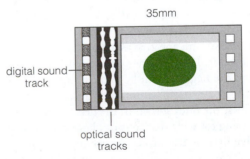

Figure 14.6

This frame shows optical sound and the Dolby form of digital sound.

of the movie. The director and timer usually look at the answer print. If the director does not like some of the timing decisions incorporated in the film, the negative can be retimed and printed again. This process goes on until the

Figure 14.7

The sound system on this projector accommodates five different types of sound. At the top is Sony's SDDS system. In the middle is DTS, which goes to an external CD-ROM. Close to the same area is Dolby Digital. The lower part of the camera has an optical sound reader, and in the middle of that is a magnetic head capable of reading the old magnetic stock. (Photo courtesy of Crest National)

Figure 14.8

These masks are inserted into the part of the projector where the light shines through to block out light and project the film at its correct aspect ratio. (Photo courtesy of Crest National)

director is satisfied—or until the producer says the budget can't take any more answer prints.

What happens next depends on how widely the movie is going to be distributed. If it is a student movie that is only going to be viewed in the classroom, the answer print may be the last one made. If only a few copies need to be made, then the negative can be run through the contact printer several times to print several **release prints,** the ones shown in theaters. If the movie is going for wide distribution, however, the negative may be used to make a number of **interpositives,** each of which, in turn, is used to make a larger number of **internegatives** from which thousands of release prints are made.

Film Projection

These release prints end up in the projection booth of local movie theaters. It used to be that one person, sitting in a projection booth with two projectors, threaded the first reel of the movie onto one projector and the second reel onto the other projector. Little white dots on the film frames indicated when the first reel was going to end, and the projectionist then started the second projector, loaded the third reel onto the first projector, and so on. Now, with theater complexes so common in malls, one projectionist, in a central location, operates movies for many individual viewing rooms. Each movie is usually on one giant reel that sits horizontally on a table and is fed up through the projector. The projectionist's job is to make sure each movie starts on time and to attend to any problems that might occur.

The modern projector needs to be fairly versatile because movies come with different sound and different film **aspect ratios.** Some projectors, such as the one in Figure 14.7, can handle all the forms of sound. Others, which are less expensive, can play back fewer forms. The solution for the various aspect ratios is simpler. The basic picture frame of a projector has a 4:3 aspect ratio, but masks can be inserted in the frame so that differing amounts of the film show depending on the aspect ratio for which it was prepared (see Figure 14.8).

Figure 14.9
This type of video projector is often used in the classroom to view productions students are working on or have completed. (Photo courtesy of Brian Gross)

The chain of events for film from production through exhibition is fairly complex. But it has worked for many, many years, and it will probably be a while before this current system is replaced by anything newer and shinier.

Video Distribution

If a movie is going to appear only on television, there is no need to go back to the original negative. The copy made through digital editing can serve as the master for television distribution. Several copies of the movie are then made so that there are protection copies, and the original material can be removed from the computer to make way for future projects.

As a student, you have many options for video distribution and exhibition. On the simplest level you can put the digital tape you outputted from your nonlinear editing system into a digital VCR and show it to a group of friends or classmates. You can either connect the VCR to a television set or to a video projector that can play back a large image on a movie screen (see Figure 14.9)

If your local cable TV system has a public access channel, you can probably arrange to show your movie there. You may have to dub from your digital tape to an analog format (**S-VHS, Hi-8**) to be compatible with your cable system's equipment. A number of cable networks accept (or even buy) short films to use as fillers between programs or to feature in programs about independent moviemaking.

Occasionally broadcast television stations air student or independent movies as part of a special program. Currently stations are most likely to be looking for material in the digital high-definition format so that they can program the material on the new frequencies they have been given as a transition from analog to digital TV. Depending on the subject matter, broadcasters in countries other than the United States may prove to be viable customers. If so, your material may need to be dubbed into the format, such as PAL or SECAM, used in that country.[7]

Video distributors, such as Pathfinder Home Entertainment and Baker & Taylor Video, can dub many copies of a movie (see Figure 14.10)

Figure 14.10
These VCRs are used to dub many copies of movies. (Photo courtesy of Crest National)

and distribute the copies to video stores. Sometimes they pay outright for the movie, and sometimes they pay the creator a percentage of the money collected through video sales and rentals. Most distributors still make both videotape and **DVD** copies of material, but DVD is fast overtaking **VHS.** Of course, you, yourself, can make videotape or DVD[8] copies of your movie and try to distribute it yourself by placing ads on the Internet or in appropriate magazines or newspapers. If you plan to put your material on DVD, it is a good idea to have something besides the movie, such as an interview with the director or "Making of" footage that can give viewers the extras they have come to expect on DVDs.

Netcasting

Increasingly the Internet is becoming a distribution path for movies. Five major movie companies (Sony, Warner, Paramount, Universal, and MGM) have joined together to offer feature-length movies through Movielink, a Web site that allows people to watch movies on their computer screens. They have started with a small group of movies, but they plan to test their system, get feedback from viewers, and then improve their offerings.[9]

As a student, it is even easier to put a short movie on the Internet. Web sites such as iFilm and the Independent Film Channel welcome independently produced films. You can send a digital or VHS tape copy of your movie, and they will prepare the material for their site. Others prefer the file you created in your nonlinear editing software.

You can also put the movie on your own site, perhaps your home page or a page provided by your university. An uncompressed movie takes a long time to download, so you will need software such as Media Cleaner or iCanStream to reduce your full resolution file so it can **stream** over the Internet quickly.[10] Most of this software can help you selectively decide what to compress while leaving parts of the movie uncompressed. For example, the software can analyze the movie and only compress the complicated parts, such as transitions, so that those parts will keep moving as they are streamed over the Net.

Companies are developing products aimed specifically at making productions for the Internet. For example, JVC has a camcorder with MPEG 4 compression, which is mainly for putting material on the Internet but also can handle other innovations such as movies delivered to cell phones.[11] In general, equipment is getting cheaper and easier to use, so independent moviemakers can afford to produce more movies and distribute them more widely.

If you don't want to put your entire movie on the Internet, you can build a **trailer** to advertise it on the Web. Some people have been successful at selling video copies of their works based on trailers placed on the Internet. On a more simple level, you can place frames of your movie on the Internet to advertise and promote it.

Festivals

If you can win a contest with your movie or have it exhibited at a film festival, you can build credibility and perhaps get a sale or recognition that will help you with your career. The most high profile of the festivals is Sundance, but festivals occur all over the world at all times of the year. Some are regional in nature, and others are for productions on particular subjects such as drug abuse or ecology. Some of them give prizes, and others just exhibit films. Getting feedback from people who watch your movie at a festival can be very valuable. You can visit the Web site www.filmfestivals.com to keep up to date on what is happening in the festival circuit.

A number of contests are designed specifically for student movies or cater to such productions (see Figure 14.11). Both the motion picture academy and television academy have prestigious student contests, and a comprehensive list can be found at www.studentfilms.com. Winning a contest greatly enhances a résumé, and some students have gotten their careers off the ground because someone viewing or judging a festival took an interest in their work and opened doors.

```
        SELECTED FESTIVALS FOR STUDENT MOVIES
Academy of Motion Picture Arts and Sciences Student Academy
Awards
        www.ampas.org/saa/index.html

Academy of Televison Arts and Sciences College Television Awards
        www.emmys.org/foundation/college.htm

Cotswold International Film and Video Festival
        www.cotswoldfilmvideofest.co.uk

David L. Wolper Documentary Student Achievement Award
        www.documentary.org

FilmFront International Student Film and Video
        801-484-2092

National Student Media Arts Festival
        716-442-8676

New York International Independent Film and Video Festival
        www.nyfilmvideo.com

Raw Energy: A Celebration of Student Film & New Media
        rawenergy.passport.ca

Telluride Indie Festival
        www.tellurideindiefest.com

University Film and Video Association NEXTFRAME Film and Video
Festival
        www.ufva.org
```

Figure 14.11
A partial list of video festivals of particular interest to students.

Other Possibilities

Some of the newer technologies allow short movies to be viewed on cell phones or on portable TV screens that can receive satellite signals. **Video-on-demand** may improve the market for movies. If movies are kept in a large database and people can access them whenever they choose, movies will not need the massive appeal they currently require. Films can be successful if they accrue an audience over a period of time rather than gathering them together for a mass showing.

Sometimes you can make something more than a movie out of your project. You might, for example, develop a video game based on the concept. Video games are big sellers, bringing in more money than movie theaters.[12] You can also distribute the music from the score for your movie, and, of course, there is always the possibility for **ancillary** products such as coffee cups, T-shirts, and the like.

Digital Cinema

The exhibition of film in movie theaters seems headed for changes of a digital nature. The process of making thousands of release prints so that a movie can open simultaneously in many theaters may someday be a thing of the past. Instead, movies may be projected digitally, in effect completing the digital evolution of moviemaking. Starting in the 1980s, digital technologies were used in editing, with nonlinear electronic editing replacing the cutting and taping of strips of film. About the same time,

the planning stage of movies evolved from pencil and typewriter to computer software, and most people involved with moviemaking paperwork now tote their laptops with them everywhere. Digital cameras, particularly the 24P high-definition digital variety, are making inroads in the production of movies. The area that has been least affected by digital technologies is distribution and exhibition, but digital cinema may be on the way.

A number of different processes are in development and, to some extent, in use. A digital signal can be sent to theaters via satellite or over wires, such as fiber optics. Or the movies can be placed on large hard drives and delivered to movie theaters. Depending on the means of delivery, the movies can be shown as they are received or stored on large servers at the theater complex and then shown as needed. The stream of digital data can go from satellite receivers, wires, or servers to digital projectors. These projectors are being developed and perfected by a number of companies, including Texas Instruments and Hughes. One basic design involves more than a million tiny mirrors, each mounted on a hinge that can tilt as many as 50,000 times a second. Some of these mirrors respond to digital data representing reds, some to blues, and some to greens. The 0s and 1s to which the image has been reduced instruct each mirror to pivot so that it either reflects or deflects the colored light needed for that image to appear. The light from the mirrors is recombined by a prism, magnified, and focused on the cinema screen to reproduce the image.[13]

There are a number of financial advantages and disadvantages to digital projection. The studios would be spared the cost of delivering film to theaters, about $2 billion a year ($1 billion to make all the release prints, and $1 billion to get the release prints to the theaters).[14] Of course, there are costs involved with digital distribution. If hard drives simply replace release prints, the savings of switching to digital would be minimal. Buying satellite time can be expensive, although not as costly as the current release print distribution system. Wire delivery is the cheapest of all.

Another cost to consider is the cost to convert all theaters to digital, which would be about $5 billion.[15] Individual theater owners would have to pay between $150,000 and $200,000 to convert each screen. And therein lies the debate. The theater owners say they do not have the money and that, even if they did, the conversion would not benefit them. They don't feel audience members will flock to movies just because they are projected digitally when they seem quite happy with the current film projection. The theater owners feel the studios should pay for the conversion because they would be the ones benefiting financially. The studios do not agree, but, at present, they seem willing to discuss and negotiate the conversion process.[16]

Even if movies are going to be shown on film, they can profit financially by using the digital process for release prints. Rather than cutting the negative and going from negative to interpositive to internegative to release print, the internegatives can be made directly from the computer.

Technically, many people believe digital video projection is inferior to film projection because video does not have as much resolution and is too stark. The opponents to this point of view counter that film, as seen in a theater, is not as high quality as video. Although the original film negative may be better than video, people sitting in a theater do not see the negative. By the time the film has gone through all the interpositive and internegative stages, the release print only has a resolution of 700 to 800 lines, and that is less than digital video. Also, the digital signal doesn't deteriorate over time. It doesn't get scratched or smudged as film does, and it doesn't fade. As digital production improves, so will digital projection because movie frames can be projected at the same resolution as they are shot. Digital video does have a different look than film, but video proponents claim that is a matter of taste and that audience members are not concerned with maintaining the "film look."[17]

As the debate rages on, digital cinema is making inroads. George Lucas distributed his new *Star Wars* movies— *The Phantom Menace* and *Attack of the Clones* (see Color Plate 8)— digitally as well as through the conventional film process. When *The Phantom Menace* was released in 1999, 8 theaters projected it digitally;

in 2002, 52 screens showed the digital version of *Attack of the Clones* (and 3,161 exhibited on film). Since then more theaters have converted to digital as other directors, such as Steven Soderbergh and Robert Rodriguez, also produce and distribute digitally.[18]

However, in the final analysis, the essence of the future of moviemaking will not deal with equipment but rather with how technology is used to accomplish an objective. Regardless of the method of distribution or exhibition, there must be a product that is worthy of viewing. What really matters in moviemaking, now and in the future, is how well an idea is brought to life.

Notes

1. "HDTV Users in Surround Sound," *TV Technology,* 19 May 1999, p. 42.
2. "Day-Date Worldwide Release," *Mix,* June 2000, p. 90.
3. "Cineon's International Success Is No Illusion," *In Camera,* Autumn 1995, p. 17.
4. "Lessons from 'Chelsea Walls,'" *TV Technology,* 10 July 2002, p. 20; and Bruce Mamer, *Film Production Technique* (Belmont, CA: Wadsworth, 2003), p. 17.
5. "New Heroes of Post," *Film and Video,* October 1991, pp. 58–60.
6. "Digital Sound in the Cinema," *Mix,* October 1995, pp. 116–129; and "Digital Sounds Off," *Hollywood Reporter,* 1 March 2000, p. S10.
7. PAL is a color television distribution system developed in Germany that is used primarily in Europe and in countries that were once British colonies. SECAM is a different color TV system that was developed by the French and is used mainly in previously Communist countries.
8. To burn a DVD, you need authoring software such as Impression DVD put out by Pinnacle.
9. "Online Movie Service Launches," *Los Angeles Times,* 11 November 2002, p. C1.
10. "iCanStream, You Can Stream," *TV Technology,* 9 August 2000, p. 28.
11. "Crunch Time for MPEG-4 Standard," *Electronic Media,* 29 October 2001, p. 9.
12. "Billion-Dollar Blitz," *Los Angeles Times,* 10 September 2001, p. C1.
13. "Hello, Mr. Chips (Goodbye, Mr. Film)," *Fortune,* 16 April 1999, pp. 138–139; and "Debate Brews Over Special 'K' Standards," *Daily Variety,* 9 October 2002, p. A10.
14. "The Digital Force Is with Big-Time Directors," *USA Today,* 5 August 2002, p. 4D.
15. Ibid.
16. "Hollywood 7 Unite to Push Digital," *Hollywood Reporter,* 14 March 2002, p. 1.
17. "Will Exhibs Get Hooked on 'Tronics?" *Daily Variety,* 4 April 1997, p. 28; and "Digitally Mastered," *Los Angeles Times,* 11 May 2002, p. C1.
18. "Star Wars: Episode II—From Set to Screen," *Hollywood Reporter,* 16 May 2002, pp. 14–15; and "Getting the Images to Theaters," *Mix,* June 2002, p. 88.

Glossary

Aaton dots A special form of time coding that Anton has for the cameras it manufactures.

above-the-line Refers to expenses for the many administrative, conceptual, and creative aspects of a specific motion picture, such as writing, producing, acting, and directing.

A-B roll A process that enables two pictures to overlap, either by printing two rolls of film or by overlapping two shots on a non-linear timeline.

AC Alternating current; usually used to refer to the power found in homes and offices.

Academy ratio The standard of three vertical units to four horizontal units adopted by the Academy of Motion Picture Arts and Sciences as the aspect ratio for movies; also a standard television aspect ratio.

accountant A person who keeps track of the expenses and other financial materials related to a movie.

actor A person who is on-screen in a movie.

AD See *assistant director.*

adaptation A movie script that is based on something else that has already been written such as a novel or a stage play.

ADR See *automatic dialogue replacement.*

ADR editor A person who decides which specific pieces of recorded dialogue need to be re-recorded.

ADR mixer A person who records actors as they are saying lines of dialogue that are being re-recorded because, for some reason, the dialogue recorded during production cannot be used.

AGC See *automatic gain control.*

alligator clamp A spring-loaded clamp that opens in such a way that it can secure a light almost anywhere; also called *gaffer grip.*

ambient sounds Background noise recorded asynchronously, either during production or at a different time, for use during editing.

amp A unit of electrical current or rate of flow of electrons.

amplification Boosting a signal by an apparatus that draws power from a source other than the input signal and then increases the essential features of the input.

amplitude The height of a sound wave.

analog A recording, circuit, or piece of equipment that produces an output that varies as a continuous function of the input. Analog recordings tend to degrade as material is transferred from one source to another.

anamorphic lens A lens that optically squeezes an image during filming and then unsqueezes it during projection to produce a widescreen aspect ratio.

ancillaries Products related to a movie, such as T-shirts or lunch boxes, that are not part of the movie but can be sold in conjunction with the movie, especially a successful one.

answer print The first semifinished version of a film that is obtained from running print stock through the contact printer along with the cut negative.

aperture The variable opening in a lens that controls the amount of light passing through it.

arc Moving a camera and its supporting device in a circular manner around an object.

art director A person who deals with the look of sets and other visual aspects of a movie.

ASA A rating system developed by the American Standards Association that refers to the sensitivity to light of different film stocks. See also *exposure index.*

aspect ratio The relationship of the width to the height of a picture; for example, most current TV screens are four units wide for each three units high, creating a 1.33:1 (or 4:3) aspect ratio.

assistant director In film production, the person who does work delegated by the director, such as conducting rehearsals or directing a second unit; abbreviated AD.

assistant editor A person who helps an editor by editing portions of a movie, preparing edit decision lists, and handling other duties.

associate producer A person who helps the producer by researching funding possibilities for the movie or helping with paperwork.

atmosphere sound General background noise recorded to add a certain feeling or sense of location to a scene.

attack The amount of time it takes a sound to get from silence to full volume.

audio mixer A board used to combine various audio inputs and then send them to other equipment; a person who combines sounds by using an audio board.

audiotape recorder A device that can be used to record, store, and play back sound.

automatic dialogue replacement Rerecording dialogue that for one reason or another was not recorded properly during production; abbreviated ADR.

automatic focus A device that continuously alters the focus control of a lens to keep the picture sharp and clear.

automatic gain control A device that continuously alters the strength of a video or audio signal to produce the best possible picture or sound; abbreviated AGC.

automatic iris A device that continuously alters the diaphragm of a lens to create the best exposure possible.

axis of action The principle that places an imaginary line between two people talking or the screen direction established by a walking character or moving object. If the camera is placed on one side of this imaginary line anywhere within a 180-degree arc, spatial continuity will be maintained; if the camera is placed beyond 180 degrees, screen direction will change on the cut.

back light A spotlight placed above and behind a person or object to make it stand out from the background.

background light A light that illuminates the scenery, giving depth to the scene; also called *scenery light.*

balance The relative volume of different sounds or the relative weight of different portions of a picture.

balanced Refers to cable that has three wires, one for positive, one for negative, and one for ground; also refers to a composition that has the same relative weight on both sides of the frame.

barndoor Black metal flaps placed on a lamp or lamp housings to block part of the light beam.

barney A soft, foamy case that dampens the noise of film cameras.

base The part of film that serves as a support for the emulsion.

base plate A light fixture that attaches to a flat surface to hold a light.

baselight level The minimum amount of light needed to ensure proper exposure by a particular imaging system.

batch capturing A method of putting footage into a computer wherein all the shots are first logged and then put into the computer as a group.

beat A small part of a scene where there is a change in direction or emotion.

below-the-line Refers to expenses, usually in the crafts areas, that could be associated with any movie, such as costumes, camera rental, set designers, camera operators, and transportation.

best boy A person, originally a local young man, who helps with lighting or carrying things on a movie set.

Betacam A ½-inch, professional-level video format from Sony.

Betamax The first ½-inch, consumer-grade video format, introduced by Sony.

bidirectional A microphone that picks up sound from two directions.

bit depth In digital audio, the number of tones per sample, usually 8, 12, or 16.

bit players Actors with five lines of dialogue or fewer in a movie.

black reference Something in a scene that is at the lowest level of the brightness range the camera can reproduce.

blimp A hard camera cover that softens the noise of film cameras.

blocking Placing actors and determining their movement within a particular shot; also called *staging*.

blue-screen A photographic or electronic process for creating different layers in a special effects shot. An actor or object is filmed against a blue (or green) backdrop. The blue drops out of the shot, and the actor (or object) is inserted into a separately photographed background, producing a seamless marriage of the two image layers.

BNC connector A bayonet-type video connector that uses a twist lock.

body brace A device that attaches to a camera and a person's body, enabling the person to hold the camera steady.

boom A long, counterweighted pole that holds a microphone; moving a camera and what it is mounted on up and down.

boom arm A device for mounting a lightweight light.

boom operator The person who positions the boom microphone before and during production.

bounce light Light reflected into a scene from a ceiling, wall, or reflector.

bracket To shoot a scene at several different f-stops above and below what you think the actual f-stop should be; to have actors play a scene with varying degrees of emotion.

breakdown To analyze a script to determine all the different elements (props, costumes, and so forth) that will be needed to shoot the movie.

brightness How light or dark a particular color appears on a black-and-white camera or monitor or how much light a color reflects on a color camera or set.

broad A rectangular floodlight that has an open-faced housing.

business Actions that actors perform while portraying their characters during any particular scene to add realism or emotion.

butterfly scrim A large piece of translucent black fabric or stainless steel mesh suspended from a frame to reduce the intensity of sunlight.

call-back Having actors who have already auditioned come back again so that the director and others can further assess their appropriateness for a role.

call sheet A list posted during production to let people know when and where they should report each day.

camcorder A single unit that contains both a camera and a videocassette recorder.

cameo A type of lighting where the performer is in a pool of light and the background is not lit.

camera assistant The person assigned to help the director of photography.

camera mics Microphones built into or mounted on video cameras.

camera operator The person who actually sets up and handles the film or video camera during production, doing such things as framing shots and focusing.

camera report A sheet filled out during production that lists the scenes and takes recorded and gives information about them as well as information needed for film processing and editing.

canted shot Picture composition in which the framing is not level with the horizon.

capacitor The element in a condenser mic that responds to sound.

capturing Putting footage into a computer so that it can be edited by nonlinear editing software.

cardioid A microphone that picks up sound in a heart-shaped pattern.

casting Deciding who will act the various roles in a movie.

casting director A person who gathers people to try out for particular parts in a movie and who sometimes makes decisions about who will play what roles.

caterers People who provide meals for cast and crew on a movie set.

CCD See *charge-coupled device*.

C-clamp A clamp with a screw that locks against a pipe or other support to hold a light.

center-weighted metering A light-metering system that measures light for the entire frame but is biased toward a rather small area in the middle of the frame.

character generator A device for creating titles and other graphics that can be either free standing or part of a nonlinear editing program.

charge-coupled device A solid-state imaging device (also called a chip) that translates an image into an electronic signal in a video camera; abbreviated CCD.

chrominance The color characteristics of a video signal.

cinematographer The person who has the overall responsibility of making sure all shots are properly lit and composed; also called the director of photography or DP.

clean room A spotless room with filtered air used to cut the original negative of a film.

clip capture A method of putting footage into a computer wherein each shot is put in separately as it is decided upon.

close-up A shot that isolates a subject in relation to the surroundings; abbreviated CU.

codec A device used to convert analog or uncompressed digital signals into compressed digital form and then decompress them back when needed.

color balance Refers to the way a film stock is manufactured to produce the correct colors in different lighting conditions (such as daylight or tungsten light).

color bars The colors red, green, blue, yellow, magenta, cyan, white, and black as shown on a monitor for test and setup purposes.

color circle A graphic representation of which colors complement each other.

color compensating filter A filter that compensates for subtle shifts in the color temperature of light.

color conversion filter A filter that converts daylight-balanced light for use with a tungsten-balanced film or electronic imaging system, or that converts tungsten-balanced light for use as daylight.

color correction Making subtle color changes in a video or film picture; sometimes called a *timing*.

color temperature A measurement, expressed in degrees Kelvin (K), that provides color information about light. The lowest numbers are reddish, and the highest numbers are bluish.

color temperature meter A piece of equipment that measures the Kelvin rating of a lamp.

color timer A person who adjusts the color of frames of film or video.

colorist A person who fixes small color problems in either film or video by adjusting timing equipment or functions.

colorization The process of making small color adjustments in film or video.

completion guarantee A type of insurance that covers expenses so a movie can be finished if its original funding is inadequate.

composer The person who writes the music that is part of the movie.

compositing Putting layers of pictures together, usually for a visual effect, in such a way that it makes a unified whole.

compositing supervisor The person who oversees putting various layers of pictures together in a computer.

compression A technique for placing more video information in less space, for example, by including only elements that change from one frame to another.

computer system engineer A person who keeps a computer system operating.

concept A brief written account of the basic idea for a story.

condenser A microphone construction that is based on moving a diaphragm which then results in changes in capacitance.

conductor The person who leads an orchestra when the music for a movie is recorded.

conforming Matching the camera original negative film to the editing list from the nonlinear editor.

construction coordinator A person who oversees the actual construction of sets in a shop environment.

contact printer A piece of equipment that prints film by running the negative and the unexposed print stock next to each other and past a light source so that the light passes through the negative and exposes the emulsion on the print stock.

continuity Consistent and unobtrusive progression from shot to shot in terms of screen direction, lighting, props, audio, and other production details.

continuity editing A cutting method designed to maintain a smooth and continuous flow of time and space from one shot to the next.

contrast The varying levels of brightness and darkness within a particular scene.

contrast range The range of the brightest area in the scene to the darkest area in a scene.

contrast ratio A ratio (for example, 8:1) of how bright the brightest part of a scene is in relation to how dark the darkest part is.

co-producer A term used when more than one person is equal as a producer for a movie.

copyright The exclusive right to a publication or production.

core A small round piece of plastic on which film is often stored.

costume designer A person who plans and creates what people will wear in a movie.

costume supervisor The person who oversees the creation of costumes and wardrobe.

costumer A person who sews costumes.

countdown Numbers (usually 10 to 2) on a tape or film just before the program material that are used for cuing.

coverage The amount of detail a director shoots of a scene so that there will be enough material to edit into a meaningful whole.

craft services People who supply snack food on a movie set.

crane A large piece of equipment that holds the camera and its operator and moves in many directions, including up and down; moving the camera and its supporting device up or down.

cross-cutting Editing back and forth from one location to another or one story line to another to imply that the two actions are taking place simultaneously; also called *parallel editing.*

crossfade To gradually bring in one sound while another is gradually fading out.

crystal The crystal-controlled timing element in film cameras and audiotape recorders that allows both to run at the same speed without a connecting cable.

C-stand A heavy-duty support for lights that is generally used for location shooting.

CU See *close-up.*

cue sheets Vertical lists that indicate when each sound of a movie should be brought in and taken out during the mix.

cut A transition that is an instantaneous switch from one shot to another.

cutaway A shot of someone or something not directly visible in the previous shot. It is frequently used to show some related detail or reaction to the main action.

cut-in A cut to a shot that isolates some element in the previous shot.

cuts-only A form of editing that only places one piece of material after another. It cannot involve dissolves or other transitions.

cutting-on-action Refers to shots edited so that action begins in the first shot and is completed in the second.

D1 A digital format introduced by Sony in 1986.

D2 A digital format introduced by Ampex in 1988.

D3 A digital format introduced by Panasonic in 1990.

dailies The unedited workprint of a film that comes from the lab each day, allowing the director and others to view their work before the next day's shooting.

daily production report A report, usually on a standardized form, that tells what was accomplished during each day of production.

DAT See *digital audiotape.*

DAW See *digital audio workstation.*

day-for-night Shooting during the day but making it look as though the footage were shot at night.

daylight Film that is manufactured so that it shows true color when it is shot in sunlight but needs a filter to show true color under artificial light; outdoor light.

dB See *decibel.*

DC Direct current; usually used to refer to battery power.

DCT The first compressed digital format introduced by Ampex in 1992.

decay The time it takes a sound to go from full volume to silence.

decibel A measurement of noise or loudness; abbreviated dB.

depth of field The area in which objects located at different distances from the camera remain in focus.

DFW See *digital film workstation.*

dialogue Words spoken by characters in the movie.

diaphragm The adjustable ring of a lens that opens and closes to allow more or less light to pass; an element in a microphone that vibrates to create electronic impulses in the form of sound.

diegetic sound Sound that comes from within the story space.

diffusion filter A filter that scatters light, making for a softer, less detailed picture.

digital Refers to a recording, circuit, or piece of equipment in which the output varies in discrete on-off steps so that it can be reproduced without generation loss.

digital audio workstation Computer equipment that can be used to record, create, store, edit, and mix sounds, all in digital form; abbreviated DAW.

digital audiotape A high-quality audiocassette format that records digitally; abbreviated DAT.

Digital Betacam A compressed format introduced by Sony in 1993.

digital film printer A piece of equipment used to transfer an image from a computer to film.

digital film workstation A sophisticated, powerful computer used to create visual effects; abbreviated DFW.

digital versatile disc A video disc with a large capacity for storage; abbreviated DVD.

digitize The process of converting an analog film or video image and/or sound into digital form.

dimmer board A device that reduces the intensity of light by varying the voltage supplied to the lighting instruments.

diopter A ring on a camera eyepiece that allows the viewer to adjust the view for less than perfect eyesight.

direct capture A method of putting footage into a computer wherein all the shots capture as they are viewed without first being logged or having inpoints or outpoints.

direct sound Sound that does not bounce and therefore sounds dead.

directionality A microphone's ability to pick up sound from a variety of locations.

director The person responsible for the overall creative aspects of a motion picture.

director of photography The person responsible for making sure all shots of a movie are properly lit and composed; abbreviated DP; also called *cinematographer*.

director's cut The edited version of a movie that includes the ideas and vision of the director.

dissolve The gradual fading in of one picture while another is gradually fading out.

distortion Muddy audio caused by recording a sound at a higher volume than the equipment can handle.

dolly A wheeled cart used to move a camera during shooting; moving a camera and its supporting device forward or backward.

dot A round piece of metal or cloth that can be placed between a light and a subject to create shadows or keep light from reaching certain surfaces.

double action Having the same movements appear in two consecutive shots.

double system A method of recording the sound on one piece of equipment and the picture on another.

DP See *director of photography*.

dropouts Areas where imperfections in the oxide leave small unrecorded portions on the audiotape or videotape.

duration The length of time a particular sound lasts.

dusk-for-night Shooting at twilight to create the effect of shooting at night.

DV See *Mini-DV*.

DVCAM Sony's ¼-inch compressed digital tape format.

DVCPRO Panasonic's compressed digital tape format.

DVD See *digital versatile disc*.

dynamic mic A microphone that creates an electrical current based on the motion of a

diaphragm attached to a movable coil suspended in a magnetic field.

dynamic range The degree of loudness and softness that a piece of equipment can accommodate.

echo Sound that has bounced off a surface once.

edge numbers Numbers along the side of film used to synchronize and to conform the camera original with what comes out of a nonlinear editing system.

edit decision list A step-by-step list of each video edit (usually based on SMPTE time code) to be made, along with a description of the material, including the reel numbers involved, whether the edit is to be a cut or a dissolve, and the duration of the edit; abbreviated EDL.

edit deck The VCR onto which material is recorded.

editor The person who cuts together the picture and principal dialogue of a movie.

editor's cut A version of an entire movie that is put together by the editor, often before the director has become involved with the editing process.

editor's script A script prepared by the script supervisor for the editor that includes information about each shot as well as the changes made in the script during production.

EDL See *edit decision list*.

EI See *exposure index*.

8mm A film format that was developed for consumer use.

electret condenser A type of condenser mic with a permanently charged backplate.

electrician A person who sets up lights for a movie; also called a *gaffer* or *lighting technician*.

electromagnetic spectrum The continuous frequency range of wavelengths that includes radio waves and light waves.

emulsion The film layer containing the light-sensitive materials that record the image.

equalization Emphasizing, lessening, or eliminating certain audio frequencies.

establishing shot A shot that orients the audience to a change in location or time.

executive producer The person who oversees a number of different movie projects.

exposure index A measure of the speed or light sensitivity of a film; abbreviated EI.

extendable lighting pole A device for mounting a lightweight light.

extra A person who is part of the atmosphere of a movie but does not have any distinguishable lines.

eyelight A small focusable light placed near the camera to add sparkle to a person's eyes.

eyeline match Matching two shots so that a person appears to be looking at the right person or in the right direction.

eyepiece The part of a camera that the operator looks through to see the shot being recorded.

fade To go gradually from a picture to black or from black to a picture; also, to go gradually from silence to sound or sound to silence.

fade-in To go gradually from black to a picture; to go gradually from silence to sound.

fade-out To go gradually from a picture to black; to go gradually from sound to silence.

fast film stock Film that is very sensitive to light but does not record a particularly rich range of grays.

fast lens A lens that can transmit a large amount of light. A fast lens requires less light than a slow lens.

field Half of a frame that contains a scan of the odd-numbered lines or the even-numbered lines of the 525 lines of a standard TV image.

fill light Light that reduces the shadows and high-contrast range created by the key light; a lighting instrument, typically open-faced, used for fill lighting.

film recording technician A person who oversees the transfer of movie material from a computer onto film.

film-style lighting Setting up a new lighting scheme for just about every shot.

filter A glass or gelatin that alters light; something that changes audio sound by cutting out or letting through certain frequencies.

filter box See *matte box*.

filter factor The degree of light exposure compensation needed for a particular type of filter.

filter wheel The part of a video camera that allows the operator to select the correct filter for different lighting conditions.

final cut The last edited version of a film or videotape.

finger A long, thin piece of metal or opaque material that can be placed between a light and a subject to create shadows or to keep the light from reaching certain surfaces.

FireWire A connection that enables digital signals to be sent from one piece of equipment to another.

fishpole A type of mic boom that consists of a simple pole held by an operator.

5.1 sound Surround sound that has front left, center, subwoofer, and right speakers, and back left and right speakers.

fixed lens A lens of a single focal length, as opposed to a lens (such as a zoom lens) with a variable focal length; also called a *prime lens*.

flag A rectangular piece of metal or opaque material placed between a light and a subject to create shadows or to keep the light from reaching certain surfaces.

flashback Portrayal of events that happened before events already shown.

flash cut A shot of just a few frames, the effect of which is almost subliminal, that can be used to present a brief image from the past or the future.

flashforward A cut forward to portray events in the future before returning to the point in the movie at which the time shift began.

flat In audio, a term describing frequencies picked up equally well; in lighting, a term describing placement of lights so that there are very few shadows; in set design, a large piece of wood or canvas stretched over wood that serves as scenery background.

flatbed An electrically powered film editing machine that is in a horizontal configuration.

flood To adjust a variable-focus lighting instrument to the position that allows it to cover a broad area.

floodlight A diffused light that covers a wide area.

floor stand A pole device that rests on the floor and is used to hold a microphone.

fluid head A mounting device on which a camera is placed that allows for smooth operation because it uses hydraulic resistance.

flying spot scanner A machine that produces a high-quality transfer of the film image to videotape and does not pull on the film.

focal length The distance from the optical center of the lens to the point in the camera where the image is in focus.

focus To make an image look sharp and clear.

fog filter A filter that scatters light from bright areas to areas with shadow, thereby lowering contrast and sharpness.

Foley Recording sounds, such as rustling dresses and footsteps, in sync with the picture; the room where this activity takes place.

Foley artist The person who performs the motions needed to create the sounds.

Foley editor A person who decides where Foley is needed in a movie.

Foley mixer A person who records what the Foley walkers do in the Foley room.

Foley setup sheet A list given to Foley walkers that shows when Foley sounds will be needed within a movie and what supplies will be needed to make the sounds.

Foley walker A person who creates the sounds in a Foley room.

font A particular letter style for graphics.

food stylist A person who makes sure that food on the set of a movie looks appealing or in other ways appropriate for the needs of the story.

footcandle The amount of light that is present 1 foot from a source of 1 candlepower.

forced development Increasing the developing time when film is processed so that underexposed film receives more exposure. The effect of forced development is to increase film speed; it is also called *pushed processing*.

formats The specific size or characteristics of particular film or video systems (for example, 35mm, Super 8, VHS, DVCPRO, Hi-8).

frame In film, a single picture within a motion picture; in TV, one complete scan, from top to bottom, of the lines of video information.

freeze-frame To stop (that is, freeze) the action on one frame of film or video and show it for a period of time.

frequency A measurement of wave movement expressed in cycles per second (hertz).

frequency curve A line indicating how well a particular piece of equipment picks up different sound frequencies.

frequency response The range of sound frequencies that a particular piece of electronic equipment is capable of reproducing.

Fresnel spotlight A light with a well-defined lens. The beam width is varied as the bulb is moved toward and away from the lens.

friction head A tripod head, the movement of which is controlled by a spring or sliding mechanism.

front focus Focusing the elements of a zoom lens so that the image will stay in focus throughout the zoom range.

f-stops Numbers that indicate the setting of the lens aperture.

fundamental Refers to the main frequency of a particular sound.

gaffer A person who sets up lights on a set or directs others on how to position and plug in lights; also sometimes referred to as an *electrician* or *lighting technician*.

gaffer grip A spring-loaded clamp that can secure a light almost anywhere; also called an *alligator clamp*.

gaffer tape Strong adhesive tape used primarily for securing lighting equipment.

gain The amount of amplification an audio or video signal receives.

gelatin filter A filter made of a soft substance from animal skins that is placed over lenses, lights, or windows or in filter holders placed between the lens and the imaging device.

generation loss A deterioration of picture or sound caused by dubbing material from one tape to another.

glass filter A filter that has gel cemented between two pieces of glass, or dye laminated between two pieces of glass, or dyes added to the glass during manufacture.

graduated neutral density filter A filter that darkens only part of a frame, usually the top.

graphic designer A person who design titles and other artwork for a movie, usually by using a computer.

graphics generator A stand-alone piece of equipment or part of a nonlinear editing system that can be used to create titles and designs.

greensperson Someone who keeps plants or other vegetation needed for a movie looking fresh and appropriate.

grid Pipes near a studio ceiling from which lights can be hung.

grip A person who does physical labor on a shoot, such as carrying set pieces, pushing dollies, and handling cables.

hair stylist A person who makes actors' hair look appropriate for the shoot.

handle On a nonlinear timeline, a node used to start or end a fade or to guide movement.

hard effects Sound effects that are synchronous with the picture.

hard light Light that has a narrow angle of illumination and produces sharp, clearly defined shadows.

harmonics Pitches that are part of an overall sound and are exact multiples of the fundamental frequency of that sound.

haze filter A filter that eliminates the bluish cast on overcast days.

HDTV See *high-definition television*.

head A device placed between a tripod and a camera that allows the camera to pivot smoothly; magnetic elements that can erase, record, or play information on or from a videotape or audiotape; extra material at the front on a video clip.

head gaffer The person in charge of other gaffers, electricians, or lighting technicians.

headroom The amount of space above a character's head in a particular framing configuration.

hertz A frequency measurement of 1 cycle per second; abbreviated Hz.

hidden editing See *invisible editing*.

hidden mics Microphones placed in the set so they cannot be seen.

Hi-8 An improvement on the Sony Video-8 format that uses metal particle tape and a wider luminance band.

high-angle shot A shot taken from above, looking down on a scene.

high-definition television　TV that scans more than 1,000 lines per frame and has an aspect ratio of 16:9; abbreviated HDTV.

high-frequency fluorescent　A type of light that outputs reds, greens, and blues in a consistent manner to produce 3,200 Kelvin light that oscillates between 25,000 and 40,000 cycles per second; also called *high-speed fluorescent*.

high hat　A camera mounting device that is close to the ground because it has very short legs.

high-key lighting　Lighting that is generally bright and even, with a low key-to-fill ratio.

high-speed fluorescent　See *high-frequency fluorescent*.

hiss　A distracting high-frequency noise often inherent in low-quality audiotape.

HMI light　A hydrogen medium-arc-length iodide lamp that is daylight balanced and therefore used to supplement the sun as a light source.

horizontal resolution　The common way of describing a video camera's ability to distinguish fine detail in a picture; the number of vertical lines per millimeter that can be distinguished by a camera imaging device or a monitor.

hue　The specific tint of a color, such as red or purple.

hypercardioid　Refers to a microphone that picks up in an extreme heart-shaped pattern.

hyphenate　A person who handles two jobs for a movie such as a producer-director or a writer-director.

Hz　The abbreviation for hertz.

image stabilization　A camera feature that makes for steadier shots by digitally magnifying part of an image and tracking it as the camera moves.

imaging device　The part of a camera on which the image gathered by the lens is focused.

incident light meter　An instrument that measures the amount of light falling on the meter.

inpoint　The precise location where an edit is to begin.

interlaced scanning　Combining two video fields in one frame by scanning all the even lines and then all the odd lines.

internegative　A copy of a film that is made from an interpositive and is used to make multiple release prints of the movie.

interpositive　A copy of a film made from the original cut negative that is used to make internegatives.

inverse square rule　The principle that light intensity decreases by the square of the distance from the subject.

invisible editing　A process that attempts to mask edits and make them unobtrusive; also called *hidden editing*.

iris　The adjustable metal diaphragm of a lens that can be opened and closed to allow more or less light to pass through.

jib-arm　A cranelike, counterweighted mounting device for raising or lowering a camera.

jog　An editing control that allows you to advance the video one frame at a time.

jump cut　A distracting break in continuity caused by a mismatch in object position, screen direction, action, setting, or other production details.

Kelvin (K)　The scale in degrees for measuring color temperature.

key grip　The person who is the head of the grips, directing them in what to carry or move.

key light　The main source of light in a typical lighting setup, usually a spotlight set above the subject and to the front and side.

keyframe　A representative point in nonlinear editing used to define movement; for example, to plot out the movement of a title or graphic in and out of the frame.

Keykode　Eastman Kodak's system for marking film so that the negative can be cut accurately; it identifies frames with a bar code that can be related to a time code for electronic editing purposes and afterwards be related to edge numbers.

kicker light　A light placed low and behind a subject to provide more separation of the subject from the background.

kino　High-frequency fluorescent lights, so named because Kino Flo is the main manufacturer of them.

latitude　The difference, expressed as an amount, between the brightest and darkest areas that can be faithfully reproduced by a particular film stock or video imaging system.

lavaliere　A small microphone, usually attached to a person's clothing.

lead　An actor who has a major part.

leader　Material that appears on a videotape before the program material; usually consisting of color bars, tone, a slate, and a countdown.

lead person　The person who supervises the set dressers.

leadroom　The space to the side of the frame that is in front of someone or something that is moving.

lens　The part of the camera that gathers light and focuses the image.

lens hood　A cover built into or attached to a lens to keep stray light out.

letterbox　A method for displaying a widescreen movie on a TV set where the top and bottom of the screen are black.

light meter　An instrument used to measure the amount of light falling on or reflected from a subject.

light stand　A device that holds lights, consisting of a tripod base and a pole that can be telescoped.

light-balancing filter　A filter that makes a slight shift in the color temperature of light.

lighting plot　A diagram showing the camera position, the set, and the location, size, type, and direction of the lighting instruments.

lighting ratio　The ratio of key light plus fill to fill light alone.

lighting technician　A person who sets up and connects lights on a set; also sometimes referred to as a *gaffer* or an *electrician*.

line inputs　Jacks built into equipment for connecting tape recorders, CD players, and other pieces of equipment (but not microphones).

line producer　The person who represents the producer on the set and makes sure all is being accomplished on time and on budget.

linear　Refers to video material edited together in sequence from beginning to end.

linear CCD array　A film transfer device using two different sets of CCDs (one following another) to scan the image. The first device (with four separate sensors) scans only the luminance information; the second device contains three CCDs, one each for the red, green, and blue information. Together they produce a very high-resolution image with an excellent signal-to-noise ratio.

location manager　The person in charge of finding places where a movie can be shot.

location scout　A person who often works for a location manager who actually goes to various sites to see if they would work for a particular movie.

log　A list of all the shots, in the order they are taken or the order they are to be placed in a computer, and a description of each shot; also, to make a list of shots.

logging　Selecting shots or parts of shots to be placed into a nonlinear editing system for editing purposes.

long lens　A lens with a long focal length that magnifies a subject and foreshortens distances.

long shot　A shot that emphasizes the surroundings and the subject's placement in them; abbreviated LS.

look space See *noseroom*.

loop Something that plays over and over such as one sound effect under a whole scene of video.

looping An old term for automatic dialogue replacement.

lossless A compression system that preserves all information so the clip can be restored to its original form when it is decompressed.

lossy A compression system that does not preserve all information and, therefore, cannot restore a clip to its original quality when it is decompressed.

low-angle shot A shot for which the camera is positioned low and angled up at the subject.

low-contrast filter A filter that scatters light in a scene so that it brightens shadows but does not reduce sharpness.

low-key lighting Lighting that is dark and shadowy with a high key-to-fill ratio.

LS See *long shot*.

luminance Pertaining to the brightness characteristics of a video signal.

macro A setting on a lens that allows it to focus on objects very close to the front element of the lens.

magnetic film A sprocketed audiotape used in film editing that had the same dimensions as the film and moved at the same speed.

makeup artist A person who applies cosmetics to actors so that they look appropriate for the movie being shot.

master shot A shot that covers an entire scene from an angle wide enough to establish all the major elements.

match cut A cut that provides a continuous sense of time and space between two shots.

matchmove Scanning a human movement pattern into a computer and then using that as a pattern for a computer-generated character.

matchmove artist A person who serves as a model of human movement for something that is further developed in a computer.

matchmove supervisor A person who oversees the process of using models to create movements that can be replicated and altered in a computer.

matte artist A person who draws background for movie frames that are largely computer generated.

matte box An adjustable bellows that attaches to the front of the camera and extends beyond the lens to hold filters or mattes that cut off part of the image; also called a *filter box*.

matting Placing one picture over another so that they look like one unified picture.

medium shot A shot that gives a sense of the subject and the subject's surroundings; abbreviated MS.

M-format A professional-level 1/2-inch video format developed by JVC.

MIDI See *musical instrument digital interface*.

mic inputs Jacks built into equipment for connecting microphones.

midside miking A stereo pickup method that combines bidirectional and supercardioid microphones. Also called *M-S miking*.

miniature designer A person who develops a small-sized version of something large that is shot on a set so that the smaller one can be used for effects or other purposes.

Mini-DV A digital tape format intended for consumer use.

miniphone plug A small audio connector most commonly found in consumer-level equipment.

mise-en-scène A theatrical term that describes the placement of scenery and actors. In film and TV it refers to the director's control of such elements as lighting, sets, locations, props, makeup, costumes, and blocking and direction of actors; in other words, it refers to everything that can be controlled before the camera comes into play.

Mr. Code Fuji's system of marking film so that the time code can be matched to edge numbers and the negative cutter can cut the film for a movie that has been edited on a nonlinear editing system.

mix See *sound mix*.

mixed lighting Lighting that contains daylight and artificial light.

mixer An audio board that combines audio from various sources and then sends it to other equipment; a person who combines sounds.

model maker A person who constructs smaller versions of sets and other elements of a movie that can be used to plan for the overall movie.

monaural Single-channel audio; also called *mono*.

monitor A TV set that does not receive off-air signals but can receive line level signals straight from a camera or a VCR.

mono See *monaural*.

montage editing Editing built on the relationships of the material being edited, such as size, theme, or symbolism, rather than its continuity.

morphing Gradually changing one video or film form into another, such as a man into a beast.

motif A particular musical refrain that follows a character or event throughout a movie.

MS See *medium shot*.

M-S miking See *midside miking*.

multitrack audiotape recorder An audiotape recorder that can record and play back a number (usually 4, 8, 16, or 24) of signals on separate channels.

music editor A person charged with figuring out where music should be placed in a movie.

music supervisor A person who finds non-original music for a movie and makes sure it is copyright cleared.

musical instrument digital interface A communication system that allows musical instruments and other electronic gear, such as digital audio workstations, to interact; abbreviated MIDI.

narration Nonsync audio that accompanies the picture, often commenting on what is occurring in the picture.

negative A photographic image that reverses the light values; in color, every color is reproduced as its complement; in black and white, dark areas are recorded as light and light areas are recorded as dark.

negative cutter The person who edits together the original negative for a movie being released on film using numbers generated during nonlinear editing.

neutral density filter A filter that reduces the amount of light reaching the imaging device without affecting the color in any way.

night-for-night Shooting at night to create the look of night.

noise Any type of unwanted audio or video interference.

nondestructive Digital picture or sound editing that does not physically alter or damage the original recording and keeps everything available even though it is not used for editing a particular shot.

nondiegetic sound Sound that is from outside the story space, such as the musical score.

nonlinear Refers to video material that can be edited without having to lay one shot after another; the end can be edited before the beginning.

normal lens A lens with a focal length that shows objects approximately as they appear to the eye.

noseroom The space to the side of a frame at which a person is looking, sometimes called *look space*.

NTSC The type of standard television transmission system used in the United States as originally approved by the National Television System Committee.

off-line Video editing that does not produce a final product but prepares material or code numbers for that final product, often

by using workprints rather than original footage.

off-line editor A person who makes a version of a movie on inexpensive equipment so the decisions made can later be made on an on-line system.

off-screen space Areas beyond the edge of the screen and to the front and rear of the frame that can be used to imply that an action or a sound is coming from somewhere just beyond the visible picture area.

omnidirectional A microphone that picks up from all sides.

180-degree rule The principle that places an imaginary line between two people talking, or the screen direction established by a walking character or moving object. If the camera is placed to one side of this imaginary line and anywhere within a 180-degree arc, spatial continuity will be maintained; if the camera is placed beyond 180 degrees, screen direction will change.

on-line Refers to editing that uses original material and actually prepares all edits for a finished master product.

on-line editor A person who edits the final version of material that is intended for distribution in video form.

on-set editor A person who starts putting together scenes at the shooting location shortly after the scenes are shot.

open casting General auditions that anyone can come to in order to try to obtain a part in a movie.

optical center The part of a lens where the image is turned upside down so that it can be sent to the imaging device.

optical printer A piece of equipment that prints film by projecting the camera original onto unexposed film stock.

optical sound A visual representation of film sound that runs along the side of the film and depends on the modulation of a beam of light.

opticals supervisor The person who oversees film-based visual effects that involve building layers on individual frames.

option When a producer pays a writer a small amount of money to obtain the rights to a script for a certain period of time to try to arrange for it to be made into a movie.

OS See *over-the-shoulder shot*.

outpoint The precise location where an edit is to end.

overlap cut An edit that is made so that the actor's lines are heard while something else appears on the screen.

overlapping action A method of shooting film or tape in which some of the action in one shot is repeated when the next shot is recorded. The technique is used to provide the editor with options.

overmodulation A signal recorded at a level higher than the system can handle, resulting in distorted sound.

over-the-shoulder shot A shot that looks from behind the shoulder of one character toward another character or object; abbreviated OS.

overtones Pitches that are part of an overall sound that may or may not be exact multiples of the fundamental frequency of that sound.

over-under method A way of coiling cable where the cable is circled around the hand but twisted with each circle.

package Several key people, such as a well-known actor and director, who are attached to a movie, mainly to obtain funding.

PAL A system of television transmission used in Europe and other parts of the world that has 625 lines of resolution and encodes color differently than the NTSC system of the United States or the SECAM system of Russia.

pan Moving the camera left or right on a tripod or by hand.

pan and scan A method for showing widescreen images on a standard TV set by eliminating portions so that the main elements are centered.

parabolic reflector A lamp housing that produces a concentrated beam of hard light.

parallel editing Cutting back and forth from one location to another or one story line to another, usually to show that two actions are occurring simultaneously but sometimes to compare or contrast two actions; also called *cross-cutting*.

peaking in the red Recording sound at such a high volume that the needle of the volume unit meter is almost always in the red area.

pedestal The control on a time-base corrector or other piece of video gear that sets the darkest level. Normally, this level is set to 7.5 percent on a waveform monitor.

perspective The spatial relationships established in regard to some source (audio or visual) within the picture.

phase The relationship of one sound wave to another, expressed in time; waves are *in phase* if they are at the same point in their cycles at the same time; they are *out of phase* if they are at different points.

phone plug A long slender audio connector often used for microphones and headphones.

phono plug A connector with a short prong and outer covering; also called an *RCA connector*.

pickup pattern The particular directions from which a microphone gathers sound.

pitch How high or low a particular sound is in terms of frequency.

pixel A light-sensitive picture element used to pick up and display video information.

playhead A marking on a nonlinear editing screen that shows what frame is being shown on the monitor and can be used to move the movie forward and backward.

point-of-view A shot that shows a scene as a particular character in the movie would see it; abbreviated POV.

polarizing filter A filter used to minimize reflections by influencing the angle of the light between the lens and a shiny surface.

positive Film that produces an image with lights and shades corresponding to those of the subject.

postproduction The stage of moviemaking that occurs after the shooting and that includes the editing and sound building.

POV See *point-of-view*.

practical light A light, such as a table lamp or lighting fixture, that is visible in a scene.

premix Certain sounds, such as multiple sound effects, mixed together before the final sound mix is undertaken.

preproduction The stage of moviemaking that involves making the decisions, plans, and budget for production and postproduction.

preroll The time during which VCRs get up to a stable speed during the linear editing process.

presence The authenticity of a sound in terms of perceived distance and fidelity.

prime lens A single-focal-length lens; also called a *fixed lens*.

principal actors The people who have the main speaking parts in a movie, usually the leads and the supporting cast.

print to tape Outputting video and audio material from a nonlinear editing system directly to videotape.

prism A device in a camera that breaks incoming light down into the primary reds, blues, and greens present in a particular video image.

producer The person who is in overall charge of a particular movie, especially the schedule and money.

product placement Having material with brand names showing in a movie in return for payment from the company that makes the material.

production The stage of moviemaking during which all picture and principal sound are shot.

production assistant A person who performs a variety of general tasks during the production phase of moviemaking.

production coordinator A person who assists the unit production manager with such chores as schedule breakdown.

production designer The person whose job it is to make sure the overall look of the film is consistent.

production schedule A detailing of the lengths of time allocated for various parts of the moviemaking process.

production sound mixer The person who records sound during the shooting phase of moviemaking.

progressive scanning Laying down video information from top to bottom to create a frame, as opposed to laying down two fields, which is done in interlaced scanning.

prop An item that is necessary to the plot of a movie.

property master The person who is responsible for acquiring props and making sure they are properly placed on the set.

proximity effect A phenomenon produced by certain microphones wherein low frequencies are boosted when someone speaks close to the mic.

public domain The legal condition covering copyright that states that when material is a certain age it can be used without having to pay or obtain permission.

publicist A person who sees that a movie is properly promoted and advertised.

pulling focus Manually changing the focus of a lens as a shot is in progress.

pushed processing See *forced development*.

pyro technician A licensed person who handles explosions and other fire-related effects needed on a movie set.

quartz lamp See *tungsten-halogen lamp*.

quartz-halogen lamp See *tungsten-halogen lamp*.

rack focus To change focus from one object or area in a frame to another during the course of a shot.

random access The ability to bring up audio or video material instantly, in any order, such as from a disk, without having to wait for tapes to rewind.

RCA connector See *phono plug*.

reaction shot A shot that shows someone responding or reacting to what someone else is saying or doing.

read through Having the actors read the script out loud without engaging in any action.

record deck The VCR onto which material is edited after receiving the signal from the source deck.

reel A round device for storing and unspooling tape or film.

reflected light meter An instrument that measures the amount of light bounced off a subject.

reflector A light-colored surface used for bouncing light back into a scene; often used for fill lighting outdoors.

refresh rate Showing a frame multiple times to give the picture the effect of greater resolution and stability.

release The amount of time it takes a sound to go from its sustained level to silence.

release print The final print of a film, the one that is shown in movie theaters.

Rembrandt lighting Lighting that emphasizes a particular item, such as a hand.

render A CPU-intensive process of creating multilayered graphics, animations, transitions, or effects in the computer.

re-recording mixer A person who records the final sound for a movie, mixing together dialogue, music, and sound effects.

resolution The degree to which fine detail in the image can be distinguished.

resolving unit A piece of equipment that uses the sync pulses recorded on ¼-inch audiotape to transfer the sound to magnetic stock so that it can be edited in sync with the filmed picture.

reverberation Sound that has bounced a number of times or has been processed so that it sounds like it has bounced.

reversal Camera film that produces a positive print when it is developed.

riding in the mud Recording sound at too low a level, one in which the needle of the volume unit meter is usually below 20 percent.

rigging grip A person who positions lights near the ceiling of a studio or other location.

ripple In nonlinear editing, the effect produced by one change in an edit, which automatically changes all the footage positions that follow.

room tone The noise or the general ambience where a movie is being shot, recorded during production to be used as background during editing.

rough cut A loose assemblage of the pictures and dialogue of what will eventually become the edited master of a movie.

rubber band On a nonlinear timeline, a line that extends up or down to indicate a fade or a movement.

rule of thirds The principle that, to make composition more dynamic, it is better to try to break a frame into thirds rather than halves.

safe area The area on a screen that will definitely show graphics if they are typed within that space.

sampling rate In digital technology, the number of times a particular signal is converted to 0s and 1s.

saturation The intensity or purity of a color.

scene A shot or series of shots presenting a unified action and occurring in a single place and time.

scene outline A list in numerical order of all the scenes in a screenplay, with a barebones description of what occurs in each scene.

scenery light See *background light*.

scenic artist A person who makes drawings and models of what a set will look like.

S-connector A video connector used to input and output luminance and chrominance information separately.

scoop A floodlight that contains a single bulb in a bowl-shaped metal reflector.

score mixer The person who records the music for a movie.

scratch disk An area in a nonlinear editing system that has commands that make everything related to one particular project go to that project and not to some other project.

scratch track Dialogue that is recorded during the shooting of a movie with the knowledge that it will not be used during editing but that it will serve as a guide to actors when they re-record this dialogue in an ADR session.

screen direction The spatial relationship established by composition or movement within the frame.

screen test Filming or taping actors to see how they will come across in general or in particular roles.

screenplay The final script for a movie that includes all the dialogue and action.

scrim A translucent black fabric or a stainless steel mesh used to reduce light intensity.

script breakdown A list of all essential elements of each scene, such as whether it is interior or exterior, the time of day it is supposed to take place, and the actors and props needed.

script breakdown sheets The forms on which script breakdowns are written.

script supervisor The person in charge of seeing that all parts of the script are actually shot and that continuity is maintained.

scrubber A feature available in many nonlinear editing programs that allows the user to hear or see an audio or video file as the mouse drags through it.

SDTV See *standard definition television*.

search dial The dial on an editing controller that allows the operator to find particular points on a tape by shuttling at various speeds.

SECAM A television transmission system used in Russia and other parts of the world that has 625 lines of resolution and encodes color in a different fashion than the NTSC

system of the United States or the PAL system of Europe.

second unit A group of production people who shoot scenes that do not involve the principal actors while those actors are involved in the main production.

segue An abrupt cut from one sound to another.

separation light A light that enhances the modeling and three-dimensional effect of the three-point lighting system.

sequence A group of scenes linked together or unified by some common theme, idea, or action.

serifs Tops and tails on alphabet letters in some fonts that lead the eye to connect the letters and give them a fancy appearance.

server A large computer that can be used to send the same material to many other computers.

set decorations Items that give an overall feel to a scene but are not essential to the plot.

set decorator A person who buys items to go on a movie stage or location and decides how they will be arranged.

set designer The person who plans and makes drawings that define the look and needs of any location areas or sets built specially for a movie.

set dresser Someone who places items such as pillows and vases on a movie stage or location.

70mm A large film format that is used primarily for high-budget films.

shock mount A device that keeps a mic stable, even if the pole it is on is moved.

shooting schedule A list of what is to be accomplished during each day of production.

shooting script The director's breakdown of a master scene script into individual shots with particular camera angles, movements, or positions.

shop manager A person who oversees workers who construct sets.

short lens A lens with a short focal length that makes objects appear smaller and farther apart than they appear to the naked eye; also called a *wide-angle lens.*

shot An element of a movie that begins when the camera starts running during production and ends when it stops running.

shotgun mic A microphone with a long, narrow pickup pattern that is used to gather sound from a great distance.

shot/reaction shot An editing pattern that cuts from some action or event to a character's response to it.

shot/reverse shot An editing pattern in which shots in succession mirror the framing of each other.

shoulder mount A device attached to the camera so that it rides comfortably on a person's shoulder.

shutter The part of a film camera that shuts out light while the film is moving from one frame to another; a control on a video camera that allows high-speed action to be shot without blurring.

shuttle A control on a VCR or in a nonlinear editing system that enables one to go through a tape with varying speed depending on how far the control tab is to the left or right.

signal-to-noise ratio The amount of desired audio or video a piece of equipment picks up in relation to the amount of unwanted electronic disturbance it picks up; abbreviated S/N.

silhouette lighting A form of lighting where the background is lit and the actors are not.

single system A method of recording sound and picture on the same medium.

16mm A film format used occasionally for professional shooting but more often used for educational purposes.

sky filter A filter that blocks out haze for black and white photography.

slate A tablet that provides pertinent information about a shot. It is held in front of a camera and recorded just before a shot is started. Also, an identification on a tape that precedes program material, listing such information as the length of the program and the director's name.

slow film stock Film that is not very sensitive to light but reproduces a rich range of grays and a sharp image.

slow lens A lens that cannot transmit a large amount of light. A slow lens requires more light than a fast lens.

S/N See *signal-to-noise ratio.*

snoot A metal funnel that restricts a light beam to a circular pattern.

soft contrast filter A filter that reduces contrast but preserves fairly dark shadows.

soft light Gentle, diffused, shadowless lighting.

softlight reflector A lamp housing (reflector) that blocks the light coming directly from the lamp and bounces it back into and off the reflector's surface.

softlights Lighting instruments that produce diffused light.

software engineer Someone who writes and debugs computer programs used for movie-making applications.

sound designer A person who develops the overall approach for the audio elements of a movie.

sound effects Noises that accompany what is happening on the screen, either synchronously or asynchronously.

sound effects editor Someone who acquires and compiles sound effects needed for the movie.

sound effects mixer Someone who records sound effects.

sound flashback The use of particular dialogue, music, or other sound to indicate within a movie something that happened in the past.

sound flashforward Particular dialogue, music, or other sound used to indicate within a movie something that happens in the future.

sound mix The final joining together in a single recording of all the sound elements of a movie so that they relate properly and are at the correct volume.

sound mixer A person who mixes or records sound.

sound recordist A person who records sound on the set.

source deck The VCR that supplies the video image and sound to the record deck during linear video editing.

source lighting Lighting that mimics the direction and source of the light that might actually be in the scene, such as sunlight that might be coming through a window, or a streetlight in a dark alley.

space-clamp A device for holding lights on shelves or other structures.

spatial compression A method of compressing video that saves space by not repeating digital information common to a number of frames.

special assistant A person who undertakes personal and professional chores for someone involved with a movie, such as a director or a particular star.

special effects Complicated actions, such as fire or flying people, done on a set that cannot be performed with ordinary materials.

special effects coordinator A person who is on a set to oversee any particular effects that need to be performed.

speech bump The phenomenon that allows a microphone to pick up speech frequencies better than other frequencies.

split screen An effect wherein one picture is shown on the left-hand side of the screen and another picture is shown on the right-hand side.

spot To determine where sound effects, ambient sounds, automatic dialogue replacement, Foley, or music should occur within a movie; focusing the rays of a lighting instrument to a narrower, more concentrated pattern.

spot meter A special type of reflected light meter that measures the light coming from a very narrow angle of view.

spotlight A concentrated light that covers a narrow area. It usually provides some means for varying the angle of the illumination by moving the bulb within the housing.

spotting The process of deciding where music, sound effects, and other sounds should go in the movie.

spotting sheet A paper compiled by a sound editor that indicates at what point in a movie sound effects, ambient sounds, automatic dialogue replacement, Foley, or music should occur.

sprocket holes Holes at the edge of film used to keep the film moving evenly through a camera or projector.

staging See *blocking.*

standard definition television The television system used in the United States starting in the 1940s that has 525 lines of resolution and a 4:3 aspect ratio; abbreviated SDTV.

standby A switch on a camera that allows the camera's circuitry to preheat without using full power.

stand-by painter A person available on a set to touch up an area that may need some paint.

stand-ins People who replace principal actors in a scene when equipment needs to be set up or changed.

star filter A special type of diffusion filter that turns a bright point of light in a scene into a bright star pattern.

Steadicam A counterweighted camera mounting device that allows extremely smooth handheld camera operation.

stereo Sound that is picked up and reproduced through two separate channels to simulate the way the ears hear.

still photographer Someone who takes photos on the set and otherwise that can later be used for publicity for the movie.

storyboard Drawings that show the main actions of a movie; in nonlinear video editing, the pictures on the computer edit screen that show a frame grabbed from each shot being used.

storyboard artist The person who draws pictures to show the main actions and elements of a movie.

stream To send material over the Internet in such a fashion that each computer receiving the output from the server can display the material; usually this is accomplished by first buffering material in the receiving computer(s) so that it will play smoothly as more material is sent.

strike To tear down and clean up after shooting.

stripboard A large board that summarizes the scenes, locations, and actors needed for each day of movie production, or a computer-generated simulation of such a board.

stunt coordinator A person on a movie set who oversees the execution of stunt performances.

stunt people People who undertake difficult or dangerous actions for a movie so that the movie stars do not need to do them.

Super 8 A film format developed for consumer use that has been largely replaced with video cameras.

Super 16 A film format that gives more picture space than regular 16mm by eliminating sprocket holes.

Super VHS A ½-inch video format that was enough of an improvement on VHS that it could be used by professionals as well as by consumers. Also referred to as *S-VHS.*

supercardioid A microphone that picks up in an extreme heart-shaped pattern.

supporting role An actor who has a fair number of lines in a movie but not as many as the lead actors.

surround sound A sound recording or processing technique that emphasizes spatial relationships, giving the audience a sense of the sound moving around them.

sustain The amount of time a sound is at full volume.

S-VHS See *Super VHS.*

sweetening Improving or in other ways working with sound during postproduction.

switcher A piece of equipment used to select or mix video inputs and send them to an output device such as a VCR.

sync To coordinate two elements, such as audio and video, with each other; in video, the electronic timing pulses that coordinate the scanning process.

synchronous sound Sounds recorded during production that need to be in sync with the picture, such as dialogue and some sound effects.

table stand A device that rests on a table and holds a microphone.

tail Extra material at the end of a clip or the end of a tape or film.

tailor A person who cuts and fits costumes and wardrobe.

take An indication of the number of times a certain shot is recorded; the first recording would be take 1, the second would be take 2.

technical rehearsal A run-through of a shot or scene that is held mainly for the benefit of the technical crew rather than the actors.

telecine A device for transferring film to tape.

telecine operator The person who operates the equipment that transfers film to tape.

telephoto lens A long focal length lens that magnifies and foreshortens a subject.

temp track Sounds that are put with the picture just to give an indication of what will be in place for the final movie.

30-degree rule The convention of changing the camera angle at least 30 degrees between two shots to minimize the apparent jump in size or volume when those shots are edited together.

35mm The main film format used for professional movies.

3-D computer artist A person who develops computer images that have shadows and in other ways appear to be three-dimensional.

three-point lighting A traditional approach to lighting that employs a key light, fill light, and back light.

three-to-one rule The principle that states that no two mics should be placed closer than 3 times the distance between them and the subject so that multiple mic interference will not occur.

three-two pulldown A process used when film is transferred to video to account for the fact that film runs at 24 frames per second and video scans at 30 frames per second; the odd film frames are transferred to two fields of video, and the even film frames are transferred to three fields of video.

three-two pullup A process that is opposite to three-two pulldown and is used when video is transferred to film.

threshold of pain The point at which sound hurts the ears, usually about 120 dB.

thumbnail A small picture of a frame of video footage that is used in nonlinear editing systems to identify the clip from which the frame came.

tilt Moving the camera up or down on a tripod or when handheld.

tilted shot See *canted shot.*

timbre The particular sound that each musical instrument or voice has, involving such characteristics as mellowness, sharpness, and resonance.

time code A system for marking frames that is used to sync various audio and video sources and is also used to identify particular spots in a movie. It has numbers to indicate hours, minutes, seconds, and frames.

time code generator A device that produces numbers indicating hours, minutes, seconds, and frames of video.

time code reader A device that displays on a monitor or other device the hour, minute, second, and frame numbers embedded in a tape or disk.

timeline A graphical editing interface common in nonlinear editing software in which thumbnail representations of video and audio clips are arranged along a display of the different tracks.

timer A person who evaluates each scene of a film or tape and then corrects for exposure and color balance as needed.

timing Making minor color corrections to a film or video image.

timing sheet A list that aids the music composer by providing the time code numbers for the places where music is to be heard, the length the music is to run, and a description of the scenes.

title designer A person who uses computer graphics to put together the opening and closing credits of a movie.

tonality The range of colors or black and white that a particular film stock reproduces well.

tone A high-pitched hum, usually coming from an audio board, that can be set at 100 percent to calibrate audio equipment.

track Moving a camera and its supporting device left or right, parallel to the subject; a portion of tape on which audio or video resides.

trailer An advertisement for a film that shows some of the scenes from the film.

transitions Methods, such as dissolves and fades, used to get from one shot to the next.

transportation captain The person charged with making sure people and things get to and from shooting locations.

treatment Written prose that gives the story line for a proposed screenplay.

trigger Part of a computer program that stores information about such sound elements as pitch, duration, and volume and then re-creates those, through MIDI, to activate electronic musical instruments.

trimming Changing an edit point slightly so the clip is a little longer or a little shorter.

tripod A three-legged device for supporting a camera.

t-stop Lens stop, similar to the f-stop, based on the actual amount of light transmitted through a particular lens.

tungsten Film that is manufactured so that it shows true color when it is shot in artificial tungsten-based light but needs a filter to show true color under outdoor sunlight; a term commonly used to describe artificial light.

tungsten-halogen lamp A light that has a tungsten filament and quartz envelope (bulb) filled with halogen. It maintains color temperature and brightness longer than regular incandescent lamps.

tungsten lamp See *tungsten-halogen lamp.*

24P A high-definition digital video format that captures the image at 24 frames per second just as a 35mm film does.

ultracardioid A microphone that picks up in an extreme heart-shaped pattern.

ultraviolet filter A filter that eliminates haze by blocking out ultraviolet rays; also called a *UV filter.*

U-matic A ¾-inch videotape format.

umbrella reflector Shiny material in umbrella shape that is attached to a light stand so that the lighting instrument can be turned into it and the light can be bounced off it, creating a diffused effect.

unbalanced Refers to cable that has two wires, one for positive and one for negative and ground; also refers to a composition with more relative weight on one side of the frame than the other.

undo Part of nonlinear editing software that enables you to go back to an earlier point in your editing.

unit production manager The person who breaks down a script and handles much of the scheduling and detail work of planning and production; abbreviated UPM.

UPM See *unit production manager.*

upright An electrically powered film editing machine in a vertical configuration.

UV filter See *ultraviolet filter.*

variable focal length lens A lens that can capture wide and narrow shots and everything in between; commonly referred to as a *zoom lens.*

vectorscope A piece of equipment that displays the color characteristics of the video signal.

velocity The speed of sound.

vertical resolution The number of horizontal lines per millimeter that can be distinguished by a camera imaging device or a monitor.

VHS A ½-inch consumer-grade video format introduced by JVC that became very popular.

video assist A tap off a film camera that displays what is seen through the camera eyepiece on a video monitor.

video assist operator The person who handles the tap from the film camera to a video monitor, sometimes recording the image onto videotape.

Video-8 A consumer-grade video format introduced by Sony, which uses tape that is 8mm wide.

videographer The person in video production who has overall responsibility for making sure all shots are properly lit and composed.

video-on-demand A system that allows a viewer to select a particular movie at an exact moment he or she wants to view it.

viewfinder The part of the camera that shows the picture that is being framed.

virtual set Background for a movie that is created in a computer and does not actually exist in a tangible form.

visual effects Complicated movie scenes that are created in a computer.

visual effects editor A person who creates computerized elements needed for a movie.

visual effects supervisor A person who oversees several people who are using computers to create elements of a movie.

VO See *voice-over.*

voice-over Words spoken by an off-screen narrator or character; abbreviated VO.

volt A unit of measure of electromotive force that equals the force required to produce a current of 1 amp through a resistance of 1 ohm.

volume unit meter A device, either with a meter and needle or a digital readout of lights, that shows how loud a sound is recorded or played back; also referred to as a *VU meter.*

VU meter See *volume unit meter.*

wall plate A light fixture with a flat surface that attaches to a wall to hold a light.

walla walla A background sound that involves recording people's voices so that the actual words they are saying cannot be understood.

watt A unit of electrical power that equals the power expended when 1 amp of current flows through 1 ohm of resistance.

waveform A visual representation of an audio or video signal.

waveform monitor A piece of equipment that displays luminance information about a video signal.

wavelength The distance between points of corresponding phases in electromagnetic waves.

white balance A control on a video camera that adjusts the imaging system so that it reproduces white (and therefore all other colors) correctly for a particular lighting situation.

white reference Something in a scene that is at the highest level of the brightness range the camera can reproduce.

wide-angle lens A lens with a broad angle of view that makes objects appear smaller and farther apart than they appear to the naked eye; also called a *short lens.*

widescreen An aspect ratio wider than 1.33:1, such as 1.85:1, 2.21:1, or 2.35:1.

wild sounds Asynchronous noise recorded separately from the picture and generally supplied during editing for background.

window Part of a computer screen on which one type of information appears.

window dub A copy of recorded material that shows time code numbers burned into a rectangular area somewhere in the picture area.

windscreen A metal or foam cover for a microphone that cuts down on small disruptive noises.

wipe Gradual replacement of one picture with another by having one picture push the other off-screen.

wire removal A generic term that refers to taking something out of a picture frame, but it usually refers to removing wires that have been used to make actors fly or in some other way hold them up.

wireless mic A microphone that operates on FM frequencies and has an antenna that transmits to a receiver. It does not require a long audio cable.

workprint A copy of the original film or tape footage used for editing so that the original does not become damaged.

writer The person who creates the script for a movie.

XLR connector A connector that has three prongs and an outer covering.

X-Y miking A stereo pickup method that uses two cardioid mics placed next to each other.

zebra stripe A pattern that appears in the viewfinder of a camera over material that is too bright for the camera's circuitry.

zoom To adjust the focal length of the shot on a variable focal length lens while the shot is being executed.

zoom lens A complex lens with variable focal lengths, adjustable in a range from wide to telephoto.

zoom mic A microphone that can be changed gradually from cardioid to super-cardioid so it can pick up sounds at different distances.

Index